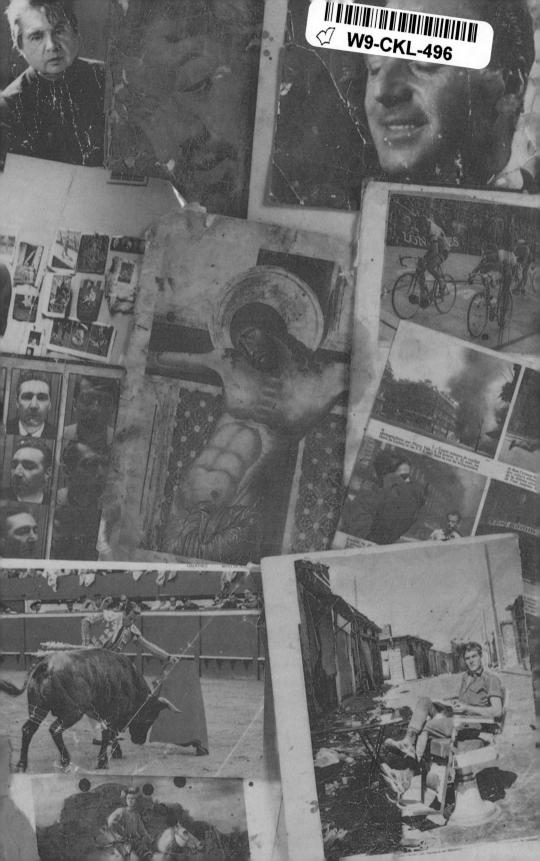

FRANCIS BACON

Anatomy of an Enigma

Mellin dos

MICHAEL PEPPIATT

FRANCIS BACON

Anatomy of an Enigma

Donation from the library of Jose Pedro Segundo 1922 - 2022 Please pass freely to others readers so that everyone can enjoy this book!

Farrar, Straus and Giroux New York

Farrar, Straus and Giroux 19 Union Square West, New York 10003

Copyright © 1996 by Michael Peppiatt All rights reserved

Published simultaneously in Canada by HarperCollinsCanadaLtd
Printed in the United States of America
First published in Great Britain in 1996 by Weidenfeld & Nicholson, London
First American edition, 1997

Library of Congress Cataloging-in-Publication Data

Peppiatt, Michael.

Francis Bacon: anatomy of an enigma / Michael Peppiatt.

p. cm.

Includes bibliographical references and index.

ISBN 0-374-10494-8 (cloth: alk. paper)

1. Bacon, Francis, 1909- . 2. Painters—Great Britain—

Biography. I. Title.

ND497.B16P46 1997

759.2-dc21

[B]

97-7554

CONTENTS

List of Illustrations Acknowledgements Preface		ix xiii
		PA
1	Origins and Upbringing, 1909–26	3
2	Educated Abroad: Berlin and Paris, 1926–28	23
3	A Brief Apprenticeship, 1928–33	43
4	'Insufficiently Surreal', 1933–39	60
5	A Vision Without Veils, 1939–44	77
PA]	RT TWO 1944-63	
6	Father Figures and Crucifixions, 1944–46	95
7	Towards Other Shores, 1946–50	111
8	Hounded by Furies, 1950–54	132
9	Truth Told by a Lie, 1954–58	153
10	Recognition at Home: The Tate Retrospective, 1958–63	176
PA	RT THREE 1963-92	
11	'A Brilliant Fool Like Me', 1963–69	199
12	All the Honours of Paris, 1969–72	233
13	Elegy for the Dead, 1972–75	243
14	'My Exhilarated Despair', 1975–81	265
15	Alone in the Studio, 1981–84	288
16	'The Greatest Living Painter', 1984–92	303
Postscript		317
Notes		324
Main Exhibitions		343
Selected Bibliography		345
Index		351

ILLUSTRATIONS

Between pages 142 and 143

Francis Bacon, photographed by John Deakin, 1952 (© Vogue)

Winifred and Edward Bacon, the artist's parents, c. 1910 (Private collection)

Francis and his mother, 1912 (© Private collection)

Francis with his younger brother Edward and their Firth cousins (Private collection)

Francis Bacon at Cannycourt House, Ireland (© Private collection)

Francis Bacon, aged 16, before he left for Berlin (© Private collection)

Jessie Lightfoot, the family nanny who lived with Bacon until her death in 1951 (© Francis Bacon Estate)

Furniture and rugs designed by Bacon, photographed in 1930 for *The Studio* magazine

Interior of Bacon's Queensberry Mews studio in 1932, showing wall-bracket, rug, table and sofa designed by him and left there (© Private collection)

Bacon photographed by Helmar Lerski, Berlin, 1927

Bacon photographed by Cecil Beaton in his Battersea studio, 1959 (Cecil Beaton Estate)

Working document from Bacon's studio of a charging rhinoceros (from Marius Maxwell's *Stalking Big Game with a Camera in Equatorial Africa*, 1924)

Working document from Bacon's studio of a corrida (Private collection) Working document from Bacon's studio showing a male patient during a fit of hysteria at the Salpêtrière Hospital, Paris, 1882

Working document from Bacon's studio of men wrestling by Muybridge Working document from Bacon's studio showing Hitler during the French campaign (Private collection)

Working document from Bacon's studio of an Egyptian death mask (Private collection)

George Dyer in the studio, photographed by John Deakin (© Francis Bacon Estate)

Peter Lacy, photographed by John Deakin ($\mathbb O$ Francis Bacon Estate)

Bacon with Dyer in Soho, photographed by John Deakin ($\mathbb C$ Francis Bacon Estate)

Lucian Freud, photographed by John Deakin (© Francis Bacon Estate)

Muriel Belcher, photographed by John Deakin (© Francis Bacon Estate)

Henrietta Moraes, photographed by John Deakin ($\mathbb C$ Francis Bacon Estate)

A previously unpublished paintbrush sketch of a raised chair with owls

A previously unpublished line drawing (c. 1960) after Picasso's portrait of the wounded poet Apollinaire

Picasso's pen and ink portrait of the wounded poet Apollinaire, 1916

Bacon with the French writer, Michel Leiris, 1970, photographed by Morhor (© Francis Bacon Estate)

Bacon with Michael Peppiatt photographed by David Hockney in Paris, mid-1970s

Bacon at the dinner given to celebrate the opening of his exhibition at the Grand Palais in 1971, photographed by André Morain (© André Morain)

Bacon photographed in his Reece Mews studio by Jesse Fernandez, c. 1980

Between pages 238 and 239

Crucifixion 1933 (Private collection)

Three Studies for Figures at the Base of a Crucifixion 1944 (Tate Gallery, London)

Painting 1946 (Museum of Modern Art, New York)

Head II 1949 (Ulster Museum, Belfast)

Pope I 1951 (Aberdeen Art Gallery and Museums)

Two Figures 1953 (Private collection)

Study of a Baboon 1953 (Museum of Modern Art, New York, James Thrall Soby Bequest)

Study for Portrait of Van Gogh VI 1957 (Arts Council Collection, Hayward Gallery, London)

Three Studies for a Crucifixion 1962 (Solomon R. Guggenheim Museum, New York)

Lying Figure with Hypodermic Syringe 1963 (Private collection)

Crucifixion 1965 (Staatsgalerie Moderner Kunst, Munich)

Portrait of Isabel Rawsthorne 1966 (Tate Gallery, London)

Triptych inspired by T. S. Eliot's Poem 'Sweeney Agonistes' 1967 (Hirshhorn Museum and Sculpture Garden, Smithsonian Institution, Washington D.C., Gift of Joseph H. Hirshhorn Foundation, 1972)

Two Studies for a Portrait of George Dyer 1968 (Sara Hildén Foundation, Sara Hildén Art Museum, Tampere, Finland)
Study for Bullfight No. 1 1969 (Private collection)
Triptych May–June 1973 (Private collection, Switzerland)
Triptych 1976 (Private collection)
Second Version of Triptych 1944, 1988 (Tate Gallery, London)

Front endpaper: Documents found on the floor of the artist's studio © Francis Bacon Estate

Back endpaper: Francis Bacon's studio photographed May 1992

© Francis Bacon Estate

ACKNOWLEDGEMENTS

I should like to thank the following people very warmly for their help and encouragement: Valerio Adami, Ronald Alley, Guy Andrews, Frank Auerbach, Kate Austin, Loredana Balboni, Peter Beard, Mary Rose Beaumont, Valerie Beston, James Birch, David Blow, Peter Bogdanovich, Sir Alan Bowness, Dr Paul Brass, Holly Brubach. Don Bruckner, Henri Cartier-Bresson, Narisa and Neil Chakra Thompson, Rudy Chiappini, Krzysztof Cieszkowski, Lydia Cresswell-Jones. Anne-Marie Crété de Chambine, Joe Downing, Jacques Dupin, Françoise Gaillard, Michael Gibson, the late Jaime Gil de Biedma, Alberto Giorgi, Colin Gleadell, John Golding, Claude Bernard Haim, Nadine Haim, Philip Herrera, David Hockney, Timothy Hyman, Ben Jakober, Barry Joule, Elsbeth Juda, Amanda Lee, Joan and Patrick Leigh Fermor, the late Michel Leiris, the late Helen Lessore, Gilbert Lloyd, Elizabeth Martin, Raymond Mason, Maria Massie, Pamela Matthews, Henry Meyrick Hughes, Henrietta Moraes, Richard Morphet, the late Hans Namuth, Janetta and Jaime Parladé, Ricardo Pau-Llosa, Ann Peppiatt. Jane Rankin Reid, John Richardson, Bryan Robertson, Deborah Roldàn, John Russell, Piers Russell Cobb, Harry Seydoux, Pauline and Frank Slattery, Jeremy Snoad, Angus Stewart, Antoni Tàpies, Nick Tite. Hervé Vanel. Lord Weidenfeld. Octavia Wiseman, Kim Witherspoon and Michael Wollaeger.

I should also like to thank the staff at the Courtauld Institute of Art Library, the London Library, the National Art Library, the Tate Gallery Library and the Tate Gallery Archive in London, and at the libraries of the Centre Georges Pompidou and the Musée Picasso in Paris. I have been greatly helped in my research by Alyson Wilson.

I am deeply grateful to Ion Trewin, Nick McDowell, Elsbeth Lindner and their colleagues at Weidenfeld & Nicolson in London: they have shared their admirable professionalism with me at every stage of the book. Jonathan Galassi and Paul Elie at Farrar, Straus & Giroux in New York have encouraged and guided this biography from the outset.

PREFACE

I first met Francis Bacon in the summer of 1963 when I interviewed him for a special issue on Modern Art in Britain for a student magazine I was editing called *Cambridge Opinion*. Several other artists who particularly interested me, such as Frank Auerbach, Lucian Freud and R. B. Kitaj, also featured prominently in the issue; none of us was aware of it then, but this turned out to be the first time that the views of a group of artists later called the School of London were brought together.

Francis was by far the best known, having just had his first retrospective exhibition at the Tate Gallery. I had heard that the easiest way to meet him was simply to wait in the French pub in Soho until he came in. I did just that, standing there for a long time before I found the courage to ask a small man sitting serenely on a bar stool whether he knew Bacon.

The small, smiling man first informed me that I had been lucky enough to meet the photographer John Deakin. Having quizzed me about my business, Deakin then announced, in arch tones that cut through the boozy talk and laughter: 'As a rule the *maestro* does not give interviews to *student* magazines. At least not now she has become so *famous*.' There was an instant commotion, and a man at the bar with a wide face and a quick, attentive stare turned round saying: 'Don't listen to that old fool. I *adore* students. It's marvellous to meet you. Now, what are you having to drink?' Nothing could have seemed simpler, and an hour later, with Deakin in tow, our interview began over a lunch of fish and white wine round the corner at Wheeler's.

The interview begun that day was to continue for the next thirty years. It grew into an obsession. Bacon fascinated me, not only because he opened up new worlds, but because he seemed quite free of the constraints under which most people live their lives. I became a kind of Boswell to his Johnson, accompanying him through Soho's private clubs, listening to him talk late into the night and meeting the people with whom he liked to let himself go. I learnt a great deal

about painting and about life; I also had tremendous fun. For Bacon, there was the attraction of being able to talk uninhibitedly to a young man who was a good listener and visibly under his spell. Because I spoke a number of languages, which he felt he was incapable of doing, Bacon also attributed to me an agreeable variety of talents. Sometimes, rather than follow the round of club, restaurant and casino, we met at the studio, where he liked occasionally to cook dinner. Even more occasionally, when he was pleased with the way his work had gone, he would let me see a new picture.

These were among my fondest memories of London when I went to live in Paris in 1966. I imagined I would see less of Bacon once I settled there, but Paris had always been the city where he most wanted to be recognized as an artist, and when his reputation was triumphantly confirmed by the Grand Palais retrospective of 1971 the city became his second home. I found him a small flat where he felt he would be able to paint, and from the mid-1970s I began to spend as much time with him as I would ever have done in London.

Throughout this period I noted down what Bacon told me about himself and his work. It had become second nature for both of us to fall into a conversation that moved easily from his memories to questions of aesthetics to gossip – unless Francis was too bad-tempered or hung over to want to say anything beyond a few bitterly reductive phrases. As our friendship deepened and my notes grew more copious, I began to consider the possibility of using them in a book. As an art critic I had written several essays about Bacon's work; but our conversations were also highly revealing about his life. I was well aware of how carefully he guarded against the possibility that his painting might be viewed (and, he feared, interpreted and trivialized) in the light of his own biography. Yet when the book was under way and I pointed out that much of the material I had gathered from our long talks might be considered indiscreet, the prospect seemed to delight him. 'Well, yes of course, you must be as indiscreet as you want,' he said enthusiastically. 'After all, that's what people are most interested in. The more indiscreet you are, the better the book will be.'

The book that I intended to publish, twenty years ago, was nevertheless not to be. As with several other projects to which Bacon initially lent his support, he drew back at the last moment, fearful – for all his recklessness – of revealing 'too much' about his life. Our friendship survived, and in his final years Bacon gave me his generous

Preface xvii

support and encouragement when I relaunched the magazine *Art International* in an attempt to revive some of the principles of the great French art magazines of the 1920s and 1930s which both he and I admired.

Bacon also continued to talk as openly as ever about his life. In one of our last dinners together he went off into a reminiscence which suddenly filled in a few precious spaces in the patchy jigsaw of his past. 'It might sound pretentious,' he said, as he had said so often before, 'but you see I have had the most extraordinary life. The life is more extraordinary than the paintings. You would have to tell the whole story, yet present it in a way that would undercut mere anecdote. There it is,' he concluded, flashing me the briefest of smiles, 'it would take a Proust to tell the story of my life.'

The book I have written here could not conceivably have been published during Bacon's lifetime. It is inspired by the friendship we had and based on records of the conversations that took place over thirty years. But beyond this it forms the first comprehensive account of the artist's life and his work, and the vital interaction between the two. Bacon was right. He did have an extraordinary, even improbable life. But the reason why we are interested in it is that he created such extraordinary pictures. The desire to know more about the background from which these images sprang is perfectly legitimate, however vigorously Bacon argued the contrary. We are confronted by a body of work which continues, like an unsolved murder, to pose the most urgent questions. It involves us intimately, challenging the sense we have of ourselves and the uneasy conscience of our age. With Bacon no longer present to decree that his work 'says' nothing and 'means' nothing, we are bound to want to explore the life out of which these images rose.

I have been fortunate to find a significant amount of new information about Bacon's family and his early years. I have drawn a great deal, of course, on what Bacon himself told me about his youth, but I have discovered, not altogether to my surprise, that his version of events was often dramatically edited. New facts have also come to light about his first trip abroad, which marked him for life, defining his ambition and his belief that images could transform the way people felt and thought. In Paris he discovered Picasso and the Surrealists, and they were to remain fundamental to his inspiration and his attitudes. Bacon was nothing if not a European artist, and

he was deeply attached to the notion of renewing tradition. He explored this by going as far back as Egyptian art, which he saw as an integral part of our culture. He was also deeply drawn to the most radical manifestations of what was new, whether it was Bauhaus design, *Ulysses* or the early masterpieces of Buñuel. Later he sustained his attachment to Paris by cultivating friendships with leading French intellectuals, notably with the writer and former Surrealist Michel Leiris.

But Bacon's aesthetic credo, like his formative years, is only part of a formidably complex sum. Within my simultaneous account of the life and the work, I have attempted to bring back something of Bacon's magnetic presence. He could light up the day with his wit and generosity; he could equally well plunge it into gloom; and part of the excitement of being with him lay in not knowing for long which way it would go. It was fascinating to watch such sudden changes and contradictions within one person. The man who flaunted his indiscretions publicly would also agonize about what a relative might think of his homosexuality. The painter of high tragedy was also a virtuoso of high farce, and after a tirade about the nothingness of life he would topple existential despair with one camp remark. The genial host who had spent a fortune wining and dining his friends often chose to return home by tube. Similarly, the Satanic figure in black leather who cut a swathe through Soho, pushing his luck with sadists and criminals, could also be surprised taking fruit to a sick friend in hospital.

Bacon could not be pinned down. The closer you got to him, the more likely he was to turn nasty or simply disappear – to go through a wall into a life where you could not follow. He was a past master at slipping from one situation, one social level, to another, and at being many things to many people. As he performed these feats, emerging from the underworld to charm a rich collector's wife, or surfacing from within a boxer's embrace to continue a discussion about Velázquez, he seemed inviolate. The enigma that he sought in his work surrounded him like a protective cloak, allowing him repeatedly to break the mould of accepted thought and accepted behaviour. Enigma was the source from which he drew his greatest strength and inventiveness. It was a magical gift, the secret of his genius, allowing him to live out the extreme contradictions of his nature and embed them in images of oracular power.

PART ONE 1909-44

Origins and Upbringing 1909–26

No mind can engender till divided into two.

W. B. Yeats

Even though he did not often mention his childhood, Francis Bacon acknowledged that it had been central to his whole development. 'I think artists stay much closer to their childhood than other people,' he told me on several occasions. 'They remain far more constant to those early sensations. Other people change completely, but artists tend to stay the way they have been from the beginning.' When talking amongst friends, the picture he gave of his earliest years and his family was extremely sketchy, but what came inevitably to the fore was his parents' lack of affection for him, and his own natural waywardness. The episodes which he chose to recount were usually accompanied by a manic laughter that invited his listeners to share his hilarity, as if the whole point of his childhood and his upbringing lay in their absurdity.

But a distinct underlying bitterness could be heard at times, with resentment welling up at particular memories. The dominant impression Bacon conveyed was that he had been ill-starred from the start by being born into a family which took no interest in him, and a social class in which he felt himself to be an outsider. This unhappy family life was to some extent tempered by its backdrop; and later on, although he was never to return there, Bacon would always speak with affection and admiration about Ireland and the Irish.

Francis Bacon was born on 28 October 1909 in a nursing home in the heart of old Georgian Dublin, at 63 Lower Baggot Street. His

parents, Anthony Edward Mortimer Bacon – known as Eddy – and Christina Winifred Loxley Firth – known as Winnie – already had one son, Harley, born four years previously; later two daughters, Ianthe and Winifred, and one further son, Edward, were born to them. Both parents were English by origin and had no Irish blood. Eddy Bacon had been born in Adelaide, South Australia, in 1870 to an English father, Edward Bacon, formerly a Captain in the Hussars, and an Australian mother, Alice Lawrence. The family returned to England not long after Eddy's birth and lived in the manor house at Eywood, Herefordshire, which had belonged to the family of the Earl of Oxford. Edward, Francis's paternal grandfather, was appointed a Justice of the Peace and Deputy Lieutenant of the county; he listed his occupation as 'resident landowner', maintaining a household of five children and seven servants.

Bacon's family on his father's side did not lack distinguished forebears. Ever since they became established in the early eighteenth century as iron-masters and colliery owners in Wales, the Bacons had claimed descent from Nicholas, the half-brother of Francis, the Elizabethan statesman, philosopher and essavist. Eddy Bacon himself was sufficiently certain and proud of this collateral connection to have the one-time Lord Chancellor's coat of arms on his dinner plates: he also mentioned that he had once owned some of Francis Bacon's letters, which he had sold to the Duke of Portland to pay a gambling debt. Francis Bacon the painter made little of his family's traditional claim. He was flattered enough by the idea of having such a famous ancestor, and amused by his namesake's well-known prodigality and homosexuality. What excited him most, however, was the notion that the philosopher-statesman might also have been 'Shakespeare', whose work he revered; and he was intrigued by the great essayist's experiments with refrigeration, since inventions of all kinds fascinated him. But he tended to question the claim and to maintain that there was no definite proof of the kinship.

If we search more recent generations of the family for traces of the character and qualities that set Bacon the artist apart, we can certainly find some in his great-grandfather, General Anthony Bacon (1796–1864). Having left Eton to join the 10th Hussars, this colourful and determined figure fought in the Peninsular War, then distinguished himself as the youngest of Wellington's officers at Waterloo. Later he formed a private army and entered the service of Don Pedro of Portugal, which left him impoverished since he never

received the money he had advanced to his soldiers. In the meantime, he had married Lady Charlotte Harley, daughter of the fifth Earl of Oxford, whose story adds an intriguing note to Francis Bacon's family history. Charlotte's mother (Bacon's great-great-grandmother) had counted among her numerous lovers Lord Byron, who grew deeply attached to Charlotte when she was a child. He carried a lock of her hair and dedicated *Childe Harold* to the beautiful young girl, whom he addressed as 'Ianthe'. The attachment was mutual and quite possibly passionate. When Lady Charlotte went to live in Australia she travelled in a coach that had belonged to the poet, with his coat of arms and his motto, 'Crede Byron', emblazoned on its doors.

Eddy Bacon remained very conscious of his family's history. He never forgot that Queen Victoria had offered his father the possibility of reviving the lapsed title of Lord Oxford; since the family had never recovered its fortune, his father had declined the offer, claiming that a title would double his bills. But Eddy gave his first son the Oxford family name, Harley, and commemorated Byron's homage to his grandmother by naming his elder daughter Ianthe.²

Eddy himself had come to Ireland by a circuitous route. After being educated at Wellington, a public school with strong military connections, he joined the Durham Light Infantry. As a young lieutenant, he was initially posted to Ireland, where he developed a lifelong passion for horses and hunting. Then, in 1902, as a Captain in the Fourth Militia Battalion, he was shipped out to South Africa to fight in the last stages of the Boer War; he saw action for four months, much of it on horseback, and he was later awarded the Queen's Medal with clasps. When Captain Bacon returned to England, he was stationed at the regimental depot in Newcastle-on-Tyne, where he met, and not long after married, Winnie Firth.

Francis Bacon's own recollections of his parents' marriage cast it in a most unflattering light. According to him, it was only when his father had first proposed to a wealthier relation of his mother's and been rejected that he considered marrying Winnie, with a view above all to the money she would inherit from her family's business, Firth Steel. Winnie accepted him in spite of vigorous opposition from her family. They were married in London, at St George's, Hanover Square, in 1903; the groom was thirty-three years old and Winnie only nineteen. Eddy Bacon had resigned from the army shortly before the wedding with the rank of Honorary Major, although he continued to style himself Captain Bacon. Fifteen years as an infantry officer had

fostered his innate belief in physical courage and toughness, but it had scarcely equipped him for civilian life. His keen interest in horses and field sports was undiminished, however, and, encouraged by the comfortable dowry his bride had brought to the marriage, he decided to try his hand at training racehorses.

The retired Captain had fond memories of Ireland from his hunting days, but above all he was aware that it would cost considerably less to set himself up there than in England. The first property the Bacon family rented in Ireland was Cannycourt House, a large, plain-fronted building with extensive stables situated near the small town of Kilcullen, in County Kildare, not far from Dublin. In the census returns for 1911, Eddy Bacon listed Cannycourt as consisting of eighteen rooms, occupied by the family and five servants, and twenty 'out-offices and farmsteadings' where the nine grooms lived and worked.³ But the property's main advantage, in Captain Bacon's eyes at least, was its proximity to the Curragh, one of the largest British Army barracks in Ireland and by extension an important centre for breeding and training horses.

By all accounts, life at Cannycourt House was not particularly agreeable. The house was run on military lines, with the emphasis on self-discipline, a regular routine and punctuality. The children were kept to the back of the house, and they rarely saw their parents except for half an hour after tea and, occasionally, for Sunday lunch. Eddy Bacon had time on his hands and he appears to have used it chiefly to tyrannize the household. He was remembered, not only by Francis, but by most people who met him, as opinionated, quarrelsome and rancorous. As a result, he always fell out with any friends he made, a serious handicap in the sociable world of breeding, training and racing horses. Although he had been quite dashing in his youth, photographs taken of Eddy Bacon in middle age show a sturdy, upright man with a hooded, supercilious gaze and a 'military' moustache: the only discernible similarities with his famous son are the powerful forearms, which he holds folded over his body, and the unusually large, fleshy hands. At home he was known and feared for his outbursts of rage, which were often prompted by such minor incidents as finding his boots not polished to his liking (the offending articles would then be hurled down the stairs). The retired Captain, who seems to have exuded a sour mixture of superiority and frustration, also had a moralizing, puritanical streak which, among other things, led him to ban alcohol from the house – an enforced abstinence for which his son would take spectacular revenge. On the other hand, the teetotal father gambled a great deal, particularly on the horses – which is something, as his no less censorious son remarked, that the best trainers do not do; and Francis himself described how he would be sent down regularly to the local post office to place his father's bets by telegram before the 'off' (which Francis, with an element of self-parody, pronounced the 'orf').

Musing over his childhood, Francis had little but negative comments to make about his father. He considered him an intelligent man who had never developed his mind and who had wasted all his opportunities, including the money his wife had brought to the marriage. Francis also emphasized how little liking or understanding there had been between father and son, particularly during his adolescence, when he was developing inclinations and ideas that could not have been more contrary to the conventional 'manliness' which Captain Bacon exemplified. Yet Francis remembered thinking his father was a good-looking man, and he experienced erotic sensations about him before he was even aware what sex was.

Winnie Bacon came from a background which contrasted sharply with her husband's. In place of fallen grandeur, with its hints of high office and lapsed titles, there was an exemplary North Country Victorian success story, characterized by hard work, shrewdness and a remarkable degree of philanthropy. Winnie's great-grandfather, Thomas Firth, established a small steelworks in Sheffield in the middle of the nineteenth century which grew into one of the world's biggest suppliers of castings for guns. Part of the fortune which his sons amassed by manufacturing cutlery as well was spent on providing Sheffield with almshouses, a public park (opened by the Prince of Wales in 1875) and Firth College, a large establishment devoted to higher education. Although money did not marry money in Winnie's case, her mother's sister, Eliza Highat Watson, had become the wife of Charles Mitchell, heir to a shipbuilding fortune; they lived in a vast neo-Gothic mansion called Jesmond Towers outside Newcastle, where her great-nephew Francis Bacon was to spend several holidays during the First World War. Winnie and her two brothers were brought up in an atmosphere of social ease and conventional respectability. Her father, who had been a Justice of the Peace, died at an early age, having suffered from chronic asthma, an affliction which Francis inherited; but even during his lifetime, John Loxley Firth had been overshadowed in the family circle by Winnie's mother, a lively,

strong-willed woman who later followed her daughter to Ireland where, in addition to remarrying twice, she developed the closest of friendships with her grandson Francis.

This flamboyant and forceful grandmother was the one relative about whom Bacon spoke with unreserved warmth and admiration. She had taken, as her second husband, a leading Master of Foxhounds called Walter Bell, whose cruelty to animals and to his own children, which included horsewhipping them, led her to divorce him. She then married Kerry Supple, whose post as the Chief of Police for County Kildare made them particularly vulnerable to attack during the Troubles, and they lived in an attractive house she had bought. called Farmleigh, near Abbeyleix. Granny Supple, as she was known in the family, patently disliked Captain Bacon, which may be one reason why Francis felt especially drawn to her. The freedom with which she conducted her life, marrying three times and entertaining on a lavish scale, impressed him, particularly in view of the social constraints of the time and the rigours of his own upbringing. 'She had this marvellous ease and vitality,' Bacon recalled affectionately. 'And she was all the more remarkable if you think of what life was like in Ireland then. She loved having lots of people around her all the time, and she gave these parties that attracted a great deal of attention. There was one I remember that the Aga Khan came to, and that did strike local people as very exotic.' As well as being an accomplished hostess, Granny Supple showed a remarkable gift for needlepoint: she had such an instinctive sense of form, proportion and colour that she made large compositions directly in crewel, without referring to a preparatory sketch or a pattern. Francis sometimes stayed for long periods at his grandmother's house, and they grew particularly close. 'My grandmother and I used to tell each other everything,' Bacon recalled. 'I was a kind of confidant for her, I suppose, and I used to take her to the hunt balls and other things that went on when I was an adolescent. I never knew what to do when we got there, of course. She went off dancing, and I just stood around and looked ridiculous, because I was so shy at that time.'

In Francis's memory, his own mother was something of a pale reflection of this expansive, gregarious woman. Photographs of Winnie around the time of her marriage to Eddy Bacon show an unusually pretty, dark-haired young woman with an open face, well-defined features and an air of knowing her own mind. She was renowned for her composure, fixing her friends with her cool blue

eves and making remarks like: 'If you go away for a month, my dear, don't be surprised when you come back to find another woman in your husband's bed.' Practical and not given to shows of emotion. she remained superbly unflustered whenever Eddy raged around the house, which she kept in immaculate order, making sure that the most unlikely nooks and crannies were dusted. Although he got on well enough with his mother. Francis was scarcely less critical of her attitude towards him as a child than he was of the Captain's wrathful, censorious ways. He liked the fact that she was much more easygoing than his army-schooled father and enjoyed entertaining, but he resented the way her own pleasures always appeared to take precedence over his needs as a small, unusually demanding and sensitive son. After his father's death, when his mother had remarried and settled in South Africa, Bacon's relationship with her improved considerably; he took pride in the fact that she had remade her life. and when, as a successful artist, he went out to visit her, he realized that some of the bitterness he felt about her and his childhood had faded away.

For a shy, delicate day-dreamer of a boy, certainly, there was little comfort in the strict daily round of the Bacon household and the immediate outer world of horse-racing and hunting. Because of his asthma and other recurrent ailments, Francis was considered from early on the sickly child of the Bacon family – the 'weakling', as he himself put it. This did nothing to endear him to his physically robust, military father, who insisted on putting him astride a pony and sending him off to hunt at every opportunity. Any prolonged contact with dogs and horses brought on an asthma attack so severe that Francis would lie in bed for days, blue in the face, struggling for each breath. It can never have occurred to Eddy and Winnie, as they watched their son being given liberal amounts of morphine to ease his suffering, that Francis would turn out to be exceptionally resilient as an adult, as well as the only one of their three sons to live beyond the age of thirty.

The lack of parental affection was to some extent made up for by a person whom Bacon mentioned rarely in later life but to whom he remained deeply attached: the family nurse, a woman called Jessie Lightfoot, who was thirty-nine years old when Francis was born and who later went to live with him – in a ménage of poignant eccentricity – for the last twelve years of her life while he was attempting to establish himself as a painter in London.⁴ Bacon's grief at the death

of this unlikely companion was so extreme that one close friend, the painter and writer Michael Wishart, wondered whether Jessie Lightfoot had not in fact been the artist's mother.

Disaster was the leitmotif of nearly every memory Bacon chose to bring up when he talked about his childhood. To be sure, it struck the Bacon family on several occasions. Their youngest son, Edward, suffered from a weak chest like Francis, but he was not endowed with the same resilience, and he died as an adolescent in 1927. Edward's lack of robustness, curiously, does not seem to have alienated his father, who showed rare affection for his youngest boy. Captain Bacon had set his heart on Edward's going into the army, thereby continuing the family tradition, and he was devastated by his early death. Francis remembered the loss as the only time he had seen his father express real emotion; nevertheless, once the son's death had been announced, no one in the family mentioned it again. As Francis's cousin Pamela Matthews (née Firth) remembers: 'Those things were heard and never discussed. You were just supposed to get on with your life.' Francis himself was convinced he knew why Edward had died. 'Edward had started going to the same school as I did, Dean Close in Cheltenham, and they asked for him to be taken away because he had been going with other boys. And then he developed tuberculosis, which as you know can be an emotional thing. There was no cure for the disease then, and he died.'

Captain Bacon's intolerance was by no means reserved for Francis. Harley, the eldest son, also crossed his father by becoming attached to the daughter of a hotel owner on the island of Anglesey, where the family had gone on holiday. 'My father thought it was quite impossible that my brother should be going with someone of that class,' Bacon recalled, 'so he sent him off to a job in South Africa. My brother worked there for a bit, then he went up to Northern Rhodesia and joined the police force. He was out somewhere with them while the Zambezi was in flood and he got lockjaw. They couldn't get him to a hospital in time and he died.'

Spurred no doubt by the feeling that their family had once been held in high respect in England, the Bacons were colonialists to the core. Captain Bacon's military service in South Africa set a pattern for the whole family: his eldest son and both his daughters moved to what was then Rhodesia; and after his death in 1940, his wife began a new life by remarrying and settling in the South African town of

Louis Trichardt. The older daughter, Ianthe, who had been born twelve years after Francis, married a South African farmer and brought up a family on a vast farm beside the Limpopo, in the southernmost part of Zimbabwe. After her husband's death, she moved down to Transvaal, where she lives today. Of all the children, only Francis did not follow the family pattern, in this as in so many other respects.

Bacon's earliest memory went back to the eve of the First World War. He was marching up and down an avenue bordered by cypress trees, exulting in the magic conferred on him by his brother's cycling cape. Disguise and concealment were frequent sources of delight. He remembered vividly hiding behind trees with two little girls because they thought Reggie, an older boy they had met at children's parties, was after them. "He's coming, he's coming," we used to tell each other,' Bacon recalled. 'He never came, naturally, and in a way we knew perfectly well he wouldn't, but for some ridiculous reason we used to love hiding there and pretending he might find us. Of course, being older, he was far too important to be bothered with us.' There was also the thrill of lying in bed, a small boy in an Irish country house, listening to the sound of bugles and hearing British cavalry from the Curragh on manoeuvres in the woods outside. It would not have been difficult for an imaginative child to visualize the splendidly uniformed men as they wheeled their horses round and crashed past each other in the dark; on one occasion that remained alive in Bacon's mind, a cavalry detachment rode up and down the driveway to Cannycourt before fanning out on a practice mission. The landscape surrounding the Curragh, a huge expanse of grassland echoing with the sound of rehearsed hostilities, was one that continued to exercise the painter's imagination. 'I was brought up for much of my childhood on the edge of very flat marshlands full of snipe and ployer,' he recalled when describing his early life. 'That's the kind of country I find exciting.'5

Once Germany had occupied 'little' Belgium and war had been declared in August 1914, Captain Bacon longed to serve his country yet again. At forty-four he was too old for active service, and his irascible temperament was too well remembered by former fellow-officers for his name to be put forward for any special duties. When he was offered a job at the Record Office for the Territorial Forces, he accepted, if only because he was offered nothing else. The family was accordingly transported to London, where they lived for most of the

war in Westbourne Terrace, a long, lugubrious stretch of porticoed houses near Paddington Station. Francis was barely five years old when this, the first of many Bacon family migrations, took place, and he had correspondingly few memories of the period. Nevertheless, it was his first contact with a big city – the only environment he would tolerate from the moment he was free to choose his own mode of life. The great iron-and-glass barrel vaults of Paddington Station constantly disgorged new arrivals into the capital, and the whole area, with its rented flats, small hotels and boarding houses, smelt of transience and anonymity. After the muddy paddock and the smell of horses which he would associate for ever with his asthma attacks, the small boy breathed in the stale city air almost voluptuously. The taste for maximum concentrations of humanity, where the flow of life and the variety of passion were greatest, was never to leave him.

The only place to recall the green pastures of County Kildare was Hyde Park, where Nanny Lightfoot often took the little boy for his daily walk. What struck Francis there was not the sweep of well-kept lawn but the men with watering-cans who walked up and down spraying everything in sight with a phosphorescent liquid that glowed at night, in the hope that it would trick the Zeppelins into dropping their bombs out of harm's way on the grass. 'Of course,' Bacon would add, sardonically amused, 'it never worked for a moment.' The most memorable experience, however, came during the black-outs, when searchlights raked the dark sky for Zeppelins. For a child with a vivid imagination, the notion of instant death falling in the night made a deep and lasting impression.

Throughout Bacon's boyhood, Ireland was the scene of deep social and political unrest as the movement for independence from Britain, represented by Sinn Féin, gathered strength, culminating in the Easter Rising of 1916. The Bacons themselves were English and Protestant, as was their nurse, Jessie Lightfoot; but all their domestic staff and seven of their nine grooms were Irish born and Catholic. Although political tensions do not seem to have developed within the Bacon household, they became an increasingly menacing feature of everyday life in Ireland. Once the Irish Republican Army was formed in 1919, guerrilla warfare broke out. As Bacon went through boyhood, the 'rebels' posed an ever-greater threat to landowners, particularly those, like the Bacons, living on isolated estates. The growing number of attacks on British military barracks were accompanied by raids on large private houses, which were pillaged and frequently destroyed.

The atmosphere of threat and violence, the fear of the sniper in the woods and the hidden bomb, made an indelible impression on Francis and shaped his early awareness of the outside world; later in life, when asked about the violence in his paintings, he would often recall the tensions that had plagued Ireland throughout his childhood. Francis had been above all conscious that his family represented the 'enemy', and he was forever being cautioned by his father not to talk to strangers and to keep an eye out for anyone roaming around the house. Eddy Bacon was particularly worried that his horses might be stolen and used by the IRA or that his children would give away some useful information. 'If they come tonight,' he would admonish them, 'say nothing.'

When the Bacon family returned to Ireland after having spent most of the First World War in London, Francis was sent to live for a while with his maternal grandmother and her husband, who as a policeman was a prime target for Republican attack. Farmleigh, their house near Abbeyleix, had to be sandbagged against possible raids. The sensation of living in a place that might come under fire at any moment of the day or night haunted Francis, who would have been barely ten years old at the time. Nevertheless, he remained unusually fond of the house, frequently referring to the beautiful curved rooms at the back which overlooked the garden; and he even accepted - in a rare admission of a direct influence - that the memory of those rooms may have given rise to the curved backgrounds in his triptychs. He also recalled the feeling of unreality he had experienced as a boy when the family car swerved off the road and bumped across fields to avoid the ditches that had been dug and camouflaged to trap motorists (those rich enough to possess a motor car being almost by definition the Protestant overlords).

During this period, reminders of the IRA could always be found in the green, white and gold pennants that were left fluttering in the trees. Occasionally the generalized threat erupted into a specific act of aggression. One incident that was engraved on Bacon's memory took place at night when he was driving home with his grandfather Supple. Their car got stuck in the well-named Bog of Allen, a site much favoured by the rebels because it served as a natural trap for vehicles. As the lean, tough-looking police officer and the frightened boy abandoned the car, the darkness came alive with flashing lights and wild hallooings which relayed the accident from one rebel group to another. Fortunately, the two were able to find their way to a big

house near by whose owners, guns in hand, cross-examined them before giving them refuge.

An awareness of life as a perpetual hunt – the stalker and his prev. the aggressor and his victim – was to be fundamental to Bacon. It was implicit in all his images, not only in the obvious example of his coupled figures lying entwined as if in mortal combat but in the more general context of the observer and the observed. Danger, of course, sharpens the senses, and being routinely on the lookout and, in imagination at least, spied on by an unseen enemy provided the most vivid framework for the young boy's fantasy. Later on, Bacon put into his paintings certain figures called 'attendants', whose only apparent function is to watch; their motive could equally well be sexual excitement or – like the hidden snipers – the desire to destroy. The sense of being under threat made a great impression on a mind which, by its very nature, hungered for strong sensations. Even at that tender age, Bacon must have instinctively sought them out and dwelt on them, since it is clear that his actual experience of war was no more traumatic than that of countless other young people of the time.

During her extended stay in England through the war, Francis's mother had renewed her contacts with her own family. She did not lack for relatives, since her grandmother, who was part French and whose husband had been a Northumberland colliery-owner, had seven children, and her own mother three, which created a complex network of relatives with several houses to which she could take her growing family to stay. One of the Bacons' escapes from wartime London was to Jesmond Towers, the home of Francis's great-aunt, Eliza Mitchell. A mass of pinnacles and battlements, this neo-Gothic country seat was never a graceful or distinguished building (it has since become a school); but it did contain, as its prime feature, a huge toplit room built specially as a picture gallery. Taking advantage of the family fortune, Charles Mitchell had himself trained as a painter in Paris and became a fairly successful artist, exhibiting at the Royal Academy and the Grosvenor Gallery towards the end of the nineteenth century. He had also formed a large collection of works by fashionable artists of the day, from William Etty and Lord Leighton to their counterparts in France. Although Mitchell was dead by the time Francis first visited Jesmond Towers, the collection still adorned the panelled gallery, and whatever the little boy's reaction to the rows of academic nudes, portraits and pastoral scenes (which represented just about everything Bacon came to loathe most in art), he would have been impressed by the central role accorded to painting inside his great-aunt's palatial residence.

The visits to Jesmond Towers rather belie the description Bacon himself gave of his childhood when he was first officially questioned about it, around the time of his exhibition at the Tate Gallery in 1962. 'I had no upbringing at all,' he told Sir John Rothenstein, then the Director of the Tate and the organizer of the exhibition. 'I used simply to work on my father's farm near Dublin. I read almost nothing as a child – as for pictures, I was hardly aware they existed.'6 This concept of the untutored lad, coming straight from the wilds of Ireland to produce a body of inexplicable, haunting images, is one that Bacon fostered throughout his life. To be thought of as a totally natural, uncultivated talent apparently suited Bacon's purpose, no doubt allowing him more freedom; and for that reason, perhaps, the fragmentary information he himself offered about his early years presented them as disaster-ridden and dangerous, with little comfort and no culture. During his lifetime, he also vigorously discouraged any attempt to look closely into his background, with the result that very little was known about it at the time of his death.

What makes Bacon's childhood exceptional, and exceptionally interesting, is the fact that we tend to see it through his eyes – in his occasional references to it, and above all through his painting. A distant, rather brutal father, a somewhat cold, self-centred mother, chronic asthma and an early death in the family, to say nothing of the tensions of war, are certainly not obvious ingredients for a happy childhood. But nor, in all probability, was it as desolate and harsh an upbringing as Bacon made out or his work leads us to imagine. The artist's temperament was fuelled by a need for high drama and extremity to feed his painting, and it coloured everything that came within reach.

At one point or another, Bacon referred to specific incidents of cruelty that had impressed themselves on his mind. His grandmother's second husband (who filled in the interlude before the Chief of Police arrived) was remembered for his sadistic tastes. He was particularly cruel to cats, cutting off their claws and tossing them to the Leix Hounds to stimulate their taste for blood; and when deep in his cups, he enjoyed stringing them up, then lurching round the house in so threatening a manner that his wife would scurry into cupboards to

get out of his way. Bacon also referred, somewhat melodramatically, to the screams of Irish prisoners that he thought he could hear as their British captors laid into them with a cat o' nine tails. But whether or not he actually heard the screams, he was aware of the atrocities being perpetrated by both sides and fancied he could all but see what he called 'the shadow of the hangman's noose' falling across the fields where he liked to play.

More disturbing, because the cruelty was so specific and was suffered by Bacon personally, is the story published after his death about his father arranging to have his small son regularly horse-whipped by the grooms. No reason for the punishment was given in this posthumous — and possibly exaggerated — account, but presumably it reflected the father's desire to 'make a man' of his sickly boy, just as he forced him to join a fox hunt in spite of the fact that horses and hounds triggered off the child's asthma. This illness undoubtedly strengthened Bacon's resolve, once he had grown up, to keep as far away as possible from any kind of animal and, with some rare exceptions, to shun the countryside entirely.

Bacon's lifelong asthma is an important key to his childhood and to his adult sensibility. Asthma ran in the family, and in later life Bacon frequently toyed with the idea of living for part of the year in a dry climate, like his maternal grandfather, John Loxley Firth, who had tried to relieve his own asthma by spending the worst of the winter in Egypt (a fact which his grandson remembered because the location sounded so alluring). For an asthmatic the simple process of breathing is a struggle; each attack is an ordeal to be overcome, and during Bacon's childhood little existed to alleviate the protracted suffering. Nevertheless, asthmatics generally acknowledge that their condition sharpens the will to live, making mere existence - what Bacon used to call 'conscious life' - a pleasure in itself, since it has been so arduous to achieve.8 The asthmatic tends as a result to have a special fund of optimism, simply in order to surmount a new attack; and once the attack has passed, the optimism does indeed seem justified. Bacon himself referred all the time to his 'optimistic nervous system' (while qualifying it as 'optimism about nothing' and maintaining a pessimistic view of life), and this can be understood more fully in the context of his permanent struggle with asthma.

If this early ordeal gives the asthmatic unusual resilience and reserves of stoicism, it also tends to form a character that appears

aloof from the daily miseries of living. A certain unfeeling superiority or ruthlessness certainly characterized much of Bacon's behaviour in later life, to the extent that many people who came into contact with him failed to see the instinctive compassion and the sometimes startling generosity with which he responded to those whom he liked or in some way felt responsible for.

The other, even more dominant factor in the boy's life, especially as he approached adolescence, was the growing awareness of his homosexuality. Its importance to Bacon's development, to his later life and to his vision as a painter cannot be overstated: one might reasonably say that, along with his dedicated ambition as an artist, his sexuality was the most important element in his life. Bacon would refer to himself as 'completely homosexual', someone for whom no doubt or wavering had ever existed. He himself recounted one banal youthful attempt at heterosexuality – with a prostitute who apparently ate chips while her client attempted intercourse; and he is reputed to have had sex, once and unsatisfactorily, with one of his favourite female friends and models, Isabel Rawsthorne.

These, however, were the exceptions that proved the absolute, homosexual rule. 'From as far back as I can remember I used to trail about after the grooms at home,' Bacon would say. 'I just liked to be near them.' That these grooms, with whom he admitted to having sex in his early teens, were also the ones who horsewhipped him is a tempting conjecture in the light of Bacon's sado-masochism and the tangibly violent sexuality that suffuses so much of his imagery. If indeed his father, to whom he was sexually drawn, ordered and witnessed the floggings carried out by the grooms, themselves a source of erotic excitement, then the complexity of emotion – of pain, thrill and humiliation – is sufficiently extreme to make any later violence, in life or on the canvas, almost too easy to explain.

Frankness about himself and his 'tastes' was a constant in Bacon's conversation. But although he accepted his homosexuality fully and made no attempt to disguise it, he openly regretted it on occasion. 'Being a homosexual is a defect,' was the way he put it in certain moods. 'It's like having a limp.' It is not clear whether his initiation to sex came from the stableboys or from encounters at boarding school; but from around the age of fifteen, Bacon would have been more precisely aware of the nature of his sexuality than most of his contemporaries. His early schooling had been chaotic and intermittent, firstly because of his asthma and general sickliness, and a

certain indifference on the part of his parents, whose restless and generally unmotivated shifts from house to house, between Ireland and England, exacerbated the situation; and secondly because Francis repeatedly ran away from the schools he had been sent to. 'I just couldn't seem to stay,' was his disarming summary of the situation, and he seemed to imply that his parents were not much concerned whether he received a proper education or not.

In the event, for long periods of his childhood, Francis was simply left to his own devices: as long as he avoided his father, he could wander about the large houses and extensive grounds at will. If he was not trailing after the grooms or spending time with his complicit grandmother, he was often to be found day-dreaming — an activity which remained with him all his life and which (as with the Surrealists who were so central to his development) enabled him to conjure up and 'work' on the images he wanted to create. But the day-dreaming was regularly interrupted. At one point, in Victorian fashion, his patchy and neglected education was entrusted to a local clergyman, whose interest lay as much in horses as in the classics and who left no discernible trace on Bacon's formative years.

What did inevitably affect the young Bacon, though he made light of it later, was the one relatively long stay – from the third term of 1924, just before his fifteenth birthday, until April 1926 – at Dean Close School in Cheltenham. The choice of this boarding school – less prestigious than Wellington, where his father had been – was dictated by the fact that his parents had momentarily settled near by in Gotherington, where they rented a property called Prescott House. This was typical of the imposing residences that his father favoured: it had been built in 1550 and enlarged during the eighteenth century, and it was famed locally because when Lord Ellenborough, once Governor-General of India, came to live in Cheltenham, he installed two 'concubines' there.

On arrival at Dean Close, Francis was put into Brook House — or Ellam's, as the house was called, after the master who ran it at the time. Bacon thought little of the teaching he received there and indeed of the school itself ('a *minor* public school,' he insisted witheringly), but this eighteen-month period nevertheless marked an important phase in his sentimental education. 'My parents did this awful thing of putting me at Dean Close in mid-term,' he told me with undisguised gusto. 'So I was led with them right the way down the dining hall where the whole school was sitting. And of course what's called all

conversation stopped and everybody just sat and stared at me. I felt I was finished after that and, once I was there, I just went wandering up and down the corridors, up and down the whole time, not daring to talk to anyone. Then this very nice-looking boy came up to me and said, "You can be my friend if you like." Of course I had no idea what he really meant by being his friend. I thought, how nice to have a friend. Then this other friend — a Persian boy — came along who had "developed early", as they say. It was all rather ridiculous, my life at school. But then, for some reason, I had always known that life was ridiculous. Even as a child, I knew it was impossible and futile, a kind of charade. I was a complete fool — I could never learn anything — but a sophisticated fool, and so I became a sort of clown and I got by because I amused the other boys. In the end I left Dean Close just before they asked to have me taken away."

If Dean Close did not leave a favourable impression on Bacon, the reverse appears equally true. Shortly after the artist's death, an obituary appeared in the school's old boys' magazine, the *Old Decanian*, with the following laconic tribute:

Francis Bacon's great achievements were all products of his post-school life. He retained friendships with several of his contemporaries at school, but had no happy memories of his time here and, alas, could not be prevailed upon to return.

One of the few contemporaries to have survived and to remember Bacon recounts simply: 'I can picture him walking round the school grounds with one other boy, and sometimes a second, both nameless to me now. He had few friends and never looked very happy or enthusiastic about anything. He made no mark at school.' The only other recollection by a fellow-pupil at Dean Close that it has been possible to find is much fuller, and worth quoting at length for the background it provides:

I first met Francis Bacon in the Boot Room at Dean Close School ... Due to an interest in the Turf we soon became friends albeit he was in Ellam's or Brook House (which I had already 'labelled' as Balliol College so 'up market' was it) whereas I was in the more earthy Neill's or Tower House and as happy in the School as Francis made clear he was not. I stress that I neither knew nor know why a boy should have in my time been less than happy at Dean Close School. It was a Christian School run by clever Christian scholars: it was austere, yes, but harshly

run – no. Francis was not in the OTC (Officers Training Corps) as I was happy to be; he took little or no part in games or at his desk work while efforts in School and House runs were moderate from all he told me. Put another way, he 'didn't fit', as he admitted to me some years later. He was not alone in being unhappy at the School: in my wide circle of friends others were, but Francis was in Brook House, easily the most comfortable of the four.

On the Staff for Art we had the later well-known painter Adrian Daintry with whom I was to become friendly but to my certain knowledge Francis never had one lesson from him. Strange surely bearing in mind the momentous Art event to come!

As I well recall him Francis was a pleasant-mannered, fresh-faced youth always affable but clearly seeking a friend and already fit to take his place with panache at any London Dinner Party or weekend House Party.

Eventually the end of a Term came when he told me he would not return but that we must try to keep in touch especially as we were both London bound. I left in 1929 and next saw him when he became Geoffrey Gilbey's racing secretary. Gilbey was a fine writer and a truly Christian man who may have tried to help Francis as he did me in those early years. I was often in Gilbey's Ormonde Gate home but in 1932–33 Francis told me he was attracted to Berlin, Art, and life, so we did not meet for some years: in busy Newmarket to be exact in 1946 – fleetingly, in the main street outside the Jockey Club's rooms there – when I had been in and out of the Royal Marines.¹¹

After the family's return to Ireland at the end of the First World War, Eddy Bacon had bought Farmleigh House from his mother-in-law, the grandmother with whom, of all his relatives, Francis felt the most natural affinity. Despite the fact that his father and grandmother did not get on, Bacon recalled in later years that 'they were always exchanging houses with one another'. But the Bacons were never satisfied for long with any of their numerous addresses, however attractive they sound. 'There was a period when they were forever vacillating between England and Ireland,' the artist remembered, without much warmth. One further migration to England took them briefly to a house called Linton Hall, situated on the border of Gloucestershire and Herefordshire. Then they returned to Ireland and established themselves at Straffan Lodge, another agreeable mansion set in open grounds near Naas, not far from Dublin. Finally, well

after Francis had left the family fold, they returned once again to England, settling in Bradford Peverell, near Dorchester, where they stayed until Eddy Bacon died.

Eddy Bacon's horse-training ventures never prospered. Being selfopinionated and quick to find fault, he quarrelled with almost everybody who came close to him. His son Francis would describe him later with considerable disdain as a 'failed horse-trainer', who spent much of his later life obsessively twiddling the cat's whisker on his wireless set from one far-flung, incomprehensible station to another. After the death of his favourite, youngest son, Eddy found no satisfaction in family life either. Although - and perhaps to some extent because – his wife had provided most of the means to keep the family during their wanderings from mansion to mansion. Eddy apparently showed little affection for Winnie, and the marriage never developed into a satisfactory relationship. Francis had always been something of a thorn in his father's side. It was bad enough that he had choking fits and turned blue in the face whenever he came into contact with hounds or horses. It was worse when he began mentioning the fact that he might want to become an artist of some kind. because that, in the Captain's mind, could only signify unmanly decadence and penury. Worse still were the rumours that Francis had been about to be expelled from Dean Close for 'going' with other boys. Relatives had already remarked, in all innocence, 'how like a girl' Francis could look. For fancy-dress parties in the family circle, he would appear as an Eton-cropped flapper, complete with backless dress, beads, and a cigarette holder so long it reached to the candles in the middle of the table. Dressed as a curate, his father stared uneasily and said nothing as Francis rolled his eyes, shook his earrings and made all the women laugh; he was too confused to know how to react. But finally, when Captain Bacon came across the effeminate, wayward sixteen-year-old trying on his mother's underwear, his self-righteous wrath knew no bounds: Francis would have to go. He had been obliged to leave school. Now he would be 'expelled' from home.

Francis Bacon regularly recounted this final break with his father as if nothing could be more hilarious – a particularly absurd chapter in what he called his 'ridiculous and ghastly' life. But his father's disgust and dismissal wounded him deeply, in a way that he was never able to forget. Before his life had really begun, he had been rejected by his own kin and branded as an outsider. The extreme

humiliation, in someone who even as an adolescent was not unaware of his superior gifts, would find expression in an equally potent rage — which encouraged him to rebel against his father's world (with all its claims to great ancestors) and cause a shock as sharp and enduring as the pain it had given him. Despite his sensitivity, his wayward instincts and his brilliance, the son was to prove tougher and more unrelenting than the father. Having been made an outcast, the defiant young man set himself in fearsome opposition. Nothing could have concentrated a naturally refractory temperament better: from the moment of his rejection, Francis Bacon set out to take rebellion to its furthest extreme.

Educated Abroad: Berlin and Paris 1926–28

To find yourself you need the greatest possible freedom to drift.

Francis Bacon (in conversation)

The abrupt banishment from home when he was no more than sixteen left a lasting scar on Bacon. At the crucial moment when he had begun to explore his sexuality, he had been rejected by a father who responded to him with outraged disgust. In less harsh family circumstances, a child of his unusual temperament and unconventional tastes might have been given more leeway to come to terms with his 'otherness'. Here, the adolescent's destiny as an outsider had been dramatically revealed and accentuated by his own father. But if expulsion wounded the boy deeply, it also hardened his resolve to uncover and develop his real instincts, however 'unmanly' they might seem, and follow them as closely as he could.

His main ambition at the time, Bacon later recalled, was to do 'nothing': to let himself go with the drift of his nature and see where that took him. From early on, he believed that the two great shaping forces in life were instinct (which, in his view, most people never explored fully) and the huge element of chance that underpinned all existence. As a boy, he already had some glimmering of both. Being naturally intuitive and having spent so much of his childhood wandering around and day-dreaming, Francis was more in tune with his impulsive, contradictory temperament than most adolescents; and the constant shifts between houses and countries against a background of war had heightened his awareness of life as a series of hazards.

Given that the young man wanted to put as much distance between himself and his punitive father as possible, London seemed the obvious place to go. Since living there as a small child, he had always maintained some contact with the metropolis, partly through relatives, partly through acquaintances struck up while at school in Cheltenham. His fellow-pupil, as we have seen, remembered he was sufficiently sophisticated to hold his own at a London dinner party, and that he had found employment as a 'racing secretary' (contrary to Bacon's own description of himself during this period as paralysingly shy). Shortly after arriving in London, it is true, the young man embarked on a bizarre series of brief odd jobs - many of them no doubt coming his way through the homosexual underworld to which he automatically gravitated. Before Francis left home, his mother (who seems to have accepted her son's departure with stoic practicality) had agreed to provide him with three pounds a week from her family trust fund, a sum which at the time would have easily covered his basic needs, but not his precocious taste for extravagant living. Since pleasure was very much on his mind, he used any expedient he could to make a little more money and enjoy himself.

'I can't say I was what's called moral when I was young,' Bacon said to me, describing his stay in London through the autumn and winter of 1926. 'Morality is a luxury that has come on me with age. I think I just did whatever I could to get by. I'd always stolen money from my father whenever I could. And when I got to London I'd often take a room and not bother to stay and pay the rent. And then although my parents had always told me that I was ugly, I found that some people were attracted to me and thought that I was pretty at that age. So I decided to do everything to get people to take a fancy to me, and I didn't very much care what happened after that. I remember once, when I was absolutely broke, I got myself picked up by a man in Dover Street. He was Greek but he'd been living in London for a long time. And he was obviously a rich man. Well, after we had been in his bedroom, he went out into the bathroom. And I started going through his pockets. He must have been watching me in the mirror, because suddenly he came out and said, "What are you doing Francis?" and I said, "Well you know what I'm doing." Then he said. "You don't have to do that. Just ask." And he took me down to a bank and drew out one hundred pounds, which was a very large sum then, and gave it to me. It was a marvellous way to behave, and I've never forgotten it.'1

Passing encounters of this kind became a staple of Bacon's first stay as a young man in London. But he could not count on them to generate enough cash for a way of life that was already characterized by impetuous extravagance; while still an adolescent, he developed a taste for the most expensive restaurants and hotels. Having learnt a certain amount about cooking from his mother, he put himself forward as a domestic servant and was taken on by a solicitor and his wife who lived in Mecklenburgh Square in Bloomsbury. Francis's duties consisted in arriving early in the morning to prepare breakfast and clean the house, then returning in the evening to cook the couple's dinner. Although he enjoyed the cooking, Francis soon got bored and handed in his notice. 'I don't know why he's going,' he overheard the solicitor saying to his wife, 'he never does anything.' Another domestic position came to a rapid end when the new employer found Francis on his evening off having dinner with a friend at a neighbouring table at the Ritz.

One further short-lived job took the young man to a wholesale shop selling women's clothes – an environment in which he could fantasize enjoyably – in Poland Street in Soho, where his tasks included answering the telephone and taking shorthand, which he had never learnt. 'Of course,' Bacon would say in qualification, 'I made up a shorthand all of my own.' He disliked the owner of the shop intensely and whiled his day away making up poison-pen letters to him; unfortunately one of them found its way to his employer's desk, and the hapless Francis was sacked on the spot.

However chequered his attempts to supplement his weekly allowance, Francis was succeeding in his main ambition, which he called 'simply to drift and follow my instinct – to drift and see'. London offered a daily spectacle and a variety of human types that would have particularly fascinated a young man with an intense visual curiosity who had previously divided most of his time between provincial drawing rooms and muddy paddocks. Bacon later described himself at this period as being painfully gauche, not knowing how to 'present' himself or react in most social situations. 'My father was a very suspicious man,' he recalled wryly. 'He always said: ''If anyone talks to you, run and get the police.'' You can imagine what a marvellous preparation for life that was.' But another thing which could only have undermined any semblance of self-confidence in the young man was the ignorant horror with which his sexual preferences were regarded in England at the time.

London's homosexuals were both numerous – not least because of the English public school system – and fiercely repressed. They were thought of – when they were thought of at all – as generically effeminate, 'Nancy boys' or 'pansies' in the current slang. (In Evelyn Waugh's *Vile Bodies*, the unfortunate Italian waiter caught powdering his nose was thenceforth referred to as 'Nancy'.) With the effeminacy there often went a love of the arts and a generally 'advanced' taste in all matters of style. The coterie of aesthetes and flamboyant homosexuals that grew up at Oxford in the early 1920s around Harold Acton and Brian Howard had begun to influence both artistic and moral attitudes. But age-old prejudices were not easily changed. When King George V was told that someone he knew quite well was homosexual, he replied with evident bewilderment: 'I thought that men like that shot themselves.' Whatever form it took, homosexuality remained a criminal offence which was severely punished.

As Francis drifted through London's homosexual underworld, with its special glances and its meeting places, its codes and its clubs, his father decided to make one last attempt to stop his son from going completely to the bad. Amongst his few friends there was a relative on his wife's side called Harcourt-Smith, renowned for his manliness, who was about to leave on a trip to Berlin. Why not entrust Francis to this man's man, Eddy Bacon reasoned, and see if he couldn't straighten the boy out? With little warning Francis found himself plucked out of the back streets of Soho and his routine of odd jobs, petty theft and rent-dodging, and en route with his upstanding uncle to Berlin.

Berlin in the waning years of the Weimar Republic was more exciting and exotic than anything the young Francis Bacon had seen. The third largest city in the world (after London and New York), it presented the most extreme contrasts of wealth and poverty, high-bourgeois sophistication and Lumpenproletariat misery. These contrasts were to mark Francis for life, and he remained sharply conscious of the thin line between extravagant luxury and dire need.

When Harcourt-Smith and Francis arrived, in the spring of 1927, Germany was still recovering from the rampant inflation which had been triggered by the reparations imposed at the Treaty of Versailles. Rates of exchange were overwhelmingly in visiting foreigners' favour, and Francis's well-heeled uncle took full advantage of them by putting up at the city's best hotel, the Adlon, a huge fortress of privilege

dominating the Pariserplatz which few Germans were able to afford. Even in this fashionable district, with its celebrated cafés and elegant shops, the anxiety and unrest in a city with huge numbers of unemployed and violent political divisions was fully apparent. In Berlin Alexanderplatz, Alfred Döblin, doctor, novelist and leading contributor to the Expressionist magazine Der Sturm, graphically describes the mixture of gangsters, con-men and whores that made up the Berlin underworld. This complex novel, with its Joycean techniques and jarring, modernist images of man engulfed by his own progress, evokes the exact period that Bacon was in Berlin: it was published in 1929 and was banned as soon as the Nazis came to power in 1933.

For the young Francis, Berlin was above all a place of sexual liberation and indulgence. The tough uncle with whom he had departed with his father's blessing turned out to be indiscriminately virile. 'He used to fuck absolutely anything,' Bacon recalled succinctly, and not without enormous satisfaction that his father's carefully laid plans had gone awry. 'My father thought he would change me. But of course it changed absolutely nothing, because a bit later we were in bed together. He was very odd in his way, this man. Very tough – a real brute. I really don't think it made the least bit of difference to him whether he went with a man or a woman.'

Unusually tolerant, not to say encouraging, towards all manner of sexual tastes, Berlin had evolved a nightlife capable of titillating the most jaded appetites and satisfying the least conventional desires. Naughty-girl routines featuring the ubiquitous Josephine Baker in her banana skirt or homegrown striptease acts were commonplace, and these were supplemented by sideshows of nude dancing and female wrestling. Table telephones were introduced in cafés and bars like the Resi or the Femina to make it easier for clients to proposition one another. Resourceful pimps were also on hand to supply drugs (cocaine being an essential component of Berlin nightlife) and recommend specific sexual services; prostitutes advertised their specialities accordingly. such as wearing red shoes to denote their willingness to 'discipline' a client. In this 'Babylon of the modern world', the Viennese novelist Stefan Zweig wrote, 'the Germans introduced all their vehemence and methodical organization into perversion. Along the entire Kurfürstendamm sauntered powdered and rouged young men, and they were not all professionals; every high-school boy wanted to earn some money, and in the dimly-lit bars one might see government officials and financiers tenderly courting drunken sailors shamelessly.'

The city's real speciality was homosexual clubs and cabarets, male and female, and particularly what was most perverse and decadent. Boys parading in outrageous drag and Eton-cropped girls in white tie and monocle set the tone in the fashionable West End, especially in well-known transvestite clubs like the Eldorado, where drag-show stars flaunted their ambiguous charms in a whirl of spangles and feathers. Clients seeking tougher working-class 'trade' went to the blue-collar district around Hallesches Tor, while less adventurous tastes could be accommodated at an establishment called the Aleifa (short for *Alles eine Familie*, 'All One Family'), which welcomed heteros, homos and lesbians indiscriminately.

Male homosexuality nevertheless remained illegal in Germany, and was punishable under the frequently quoted Paragraph 175 of the German Criminal Code – though the punishment was never extreme until the Nazis took over. To combat this law and create more tolerance, a certain Dr Magnus Hirschfeld had founded an Institute for Sexual Science in Berlin in 1919. With the same German thoroughness that had struck Stefan Zweig, he set out to explore and explain every facet of sexuality, from the proper preparation for marriage through venereal disease to rare items of erotica. Hirschfeld himself was well known in homosexual circles, and it may be that Bacon was sufficiently curious to visit the Institute, as Christopher Isherwood did two years later, in 1929. Isherwood gave the following inventory of what he saw:

Here were whips and chains and torture instruments designed for the practitioners of pleasure-pain; high-heeled, intricately decorated boots for the fetishists; lacy female undies which had been worn by ferociously masculine Prussian officers beneath their uniforms. Here were the lower halves of trouser-legs with elastic bands to hold them in position between knee and ankle. In these and nothing else but an overcoat and a pair of shoes, you could walk the streets and seem fully clothed, giving a camera-quick exposure whenever a suitable viewer appeared.³

The cabarets which Bacon visited actually drew inspiration for their 'themes' and tableaux vivants from the Hirschfeld Institute. He often recalled how amazed he had been by the freedom and directness with which homosexuality was treated in Berlin. 'There was something so extraordinarily open about the whole place,' he said. 'You had this feeling that sexually you could get absolutely anything you

wanted. I'd never seen anything like it, of course, having been brought up in Ireland, and it excited me enormously. I felt, well, now I can just drift and follow my instincts. And I remember these streets of clubs where people stood in the front of the entrance miming the perversions that were going on inside. That was *very* interesting.' W. H. Auden, who like Isherwood visited Berlin in 1929, put it in a nutshell: 'Berlin is the bugger's daydream. There are 170 male brothels under police control.' The city's underlying seediness is admirably personified in Isherwood's main character in *Mr Norris Changes Trains*. Although Bacon did not meet the real-life model for Mr Norris, an unscrupulous but engaging trickster called Gerald Hamilton, during his time in Berlin, he became a good friend of his later on in London and made a point of taking him a large pot of Fortnum & Mason's caviare on his birthday.

Berlin gave Bacon not only his first full exposure to metropolitan vice and what he called, with evident relish, 'emotional violence', but also his first taste of Continental sophistication. The Hotel Adlon where he was staying was a byword for luxury. Its first chef had been Escoffier, and its cellars were famous for the million bottles of vintage wine they contained. Its rooms - above all, the spacious apartments known as the 'ducal suites' - were the most comfortable of their kind, attracting not only the nobility but also stars, like Caruso or Valentino, who stopped in Berlin. 'It had a kind of luxury that could hardly exist anywhere these days,' Bacon recalled fifty years later. 'I always remember, it sounds absurd now, but I remember putting my hand through the hangings of the four-poster bed we had and pulling the breakfast trolley – it was an extraordinary thing with a silver swan's neck at each corner, well, just grasping one of these swan's necks and drawing the whole silver thing over to the bed. And of course everything came in silver dishes, with the toast wrapped in linen and that kind of thing. And all the time vou knew that just outside the hotel the most appalling poverty was circling around.

During the day, Bacon had plenty of time to explore the city in more depth, catching glimpses of its decidedly unluxurious aspects. He would almost certainly have wandered through the working-class districts and the picturesque old Jewish quarter known as the Scheunenviertel. With the fascination he had even as a young man for butcher's meat, he may well have visited Berlin's famous abattoirs on the east of the city, just as he later frequented Les Halles in Paris.

In *Berlin Alexanderplatz* Alfred Döblin has left a riveting description of the lugubrious ceremonies that took place there, in a passage which seems almost to foreshadow Bacon's later portrayals of animal fear and cadavers:

Nothing can be seen, the steam is too thick. But a continuous noise of squealing, snorting, clattering, men's voices calling back and forth, tools being dropped, slamming of lids. Somewhere around here are the hogs, they came in from across the way, from the door at the side. This thick, white steam! Here they are, the hogs, some of them are hanging up, already dead, they've been cut up, almost ready to eat. A man with a hose is squirting water on the white halves of the hogs. They are hanging on iron posts, head downwards: some of the hogs are still whole, their legs are locked in a cross-bar above, a dead animal can't do anything at all, nor can it run. Pigs' feet, hacked off, lie in a pile.⁴

Bacon later claimed that his two months in Berlin had been a period of pure 'drifting', of exploring his sensuality and the variety of ways he could indulge it. But being unusually perceptive about life in general, he could not have failed to absorb the extraordinarily potent cultural atmosphere of the city. The furniture he began to design very shortly afterwards, when he moved to Paris, shows how much Bauhaus design had impressed him. For nearly ten years the famous school had been transforming the look of everything from factories to tea-cups, and its influence was apparent in all the visual arts. In Berlin Francis could have seen examples of Bauhaus-inspired furniture at first hand in the city's avant-garde interiors and shops. Berlin was also the cinema capital of the world, and Bacon was already deeply drawn to photography and film. However fascinating the sexual mummery and nightly display of desire, he would surely not have missed Fritz Lang's classic Metropolis, with its haunting images of robot-like workers and vast, crushing machinery. Sergei Eisenstein's Battleship Potemkin, which had been released in 1926 after being banned several times, made an especially lasting impact on Bacon, and he may have seen it first in Berlin. He watched the film many times, and he later referred to it as one of the key catalysts on his own artistic imagination.

'Don't forget that I look at everything,' Bacon used to point out once he was an established artist and in the mood to tantalize critics writing about his work. 'And everything I see gets ground up very fine. In the end one never knows, certainly I myself never know,

what the images in my paintings are made up of.' The visually alert young man would have been conscious of the attention painters were paying to a precise rendering of reality, and he may have visited the influential 'Neue Sachlichkeit' (New Objectivity) exhibition at the Galerie Nierendorf early in 1927. Curiosity may also have led him to the big Malevich show which stayed in Berlin for most of the year; however violent Bacon's rejection and disparagement of abstraction in his maturity, it clearly fascinated him in his own first experiments as a painter. At some later point, he was bound to have seen, if only in reproduction, such haunting evocations of Berlin's blend of luxury and degradation as Otto Dix's Big City Triptych, painted in 1927–28. The three-panelled form (which other German artists, notably Nolde, Pechstein and Beckmann, also used) allowed Dix to present the most contradictory and conflicting images side by side. Bacon also visited the city's great museums, above all the Pergamon, where the classical antiquities made such an impact on him that he went back to see them, sixty years later, when he revisited Berlin as a world-famous painter.

Although he liked in later years to emphasize his role as a bad boy in Berlin's sexual circus, there can be no doubt that Bacon was acutely self-aware and self-questioning during this period of his life. One photograph of him at this time is a studio close-up in threequarters profile lit from below and showing every pore in his delicate face. The photographer in this case was Helmar Lerski, who had noticed the young man in the street and asked him to sit for his portrait. Lerski later published a book entitled Köpfe des Alltags (Everyday Faces), which was made up of photographs of people he had met by chance. The only full-length picture of this period shows a slim youth standing by a statue in the park of Schloss Charlottenburg, on the west side of Berlin. Carefully attired in a formal suit with a neat waistcoat, and clutching a dark homburg hat and gloves in his hand. Francis looks less like the roaring boy of his own legend and much more like the gentleman's gentleman that he had so recently been. The hair impeccably parted just to the left of centre, the high white collar and tightly knotted tie all convey an impression of respectability. In the late afternoon sun the young man's shadow climbs wraith-like, exactly as in many of Bacon's later imaginings, up the side of the statue's huge base.

Francis's uncle had moved on some time before. 'He soon got tired of me, of course, and went off with a woman.' Bacon recounted in

mock dismay. 'I didn't really know what to do, so I hung on for a while, and then, since I'd managed to keep a bit of money, I decided to go to Paris.'

When Bacon arrived in the French capital, in the late spring of 1927, no city could have been more seductive. After the architectural dourness of Berlin, with its heavy nineteenth-century façades, the elegance and excitement of Paris left a lifelong impression on Bacon, causing him to visit the city regularly later on and to live there for a while. If he had chosen to go to Paris, it was because he was aware, like anyone with an interest in the arts at that time, of its preeminence as a cultural centre and the undisputed capital of style. He was drifting, to be sure, as far as possible from the constraints of his upbringing; but he was drifting with instinctive purpose towards what he needed most: the awareness and realization of himself as an artist, however uncertain and gradual that would turn out to be.

Francis's dislike of organized learning and his sporadic schooling had left him with next to no French. After two months of being frequently tongue-tied in Berlin, he was aware that he would never make his way in Paris without a basic command of the language. He needed not only a good French teacher but also someone to help him feel at home in the alluring but intimidating French capital. Having sampled a couple of unsatisfactory cheap hotels, Francis also needed a good place to stay. With the combination of instinct and luck which later stood him in such good stead as an artist, he succeeded in solving all three problems at once.

The seventeen-year-old boy had already begun to visit the galleries within the first few weeks of his arrival. He appears to have conquered his shyness sufficiently to have gone to certain openings and mingled with the sophisticated Paris art world. It was at one such vernissage that he met Yvonne Bocquentin, a pianist and connoisseur of the arts. Intrigued by Francis's curiosity and charm, Madame Bocquentin decided to take him in hand. She offered him a room in her comfortable house near Chantilly, a short train ride from Paris, where her husband managed several large estates, such as the local forest and a stone-quarry belonging to Baron Robert de Rothschild. She also undertook to give Francis a good grounding in French and to introduce him to all the aspects of Paris she herself found fascinating.

It was the beginning of what Madame Bocquentin's daughter, Anne-Marie Crété de Chambine, calls an 'amitié amoureuse'. An

instinctive sympathy and understanding grew between the elegant femme du monde and the diffident but clearly gifted vouth. It was a mother-son relationship with the extra excitement of shared interests and the ambiguity that arose out of the pleasure they took in being constantly in each other's company. When they were not studying French (which Francis picked up with impressive speed), they would spend the day in Paris, visiting exhibitions and going to concerts or the theatre. Whatever yearnings he may have had to plunge into low life, the young man knew exactly how to behave in polite society. He dressed with dandyish refinement and never missed an opportunity to be gallant. When he ventured into Paris alone, he always returned laden with carefully chosen presents. Francis was always grateful to my mother,' Yvonne Bocquentin's daughter recalls. 'He brought presents for all of us, but for my mother he would bring very pretty. feminine accessories, like an evening bag or some extravagant costume jewellery. Once he gave her a yellow ostrich feather fan, which she adored so much it became a family heirloom. I was a very small girl at the time, but I remember he always had this wide-eyed, startled look. as if everything astonished him. My mother always said he was "hors norme": he simply wasn't like anyone else in whatever he did."

Later on, his stay in Chantilly never featured much in Bacon's conversation, perhaps because it did not tally with the image he preferred to give of himself as an uncultivated misfit forever veering to the seamy side of life. Although he went on visiting the Bocquentin family until Yvonne died, he never mentioned their existence even to his close friends. Yet he made no secret of the fact that one experience he had there - seeing Poussin's Massacre of the Innocents at the Château de Chantilly - acted as a vital catalyst on his imagination. It was typical of Bacon, even at seventeen, that he returned several times to the Château, where the Grand Condé had entertained Louis XIV, and that out of an impressive display of Old Masters, from Memling through Raphael to Ingres, he chose to concentrate on one painting alone. Poussin's painting, his second, far more intense treatment of the theme - showing a mother trying frenziedly to prevent a soldier from putting her infant to the sword – was the first image which Bacon remembered as having a definite influence on him. In point of fact, it crystallized an obsession with the mouth opened in a scream which already inhabited the rejected, footloose adolescent, who would refer to it urbanely in later life as 'probably the best human cry ever painted'. Why he was fixated on this most

fundamental expression, in which man is indistinguishable from animal, he never cared to explain. But the cry corresponded to the release of a tension so deep within him that it became the prime focus of his painting.

However gauche he seemed to himself, with his tentative French and the painful self-consciousness for which he blamed his parents, Francis was already well on the track of what troubled and fascinated him visually. The sensations which Poussin's cry revived in him were undoubtedly complex, but what is remarkable at this point is the uncanny single-mindedness with which the intuitive but barely educated adolescent homed in on the images that mattered most to him. If Francis had not seen Eisenstein's Battleship Potemkin in Berlin, he certainly did so in Paris; in that masterpiece, it was the nurse's bloodied face and terrified scream in the Odessa Steps sequence which riveted him. Shortly after he settled in Paris, this obsession led him to find a medical book with hand-painted illustrations of diseases of the mouth. The 'beautiful colours' which it showed of the inside of the mouth fascinated him: he bought the book and later kept it to hand in his studio, referring to it constantly when he came to paint his own versions of the human cry. This early interest in pathological conditions no doubt reflects an inherent morbidity in the young man. but it is also worth remembering that the Surrealists were drawn to clinical photography. Bacon was precociously aware of the latest intellectual developments in France and, as we shall see, an avid reader of the literary and artistic magazines at the cutting edge. In this respect, he would almost certainly have leafed through the issue of La Révolution Surréaliste (published in March 1928, while he was still in Paris) which celebrated 'Fifty Years of Hysteria' with a series of beautiful photographs of a hysterical patient at various points of 'crisis'. Later Bacon kept sheaves of old clinical photographs in his studio showing extreme cases of hysteria in both men and women; and he was particularly fascinated by those in which the manifestations of the illness were indissociable from those of sexual ecstasy.

When Francis left Chantilly, having learnt enough French to live in Paris, he headed, with the same underlying sense of purpose, directly to the hub of the city's artistic activity, Montparnasse. He put up at a hotel on rue Delambre, by the crossroads between boulevard Raspail and boulevard du Montparnasse. The Hôtel Delambre was a modest enough establishment but quite well known in the 1920s, when Montparnasse acted like a magnet on artists and writers

throughout the world. André Breton himself had lived there for a period in 1921 – a fact that impressed the young Bacon once he had found his feet in Paris, since Breton was already notorious as the leader of the Surrealists, with two key publications, the *Surrealist Manifesto* and *Nadja*, to his credit. The hotel catered mainly to intellectuals and foreigners with little money who would stay by the month at specially reduced rates. With its mixed and transient population, the establishment was no stranger to scandal, and at one point shortly before Francis arrived it was the scene of a double killing, involving a young French woman who killed her Argentinian lover in her room before shooting herself.

Because it stood at a discreet distance from the main thoroughfares. with their famous cafés and brasseries, the rue Delambre was a 'hot' street, favoured by prostitutes. It was also favoured by Montparnasse's expatriate intellectuals. Foujita had his studio there and lived next door with Kiki, the artist's model who had become a symbol of Montparnasse's sexually liberated attitudes. At the corner, beside the Café du Dôme, there was an influential bookshop called 'At the Sign of the Black Mannikin'. Run by the American publisher Edward Titus (who in turn was run and financed by his wife, Helena Rubinstein). the bookshop drew all the American and British writers in Paris not only for its display of rare editions but because Titus published a literary review, The Quarter, which specialized in expatriate poetry and fiction, and had brought out a privately printed edition of Lady Chatterley's Lover. Another landmark on rue Delambre for the expatriate community was Le Dingo, an American bar and restaurant patronized by Scott Fitzgerald, Ernest Hemingway and Nina Hamnett. It was from the vantage of this well-chosen little street that Francis began his foray into Parisian life.

Although he later emphasized the pleasure-seeking nature of his stay there, Bacon lost no time in finding out what was new and most controversial in Paris. Montparnasse had become a vitrine where anyone who was so inclined could see, if not meet, most of the artists and writers at the centre of the city's turbulent creative life. The big cafés, from the Rond-Point and the Dôme to the Sélect, competed with one another to attract the most colourful personalities, knowing that they would bring in their wake a horde of admirers.

Paris appeared prosperous, especially compared to Berlin, and the art market in particular was thriving. While Bacon was living in Montparnasse, the Coupole inaugurated its cavernous Art Deco restaurant and downstairs dancehall to cater to the artists, foreigners and assorted drifters drawn to the boulevard as to the centre of the world. By that time, Kiki was well established as the 'Queen of Montparnasse' - which, as Ernest Hemingway remarked, meant something 'very different from being a lady' - and nobody in the area could miss her when she swept into one of the cafés accompanied by her lover of the moment, which might have been Man Ray or any of the artists for whom she posed. Her raucous good humour and visible lack of inhibition summed up much of what made Montparnasse attractive: nobody had to hide their sexual preferences, their fondness for alcohol or their drug habit. Kiki herself had a soft spot for American sailors, and on one occasion gathered no fewer than thirty of them around her on a café terrace. For many, Montparnasse itself turned out to be a drug. 'There are people who have got off by accident at the Vavin métro station and who have never left the area again...' Kiki reflected in her memoirs. 'You don't know how you get into it, but getting out again is not so easy.'

Even if he was too diffident to seek out particular artists, Bacon was soon au fait with what was being published and exhibited in Paris. His literary preferences proved to be as demanding and concentrated as his visual tastes. He already admired James Joyce and was aware that instalments of 'Work in Progress' (later Finnegans Wake) were being published in transition, Paris's new English-language literary review, although he later considered that, in his last book, Joyce had 'taken his technique too far and ended up with a form of abstraction'. In the early issues of transition, he also came across the intricate prose of Djuna Barnes, whose astonishing confession, Nightwood, he later warmly recommended to many friends. Shakespeare and Company. presided over by Sylvia Beach, had published Joyce's *Ulysses* in 1922. and its shop on rue de l'Odéon had become a landmark frequented by all the foreign intellectuals as well as certain French writers and the occasional literary patron. Bacon had already seen in Berlin where private patronage was an essential ingredient of success how useful a moneyed admirer backing one's efforts could be; this realization was to stand him in good stead as a decorator and also during his early days as a painter in London.5

The instinctive sense of purpose which attracted the young man to Poussin's painting at Chantilly also led him to a crucial revelation in Paris: the exhibition of over a hundred drawings by Picasso which the art dealer Paul Rosenberg put on in the summer of 1927 at his

gallery on rue La Boëtie. Bacon, who was still living near Chantilly at that time, repeatedly cited the 1927 exhibition of Picasso drawings as the first definitive catalyst in his development as an artist: 'They made a great impression on me, and I thought afterwards, well, perhaps I could draw as well.' This large show consisted of 106 works, with drawings in India ink, sepia, sanguine and charcoal, as well as several watercolours. It was divided into seven categories: Arlequins. Pierrots et Saltimbanques, beginning in 1917; Nus au Bord de la Mer (1921-25); Paysages (1919-21); Le Peintre et son modèle (1926); Scènes (1926); Scènes de Théâtre (1926); and, finally, all other subjects, grouped as Divers (1918-26). Most of the drawings were classical, and much to the disappointment of certain reviewers of the show, no cubist compositions were included. Seeing Picasso's fluidity of line and restless inventiveness in a mass of images like this made an indelible impression on Bacon. From this point on, however sporadically, he began to draw and make watercolours by himself. without any technical training or professional advice.

It has previously been assumed that the first of Picasso's biomorphic figures, which had such a telling influence on Bacon's development, were included in this exhibition at the Galerie Rosenberg; and Bacon himself is mainly responsible for the confusion, since they and the first Picasso show he saw appear to have merged in his memory. 6 In point of fact, these haunting figures had not even come into being by the time the exhibition opened: they began to emerge that same summer of 1927, which Picasso spent at Cannes, and continued to develop with brilliant ferociousness through the summers of 1928 and 1929 at Dinard. These images struck a deep chord in Bacon when he saw them, in reproductions and in subsequent exhibitions; and it was ultimately they, rather than the considerably less daring and less aggressive works that Rosenberg showed in 1927, which suggested to him how he might come into his own as a painter. Yet it was this initial contact with Picasso - the artist whom he later described as having come closer than anyone in the century to 'the core of what feeling is about' - which gave Bacon the first glimpse of his destiny by prompting him to make his earliest drawings and watercolours.

Strong as the shock of Picasso had been, it was by no means the only influence on the adolescent traveller at this critical, formative period in his life. Soutine and de Chirico both had one-man exhibitions during the summer of 1927, and later in the year there were shows

of recent work by Arp and Picabia; the following year, there was more Picasso, some key Mondrians and a Juan Gris retrospective. Bacon later described his beginnings in an extremely simplified way. referring to a minimum of sources – such as the Poussin painting at Chantilly, or the imagery of Battleship Potemkin. But one source which he assiduously absorbed was Cahiers d'Art, the influential art magazine which the Greek-born art historian and publisher Christian Zervos had launched in Paris in 1926. Like artists all over the world. Bacon remained eager, once he had returned to London, to keep abreast of what was going on in Paris; and the Cahiers (which he continued to consult at Zwemmer's bookshop and gallery) established itself as the prime forum of well-argued, influential opinion. Zervos himself was a passionate advocate of Picasso: the Cahiers duly reviewed the 1927 exhibition which Bacon had seen and included all kinds of other articles on Picasso, such as the poet Max Jacob's recollections of his Spanish friend's early years in Paris.

The Cahiers also provided a wealth of other fascinating images, ranging from prehistoric, Egyptian and African tribal art to contemporary architecture and design. Subtitled the Revue de l'avantgarde de tous les pays, the magazine covered all the arts, publishing reviews of Battleship Potemkin, Metropolis, and Abel Gance's Napoleon. Bacon saw the latter, which was projected on three screens, at the Opéra. In his later choice of the triptych form, he was probably more influenced by Napoleon, with its simultaneous movement of figures on three screens and its complex interaction of close-up and long shot, than by any three-panelled painting from the past.

The critic who reviewed *Napoleon* for the *Cahiers d'Art* was Luis Buñuel, whose work Bacon came to admire deeply. Buñuel had started off in Paris as a cinema critic, but early in 1929 he returned to Spain to make *Un Chien Andalou* with Salvador Dali. This provocative bombshell of a film came out of two dream images: a long, tapering cloud which sliced the moon in half, matched with a razor blade slicing through an eye; and a man's open palm crawling with ants. The film still has the power to shock and disturb, and it caused a scandal when it was first shown later that year – when Buñuel armed himself with stones to throw at what he expected (wrongly, as it turned out) to be a hostile audience. After its première at the Cinéma des Ursulines, the film was transferred to Studio 28, where it had a successful eight-month run. During the same period, Dali's paintings were exhibited for the first time in Paris.

Buñuel's ability to jolt the senses and create an atmosphere of threat fascinated Bacon, who also admired L'Age d'or and several of Buñuel's later films – notably Belle de Jour, with its brilliant portraval of sexual fantasies. The desire to shock was inherent in most of the new art. 'In the hands of a free spirit,' as Buñuel put it, 'the cinema is a magnificent and dangerous weapon.' Many of the areas outside art which fascinated writers and artists of the time also had a notable shock value. Documents, the review founded by Georges Bataille, published photographs of the screaming mouth, as well as a reportage on the abattoirs at La Villette which showed animal cadavers on a blood-smeared floor and pyramids of severed hooves. Bacon was immediately drawn to *Documents* and later kept copies of the magazine beside him as he painted. Given his own orientation, he may also have read in Documents the essay by Michel Leiris (who was to become his close friend some forty years later) in which the French writer suggests that 'Masochism, sadism, almost all vices, in fact, are only ways of feeling more human'.7

Un Chien Andalou could not have been made, Buñuel freely admitted, if surrealism had not existed. Bacon later categorically denied that he had been affected by surrealist imagery and practice, but the very least that can be said is that he continued for a long time to be extremely aware of the movement and the ripples it had sent out into every corner of contemporary culture. Once he was established. he made a point of dissociating himself from any specific movement in the arts, and he became a past master at outwitting critics who attempted to categorize his work. If it was put to him that someone who had been so influenced by Picasso and Buñuel must have been to some extent affected by surrealism, he would sidestep the issue by suggesting, disarmingly: 'Perhaps all Spaniards are surrealist', or confound any further enquiry with a skilful feint. 'After all,' he might retort genially, 'what could possibly be more surrealist than the Oresteia?' Nevertheless, no one as open as Bacon was to the most inventive art and thinking of the period could have remained untouched by surrealism; and elements of its influence, as we shall see, helped to form his whole approach to image-making.

One attitude of the Surrealists which wounded and alienated Bacon, however, was their strong antagonism, spearheaded by Breton himself, to homosexuality. The only homosexual to have been allowed to join the group, the poet René Crevel, himself described homosexuality as a source of weakness and misery, although in his later

writings – which date from shortly before his suicide in 1935 – he talks of it in more positive terms as a subversive, revolutionary force. But outside the Surrealist group, these and other 'advanced' attitudes had wide currency in Paris, which was second only to Berlin between the wars as a centre for homosexuals. Although homosexuality remained officially illegal, as elsewhere in Europe and America, the French tradition of tolerance in matters of private morality prevailed, a state of affairs that was undoubtedly helped by the fact such eminent men of letters as André Gide and Jean Cocteau were widely known to be homosexual.

This was an aspect of Paris which Bacon, of course, found particularly congenial. It would be as misleading to suggest that he was entirely absorbed by Paris's intense intellectual climate as it has been to paint him as a simple roaring boy cutting a swathe through homosexual low life wherever he happened to be. The truth lies between the two, but Bacon would have been able to inhabit both worlds because he had an unusual capacity for operating at several levels in society. When he visited the Bocquentin family, for instance, he continued to fit effortlessly into their world, bringing them not only well-chosen gifts but also folders filled with the cubist-inspired drawings he had been doing, partly at an 'atelier libre', partly on his own. He also moved in more frivolously fashionable circles, going to large parties such as the one which the exotic model 'Toto' Koopman (who later lived with Bacon's dealer, Erica Brausen) gave on her twentieth birthday. There would have been a strong connection between the artistic and the homosexual sphere which Bacon, very much on the make, would have exploited to the full. Although he played the fact down as much as possible later on, it was during this time – no doubt through homosexual friends connected with interior decorating - that Bacon first developed his skills as a furniture designer, the métier which he would practise with flair and notable success on his return to London.

Bacon's own account of his formative *Wanderjahre* emphasized his ineptness as a young man. As far as the artist was concerned, he had definitely been a late developer. It is true that he did not come into his own until his father was dead, when he began to find expression for the deep wounds left by his childhood. But from the start Bacon had been precociously aware of everything that was happening around him, in art as in life. And however much he liked to underline his homosexual exploits in Paris and Berlin, his

imagination was feeding on much more than painted boys in neon bars. 'Berlin had shown me how to follow out my instincts, you see,' Bacon told me on several occasions, in almost exactly the same words. 'And although I was terribly shy when I arrived in Paris and didn't dare talk to people or even go into a shop and ask for something, I didn't keep myself to myself all that long, thank God! I started going round with a male prostitute, and we went to places like the Sélect in Montparnasse, which was one of the big homosexual cafés at the time, and to the bars behind the Lido. For a while I just drifted round with him, living that kind of life. I still had the allowance from my mother, and that did help a little, but most of the time I went around with the people that I picked up.'

Although homosexuality was not flaunted as aggressively as in Berlin. Paris's homosexual subculture in the 1920s was extensive and well organized, with a range of bars and clubs with evocative names such as Les Troglodytes, Tonton, La Petite Chaumière or Chez ma Cousine. Turkish baths were also a feature, and one of them, in the rue Saint-Lazare, was kept by the man who inspired Proust's Jupien, whose bizarre relationship with the Baron de Charlus is so beautifully caught in Sodome et Gomorrhe (Bacon, who adored Proust. once remarked that the preface to Sodome et Gomorrhe 'said everything there is to say about homosexuality'). Transvestites were well served, with flamboyant Mardi Gras balls staged at specialized meeting places like Magic City, which had sprung up in the otherwise very sedate rue Cognacq-Jay. A contemporary report of one such event underlines the notion – to which Bacon subscribed completely – that this parade laid bare a truth hidden by the conventional masks of bourgeois society:

Everything here is lit up, underlined and bared. Everything becomes possible this evening, and everything happens. For a night, for one night only, these human beings, who will be unrecognizable tomorrow under the mask which society's hypocrisy forces them to wear, show themselves naked. All those taking part the day before in the farce they will have to resume on the morrow, all those for whom life is a constant struggle against a world of incomprehension, are gathered together by an invisible host, happy to find themselves with so many like human beings, glorifying for one night in the extraordinary spectacle of their liberated instincts.⁸

Thus artifice reveals truth, a guiding principle for Bacon, not only

in his own lifelong preference for dressing up in female underwear, but also deeply embedded in his painting. Disguise and transformation were clearly as essential to his artistic attitudes as to his sexual ones; and it is no exaggeration to say that at times they paralleled each other exactly. During the Paris period, Bacon's attempts at drawing and watercolour were apparently kept secret, but not the extravagant artifice he practised on his own youthful face. Young men in makeup were a standard part of the homosexual scene, and the male prostitutes advertised themselves more clearly by the paint they put on.

Bacon had seen how the Surrealists equated the desire to express something new with the need to shock, and it was to form the core of his own artistic belief. When the 'wild boy from Ireland' returned to London towards the end of 1928, he was set on a course that would not only scandalize conventional sexual and social morality. He had something far more subversive to do: to disrupt all notions of what art was and what it could express. Beneath the carefully calculated frivolity and the unresolved pain of a rejected son lay the iron determination of a man readying himself to throw a bomb and be held responsible for it.

A Brief Apprenticeship 1928–33

An artist is a person who has invented an artist.

Harold Rosenberg, Discovering the Present, 1974

In the malicious serenity of old age, Francis Bacon enjoyed dismissing his youth as a chapter of accidents and ineptitude relieved by the odd revelation. He saw himself as awkward and aimless, tossed out into the world with little more than the deep, unresolved conflicts inside him. This condensed, unflattering verbal portrait of himself when young was delivered, as were most of Bacon's views, with an emphasis which precluded discussion. This is how the artist saw himself: this is how it was — unquestionably. As a result, it has now become an established part of the Bacon myth that until 1944, when he was thirty-five years old, he led a chaotic, rebellious life — part Rimbaud, part Genet, part thief, part prostitute.

To a limited extent, this is an accurate picture. Bacon may well have embellished his 'bad boy' image in later life, making himself sound more mercenary and devious than he really was. 'I always used everybody to get what I wanted,' he would freely admit, with no sign of regret; but it is difficult to imagine him, even in his more desperate moments as a penniless hooker, entirely lacking in spontaneity and style. He was, after all, simply 'drifting', trying to make some sense of himself and the world, and his early manhood seems to have been overshadowed by the struggle to bring his personality and his real ambition into focus. After his return to London in 1928, it was indeed to take fifteen years before he burst on to the art scene with *Three Studies for Figures at the Base of a*

Crucifixion. Nevertheless, there is another side to the story.

Stronger than Bacon's love of freewheeling voluptuousness was a sense of purpose without which the young man would never have surfaced from the sea of painted faces and easy champagne to stake his claim as an artist. Whatever tight corners he got into, however much he drank and gambled – and his astonishing capacities in these departments are matters of fact, not legend – Bacon was from the start motivated to create. He was impatient of preliminaries, and having turned his back on all formal education he was naturally reluctant to seek tuition. Rather than being a late developer, he had made it very hard for himself to develop. But that was also an essential part of his formation as an artist, because he had to test himself against all kinds of frustrations and failures before he could begin to bring to the surface the monstrous vision of pain and distress he needed to express.

When he returned to London, Bacon was barely nineteen. From his time in Berlin and Paris, he gained an insider's familiarity with corrupt metropolitan life at many levels, and the unblinkered insight that gave him into human behaviour. He also had a command of French, and of French savoir-faire, that was to serve him admirably, and a remarkable grasp of what was most important in the Paris arts scene and what might best serve his purpose. This driving sense of purpose had also enabled him, with no prior training, to emerge suddenly as a fully fledged young furniture designer and interior decorator, with several commissions to his credit, it seems, by the time he left Paris.

In the official legend, the designer-decorator experience is barely acknowledged. Bacon rejected it out of hand, dismissing it as a brief, unimportant episode in which he did nothing of any originality or value. There are two good reasons for not agreeing. Firstly, his work was immediately singled out – in an article in *The Studio* entitled 'The 1930 Look' – as being impressively avant-garde. Secondly, his experience with interior spaces and his predilection for mirrors, tubular steel furniture and curtains hanging (to quote the article) 'in sculptural folds' never left him. The room-space, the sparsely decorated interior, was to provide the theatre for nine-tenths of everything he painted; and curtains, mirrors and tubular constructions remained preferred devices for isolating his embattled figures and compounding their confusion. Curiously, it is as if in his search for a subject that would satisfy his needs as a painter Bacon had begun by defining the

background – the interior in which he would later set his drama of mid-century man caught in an animal awareness of his futility and despair.

Bacon dismissed his work as a designer contemptuously, mainly because he felt it detracted from his prestige as a painter, even though several of the most dedicated of his contemporaries, such as Graham Sutherland, had done a fair amount of design and decorative work. As a result, information about this phase in his life has remained especially difficult to come by. There is no indication, for example, of how he began. After all, even if you have a natural eve for proportion and a quick understanding of a new style, which Bacon clearly had, and you rely on craftsmen to produce the objects, you still need to know about materials and techniques. Presumably Bacon came across someone, possibly through the homosexual circles he frequented in Paris, who was able to guide him rapidly through the basics of the métier – as an observer or even an assistant. Similarly, he would have been able to keep up with the latest developments in the Salon des Décorateurs in Paris and in the specialist magazine, Art et Décoration. From the start, Bacon was particularly interested in the way the most inventive designers had been incorporating metal into their furniture. and he had quickly absorbed Paul Frankl's influential book, New Dimensions: The Decorative Arts of Today in Words and Pictures, published in 1928. But of the commissions which, according to the Studio article, Bacon was given abroad, no trace has yet been uncovered.

Within months of returning to London, nevertheless, Bacon had established himself as a designer and decorator in a stylishly converted garage, over which he had his living quarters, at 17 Queensberry Mews West, in South Kensington. This studio was also his showroom. and he lost no time in holding an exhibition there to present a full range of the furniture and rugs he had designed. Friends, or friends of friends, bought a few of the pieces, more or less enabling the young decorator-artist to cover his expenses. It was at this point that The Studio selected Bacon's designs as one of three examples of the '1930 Look in British Decoration'. The photographs they published of Bacon's studio indicate that he had cleverly picked up the latest ideas of Breuer and Le Corbusier and made an even more simplified, somewhat daintier version of them. Glass and steel dominate the sparse stylishness of the interior, which is regularly punctuated by rugs with abstract motifs - which the article describes as 'purely thought forms'.

Bacon designed a number of rugs, and indeed his earliest surviving paintings – two watercolour studies, dated 1929 – have clearly grown out of the same overall concept. Seven of these rugs are still extant, and they reflect his interest both in synthetic Cubism and the Bauhaus and in such fashionable figures of the time as the French painter and tapestry designer Jean Lurçat, whose work was reproduced in Cahiers d'Art and exhibited in London, at the Lefevre Gallery, in 1930. Under the latter's influence, it seems, Bacon hung some of his rugs like tapestries on the wall, thereby lending an even more up-to-date, Continental look to his interior. The rugs also directly reflect the influence of Marion Dorn and Edward McKnight Kauffer, who had held a joint exhibition of rugs in London at the Arthur Tooth & Sons Gallery in January-February 1929. This was one of the first shows Bacon saw on coming back to London, and he immediately realized that he was quite capable of designing rugs along similar lines. (One is tempted, given the ease with which he absorbed modern decoration, to recall his beloved grandmother's gift for needlepoint.) Once Bacon had decided on designs for his rugs, he sent them, like Dorn and McKnight Kauffer, to be made at the Royal Wilton carpet factory.

One reason why *The Studio* placed the recently returned young decorator at the cutting edge of contemporary design was that studio spaces – which even then were often specially converted commercial premises – had recently become all the rage in London. In the milieu towards which Bacon was drawn and where he hoped to find his future patrons, it was considered chic to live and, above all, to give parties in studios, with a throng of would-be artists and Bright Young Things. To get himself better known in London, Bacon gave parties regularly during these early days: the steel and glass cocktail bracket which figured so prominently in his immaculately designed studio was constantly in use, and the young designer gained quite a reputation both for his dry martinis and for the supple nonchalance with which he performed the latest dances. He also cultivated fashionably unconventional attitudes and 'bohemian' habits which stayed with him for much of his life.³

In his design work as later in his painting, Bacon managed to assimilate with extraordinary speed virtually everything of any note on the European art scene, from the décors of Robert Mallet-Stevens and Eileen Gray to the metal-frame furniture of Marcel Breuer and the compositions of Léger and de Chirico; he had 'borrowed' from right and left, and transformed the mass of different effects into a

style which was derivative but recognizably his own. 'Francis Bacon is a young English decorator who has worked in Paris and in Germany for some years and is now established in London,' the Studio article begins, indicating that Bacon was anything but reticent at the time about his new métier. Indeed, he advertised himself (in bold type) in the Kensington Directory of 1930 as: 'Francis Bacon Modern decoration, furniture in metal, glass and wood; rugs and lights.' In describing Bacon's studio the article singles out a desk with long steel handles like towel-rails and a writing surface in opaque white and black glass, a circular table with a top that is half clear, half mirror glass. a steel stool with a seat in black and white calfskin and the steel and glass cocktail bracket mentioned above. The windows. the article adds, were curtained with white rubber sheeting.⁴ That everything down to this last detail was the dernier cri is borne out by the fact that Madge Garland, the editor of Voque, had all the windows of her Bruton Street flat draped in white surgical rubber a few months later in 1930.

Bacon's décor was patently more modernistic than the two other examples of 'The 1930 Look' featured in The Studio: the Bloomsburystyle rooms designed by the painters Duncan Grant and Vanessa Bell. and the sober, walnut-panelled interiors of the influential architectdesigner Serge Chermayeff. Even in these early decorative schemes. Bacon's natural propensity to take a style – here the stripped-down. functional Bauhaus interior – as far as he could is quite evident, particularly when his stark studio space is set beside the lavishness exemplified by the fover of the Strand Palace Hotel, or the entrance to the Daily Express building in Fleet Street, both of which were considered to be the ne plus ultra of modern décor. Bacon's determination to be totally and ruthlessly avant-garde won him a few admirers, notably Sydney Butler – daughter of the great collector and patron Samuel Courtauld, and wife of the Conservative politician R. A. Butler – who commissioned a glass dining table from him, and the Australian novelist Patrick White, then living in London, who had several items designed by Bacon, including an impressive writing desk, with wide, shallow drawers and red linoleum top, in his flat in Eccleston Street.⁵ The Australian art historian Douglas Cooper also became a patron; but not long after, in one of the feuds for which this irascible connoisseur of cubism was famous, he turned against Bacon and apparently kept his furniture only so as to poke fun at it in front of his friends.

Commissions proved hard to come by, not least because, in the grim economic climate of strikes and unemployment, there was little interest in supporting bright young decorators fresh from the Continent. After learning how to survive in Berlin and Paris, Bacon was not daunted; but as the effects of the Depression became more palpable, he realized what an unequal struggle trying to make a living in London from foreign-inspired, ultra-modern design was going to be. He managed nevertheless to sell a few rugs, even if the clients tended to be relatives or close friends: Eric Alden, who was sharing the upper floor of 17 Queensberry Mews with him at the time, bought a couple, just as he would be the first recorded collector of Bacon's paintings;6 and a certain Eric Hall, who was to become a pillar of Bacon's life, also acquired one as early as 1929.7 Very occasionally there came the opportunity of redecorating an entire home. Gladys Macdermot, an Irish woman who had lived in Australia and begun a collection of contemporary art, asked Bacon to redesign and refurnish her flat at 98 Ridgmount Gardens, in Bloomsbury. She also bought one of Bacon's early works, Corner of the Studio (1934); and Bacon himself remembered gratefully that she was 'always filling me up with food'.8

The prime mover in obtaining most of these commissions, and a decisive influence in other areas of Bacon's life at this time, was Roy de Maistre, the Australian-born painter – and, significantly, occasional furniture-designer - whom he had got to know shortly after his return to London. De Maistre arrived in his life just when Francis urgently needed a father-figure and mentor; his influence on Bacon turned out to be both opportune and decisive. Leroy Leveson Laurent Joseph de Maistre had been born in New South Wales in 1894, and his background resembled his new young companion's in several respects. Like the Bacons, the de Maistre family remained mindful in their provincial seclusion of an illustrious forebear, in their case the late eighteenth-century French philosopher Count Joseph de Maistre (although the connection may have been more wishful thinking than genealogical fact; Roy himself had added Joseph to his long list of given names, and for a while styled himself Roi de Mestre). They felt they were more French than Australian and of a better social class than their neighbours. De Maistre's father was a successful racehorse owner, and the family lived comfortably on a large farm. Like Francis, Roy had not had a conventional schooling; and he too had rebelled

against his rural background by studying art and music in Sydney.

De Maistre was a complex and cultivated man who became involved in various parallel aspects of the arts. He developed a keen interest in the therapeutic capacities of colour, experimenting with their healing effects on shell-shocked hospital patients during the First World War. He also became fascinated by the structural affinities between music and colour, and he made a film where colour was determined by sound. De Maistre's main gifts as an artist were more analytical than imaginative. In his painting, he concentrated first on landscape, then on portraiture, religious themes (he was a Catholic convert) and studies of his own studio interior. Incisively outlined and emphatically coloured, his canvases have a brooding intensity that belied his discreet, urbane manner. 'In one's life one ought to be gentle and forbearing,' he remarked to Sir John Rothenstein, 'but in one's art one should conduct oneself quite differently. It's often necessary, for instance, to give the spectator an ugly left uppercut.'9

After living in Paris and for a considerable period in Saint-Jean-de-Luz, a manicured resort on the French Basque coast, de Maistre settled in London in 1928. Patrick White, who became his lover. described him as 'a short, thickset, bald man, more like a banker than an artist': but the lack of physical allure was made up for by his charm and his eagerness to help those he liked. De Maistre was thirty-five, fifteen years older than Bacon; whether their relationship, begun in 1929, was at any point a sexual one has been questioned. but it was at the very least based on a strong mutual attraction. De Maistre's intellectual sophistication and his experience of the ways of the world immediately appealed to Francis, whose need for a surrogate father was to dominate his emotional life until he himself had reached the age of forty. De Maistre introduced him to his wide circle of influential friends, which included Patrick White and the cantankerous Douglas Cooper. The converted café that de Maistre used as his studio on Eccleston Street, near Victoria Station, became a meeting place for artists and writers. Crowded with canvases and such improbable conjunctions (recorded by Rothenstein) as 'a collapsible opera hat reposing beside a Roman Missal', the studio also contained a sofa - described by several visitors as the most uncomfortable thing that they had ever sat on - and a screen, decorated with an abstract motif, both by Bacon.

Roy de Maistre's circle and the impression Francis made at that time is recalled in Patrick White's memoirs:

In Eccleston Street, in the de Maistre studio-salon. I met other more or less important people, among them Henry Moore. Graham Sutherland. Francis Bacon, as well as Douglas Cooper, who would start off genial and generous, then turn against those he had taken up. Needless to say I did not dare exchange a word with Moore or Sutherland, and would have avoided Bacon too. had he not been a friend rather than a guest at parties. I got to know Francis when he designed some furniture for my Eccleston Street flat. I like to remember his beautiful pansy-shaped face, sometimes with too much lipstick on it. He opened my eyes to a thing or two. One afternoon at Battersea, crossing the river together by a temporary footbridge while the permanent structure was under repair, he became entranced by the abstract graffiti scribbled in pencil on its timbered sides. Alone, I don't expect I would have noticed the effortless convolutions of line he pointed out for me to admire. To discover something that was as subtle as it was simple made me feel quite elated. In those days Francis was living at the end of Ebury Street, across the Pimlico Road, within a stone's throw of the Mozart-Sackville brothel. He had an old nanny who used to go out shop-lifting whenever they were hard up, and as a lover there was an alderman 10

What Bacon needed more than social introductions and art-world savoir-faire, however useful they proved to be, was de Maistre's technical knowledge of painting. De Maistre had been trained in two art schools: the young Englishman had no grasp of basic principles. De Maistre later said he was astounded to hear someone with an innate perception of Picasso's achievement ask questions about how to draw and paint that a schoolchild could answer. For a man who had mastered furniture design and interior decorating with such impressive speed, learning the basic techniques of art would hardly prove an obstacle. Yet, although he later claimed that not having gone to art school had proved a significant advantage. Bacon manifested a gnawing insecurity about technique for years thereafter. He quizzed a variety of other painters about the way they obtained their effects. The Italian painter Valerio Adami, who first met Bacon in the late 1940s at an open-house party in London given by the Welsh artist Ceri Richards, remembers being astonished by his obsessive concern with technical matters. 'We had learnt all those things at art school and then dismissed them as unimportant,' Adami recalls. 'And here was Bacon, with all his remarkable intelligence and knowledge of art

and literature, still asking elementary questions about technique.'11

At this point, Bacon had done only a minimal amount of painting. although he had spent a great deal of time looking at a wide range of reproductions in art magazines. He was also drawn to all kinds of photography, becoming an avid fan of early 'pictorial journalism'. The cinema continued to fascinate him, too. although he found nothing in the new 'talkies' to equal the intensity of Eisenstein and early Buñuel. He had begun thinking seriously about painting, trying his hand at drawing and watercolour, after seeing Picasso's work for the first time, but he was already in the habit of destroying everything that did not come up to his imperiously high standards. The earliest Bacon paintings of which we have any record date from 1929, and only four works are known to have survived from that year. Two of these are a watercolour and a gouache which combine a cubist use of multiple perspective with enigmatic objects such as an abandoned section of wall and the isolated classical columns used by de Chirico. The influence of Léger, whose work Bacon had probably seen in the Paris galleries, also marks these accomplished, albeit patently selfconscious, compositions. A similar synthesis of avant-garde pictorial devices and motifs was being explored in England during this period by Paul Nash, who was twenty years Bacon's senior. Another work of 1929, one of Bacon's screens – showing dark, tubular, apparently female forms painted in oil on three wooden panels – neatly dovetails the young man's interest in decoration and painting: Roy de Maistre recorded it in his topographically precise picture, dated 1930, of Bacon's Oueensberry Mews studio. (In all. de Maistre painted some ten pictures of Bacon's studios during the early 1930s, which suggests a certain obsession with the younger painter.) By late 1929, Bacon gives proof of distinct technical progress by producing his first oil on canvas, a mournful image which represents a severely pollarded tree half obscured by screen-like panels of wood. In all four surviving works from 1929 the desolate atmosphere that characterized so much British painting for a considerable period after the First World War can be distinctly felt.

The oil painting and the gouache that preceded it were probably included in another exhibition which Bacon organized in the Queensberry Mews studio in November 1930, just after his twenty-first birthday. The entrepreneurial spirit which the young man had consistently demonstrated since his return from abroad led him to invite two older and better established artists, Roy de Maistre and a

portraitist called Jean Shepeard, to share the show with him. For the purpose, Bacon printed an invitation card (in eau de nil and black) and a handlist of the works on show. In addition to Jean Shepeard's pastels and seven paintings (including a Portrait of Francis Bacon) by de Maistre, there were four pictures, one print and four rugs by Bacon. The gouache already described may be the work listed as The Brick Wall, and the first oil painting is almost certainly included as Tree by the Sea. The print, which was entitled Dark Child and limited to three copies, has disappeared without trace. So has the picture called Two Brothers; since photographs exist of Francis with his younger brother, Edward, before the latter's early death, it is tempting to speculate that this may have been a portrait in memoriam. Self-Portrait, the other painting in the show, may correspond to a portrait of a young man with a diseased skin which the artist, with his early interest in pathology and taste for self-dramatization, executed around this time. 12

Tentative and self-consciously forlorn as these images appear, standing at the very beginning of Bacon's *oeuvre*, they are surprisingly accomplished for the first works of an untrained twenty-year-old. Significantly, the prices he put on his paintings – between 25 and 45 guineas – were higher than those asked by his two better-known colleagues. The late start, if there really was one, came about because Bacon had set his sights too high and had not reckoned with the general indifference bordering on hostility which the British art establishment reserved for the emergence of a disturbing new vision. Bacon was so discouraged, a few years later, by the mixture of amused horror and blank incomprehension with which his first *Crucifixions* were received that he abandoned painting for almost a decade.

Bacon had been working from the start with a mind filled with images from Picasso and the Surrealists, Eisenstein and Buñuel, and other phenomena quite foreign to the English taste of the time. In the most 'advanced' art in Britain around 1930 there was nothing remotely comparable in emotional violence and intensity to Picasso's biomorphs, Buñuel's sliced eyeball or Max Ernst's disjunctive images. Yet many of the most prominent British artists, from Ben Nicholson and Paul Nash to Christopher Wood and Edward Wadsworth, had visited or lived in Paris and been confronted, like Bacon, with the most radical art of the day. Ben Nicholson's experience in Paris in 1921 was uncannily similar to Bacon's. 'I remember suddenly coming

on a cubist Picasso at the end of a small room at Paul Rosenberg's Gallery,' he recalls in his autobiography. 'It must have been a 1915 painting – it was what seemed to me then, completely abstract. And in the centre there was an absolutely miraculous green – very deep, very potent and absolutely real. In fact, none of the actual events in one's life have been more real than that...'

Other parallels exist between Bacon's early experiences and those of several older British painters. Paul Nash's brother John also came to painting without any formal training, and Paul Nash himself turned to interior decorating and design work (including a glass bathroom for the dancer Tilly Losch) when he could not make a living from his paintings. The artists in the Bloomsbury Group had also made it much more acceptable, earlier in the century, for painters to move freely between fine and decorative art. The closest parallel of all, though, was with Christopher Wood, who went to Paris with next to no artistic training in 1921, at the age of twenty. Attractive and charming, he was taken up by the Parisian art world and befriended by two of its undisputed leaders, Picasso and Cocteau a feat which Bacon would have envied and might have emulated, had the shyness to which he often alluded not held him back. Wood's brilliance and panache, as well as his later addiction to opium and his suicide at the age of twenty-nine, may well have impressed the young Francis - who even shared Wood's admiration for van Gogh's letters. These parallels suggest that Bacon was rather less isolated and unique in his early development than standard accounts have led us to believe. It is his ability to absorb the most diverse influences and blend them into something distinctly his own that makes his formative years appear more unusual than they really were.

Within two years of returning to London, Francis Bacon had managed to set himself up in a fashionable studio, find a benevolent teacher and friend, gain recognition as a designer, absorb the basic painting techniques he needed, move from watercolour and gouache to oil and organize two exhibitions. This rapid success was to continue for some time, like the runs of luck Bacon would occasionally enjoy later at the gaming tables. His enormous energy and natural optimism also made him constantly restless. After leaving Queensberry Mews in 1932 (when the premises were taken over by a Miss Mathewson's dance studio), Bacon embarked on the peripatetic lifestyle that was to stay with him well into middle age. His changes of domicile took

him through every kind of interior, from converted commercial space, forlorn bedsit and hotel room to a grand academician's atelier and a top-floor studio in a rich friend's house; there was even a country cottage, the very antithesis of Bacon's ideal of living anonymously at the heart of a great metropolis.

Some of his abrupt moves were never recorded and may have been occasioned by the need to disappear because the rent was in arrears or to escape a gambling debt or an importunate lover. Bryan Robertson, who curated a retrospective of Roy de Maistre's work at the Whitechapel Gallery when he was director there in 1960, remembers the Australian artist saying Francis looked like a 'somewhat dubious choirboy' and that, when they met, he was already 'often in a pickle'. The 'pickle' side of Francis's life and character is at the opposite extreme to the hard work and ambition that enabled him to accomplish so much so soon. But it is no less characteristic of the whole man, and it is fascinating to watch the two extremes being held in a precarious balance – and at times slipping catastrophically out of control.

Patrick White had been struck by Bacon's odd ménage of an old 'shop-lifting' nanny and an 'alderman' lover. The nanny was the same Jessie Lightfoot who had looked after Francis from his infancy in Ireland and who came closer to him than anyone else in the family. A determined and capable woman, she would have been in her late fifties when Francis returned to London from Paris. The Bacon family had dismissed her once they no longer had need of a children's nurse, and in the worsening economic climate, when domestic servants were less in demand, she had been unable to find other employment. By 1931 Jessie Lightfoot is listed in the electoral register as living with Bacon and Eric Alden in the Oueensberry Mews studio. It is difficult to know how this curious threesome worked, since Bacon himself made a point of subsuming specific oddities in his life into the larger madness of existence. 'My life has been so ridiculous in these ways,' he would say as he recalled a curious incident, 'but then all life is really ridiculous - ridiculous and futile - if you look at it clearly.' However, the simple fact that this domestic arrangement lasted for many years, withstanding all kinds of strain including frequent changes of address, shows how deep the attachment ran. In fact, no other relationship in Bacon's life ever approached it in terms of domestic stability and duration. It says a great deal for Nanny Lightfoot that she could fit into the emotional

and financial chaos Francis whipped up around him and that she accepted the consequences of his unusual tastes and talents. It says even more for Bacon, with his love of risk and his driving ambition, that he would allow nothing to destroy their relationship and that he supported and looked after his old nanny until she died.

Michael Wishart's conjecture that Nanny Lightfoot was Bacon's natural mother is unlikely, given what we know of Captain Bacon's moralizing superciliousness. 14 But the point is well made: Francis was manifestly fonder of Jessie than he had ever been of his own mother: and it was no coincidence that whenever he wanted an alibi he styled himself 'Francis Lightfoot'. An alias came in handy during the years that this odd duo lived together, since they were often as light of finger as of foot. To provide extra money and also because he enjoyed the excitement and uncertainty it involved. Francis began to advertise himself in The Times - its front page being then reserved entirely for various messages and insertions – as a 'gentleman's companion'. This was a well-known ploy in the homosexual world. and it appealed to Francis's keen sense of the absurd that he could make illegal solicitations through such a respectable medium. 'The replies used to pour in,' he recalled with glee years later, 'and my old nanny used to go through them all and pick out the best ones. I must say she was always right. There was one time I found myself being taken back to Paris by this dreadful old thing who took a very expensive flat just off the Champs-Elysées, on the rue Pierre 1er de Serbie. I didn't stay with him long, as you might imagine! But what was amazing was how easily you were able to pick people up in that way.'

Sometimes, beyond recalling the bare anecdote, Bacon would reminisce more generally, putting certain incidents into perspective. 'I was always very pleased to have someone new,' he said, 'because my parents had told me I was awful-looking and that nobody would like me. I remember meeting a Russian at one point in Paris who said to me, "The important thing, Francis, is how you *present* yourself." I didn't really know what he was talking about at the time, but I came to see how true that is. Of course, the French are particularly conscious of presentation — of how to make the best of themselves. I've worked on myself a great deal — I've tried in all kinds of ways to remake myself. In that sense, I'm artificial — I'm probably the most artificial person there is.'

Whenever Francis set out to find a new lover, he used artifice to

maximum effect. From the transvestite bars of Berlin to the male prostitutes on display around Pigalle in Paris, he had seen every device and disguise imaginable. He himself had no fear of appearing outrageous, and Patrick White was not the only one to remark on how much lipstick he used; a young relative of Roy de Maistre remembers meeting Francis around this time and wondering whether she should tell him he must have sucked his paintbrush and got red paint all over his mouth. 15 The array of idiosyncratic cosmetics he used to change his appearance was not unlike the variety of personally adapted techniques he came to employ in his paintings. Bacon himself told the story of how the comparison between the two was made in a way he never forgot. Shortly after he had gained some recognition as an artist, he walked into a London bar where a well-known homosexual wit was sitting. When their gazes met, the wit said loudly: 'As for her, when I knew her, she was more famous for the paint she put on her face than the paint she put on canvas.' Other wits took good note of Francis's uninhibited love of original effects. and none so tellingly as Michael Wishart, who studied this intimate form of Baconian metamorphosis at first hand:

Seated on the edge of his bath I enjoyed watching Francis make up his face. He applied the basic foundation with lightning dexterity born of long practice. He was more careful, even sparing, with the rouge. For his hair he had a selection of Kiwi boot polishes in various browns. He blended these on the back of his hand, selecting a tone appropriate for the particular evening, and he brushed them through his abundant hair with a shoe brush. He polished his teeth with Vim. He looked remarkably young even before this alchemy. 16

What Nanny Lightfoot made of these and subsequent goings-on has unfortunately not been recorded, but it is obvious that she was beyond being shocked by anything that brought in the money. According to Wishart's memoir, the subject closest to the old lady's heart was capital punishment: she longed for the day, she later told Francis's visitors, when the gibbet would be re-erected at Marble Arch, with the Duchess of Windsor as the first public enemy to be hanged, drawn and quartered there. Pronouncements of this kind, together with the fact that Nanny slept on the kitchen table (there being nowhere else), did nothing to make the Bacon–Lightfoot ménage appear less strange.

Whatever her peculiarities, Nanny clearly gave Bacon some sense

of continuity as they flitted from one address to another throughout the early 1930s. After a brief stay in the Fulham Road, the couple moved to 71 Royal Hospital Road in Chelsea. In this building (formerly a garage, like Queensberry Mews, and now destroyed), Arundell Clarke, a well-known decorator and a good friend of Bacon's, had his showroom before he moved closer to his fashionable clientele in Mayfair. Clarke, who had first exhibited his designs under the pseudonym 'Charm', showed the unconditional loyalty which Bacon inspired in his best friends and later provided the artist with premises in which to exhibit his work. Two of his most popular designs, the huge 'Arundell Clarke Easy Chair' and a chunky glass ashtray, may have made their way later into Bacon's pictorial vocabulary.

Even at his most frivolous or chaotic, disrupted by changes of lover and studio, Francis was always thinking about how best to develop his unusual artistic talents. It was becoming obvious to him that his future did not lie in design, useful as it had been in helping him make his way; however effortlessly he could paraphrase others, he did not feel impelled to invent his own style. On the other hand, the Picassos he had seen at Paul Rosenberg's gallery and the subsequent biomorphic inventions of 1928–29, which he knew from reproductions, haunted him with an intensity that he was still a long way from understanding. Yet he sensed that by allowing images to surface without control or constraint, as the Surrealists in Paris had dared to do, he might fulfil a need for self-expression that no amount of interior decorating could ever satisfy.

Whenever a commission for a chair or rug came in, he could ill afford to let it pass, but the opportunities dwindled sharply once he was no longer deploying his energy and charm to secure new patrons. By the time he left Queensberry Mews, in fact, Bacon already no longer considered himself a decorator; and in the course of 1933 all his underlying drive and ambition were focused on the series of *Crucifixions* and figure compositions he embarked on. Nothing remained here of the fashionably cubist patterning of his first decorative paintings. In place of isolated architectural fragments, stylized leaves and dead trees, Bacon concentrated on the subject that was to preoccupy him for the rest of his life: the human figure *in extremis* – crucified, X-rayed, in flight, abandoned. He is still, to be sure, a fledgling artist working in the shadow of Picasso: the berserk anatomy of endless limbs, pin heads and grasping, fleshy toes – a physicality where all the senses and all sensations are confused. But it is already

clear that what fascinated Bacon most about Picasso's bathers and nudes of the late 1920s was their polymorphous sexuality and blind erotic abandonment.

Total abandonment to instinct, above all sexual instinct, was an ideal which Bacon maintained with astonishing vigour to the end of his days. If he had a sustaining belief, it was in the supremacy of instinct as the only guiding principle in life – a philosophy expounded at length by the Marquis de Sade. Bacon had an expert knowledge and considerable personal experience of extreme sexual behaviour – and of sado-masochism in particular. He made no secret of his tastes in this area. And when he said that he 'painted to excite himself', he surely meant: to re-create certain extreme sexual sensations. It would be true to say that, at one level or another, much of what he painted is a projection of sado-masochistic practices, though, as if by some odd consensus of propriety, his pictures were almost never viewed in this light during his lifetime.

The need to accept himself, with his driving homosexuality and ambitions which flouted everything his family stood for, dominated Bacon's early years in London. Self-taught and exceptionally selfaware, he realized from the start that only by pushing back all constraints would he find room to live through the violent contradictions of his nature. In his apprenticeship to painting, however, he was by no means so self-reliant. He needed the most exacting model and the least obvious, subtlest guidance. Roy de Maistre is habitually presented as Bacon's first and, to all intents and purposes, his only mentor. This is far from the truth. De Maistre was able to show him the basic techniques he would have learnt at art school as well as the self-discipline vital to any attempt at creativity, but in terms of what painting could achieve, de Maistre's forcefully expressed but fundamentally derivative imagery had no real awakening effect on Bacon's imagination. Indeed, in the long run, Bacon was to have more influence on de Maistre than the other way round, just as later on he came to dominate another experienced, and gifted, artist: Graham Sutherland.

The only twentieth-century artist who fully captivated Bacon was without doubt Picasso. The shock of recognition at the Galerie Rosenberg in Paris not only set him on the road to becoming a painter, but continued to haunt him and to suggest his way – and even aspects of his behaviour – for years to come. In artistic terms, Picasso was Bacon's first and most important father figure. Bacon

himself acknowledged the influence unequivocally. 'Certain works of Picasso have not only unlocked images for me, but also ways of thinking, and even ways of behaving,' he said towards the end of his life. 'It doesn't happen often, but I have experienced it. They released something in me, and made way for something else.' Picasso's hold over Bacon's imagination while he was young has never been analysed in sufficient depth, even though it provides the single most important key to understanding both his origins and his coming of age as a painter.

'Insufficiently Surreal' 1933–39

La beauté sera convulsive ou ne sera pas.

André Breton, *Minotaure*, no. 5, 1934

Of all Picasso's work, Bacon remained throughout his life most specifically impressed by the period between 1927 and 1932. The Spanish artist was struggling around this time with the psychological anguish caused by his growing desire to separate from his wife, Olga, who retaliated by pursuing him like an avenging Fury. (Marie-Thérèse Walter had in fact come into Picasso's life in January 1927, but he managed to keep their liaison secret for several years.) Picasso had an even more remarkable capacity than Bacon for absorbing everything that entered his orbit and transforming it to his own ends. Like the Surrealists, whose activities he followed closely and whom he occasionally joined, Picasso was deeply interested in the fertility of the unconscious mind: he was also attracted to the dreamlike blend of the animate and inanimate in surrealist art. Out of this new freedom to re-create the human form with the metamorphic fluidity of dream, Picasso produced one of his most disquieting images, the combination of sex and mouth, or 'vagina dentata' as the Surrealists named it. This metaphor of confusion, anger and fear immediately fascinated Bacon, whose obsession with the open mouth had been confirmed very early on; his painting was to be haunted by variations on it for two decades.

What drew Bacon so forcibly to this theme, and to Picasso's brilliant treatment of it, was the paradox that the mouth embodied. On the one hand, it was sensual, soft and acquiescent; on the other,

it could attack, sever and destroy. On a rational level, it could smile and explain; on an irrational, deeper level, it could explode in laughter or give vent to a scream. It also summed up in a precise, highly graphic form a larger paradox. Perhaps because he had been brought up in close proximity to animals, Bacon retained a strong awareness of the animal in man. The more he moved in sophisticated social circles, the more aware he was of the raw, uncivilized impulses that govern human conduct. Like the mouth, with its disarming exterior, society would periodically crack open to show the savagery beneath. It was this keen sense of the beast in man which also attracted Bacon to the Crucifixion as an elevated example of man's brutishness and as a theme which allowed him to conflate images of the abattoir with some of the greatest icons of Western art.

From the mouth-sex juxtapositions of 1927, Picasso began to play freely with different combinations of limbs and organs, treating the body as a continuous metamorphosis of its parts. In 1928, during the first of his two successive summers spent by the beach at Dinard, he began his celebrated series of Baigneuses, which Bacon was to refer to and quote quite unambiguously in his painting at various points in his career. In these images the human body is reinvented as a set of dislocated, semi-organic forms, but it remains fully recognizable, creating an ambiguity between what is seen and what is signified that challenges many assumptions about what it is to be a human being. The images in particular of a baigneuse opening a beach cabin with a key fascinated Bacon, who found that they gave the scene an intensity which conventional representation (or 'illustration', as he chose to call it) could never achieve. The very lack of naturalism in these figures helped to suggest the range of sexual and psychological implications conveyed by the act of inserting and turning a key in a lock.

Sexual passion dominates the beach scenes at Dinard (where Picasso continued to see Marie-Thérèse in secret), but there is an undercurrent of tension and anxiety. By 1930, when Picasso painted his complex *Crucifixion*, the furious energy that allowed him to distort and dismember his figures so unrestrainedly seems to have turned against the artist: of the many interpretations, the biographical one of Picasso crucified by a failed marriage and the guilt of a hidden liaison still seems the most convincing. Less than two years later, in 1932, Picasso returned to the Crucifixion theme during an extended summer stay at his newly acquired country house, the Château de Boisgeloup, near Gisors, some thirty miles northwest of Paris. The

full, rounded forms of the Dinard paintings had led spontaneously to numerous sculptures, notably the bulbous female heads which he had made in his sculpture studio at Boisgeloup, and to an extraordinary series of drawings inspired by the Crucifixion panel of Grünewald's Isenheim Altarpiece, a work that Bacon also admired deeply. The small pen and ink drawings savagely dislocate the subject, then re-create it as a complex assembly of organic forms, so that the latter sketches come to resemble crucifixions of bones. Brilliant and unsparing in their analysis, the 'bone' drawings were published the following year in the first issue of the new art magazine *Minotaure*, in which the main article, by André Breton, was also devoted to Picasso, with photographs by Brassaï.

Exactly when and how Bacon encountered these different phases of Picasso's work is difficult to establish. It is most likely that he saw them first in reproduction: Cahiers d'Art, for instance, published an extensive, fully illustrated article by Christian Zervos - 'Picasso à Dinard, Eté 1928' - in their first issue in 1929. He may even have seen them *only* in reproduction, since at the end of his life he admitted he had never seen the original of Picasso's Crucifixion of 1930.1 Even at this early date, Bacon was drawn to works in reproduction, whether it was the Picassos, the Cimabue and the Grünewald crucifixions, or later Velázquez's portrait of Pope Innocent X and Van Gogh's The Painter on his Way to Work (known only in reproduction since its destruction in the Second World War). No doubt the fact that they had been distanced by the mechanical process made him feel more free to plunder them for his own use. Some reproductions were actually displayed in Zwemmer's bookshop windows. To remember what the situation had been like in England through the 1920s, it is worth recalling Kenneth Clark's tribute to Anton Zwemmer: 'In England the people who had seen a Cézanne or a Renoir, even in reproduction, were few, and for the most part hostile. More incredible still, colour reproductions of Van Gogh did not exist, and when they first appeared in Mr Zwemmer's windows they were almost deliriously exciting. The same is true of Picasso and Matisse...'2

That said, it is most likely that Bacon went to see the important 'Thirty Years of Pablo Picasso' exhibition put on by the Reid and Lefevre Gallery in London in June 1931. The show gave a substantial idea of Picasso's development and included such key paintings – especially for someone as interested in the Dinard period as Bacon was – as *La Plage* (1928) and a *Baigneuse* (1929). Picasso's most recent work was also

well represented, since the thirty-year survey ended with four paintings in the *Abstraction* series, all dated January 1930.

It is useful to have this general, stylistic hinterland in mind as one looks at Bacon's own first *Crucifixion* of 1933. The summary description given above of Picasso's meteoric progress from the early biomorphs through the Dinard figures to the bone-like *Crucifixions* fills in an essential part of the background to Bacon's first important painting. The point here is not so much his debt to Picasso, however crucial and lasting that proved to be, since talented young artists inevitably draw on the achievements of their predecessors; more important is how quick the young Bacon was to identify, and then to mine, the richest vein of possibilities to be opened in the twentieth century for an innovative figurative painter. Far more significant than the specific ways in which Picasso influenced him was Bacon's realization that the only way to make the human form central to art again lay in distorting it.

The other important point is how determined he was, even when Picasso's impact was most immediate, to synthesize that influence with parallel concerns of his own. His first Crucifixion is in fact the first recognizably Baconian image to have come down to us. Nothing in his work up to 1933 prepares the eye for this stark image strung like a bat on a primitive cross. Where Picasso had made a Crucifixion out of bones, Bacon reduced it to a wraith-like figure in X-ray. Perhaps he had heard of the Spanish custom of crucifying bats; perhaps he had been struck, in the same first issue of Minotaure which published Picasso's 'bone' drawings, by the ominous bat-like costume which André Masson had created for the figure of Destiny in the ballet Les Présages.³ It is impossible to tell, just as one can no longer disentangle what came from Picasso and what from a medical textbook showing X-rays of the human body. Already, there is a central enigma in the artist's work which resists analysis. The artist later claimed that he was drawn to the Crucifixion because, more than any other theme, it enabled him to open up all kinds of areas of emotion and so convey his most personal and profound feelings about life. But however seriously we take this claim, the central paradox remains; and we are no closer to understanding why Bacon, the defiant, outspoken atheist, returned obsessively to the most highly charged event and the most potent symbol of the Christian religion.

Certain stylistic similarities with Picasso are immediately apparent. The knob-like, featureless head of Bacon's figure unambiguously recalls the one in Picasso's *Crucifixion*. It is also interesting to note that the dark ground on which Bacon's phosphorescent figure is set not only resembles an X-ray photograph but recalls the biblical description of the darkness that covered the earth at the moment of Christ's death. Picasso observed the dark ground in several of the Boisgeloup sketches, and in Grünewald's Isenheim Altarpiece, Picasso's original source of inspiration, the dead Christ also hangs against a blackened sky. This latter image, which Bacon admired intensely, may have influenced his choice of a dark background; but the space in which the crucified form emerges is unmistakably his own. To judge from the faint lines adumbrating the base of the picture, Bacon's Golgotha is already a closed room.

In April 1933, the Mayor Gallery, which had been noted for showing new art during the 1920s, reopened after several years' closure in a custom-designed space in Cork Street. Its inaugural exhibition presented some British artists, including Nicholson, Nash and Moore, alongside work by, among others, Braque, Léger, Dali, Miró and Ernst. This was the first time in some ten years that British artists had been shown in the company of major painters from the Continent, and it marked the end of a period of isolation that had lasted virtually since the First World War. 4 A painting by Bacon called Woman in the Sunlight, long since destroyed, was also included in this breakthrough show. Heartening though it must have been for the young painter to exhibit in such prestigious company, his work was either dismissed or ridiculed in the London press. In an otherwise enthusiastic review. the art critic for the Observer wrote: 'The works shown by Max Ernst, Francis Bacon, and Paul Klee in what seems to be an intentional desire to outrage aesthetic conventions, can but be taken as practical jokes ... 'The "Lady" by Francis Bacon', another reviewer commented, 'has a little tiny piece of red mouse-cheese on the end of a stick for a head.'5

Crucifixion fared better. In fact, it scored a notable success in the small world that made up the English art scene. Herbert Read, its most perceptive and influential critic, reproduced Bacon's picture in his new book, Art Now: An Introduction to the Theory of Modern Painting and Sculpture. By placing it opposite Picasso's Female Bather with Raised Arms of 1929, Read clearly suggested the formal link he himself had registered between the two artists. The painting was also included in the exhibition Read organized at the Mayor Gallery in

October 1933 to mark the book's publication. Even more encouraging was a telegram from Sir Michael Sadler, Master of University College, Oxford, saying he wished to purchase the painting on the strength of a reproduction, which he must have seen in Read's new book.

Sadler had concentrated on buying works by Gauguin, Matisse and Bonnard before becoming one of the most daring and influential collectors of contemporary British art. He was also one of the very few to be in contact with what was happening on the Continent: he visited Kandinsky, for instance, at a time when the Russian's work was virtually unknown in England. Most of his support, however, went to emerging British artists. He was one of the earliest champions of Henry Moore, who, in turn, had his horizons significantly widened by being allowed to visit Sadler's extensive art collection. For Bacon. whose work up until this date had been bought exclusively by friends, Sadler's support was inestimable, since it conferred automatic status in the English art world. Better still, Sadler went on to buy Bacon's next picture, a larger Crucifixion, in chalk, gouache and pencil on paper, which shows three ghostly elongated figures with their arms outstretched and overlapping behind a set of cage-like bars. Further encouragement came when Sadler sent Bacon an X-ray of his skull and asked him to paint his portrait, which he intended to hang in University College. In his autobiography, Kenneth Clark, then Keeper of the Ashmolean Museum in Oxford, recalls Sadler telling him with 'uncanny foresight' one evening in 1933: 'I've discovered a new painter. He's called Francis Bacon. I've commissioned him to paint my portrait for Hall. It will be like an X-ray photograph of my nut...'6

In the event, Bacon appears to have added his interpretation of Sadler's skull to an existing canvas, his third and last *Crucifixion* (also at one point entitled *Golgotha*) of 1933. The spectral figures of the previous *Crucifixions* are replaced in this powerful work by a massive human carcass strung up against a horizontally divided gold-and-black ground, with its hands and feet cropped so as to concentrate all attention on the torso. Here for the first time is a figure of full Baconian fleshiness, with one of its flanks coloured a dark bruised blue and cream, the other picked out in red. For a moment, it seems as if the twenty-four-year-old artist has found himself, with his fascination for the macabre made more disturbing by his gift for portraying carnal voluptuousness. The summarily painted skull, looking more like a decapitated head with its thick pink lips, breaks up what would otherwise be a static, two-dimensional space in which

the crucified body radiates the mute malevolence of dead meat.

By the end of 1933, it would have been reasonable to suppose that Francis Bacon was well launched on his career as a painter. With the same speed and sureness that had marked his beginnings as a decorator, he had taken the contemporary English art world by storm, having been singled out for attention by the leading art critic, exhibited in one of the best galleries and bought by the foremost collector. Roy de Maistre's painting of Bacon's studio in Royal Hospital Road in 1933-34 confirms that the young man himself had no doubts about his new vocation. Not a trace of chromium plate or frosted glass remains in this interior of bare walls and stripped floor: all attention is focused on two completed canvases, turned outwards towards the spectator. Possibly in part because he knew Bacon's habit of destroying his own work, de Maistre clearly set out like a photographer to record the younger artist's latest images. Both paintings shown in the de Maistre work represent further variations on Picasso-inspired biomorphs. One of them, with an elongated, headless neck, is especially interesting for the way it anticipates the nightmarish creatures of Three Studies for Figures at the Base of a Crucifixion, which is dated 1944 but which, in fact, was developed over a period of several years. Interestingly, de Maistre himself also used this tubular-necked image in several of his own paintings. notably Figure by Bath (c.1937); and it has been suggested that the two painters were inspired by a stuffed, studio figure which one of them had kept for a while.7

Just as Bacon's early success seemed assured, however, the situation changed. Because of the limited scope of London's contemporary art world in the 1930s, he realized he would probably have to wait a long time before being offered an exhibition in an established gallery. Impatient to get his work known and with a self-assurance that belied his professed shyness, Francis asked his decorator friend, Arundell Clarke, who had recently taken over Sunderland House in Curzon Street, if he might use the basement of the large Mayfair mansion to put on an exhibition of his work. The idea was that, rather than depend on the established gallery circuit, the young painter would set himself up as his own dealer and hold regular shows in the space, which for the purpose he named the Transition Gallery.

In February 1934, Bacon opened his first one-man exhibition as an artist. It consisted of seven oil paintings and about six gouaches and drawings, most of which had been done since the three Crucifixions bought by Sadler. Bacon's method of preparing for a show. even this early in his career, was to get down to work only when the event was imminent and to paint with enormous intensity, so that the canvases often arrived still wet from the studio. Although all but two of the pictures exhibited were subsequently destroved by the artist as inferior work, it is still possible to form a partial impression of what was on view. The canvases recorded in de Maistre's painting of Bacon's Royal Hospital Road studio were probably included, along with a picture showing Christ's dead body bandaged and laid out on a table. There was also a Wound for a Crucifixion, the only painting of the period that Bacon later regretted having destroyed: it represented what he described as a 'very beautiful wound' in an abstract shape mounted on a sculptor's armature. There were also two Compositions in gouache showing attenuated figures in flight, which have survived because they were bought by Diana Watson, Bacon's cousin, as well as a painting entitled Studio Interior, presumably destroyed by the artist, of which no trace has remained.

Since Eric Alden, who had bought several of Bacon's early works, wanted to purchase *Wound for a Crucifixion*, and Diana Watson, who was to continue supporting 'poor Francis' (as she called him) had bought two of the gouaches exhibited, the Transition Gallery's one and only exhibition was not a total failure. Bacon had set his sights characteristically high, and he was correspondingly disappointed. Attendance beyond the usual circle of friends had been slight, and although the show was reviewed in *The Times* of 16 February 1934, the tone of the notice was anything but encouraging:

MR FRANCIS BACON

The difficulty with Mr. Francis Bacon is to know how far his paintings and drawings – at the new Transition Gallery, in the basement of Sunderland House, Curzon Street – may be regarded as artistic expression and how far as the mere unloading on canvas and paper of what used to be called the subconscious mind. As the latter they are not of much consequence – except by way of release to the artist. It is true that Mr. Bacon is an interesting colourist, but, then, colour is a natural gift, and is not in itself evidence of artistic talent. All art springs from the unconscious, but it is only to be judged upon the results of conscious formulation; it is not enough for a musical composer to make interesting noises; and Mr. Bacon does not get beyond the creation of

the uncouth shapes which are the common form of dreams.

In 'Studio Interior' he does show some capacity for organizing a picture space in all its dimensions on a basis of hints from actual objects, but his other paintings owe too much to the suggestion of their titles, as 'Wound for a Crucifixion'. Does it, as a matter of cold fact, require a high degree of artistic talent to give the impression of a wound in pigment? Certainly most of the seven paintings are too large for anything they have to say. Confidence in Mr. Bacon is not increased by the information that it is proposed to hold a series of exhibitions of his work at this gallery.

The reviewer's blend of superior judgement and faint praise was guaranteed to cut Bacon to the quick. He had been buoyed up by the unexpected support of Read and Sadler, but he was conscious enough of his lack of training and experience to be stung by this kind of dismissive criticism, particularly when it was competently argued in the country's major newspaper. Similarly, he had hoped to circumvent the art establishment by becoming his own promoter, with a whole programme of future shows at a Mayfair address. It had not worked. His public remained essentially his own intimates, and a general indifference soon shrouded the whole event.

Bacon's reaction was characteristic. If his work was to be criticized, he would be his own critic and show that, in criticizing as in creating, he was prepared to go further than anyone. In the first of many bouts of destruction, he cut up and threw away the entire show apart from the works that were already sold. His friends were alarmed, and his earliest collector, Eric Alden, openly regretted the fact that the beautiful *Wound* was no longer there to buy. As for Bacon himself, it is clear that he had already assumed a mask for his disappointment, alternating between Dostoevskyan gambler and Baudelairean dandy according to the circumstances.

If Bacon was more wounded by the exhibition's failure than he would openly admit, it was because he was sufficiently self-critical to realize that he had not yet managed to make the artistic breakthrough that he wanted. His vision was too extreme to find expression easily; it required a specific language, and Bacon was still too much under the influence of Picasso to be fully conscious of his own needs. He had come closest perhaps in the third and last *Crucifixion* of 1933, where the massive forms and rich colouring hint at the later characteristic mood of vitality shot through with horror and despair. The

problems involved in painting a contemporary Crucifixion were highly complex, on a psychological and an aesthetic level, and – unlike the problems of interior design – they allowed of no rapid solution.

Bacon talked perceptively about painting in general, and he could be particularly enlightening about his own creative process. But in discussing certain aspects of it, he would make a lapidary statement and then firmly discourage any further analysis. Having repeated on various occasions that he saw the Crucifixion in terms of a selfportrait, he did not elaborate on the astonishing implications of the concept. There is no way of knowing how literally Bacon meant this to be taken. Was he saving that his own existence felt like a crucifixion – that he had been singled out to suffer, and that only by expressing the pain in the most highly charged fashion could he convey what he felt most deeply about human life? He would not have been alone, for a number of modern artists, from James Ensor and Emil Nolde on, have identified in their paintings with Christ on the Cross. Bacon certainly had a highly dramatized view of himself and his situation in the world; his painting directly reflects that. Later, as a more mature and technically versatile painter, he was able to transmit the same force of emotion through anonymous figures in everyday situations. But for over half his career, Bacon's work revolved around two of the most potent images of the Christian faith, the body on the cross and the Pope on his throne.

The third and last Crucifixion of 1933 can be seen as the high point in Bacon's development before the war. All the other extant paintings are tentative by comparison, and on one level they appear to reflect Bacon's own growing self-doubts. Interior of a Room, an oil dated around 1933, is an ambitious exploration of successive spatial planes, using Picasso-derived tubular elements and decorative surfaces, but its crowded overlapping remains unresolved, as if the young artist had lost his way in a complex problem of his own devising. In the pen, ink and wash drawing entitled Corner of the Studio (1934), a shadowy tubular form rears up against a wall covered with squiggled graffiti that recall the surrealist practice of automatic drawing (while also bringing to mind Patrick White's anecdote about Bacon's fascination with the scribblings he found on the footbridge over the Thames). Finally, in *Studio Interior*, a small pastel of c.1934. the tubular figure is spreadeagled across the picture plane, with one appendage overlapping a crudely delineated canvas and easel.

With one exception (an enigmatic scene entitled Figures in a Garden

of 1936), these three works represent Bacon's last recorded paintings before he burst back on to the scene in 1944 with the Three Studies for Figures at the Base of a Crucifixion. He had been encouraged by his immediate early success, then cast down by the failure of his show at the Transition Gallery. In 1935, he gave up painting altogether and abandoned himself with a vengeance to drifting, from bar to bar, from person to person. His sense of life's fundamental futility was already keenly developed, and by taking it to extremes he began to turn it into a paradoxically grand style of existence. There was a furiousness in his frivolity that showed itself in the amount he would drink, the extent of his promiscuity and the recklessness of his gambling. He made them into a way of life, and began setting up a series of private – and totally illegal – gambling clubs in the lodgings that he took and left with nomadic frequency. He wanted to find out how far a situation or a person could be taken - how much alcohol. how much pain, how much loss – before toppling over the edge. The risk excited him, and the haunting visual confusion of too many bodies seen under the influence of too much drink, with all taboos transgressed, was to stay with him for ever.

Bacon's artistic hopes were once more dashed when he was instantly excluded from the International Surrealist Exhibition, which opened during the summer of 1936 at the New Burlington Galleries in London. The idea for the exhibition, which sent shock-waves through the insular English art world, came from a group of enthusiasts brought together in London by the poet David Gascovne and the painter-collector Roland Penrose, who had become close to the Surrealists during an extended stay in Paris. A committee including Henry Moore. Paul Nash and Herbert Read was set up to organize the show in England, with help and advice from André Breton. Paul Eluard and Man Ray across the Channel. The movement's major figures - de Chirico, Dali, Ernst, Giacometti, Magritte, Miró and Picasso - were well represented, and work by Duchamp, Brancusi and Picabia as well as some tribal art was also included. Dali underscored the surrealistic nature of the event by delivering a lecture from within an old diving suit, complete with brass headpiece, about his passion for his live-in muse, Gala.

A fairly large English contingent also exhibited works, with Moore and Nash well to the fore. Roland Penrose himself (to whom André Breton had paid the ambiguous tribute 'Penrose est surréaliste dans l'amitié') exhibited four paintings and two constructions. In the early

stages of setting up the exhibition, Penrose and Read had visited Bacon in his studio on the Royal Hospital Road and looked at his most recent work, which they judged 'insufficiently surreal to be included in the show'. Even though he must have been bitterly disappointed at the time, Bacon himself was rather more sardonic when he recalled the visit, claiming that Penrose had also said: 'Mr Bacon, don't you realize that a lot has happened in painting since the Impressionists?' 8

In retrospect, the decision to exclude Bacon is ironic since no other English artist had responded to the essence of surrealism so instinctively; and certainly none was to mine the seams it opened up with such cunning. But Picasso's influence on Bacon's work was much more obvious than the 'orthodox' surrealism represented by Penrose himself or by Nash in his lyrical interpretations, and it is hardly surprising that, even then, Bacon was considered to be too involved with his own traumas and fascinations to be part of a general movement. One might say that Bacon had absorbed surrealism much as Picasso had, in the sense that he took from it elements that he used to his own ends: or at the very least, that he absorbed surrealism through Picasso. What interested Bacon most about surrealist attitudes, in the cinema as in painting, was that they cultivated images made up of widely differing, not to say mutually antagonistic, elements. These disturbing conjunctions followed, of course, in the wake of Lautréamont's famous phrase, 'the fortuitous encounter on a dissection table of an umbrella and a sewing machine', which the Surrealists had adopted as a battle cry in their assault on received ideas and conventional associations. Bacon was to carry this assault forward brilliantly, and perhaps more lastingly than any other painter, in his inimitable merging of religious and profane, factual and imagined, traditional and revolutionary, high and low.

With his intensely visual intelligence, Francis Bacon had always amassed disparate phenomena and delighted in mingling them arbitrarily and incongruously. He was, in this sense, a born surrealist. Along with his fascination for mouths, opened to scream or to display diseases on the red plush of their interiors, came an obsession with a wide range of medical photographs. X-rays of the human body were a source of special interest. Later the artist always kept by him as he worked a book entitled *Positioning in Radiography*, which he consulted as assiduously as he did the photographs of human beings and animals in motion by Eadweard Muybridge; both sources left a

demonstrable imprint on the painter's own images.9

Another important source, which Bacon hardly mentioned and which has never been taken into account, is Amédée Ozenfant's Foundations of Modern Art. Published in France in 1929 and translated into English two years later, this influential book excited the young artist above all because of the extraordinary mixture of images it contained. Flicking at random through the manifesto-like text, Bacon came across photographs of pygmies in a tree and modern machinery alternating with an army marching and an Egyptian statuette. The effect was to jolt the mind out of habitual associations by juxtaposing the most disparate images or distorting well-known appearances. A plate which fascinated Bacon shows the British statesman Sir Austen Chamberlain reflected in a distorting mirror. Ozenfant's comment on this phenomenon has a prophetic ring in the context of Bacon's own development: 'Simplification, distortion of forms, and modifications of natural appearances, are ways of arriving at intense expressiveness of form.' The young painter used the book much as he referred later to Muybridge, by continually dipping into it and allowing the freest of associations to form. But, as with Muybridge, the Ozenfant book contains several illustrations which left a traceable impact on Bacon's imagery. One of them, a late nineteenth-century photograph, shows a woman seated on a chair raised on a dais which clearly recalls the small, platform-like structure on which the artist placed so many of his seated figures; the woman is being photographed, and the releasecord which the photographer holds aloft is directly reminiscent of the swinging blind cord in Bacon's works. Several copies of this photograph, ripped out of the Ozenfant book, lay around his studio at various periods. The book also contains a blurred snapshot of a monkey, and another of a man holding a monkey, which so captivated Bacon that their effect on several of his mature paintings is clearly evident.

People who remember Bacon at this time, such as his cousin Pamela Matthews, have remarked on how astonished he seemed by everything that met his gaze. His visual interests were both farranging and unpredictable. Most unexpected, perhaps, was the painter's prolonged fascination with industrial filters, of all shapes and sizes. As with his book of hand-coloured illustrations of the inside of the mouth, he kept photographs of filters which he looked at and day-dreamed over incessantly – there was, as he himself conceded, 'something a bit mad about it'. Later, he came to see the body itself

as 'a kind of filter', and no doubt his fascination with the various filters was related to anthropomorphic associations they conjured up in his reverie. This type of association – a formal implication which suggested other images and states of feeling at a near-subconscious level – was what drew Bacon most strongly to Picasso's imagery.

Alongside the surrealist principles of disjunctive juxtapositions, of bodily metamorphoses, which Bacon adopted and made his own, he was also keenly aware of the importance that the Surrealists accorded to chance. It became perhaps his own most central article of faith as an artist, and it was a theme that he developed in private conversation and formal interview throughout his career. It was chance, Bacon held – the slip of the painting hand, the dribble of paint, the collision of shapes - that gave the image its necessary injection of the unforeseen. Although his own work had been rejected for being 'insufficiently surreal', Bacon must certainly have visited the International Surrealist Exhibition, which received hostile notices in the press but drew large crowds: it was after all in the years leading up to the Second World War a rare and unrepeatable opportunity for Londoners to keep in touch with new developments on the Continent. 10 There were numerous key works in this huge assembly of over four hundred exhibits, and it is unlikely that Bacon would have been indifferent to Giacometti's haunting Palace at 4 a.m. (with its cage-like structure, which was to prove so useful to Bacon later on); or that he did not linger intently over the de Chiricos, and the corrosive visions of Hans Bellmer, Victor Brauner and Oscar Dominguez. In more general terms, the exhibition eloquently illustrated the new imaginative freedom which the Surrealists had successfully fought to achieve. The borders between dreamt and perceived, observed and imagined, had been abolished, giving way to a violent, often wilfully deformed or flagrantly irrational imagery.

At around this time of disappointment and rejection, Bacon moved from the Royal Hospital Road to 1 Glebe Place, part of a gaunt, unattractive terrace in a street which is otherwise notable for its beautiful houses and which leads off the King's Road towards the Thames in Chelsea. With his nanny still in tow, Bacon was to occupy the top floor of this house until 1941, turning one of the rooms into a studio. In another change that was to have far-reaching effects, a love affair with Eric Hall (mentioned earlier as a collector of Bacon's rugs) matured into a stable and even comparatively 'official' relationship. Hall devoted himself more and more to the younger man, paying

his rent and keeping him out of financial straits. The relationship was to have important repercussions not only on Francis's life but also on his career and on his belief in himself as an artist. An urbane, wealthy businessman and civil servant – no more the 'cruel father' Bacon pretended to seek than Roy de Maistre had been – Hall had a discerning worldliness which was to prove invaluable to the young painter. For some fifteen years, in fact, Hall supported and encouraged Bacon, sensing – beyond his infatuation – how singular and powerfully talented his protégé was. It was partly due to Hall that Francis began to paint again, albeit for a brief period, in 1936.

A portrait of Bacon by Roy de Maistre, painted at exactly this time, shows a slim young man with a face all but devoured by the intensity of his gaze and the sensual fullness of his mouth: a study in youthful idealism and vulnerability. Another portrait by de Maistre shows Eric Hall at around this date: immaculately dressed in suit, stiff collar and sober tie, the plump and balding older man exudes benevolence and, with his eyes fixed on the beyond, a wary foresight. When the two portraits are viewed side by side and in the knowledge of the twentyyear age gap that existed between the two men, the extent to which their relationship was one of father and son is obvious. This was to be the emotional attachment which would help heal the deep wounds left in Francis by his own father's uncomprehending hostility and rejection. Hall's importance for Francis reached its peak, and probably began to fade, after Eddy Bacon died, in 1940. But in 1936 their friendship was the most important thing in the twenty-six-year-old painter's life. Half-successful as a decorator, half-recognized as an artist, Francis traded on his youthful charms to propel himself towards social recognition and some kind of financial independence. Before Hall took over the basic costs of the Bacon-Lightfoot ménage, with its occasional extravagances of expensive meals and French wine, Francis had been obliged to take a variety of odd jobs, such as working as a switchboard operator at the Bath Club (where he apparently first met Hall). Although his social life would have centred around Hall, de Maistre, Francis's well-connected cousin Diana Watson, and decorator friends like Arundell Clarke, he also made the occasional foray into quite different circles. During this period, for instance, he met Virginia Woolf. Bacon recalled the meeting dismissively later on. 'All I really remember is that she shouted the whole time,' he said, nearly fifty years after the event. 'We were all sitting round at lunch, with that friend of hers, Vita Sackville-West, and Virginia Woolf just shouted right the way through.'11

Only one picture from this artistically fallow year, 1936, survives: the Figures in a Garden mentioned earlier. An interesting work which broaches several themes that came to preoccupy the mature artist, it has also been called The Fox and the Grapes (when it was auctioned at Sotheby's in London in 1952) as well as Goering and his Lion Cub. although there can be no question of Bacon himself having given it these titles, since the very idea of pictures 'telling a story' was anathema to him. Bacon had shown an immediate interest in the photographs of Hitler and Mussolini that had begun to appear in the British press, and it is likely that he had already begun to assimilate them into his pictorial vocabulary. The painting shows the torso of a man half-merged with the branches of a tree; in the foreground a dog passes with its muzzle and one front paw raised. The most arresting feature is the man's mouth, opened as in an X-ray photograph with one row of teeth prominently bared. There is a distinct awkwardness about the way the image has been painted, but this in no way diminishes the feeling of unease and menace.

If Diana Watson, Bacon's cousin, had not bought this picture, it would certainly have been destroyed, since the artist destroyed everything else he had produced during this period. And but for Eric Hall's determination to get Bacon's work better established, nothing would be known about his development before he re-emerged in 1944 (which is exactly what the artist wanted). Hall asked Agnew's, the London art gallery, to put on an exhibition of younger artists. Agnew's usually showed Old Masters and a few established modern artists such as Sickert; so it is a tribute to Hall's powers of conviction that they were persuaded to take on such relative unknowns as Bacon, Victor Pasmore, John Piper, Graham Sutherland, Ivon Hitchens, Ceri Richards, Roy de Maistre and Julian Trevelyan.

Hall's underlying ambition, which had the backing of Kenneth Clark and Herbert Read, was to create a 'permanent gallery for the constant display of works by contemporary painters and sculptors' which would also provide material support for young artists. The exhibition, which opened in January 1937, included four recent pictures by Bacon. One was the *Figures in a Garden*; another, *Seated Figure*, has been lost without trace. The remaining two were entitled *Abstraction* and *Abstraction from the Human Form*, and they are known only from the reproductions that appeared in a contemporary publication called *The Referee*. ¹² Both images clearly anticipate the

Three Studies of 1944. Abstraction from the Human Form has the tripod stand and the compact body-like form that reappear with more refined and threatening force in the central panel of the triptych. Similarly, Abstraction shows the bared teeth and anthropomorphic appendages to which Bacon was to return with renewed purpose in 1944, when the mouth appeared ready to savage everything within reach.

The reproductions were published with a caption that claimed that the artist belonged to a 'self-confessed Nonsense Group' formed in the aftermath of surrealism. Pierre Jeannerat adopted a similar dismissive stance in the Daily Mail: 'Is it a pity that the nonsense art or pseudoart of to-day conquers and invades more and more of the leading dealers' galleries of London? Messrs. Agnew, of 43 Old Bond-street, with a long-established reputation as sponsors of much that is great in painting ... have lent their galleries to an exhibition of contemporary pictures which include the representation of a set of false teeth on a tripod. No. It is not a pity. The more we see of such absurdities, the more we shall realise their emptiness and ugliness ... "Abstraction from the Human Form", by Francis Bacon, describes the human form as a distorted toy balloon.' Writing in the Sunday Times. Frank Rutter describes Bacon's Abstraction as containing 'a complete set of false teeth', and his Abstraction from the Human Form as 'more powerful and better coloured'; but he wonders whether they are not 'entirely in the later idiom of M. Picasso?'

Rutter also questioned Eric Hall's claim that the works exhibited had, in Hall's words, 'qualities more penetrating than the merely fashionable or decorative', asserting that these 'mysterious qualities' remained to be defined. Eric Hall was not slow to take up the cudgels. and in a letter written from the Bath Club and published the following weekend he accuses Rutter of quibbling and cites Bacon's Abstraction from the Human Form as a paradigm of those 'mysterious qualities'. The painting, he wrote, had 'very developed formal qualities and the beauty of the colour should. I feel, have offered no difficulties to Mr Rutter'. The letter, with its somewhat defensive note, marks the end of Bacon's first entry as a painter on to the public scene. Apart from a handful of surviving pictures he later condemned as 'abandoned works', Bacon virtually renounced painting and disappeared as an artist for the next seven years. It was not by chance that his first masterpiece was conceived in the darkest hour of the Second World War; nor that, even to a public inured to the grim experiences of wartime, his images seemed unimaginably and unacceptably horrific.

A Vision Without Veils 1939–44

Harry: No, no, not there. Look there!

Can't you see them? You don't see them, but I see them,

And they see me.

T. S. Eliot: The Family Reunion, 1939

Francis Bacon was well prepared for a world about to plunge into disaster. An instinctive pessimist despite his vitality and bonhomie, he confidently expected all human affairs to go seriously wrong at some point: and during his first thirty years, events certainly appeared to prove him right. It is worth recalling, as the artist himself frequently did, that he had grown up in the shadow of the First World War and therefore been accustomed from childhood to an atmosphere of tension and threat; then for long periods he had lived in daily fear of falling victim to the 'rebels' in Ireland. Subsequently, he had passed his youth adrift in the great capitals of Europe, savouring their turmoil and decay, and developing an unusual sensitivity to the precariousness of human existence. Berlin in particular had fixed in his mind an imagery of imminent social collapse: frenzied luxury and licence played out in full view of humiliation and distress. England too in the early 1930s had experienced a severe economic depression, which then became overshadowed by the new threat of war. The approach of catastrophe both appalled and attracted Bacon. It aroused horror but it also confirmed his belief in the essentially tragic nature of human existence. Disaster was not only inevitable, it threw the reality of life and death into sharper relief, he believed, and this heightened awareness of mortality made the desire to live life to the full all the more urgent.

Although Bacon liked to explain it as the natural outcome of specific experiences, this attitude was also clearly the product of his unusual cast of mind and temperament; it was in fact dictated by his particular genius. Vast numbers of people, after all, came closer than he did to danger without making a sense of impending doom the core of their imaginative life for ever after. Even in later years, when he had realized many of his ambitions and a less ferociously driven man might have mellowed and enjoyed the adulation he received, Bacon staved unusually alert and tense, as if never out of the grip of extreme internal contradictions. One basic contradiction stemmed from his vivid enjoyment of life and his fascination with disease, accident and injury, as if he were drawn as much to the shadow cast by the sun as to the warm light itself. The two impulses, of course, often occur together, but not with the intensity at which they coexisted in Bacon. No one meeting this boyish-looking young man with his reckless generosity, bohemian charm and infectious laughter could have guessed the interest he had in photographs of all kinds of disasters, from a car accident with bodies lying in pools of blood to a huge crowd fanning out in terrified flight as soldiers fire into it. 1 Nor would they have imagined that he regularly visited Harrods' Food Hall, a manageable walk from the Glebe Place studio, to see the great sides of beef on display and marvel at the rich marbled colouring of dead meat.

But then Francis Bacon was always more complex than he appeared even to his close friends. He showed certain sides of himself to some people, but all of them to no one. No doubt a certain discretion had been imposed on him by his homosexuality – an aspect of his life that he made no attempt to hide but which he did not dwell on unless he was confident of those present. He himself believed that he had been born homosexual and that there had never been any choice in the matter. In these early years, his feelings about his sexual tastes were strongly tinged with guilt, and this torment is embedded in the paintings which began, towards the end of the war, to erupt like strangled confessions.

Yet Bacon's experience as a homosexual and the agility with which he negotiated the homosexual world also stood him in good stead as war approached. Since all forms of homosexuality were still a criminal offence, he was used to living under threat. It is worth recalling that

in England sodomy was punishable by death until 1861, and by a maximum of life imprisonment before the Wolfenden Report urged in the 1960s that 'homosexual activity in private between consenting adults should cease to be a matter for legal prohibition and prosecution'. Prosecution was only one of the dangers facing a practising. not to say promiscuous, homosexual. There was the social stigma, as well as the risk of physical and verbal abuse. There was also the more insidious threat of blackmail, which could emerge years later. like a dormant disease, on the strength of an unguarded letter or photograph. Bacon's whole nature, as well as his sexuality, was stimulated by risk, indeed even dependent on it; and although he could trust to his charm and guile to get him out of most potentially damaging situations, there is no doubt that Bacon enjoyed sailing as close to the wind as he could in his homosexual adventures. Estranged from his family and with no assailable position in society, he would have been impervious to blackmail. Quick-witted and tough, he was able to withstand any amount of insult and injury, at times turning an ugly flare-up to his advantage by his total unpredictability. doubling the odds by a counter-attack or disarming his opponent through sheer psychological skill.

The siege-like mentality in London as the threat of war turned into a reality brought certain advantages to people accustomed to living on the edge. Social barriers broke down and were replaced by a feeling of 'we're all in this together'. During the black-out, social constraints loosened, and the homosexual cruising the streets in search of a pick-up was not slow to benefit from the more relaxed attitude. In his autobiographical novel *In the Purely Pagan Sense*, the editor and poet John Lehmann gives the following graphic account of the chance homosexual encounters that took place under the cover of night in London early in the war:

I met several other guardsmen during that strange period when the bombing had not yet started and the black-out heightened the sense of adventure as one slipped into pub after pub. My sexual hunger was avid as it was with so many others at a time when death seemed to tease us with forebodings of liquidation in terrors still undeclared. One curious manifestation of this was in the public urinals. As never before, and with the advantage of the black-out, a number of these, scattered all over London, became notorious for homosexual activities. Heaving bodies filled them, and it was often quite impossible for anyone who

genuinely wanted to relieve himself to get in. In the darkness, exposed cocks were gripped by unknown hands, and hard erections thrust into others. Deep inside, trousers were forcibly – or rather tender-forcibly – loosened and the impatient erections plunged into unknown bodies, or invisible waiting lips.²

Francis Bacon took full advantage of this aspect of London in wartime, but not just because casual sex was easier to come by. The chaos, and the sensation that people were living precariously from minute to minute, heightened his erotic interest. For Bacon, this was existence stripped to its essentials – the state he would attempt to capture above all else in his painting. What he sought was the nub. the core, the irreducible sum. Meanwhile, he had discovered a further complication in his sexual tastes: he did not really like 'homosexuals' at all, preferring men who were basically heterosexual vet could be seduced - by money, or by the novelty, or by their own desire for defiance. 'An atmosphere of heightened emotion dominated,' John Lehmann noted about the early stages of the war. 'Kisses were exchanged with those one would never in normal times have reached the point of kissing: declarations of devotion and admiration were made that might never have come to the surface otherwise; vows to keep in touch, to form closer and more meaningful alliances when peace returned ...' The war had plucked armies of men out of their marriages and jobs, and its dangers made them far readier to give in to a whim. With his infectious conviviality and his ability to seduce people by understanding what they wanted most, Bacon had a notable success. 'They began going with me for the money.' he would say, 'but they came back because I amused them more.' For many of the ordinary, often rather conventional men that he picked up. Bacon was an object of curiosity, if not fascination. He would have seemed far freer than anyone they had met before: free not only from all sexual constraints, but astonishingly free with himself and able to give very freely, of his experience and his ideas, of his time and if not always of his affection, then certainly of his sympathy. His prodigality with money, at a time when he rarely had much, and the risks he took, running up alarming debts or 'carrying on' in a provocative way, would also have impressed many a man on leave who was whiling away the odd hour in a pub.

The more difficult the men were to seduce, the more pleasure Bacon took in pursuing them, as long as they were sufficiently good-

looking. He developed a marked preference in later life for regularlooking, well-built men from a working-class background. At this time, however, he himself depended on 'protectors', and the mainstay of his life was still Eric Hall. During their long, relatively stable relationship. Hall helped Bacon in numerous ways. First and foremost. like Rov de Maistre before him, he provided the paternal encouragement and advice which the vounger man felt he had so sorely lacked. Bacon's own father was living at this time in the last of his big houses, the Old Rectory at Bradford Peverell, near Dorchester: and it was there, on 1 June 1940, that he died, aged seventy, of 'splenic anaemia'. There had been scant contact between father and son in all the years since Francis was expelled from the family home in Ireland, and, unlike Francis's mother, Eddy Bacon did not live to see his son become a famous artist. Francis visited his father during his last illness, but his memories of the meeting were dominated by the antagonism he sensed between his mother and his ailing father. 'I think my mother was overjoyed when my father died,' he told me with a bitter satisfaction. 'She was much younger than him and she couldn't wait to begin to live her own life. She managed to marry twice after his death and in a way I think she really did renew herself. I remember when my father was very ill, she kept saying to the doctor, "Can't you help him out? Can't you just help him out?" And he went on hating her right to the end. About a day before he died. he said to the nurse, "For God's sake keep that woman out of my room – tittering-tottering all over the place in those high heels!"'

The breach between father and son had been too deep to mend, and for at least the first half of his life Francis remained deeply stricken by a feeling of rejection; if he recounted the relationship later as a series of absurd misunderstandings, it was a way of coming to terms with the pain. Francis was named as sole trustee and executor of his father's will (in which Captain Bacon requests that his funeral be as 'private and as simple as possible', a style which Francis was to insist on, fifty years later, for his own burial). That he had chosen his rejected 'pansy' son as trustee did not mean that Captain Bacon had undergone some last-minute change of heart: following the early deaths of his brothers, Francis was the sole surviving male heir.

The misfortunes of the Bacon family extended to the youngest child, Winnie, who, although named after her mother and grandmother, inherited conspicuously little of their fun-loving vitality. Francis was characteristically succinct in his account of her life: 'Winnie had one

catastrophe after another, even before she developed multiple sclerosis. She only had to get on a train for it to burst into flames. She went out to Rhodesia like my elder brother, and she fell in love with a man there who was sent to prison for fraud or something. So like a fool she went and waited for him, and when he came out he simply vanished, she never even saw him, and then she found out he was already married in any case.' Although Bacon was never close to his sister, he looked after her with model generosity, paying all her hospital bills when she returned to London and visiting her regularly. Morbid as one side of him undoubtedly was, Bacon loathed going anywhere near a hospital and the visits took their toll on him. But in Winnie's case he noted with fascination the optimism she displayed when discussing her incurable disease; and the interaction between mind and body – which he came to regard as indivisible – never ceased to kindle his interest.

After his father's death, with all the unresolved conflicts and emotions it released. Bacon was able to count on unconditional support from Eric Hall – the 'alderman' Patrick White had referred to in his portrait sketch of Francis (quoted in Chapter 3). A patron of the arts, Hall had a comfortable private fortune which he spent freely on his pleasures and interests, and in his company Bacon was able to supplement his erratic, piecemeal education.³ Together they went to concerts, the cinema and the theatre; and although Bacon had developed his own interests since adolescence, he probably became more aware of the theatre, and of Greek tragedy and Shakespeare especially, during this period. It is likely, too, that his reading became more sophisticated under Hall's influence. Around this time Bacon read William Bedell Stanford's Aeschulus in his Style, which, as we shall see, shaped his impression of Greek tragedy and antiquity as a whole, thereby playing a key role in the development of certain themes in his painting.

In this belated and unorthodox education special attention was paid to the best food and wine. Eating and drinking remained high priorities for Bacon, and he credited Eric Hall with making him aware of their importance. The Ireland of his childhood had left a few fond memories, but its cooking was not among them; even so, he said his mother was good at some simple dishes – including seaweed mousse and Irish stew – and he occasionally recalled delicacies like the white raspberries from his grandmother's garden that had delighted him as a child. Later, after the wartime restrictions, he and Eric Hall were

able to indulge their gastronomic tastes more satisfactorily during trips to the French Riviera, where they put up at luxury hotels and ate at the leading restaurants.

A burlesque element crept into this love affair, even though it was in many ways the happiest and most carefree Bacon was to know. Eric Hall remained married, and his wife and two children were increasingly aware of the liaison, not least because neither of the lovers made any attempt to conceal it; indeed, on occasion, they deliberately flaunted it. Out of a mischievous desire to *épater le bourgeois*, the two men once went together to visit Hall's son while he was at Eton, and took him out to tea, braving the outraged stares of the other boys and their families.

Despite the death of his father and his frustrated artistic ambitions. the war years were for Bacon a period of intense germination, which took place under the guise of flambovant eccentricity. The war itself. certainly, did not get in Bacon's way. Because of his chronic asthma, he was pronounced medically unfit for active service. There is a story, possibly apocryphal but completely in character, that the night before the medical exam Bacon slept next to a dog – a sure way of making himself alarmingly red in the face and well beyond any call to arms as he fought for every breath. The idea of any collective war effort was anathema to him, not least, perhaps, because for several generations on his father's side the Bacons had had numerous 'good wars'. The artist was nevertheless acutely sensitive to the suffering he saw around him: houses gutted, their roofs blown off, and their inhabitants killed, maimed or trapped in the debris. He volunteered for Civil Defence and for a period worked full time in the ARP (Air Raid Precautions), which had set up its headquarters in the Geological Museum in Exhibition Road, a stone's throw from the Cromwell Place studio where, towards the end of the war, Bacon was to paint his Three Studies for Figures at the Base of a Crucifixion, ARP volunteers distributed gas masks and ensured that the black-out was enforced in their area, and after an air raid they were involved in fire-fighting. rescue and first aid, sometimes having to pull dead or mangled bodies out of the wreckage. For Bacon, with his private sense of suffering and his imagination nourished by Greek tragedy, the scenes of death and destruction probably only confirmed an underlying belief in man's inhumanity to man. Like everyone else who lived through the bombings, however, he was nevertheless deeply marked by the war.

'We all need to be aware,' he said later, 'of the potential disaster that stalks us every day.'

Worsening asthma aggravated by the clouds of fine dust obliged Bacon to give up even this involvement in the war, though one must remember that, because of his medical discharge, he was not obliged to serve in any capacity at all. To recuperate, he began to spend time outside London from 1942, renting with Eric Hall a cottage called Bedales Lodge, at Steep, near Petersfield in Hampshire. The idea of Bacon, metropolitan man par excellence, being in the country for more than the duration of a good lunch seems improbable in retrospect: and indeed the stays did not last long, since he had taken the precaution of keeping his studio at Glebe Place. His comic horror at what he called 'waking up with all those things singing outside the window' rapidly gained the upper hand. Nostalgic for the anonymity of the capital, he also came to detest small communities where, as he put it, 'you can see so clearly the ghastliness of everyday life'. But the enforced idleness, free of wartime anxieties and the distractions of London, served as a catalyst to his real ambitions. The unfulfilled artist in Bacon, who was now in his early thirties, returned with a vengeance, forcing him to think in terms of the images he wanted to paint. 'If I hadn't been asthmatic,' he reflected later, 'I might never have gone on painting at all.'

The records indicate that Bacon had completed only one picture so far during the war, although others may have been destroyed without being recorded. Entitled Figure Getting out of a Car, the painting shows a fowl-like fleshy creature laying its long, bandaged, penis-like neck on a pile of ammunition which is also unmistakably phallic-looking. The neck ends in a pair of meticulously painted teeth, bared in a snarl; and the whole spectre uncoils out of an open car drawn from one the artist had seen in a news photograph he kept of Hitler's arrival at a Nuremberg rally. This impressively aggressive image, which was probably painted in 1939-40, was recorded by Peter Rose Pulham, a well-known photographer of the period and a friend of Bacon's, in the artist's studio in 1946; shortly thereafter, Bacon repainted the canvas almost entirely, so that everything but the bared teeth of the biomorph vanishes beneath a mass of vegetation. Only the Nazi roadster survives more or less intact, and the new version, with its toned-down but more insidious atmosphere of threat, was entitled Landscape with Car.

The snarling, bandaged 'penis dentatus' of the original image

directly predicts the middle panel of the Three Studies for Figures at the Base of a Crucifixion, the work that announced, resoundingly. Bacon's definitive entry into the art world. Similarly, a Study for a Figure, painted later in the war, that belongs to the 'abandoned' (but not destroyed) canon of Bacon's works, clearly foreshadows the lefthand panel of the triptych in its crouched position, its outstretched head and the great diagonal, upward sweep – whether of flesh or fabric – from which it juts. A third abandoned image, sketched out in oil on composition board during the Petersfield interlude, consists of little more than a head, its upper half shadowed by a peaked cap, its lower split into a scream. Floating over a mass of random marks and such vestigial forms as a ghostly sketch of a hand, the mouth acts as a precisely defined exit for the inchoateness of the picture. The outpouring from this dark orifice neatly rimmed round with teeth (a precise illustration of Eliot's 'Oval O, cropped out with teeth') conveys a specific threat, since it was clearly inspired in part by photographs of the Nazi war leaders.

One likely source for the unfinished Petersfield image was a Picture Post snapshot of Goebbels, his mouth wide open in full public harangue, that Bacon kept in his studio for years (it appeared among the press clippings and reproductions photographed by the American art critic Sam Hunter when he visited Bacon's studio in 1950). It is interesting to note that Bacon's obsessive fascination with news photos was by no means an isolated phenomenon: picture journalism had just come of age, with the advent of small cameras and new printing techniques, and magazines such as Picture Post, brilliantly edited by Stefan Lorant, a refugee from Hitler. But one should be cautious, even at this early date, of seeing Bacon's pictures as the product of various, cunningly assimilated 'influences'. Bacon's interest in the open mouth may quite simply date back to his first sexual experiences; and that awakening may explain why, as a very young, artistically uncultured man, he was transfixed by Poussin's cry when he chanced upon it in Chantilly; and why that fascination, with its strange sense of beauty, half erotic, half morbid, extended to handcoloured illustrations of diseases of the mouth.

Hindsight undoubtedly helps to disentangle the many elements that went into the making of *Three Studies for Figures at the Base of a Crucifixion*. Yet even now, a half century later, nothing really prepares the viewer for the triptych's rawness as it glowers from the mid-

century with the memory of injury and the prophecy of more evil to come. What sets the *Three Studies* apart from all Bacon's previous known work is its scale and its deliberateness. The searchings of fifteen years' sporadic apprenticeship come to a dramatic conclusion here. It is as if, freed from self-doubt and inhibition (and, clearly, from the presence of his father), the artist had been goaded into making a statement of exacerbated authority. If Bacon may be said to have found his own voice in these panels, it is the unsilenceable scream of his open-mouthed monster on the right. But the basic questions continue to return, after decades of attempted interpretation. What does this howl mean? How did these ungainly, menacing figures come about? What gives the whole triptych, with its roughly delineated space and suffused orange background, its power as an emblem of brute suffering, ravening greed and generalized evil?

Despite the rawness, and for all the artist's lack of formal education. the work grew out of a highly developed visual and literary culture as well as out of emotional urgency. The most important - but by no means the only – source for this picture, as for those that led up to it, was Picasso. In 1938, at the London Gallery, there had been an exhibition of drawings and collages by Picasso which Bacon would have seen. More significantly, in October of that year, Guernica went on show at the New Burlington Galleries behind Piccadilly. The great canvas, painted in furious protest against the bombing of Guernica in April 1937, was first shown at the Spanish Republican pavilion in the International Exhibition in Paris. It came to London accompanied by over sixty preparatory studies, including the savagely brilliant etching The Dream and Lie of Franco. The exhibition, opening just after Chamberlain's pact with Hitler at Munich in September 1938, attracted considerable controversy, above all when it was transferred to the Whitechapel Gallery in the East End, where the admission charge was a pair of boots for a Republican soldier.

Bacon absorbed *Guernica* with the single-minded concentration he had given to the older artist's biomorphic period. In a sense, the *Three Studies* was his *Guernica*, a savage outburst and a decisive statement, albeit not provoked by any specific event or linked to any political cause. It is almost certain that, although this was not his usual method later on, Bacon worked on the three panels sporadically over a long period: the fact that the left panel so clearly recalls his *Figure getting out of a Car* of 1939–40 and the middle panel *Abstraction from the Human Form* of c.1936 suggests that the *Three Studies* was several years in the making.

The *Studies* may in fact have originated as independent single works and the idea of linking them as a triptych come later on (the artist's original title for the work was, in fact, *Figures at the Foot of the Cross*). From the outset Bacon had tended to favour working in series. His imagination was particularly stimulated by a sequence, with one form developing out of another; 'images breed other images in me', as he put it. He had also been fascinated, of course, by the way images on film and in photography changed – imperceptibly, then beyond recognition – from frame to frame. And even in his earliest experiments as a painter he tended to execute variations on a specific subject (which is what he intended by the word 'studies') until he felt he had got the essence of it. This was the case with the three *Crucifixions* of 1933, and it became notoriously so, in the late 1940s, when Bacon embarked on a series of *Heads* which in turn gave rise to the *Popes*.

Little in the three panels of the *Studies* in fact binds them together stylistically or thematically. The orange background, which appears to be the main unifying factor, had actually been used in two prior works, so it may be regarded more as one of Bacon's predilections of the moment (several later periods in the artist's work were to be dominated by a particular background colour). Even the summarily delineated space which the three unlovely spectres inhabit barely links up from panel to panel, and there is no particular compositional device to suggest that the three panels were originally planned as a whole. Nevertheless, all three are identical in their technique: oil and pastel on an absorbent wood-fibre support known as Sundeala board, which Roy de Maistre and Graham Sutherland had also been using, for reasons of economy, around the end of the war.⁵

Several influences may have led to Bacon's decision to present the work in triptych form. The most powerful of these was his interest in Grünewald, probably sparked off by the drawings inspired by Grünewald's Crucifixion panel in the Isenheim altarpiece at Colmar which Picasso did in 1932 (and which Bacon would have seen the following year reproduced in *Minotaure*). Sam Hunter's photographs of Bacon's studio show a reproduction of Grünewald's *Christ Carrying the Cross* from the Karlsruhe Kunsthalle pinned on his wall; and there can be little doubt that the idea for the cloth bandage above the snarling mouth of the 1944 triptych's central figure was inspired by Grünewald's *Mocking of Christ* in the Alte Pinakothek in Munich. Since Bacon was keenly aware of the historic and emotional associations of

the Crucifixion, he would also have been drawn to the three-part form in which artists have traditionally represented the theme, as being the most highly charged, even for the base or predella that he himself had in mind.

Three Studies for Figures at the Base of a Crucifixion can be seen as a homage to Picasso, from an apprentice to a master, as well as to surrealism in general. The livid biomorphs are clearly related to the radical distortions of the human form that Picasso had experimented with so hauntingly. In Guernica, and especially in the preparatory studies which led up to it, Picasso pushed these experiments further. All the cries of pain and horror issue from wide-stretched mouths and grotesquely elongated necks; and in one of the Guernica studies. the horse's outstretched neck is represented as an erect phallus.⁶ The transmutability of the body in art and the way manipulations of it can touch on complex areas of feeling never ceased to fascinate Bacon. Picasso's studies for the woman with the dead child represented on the left-hand side of Guernica show a figure in a long cloak, forming a triangular composition, which Picasso had himself drawn from the Mary Magdalene in Grünewald's Crucifixion; and this in turn clearly inspired the cloaked figure in Bacon's left-hand panel. Beyond such specific formal influences, Guernica may also have influenced Bacon by the way its composition falls clearly into three sections, like a triptych, as well as by the strongly linear mould in which its figures have been cast – a manner Bacon also adopted for the *Three Studies*.

There is moreover a combination of ambitious modernity and existential despair in Picasso's picture which would have excited the younger artist. Writing about *Guernica* while it was displayed in London, one of Bacon's earliest supporters, Herbert Read, praised the picture in resounding terms:

The monumentality of Michelangelo and the High Renaissance cannot exist in our age, for ours is one of disillusion, despair and destruction ... Not only Guernica, but Spain; not only Spain, but Europe, is symbolized in this allegory. It is the modern Calvary, the agony in the bomb-shattered ruins of human tenderness and frailty. It is a religious picture, painted, not with the same kind, but with the same degree of fervour that inspired Grünewald and the Master of the Avignon Pietà, Van Eyck and Bellini. It is not sufficient to compare the Picasso of this painting with the Goya of the *Desastres*. Goya, too, was a great artist, and a great humanist; but his reactions were individualistic – his

instruments irony, satire, ridicule. Picasso is more universal: his symbols are banal, like the symbols of Homer, Dante, Cervantes. For it is only when the widest commonplace is infused with the intensest passion that a great work of art, transcending all schools and categories, is born; and being born, lives immortally.⁷

Even when, as an internationally acclaimed artist in his own right, Bacon was outspokenly critical of Picasso's later work, his admiration for the works of the Dinard period never wavered. From Picasso and from surrealism in general, Bacon absorbed the freedom and the right to distort appearance in a bid for increased expressivity. But from the outset the source material that helped him derive his characteristic imagery was of the most sophisticated order. Paradoxically the self-taught Bacon sought inspiration in some of the most intellectually inaccessible places. Picasso constituted an extraordinary challenge to his contemporaries, but the other great influence on Bacon at the time of the *Three Studies* was more challenging still.

It is almost certain that Bacon was led to Aeschylus via another poet he admired, T. S. Eliot. Drama and poetry were the two literary forms the painter preferred, since he believed that, at their finest, they required the greatest concision of meaning; and this in turn produced what Bacon sought in his own imagery: a dense layering of fact and association. Eliot's early play, *The Family Reunion*, opened at the Westminster Theatre in March 1939, with Michael Redgrave playing Harry, Lord Monchensey, the central character. Bacon recalled having seen the play several times, and maintained it was the best of all Eliot's works for the stage.⁸

The main theme of *The Family Reunion* was drawn from Aeschylus' *Oresteia*. The action of the ancient Greek drama may be summarized as follows: Clytemnestra murders her husband Agamemnon (who has sacrificed their daughter), and she is in turn killed by their son, Orestes, who is pursued by the Furies until he is acquitted by an Athenian court. In *The Family Reunion*, the protagonist, Harry, is haunted by the Furies or Eumenides, 'the sleepless hunters/that will not let me sleep', who actually appear on stage, according to Eliot's own stage directions. Harry believes he is being punished for having murdered his wife; but his complex sense of guilt goes back much further, and he learns that his father had plotted to kill his mother while she was still carrying Harry in her womb. His mother's sister,

Agatha, reveals this dark family secret to him, and she adds, in the tones of the chorus in Greek tragedy:

What we have written is not a story of detection, Of crime and punishment, but of sin and expiation. It is possible that you have not known what sin You shall expiate, or whose, or why.

It is possible

You are the consciousness of your unhappy family, Its bird sent flying through the purgatorial flame.

Harry himself describes his guilt-infested existence in vivid, visual terms, and they conjure up, to a quite uncanny degree, the atmosphere of threat, guilt and doom which Bacon's paintings later communicated with such intensity:

In and out, in an endless drift
Of shrieking forms in a circular desert
Weaving with contagion of putrescent embraces
On dissolving bone. In and out, the movement
Until the chain broke, and I was left
Under the single eye above the desert.

The play so impressed Bacon that he felt impelled to find out more about Greek tragedy, and he read William Bedell Stanford's *Aeschylus in his Style* shortly after its publication in 1942. This fascinating, highly specialized study, full of quotations in the original Greek, made a deep impression on the artist. Clearly, the theme of obsessive guilt, in the Eliot play as in the *Oresteia*, had great resonance for him. Time and again, the sense of guilt and suffering – of something having gone badly wrong, something that has to be paid for dearly – runs almost tangibly through his painting, as if it were embodied in the thick swirls of paint. Was Bacon himself the 'consciousness' of his unhappy family, 'sent flying through the purgatorial flame'?

It is no coincidence that the picture in which Bacon first comes fully into his own should be devoted to the Furies. For a long time, the triptych was regarded as a visceral reaction to the horrors of war or, more universally still, of man's inhumanity to man. When one looks at Bacon's whole development, however, it is clear that his painting is not concerned with any social or moral issues; and also that his imagination worked from the particular to the universal

rather than vice versa. The Furies were a personal reality for Bacon. Like Orestes, like Harry Monchensey, he felt himself to be pursued by them. In one interview, filmed in 1964 in his studio, he admitted in a jocular but unequivocal aside that the Furies 'visited' him frequently. It is also worth noting in this respect that of all Shakespeare's tragedies, which he admired intensely, Bacon's first preference was always for *Macbeth*, the great drama of guilt.

'In my work I have always followed a long call from Antiquity,' Bacon remarked on another occasion. Eliot's play, with its modern psychological insight and bleak imagery, proved a revelation to the artist, apparently enabling him to understand his own inner conflict more clearly. But once Bacon had read the *Oresteia* and Stanford's commentary, Aeschylus became his point of reference for the theme of guilt and expiation which haunted him.

What excited Bacon in this ancient study of murder begetting murder, and the sins of the father being visited on the son, was its violent, intensely visual imagery. Unable, to his lasting regret, to read the *Oresteia* in the original, he depended on translations, ¹¹ and in Stanford's study of Aeschylus he especially enjoyed the author's occasional translations from the Greek. One example that impressed Bacon by its unexpected phrasing and blood-soaked imagery was Clytemnestra's description of her near-sexual delight as she murders her husband, Agamemnon:

And squirting out a sharp death-gush of blood he strikes me with dark drizzle of murderous dew, and I rejoiced as the sown cornfields rejoice at the god-sent glistening when the buds are born—

Bacon explained his fascination with the *Oresteia* by saying that the play 'bred' images in him – that a particular phrase or figure of speech might trigger off a sequence of visual associations in his imagination which in turn fed into his painting. The fragment which he quoted most frequently – 'The reek of human blood smiles out at me' – is uttered by the leader of the Furies as they close in around the hunted Orestes in Athena's shrine. Stanford chooses this arresting sentence as an example of a synaesthetic image, capable of involving several of the senses at once. 'The fact that the verb implies cheerfulness as well as brightness,' Stanford comments, 'adds a peculiar grimness.' Bacon himself, of course, wanted to create images that moved all the senses. He already had some knowledge of synaesthesia,

since he knew about his friend Roy de Maistre's experiments with music and colour; and he may well have seen the film de Maistre made in which the shades of colour were determined by the pitch of the sound. By blending invisibly so many sources – from art and from literature, from photography, design and film, from the street and the bedroom – Bacon himself set out to create a synaesthesia which would address the spectator at as many different levels, and from as many different directions, as he could devise.

A less well-known phrase in Stanford's translated excerpts from the *Oresteia* which Bacon cherished and repeated often had Clytemnestra brooding like a hen over her sorrow — a description which certainly evokes the contained malevolence of the left-hand figure in the *Three Studies*. The alchemy of Bacon's images, even at this early date, is of a sufficiently rare, high order to allow interpretation but not thorough analysis. Disquieting and repulsive, Bacon's Furies, perched on a pedestal or rooted in a patch of scrub, remain enigmatic. These 'Daughters of Night', sprung according to legend from the blood of Ouranos' severed genitals, remain contained in their loathsomeness to hurl ill-understood imprecations at generations to come.

Years later, when the triptych had taken its place in the Tate Gallery, Bacon explained, in a letter dated 9 January 1959, that the three works were 'sketches for the Eumenides which I intended to use as the base of a large Crucifixion which I may still do'. That particular Crucifixion was never painted, although imaginatively it exists, reflected in the malevolent glare of the *Three Studies*. Other scenes of dramatized distress followed, tentatively at first, then in a thick flurry, as if no amount of oil on canvas could express the artist's sense of pain and outrage.

PART TWO 1944-63

Father Figures and Crucifixions 1944–46

It is impossible to say just what I mean!
But as if a magic lantern threw the nerves in patterns on a screen...
T. S. Eliot, 'The Love Song of J. Alfred Prufrock', 1917

Although he had been sickly as a child and appeared effeminate as a young man, the adult Francis Bacon turned out to be exceptionally tough. Three generations of campaign-hardened soldiers had produced, as the last of their line, a man whose resilience was all the more unexpected for his liberal use of lipstick. However revolted General Bacon might have been by his great-grandson's flamboyant homosexuality, he would have felt a kinship with his ability to keep going against the odds. Stories abound of the artist's capacity to withstand physical pain. He impressed his doctors, for instance, by refusing a local anaesthetic, then never flinching, as stitches were removed after surgery. In his erotic adventures, which had a strong, sometimes alarming, sado-masochistic streak, he proved equally valiant, taking his lashings voluptuously; although on one occasion, when a violent lover went so far that Bacon feared for his life, discretion triumphed over valour and the artist fled into the street clad only in a pair of fishnet stockings.

Throughout his life, Bacon drew on reserves of energy which allowed him to work with ruthless concentration, to drink and amuse himself as intensely, then return to the canvas in the studio after little or no sleep. Along with this abundant physical vitality he had equal stamina for coping with the situations of extreme mental anguish which characterized some periods of his life. Indeed, he

appeared at times to court disaster, as if driven by an inner compulsion which in turn fed the needs of his art.

Convivial by nature and garrulous in drink, the artist nevertheless remained extremely guarded about certain aspects of his life and his work. It is no coincidence that at the time of his death, when the full force of media attention was turned on the internationally famous figure, only the sketchiest biographical facts could be found. Although Bacon acted with a memorable lack of caution and restraint in many areas of his life, he went to great lengths to control the kind and the amount of information about himself that was published, going so far as to take legal action to stop books on his life and art which he had initially encouraged.¹

This was consistent with the artist's own wish to keep a tight control not only of his public persona but, more significantly, of the interpretation of his work. For complex reasons, Bacon insisted that his painting be viewed in a kind of biographical vacuum. He acknowledged openly enough that his sensibility had been shaped by a vast range of influences, from cave paintings to Duchamp, Aeschylus to Eliot. When it came to any specific overlap between his life and his art, however, Bacon became altogether more chary, even though he admitted, like Picasso, that his work constituted a kind of diary of his life; 'my whole life goes into my painting,' he remarked, tantalizingly.

For all his bar-room exhibitionism, Bacon had a natural *pudeur* about experiences that had marked him deeply. There were areas of his life that, even when he was companionably drunk and at his most expansive, he would refer to obliquely or simply pass over. But the main reason why he so effectively discouraged links between his autobiography (in the widest psychological sense) and his painting is that he feared such references might in the long run sap the potency of his images. Deeply sophisticated as he was, he wanted those images to have the power which masks and fetishes carry in 'primitive' tribal ritual; deeply atheistic, he protected their mystery with the zeal of a priest preserving the sanctity of his shrine. Enigma was the lifeblood of an image, Bacon believed, and it must at all costs be sealed off; the material correlative of this was his insistence that all his paintings be glazed and framed in heavy gilt, like the Old Masters hung with their mystery undisturbed in dark churches and museums.

Enigma was a quality which Bacon prized and manipulated from very early on. His fondness for disguise has already been noted, and the paint he put on his face was also indicative of his desire to create, if not an enigma, then at least a personal mystique. Similarly, the artist became expert at slipping from one social group, such as a gathering of male prostitutes or gangsters, into a completely different one, made up of patrons of the arts or the handful of 'horsey' relatives he still occasionally met. In later life, enigma enveloped him like a protective cloak, allowing him to glide through certain situations and escape from others.

Nowhere, however, did enigma prove so vital to Bacon as in his art. This quality, alluring yet elusive, was crucial to the power of his images – not least in the artist's judgement as to which of his works to preserve or destroy. Bacon was convinced that once an image could be explained – that is, adequately approximated in words – it was worthless: it had none of the visual charge which makes some paintings so compelling, as opposed to the weak effect of others (the vast majority). For Bacon, the test of an image which 'worked', to use the artist's own term, was in part its resistance to any logical or coherent verbal explanation; everything that failed this stringent test fell into the despised category of 'illustration'. 'After all, if you could explain it,' he would point out with manic bonhomie, 'why would you go to the trouble of painting it?'

A successful image, then, was by definition indefinable, and one sure way of allowing it to be defined, in Bacon's view, was by introducing a narrative element. However unclassifiable an artist Bacon has appeared (by his own estimation, and in his own lifetime). there is no denying how deeply many of his key attitudes were imbued with modernist beliefs. It is difficult to think of any other British artist of the period who kept as close to the cutting edge of the European avant-garde; and certainly none who absorbed and translated its ideas to such telling effect. Narrative or 'story-telling', as Bacon called it disparagingly, had in one form or another been the backbone of Western art for centuries; and that in itself gave the modernists a good reason to reject it. It had moreover fallen into disfavour, on both sides of the Channel, because of the academicians of the late nineteenth century who embellished their homely, historical or exotic subjects with layers of story-telling that spectators could unravel as in a guessing game.

It was the bourgeois cosiness and shallow convention of nineteenthcentury narrative paintings that made 'story-telling' the dirtiest word in Bacon's aesthetic vocabulary. As with his own biography, the 'content' of a painting must be kept to a minimum. Bacon adhered to this principle with unwavering intensity. The great majority of his paintings have the following content, and nothing more: an unidentified figure or head in an unspecified setting; and their titles are correspondingly irreducible. Even in the early masterpieces, such as the Tate's *Three Studies* and the magnificent *Painting 1946*, which Alfred Barr was to acquire for the Museum of Modern Art in New York, there is no explicit 'story', and Bacon reiterated throughout his life that his paintings 'meant' nothing, 'said' nothing, and that he himself had nothing to 'say'. 'I'm not an Expressionist, you see, as some people say,' he would insist, sometimes adding as a last flourish: 'After all, I have nothing to express.'

In retrospect the extent to which Bacon managed to impose his own view of his art on the rest of the world is phenomenal. He not only painted his images but - and this testifies to his powers of persuasion - also told critics, collectors and the public what to think of them. This 'official' line, brilliant and revealing as it often turned out to be, also tended to obfuscate, especially as regards interpretations of his early work. From the outset, Bacon had painted subjects that were essentially religious, and which would traditionally be perceived as such. The Crucifixion theme dominated his first decade as a painter and he returned to it at several later stages in his development; one of his last great compositions was the blood-red Second Version of Triptych 1944, painted in 1988, when the artist was nearly eighty years old. He also spent a lot of time during the 1950s and early 1960s painting numerous versions of the Pope. As with all Bacon's great themes, both these subjects are painted with a compulsive intensity, as if they had touched something so intimate in the artist that he could not leave them alone. But when Bacon was questioned about the significance of such overtly Christian imagery - which he acknowledged in titles such as Fragment of a Crucifixion or Pope III he replied that the pictures had no religious meaning; he himself had no belief of any kind and, in any case, he had no 'message' whatsoever to communicate; in painting, he was merely attempting to 'excite' himself. As far as he was concerned, Bacon said repeatedly, the Crucifixion was no more than an instance of man's behaviour towards man; the form of the Crucifixion had attracted him because it elevated the figure and gave it an automatic importance which helped him present images of the human body - which was his real, and basically only, intention. Having played such a central role in European art,

the Crucifixion was, he allowed, a useful construct, a 'marvellous armature on which to hang all kinds of thoughts and feelings'.

Then Bacon made the most revealing statement, which, at the time, went virtually unnoticed.² In painting a *Crucifixion*, he remarked, he was in reality expressing his own private feelings and sensations. Indeed a *Crucifixion*, Bacon went on to say, came 'almost nearer to a self-portrait'.³ The implications of this unusually unguarded admission are far-reaching. At its most extreme, the remark could suggest that Bacon *identified* with Christ on the Cross. At the very least, it indicates that he himself had experienced suffering so intense that the Crucifixion, with its complex symbolism of betrayal, abandonment, and atonement for the sins of others, was the most appropriate image through which to express it.

Other than Picasso's brilliant skirmish with the theme, the Crucifixion has not figured prominently in twentieth-century painting.⁴ It had a passing interest, mainly because of its blasphemous shock value, for the Surrealists, but certainly not for modernism as a whole. Why then should Bacon, the loudly self-proclaimed atheist, have been obsessed by the Crucifixion? Why, indeed, did he feel himself to be crucified? Apparently the question was never asked; though if some perceptive commentator had put it to him, risking a baleful stare and withering contempt, the artist would almost certainly have evaded it. Although he professed to express nothing, in choosing the agony on the Cross as his central subject Bacon was surely driven to express a wound at the core of his being. Throughout his life, he elegantly or scornfully sidestepped such leading questions as why he painted his ferocious, writhing images, feigning indifference, citing the 'violence of life itself' and leaving his baffled critics to flounder among vague concepts of existential anguish.

Now the artist is no longer present to direct or deflect attention, Bacon's *oeuvre* is left to speak for itself. The long process of unravelling will begin in earnest, as it does for all of those artists whose work truly survives and assumes a different kind of weight and import after their death. At this point, with the posthumous record barely opened, speculation has to focus more on formulating the right questions, to which the right answers may or may not eventually be found. Was Francis Bacon's relationship with his father so traumatic that the artist sought expression for it through the Crucifixion? Was being surprised by his father, to whom Francis felt an erotic attraction, while he was putting on his mother's underwear the real humiliation?

Or was it his father's disgust and the subsequent banishment from home? Or were these simply details of a tortured childhood (which included being regularly horsewhipped by the grooms at his father's behest)?⁵

Perhaps the real reason was more deeply hidden. Besides Picasso, the greatest influence on Bacon's early, imaginative development was Aeschylus, which Bacon had discovered through T. S. Eliot's The Family Reunion. If Bacon was compulsively drawn to both dramas, it was because the theme of guilt and atonement disturbed and haunted him. One might suppose that his sense of guilt had been prompted by his homosexuality and its catastrophic discovery within his own family. But in both plays the hero is not really guilty on his own account: he has the sins of his father visited on him. For Orestes, his father's sin was sacrificing Iphigenia; and his father's death at the hands of Clytemnestra leaves Orestes no choice but to kill his own mother. For Harry Monchensey, a post-Freudian protagonist, the problem takes on more psychological overtones: his father's desire to kill his mother, while still pregnant with Harry, has left the hero with an obsessive guilt (personified by the Furies) which can only be resolved once the deeply buried cause has been dredged up into the conscious mind.

Where did Bacon's burden of guilt lie? His father had married for money (according to the son), and only after having been turned down by a relative of his mother. Beyond that, he was not much interested in her or his family, which he appears to have sired with notably less enthusiasm than he bred horses. The father was 'a highly-strung, intolerant, dictatorial and censorious character, much given to moralizing and to arguments that ended in lasting discord'.6 Did he so tyrannize his son that Francis first found himself through variations on the theme of a crucifixion - and even then only fully after his father was dead? Was it the memory of his father that the artist was struggling to exorcize as he obsessively painted menacing dictators and screaming popes? The intensity of Bacon's early images fuels this kind of speculation. Had the tension between the ill-matched parents given rise to a more sinister incident which, in the son's powerful imagination, had taken on mythic dimensions? The situation becomes more complex once its erotic content is taken into account. Did the tyranny of the father excite the son? Did the beatings - if they took place – arouse Francis sexually? Did he imagine himself his father's wife as he put on his mother's underwear? And, if so, to

what extent were the *Crucifixions* – and indeed the whole flayed population of Bacon's pictures – the voluptuous production of a strong sado-masochistic fantasy?

A key change in Bacon's life in the middle of the war, after he returned to London from his unsuccessful sojourn in the Hampshire countryside, came when he found a new studio. His life had become less peripatetic, and he had managed to keep his studio at 1 Glebe Place in Chelsea for some seven years, from 1936 to 1943. As far as his London address went, Bacon was never to stray far from the Chelsea and Kensington area again; indeed a map can be drawn of Baconian London in which most of the studios he ever had can be identified during a morning's stroll. Wild and erratic as he seemed in many areas of life, he was also essentially a creature of habit. He tended to see the same old friends and lovers (as well as scores of new ones, who came and went), and he tended to remain faithful to the same restaurants and clubs. Similarly, he followed a basically unchanging daily routine: an early start in the studio, followed, once the day's work was done, by the round of pleasure – eating, drinking, gaming and, sometimes, loving. In late 1943, Bacon moved into the grandest and perhaps the best-loved studio apartment he ever had. It was the ground floor of a substantial townhouse. 7 Cromwell Place. in South Kensington, a short walk from the Science Museum and the Victoria and Albert, whose great collections Bacon, who was interested in the whole gamut of human invention, visited regularly. The house, now the headquarters of the National Art Collections Fund, had once belonged to the hugely successful Pre-Raphaelite painter John Everett Millais and has been known ever since as Millais House. The principal attraction for Bacon was the huge vaulted studio space. built on to the back of the house, with its unwavering north light. It was to be an auspicious studio, where the artist came into his own by producing not only the Three Studies but several other early masterpieces, among them Painting 1946 and the extraordinary Head series. For nearly a decade it was also the scene of an odd, happy domestic arrangement which Bacon was never able to repeat.

Although he professed at the time to be looking for a 'cruel father', no doubt to fulfil his sado-masochistic yearnings, Bacon's preference seems to have been for civilized, gentle older men, although the relationship with Eric Hall, for example, may have taken on a quite different guise when they came to act out their erotic fantasies.

Sexual fantasies fascinated Bacon: he once said he found that they often constituted the most interesting thing about other people. The specialized nightclubs of Berlin had encouraged him to express his own fantasies freely: women's underwear and, notably, fishnet stockings were an essential part of the artist's wardrobe for most of his life. He also became well versed in the literature of sado-masochism. but theory was the least part of his interest, and at one point he owned a collection of twelve rhino whips. One can only speculate about the finer erotic points of his liaison with Hall, on the basis of Bacon's own preferences, which are relatively well documented and which can be sensed with such immediacy in his own paintings. Over the fifteen years or so that their friendship lasted, the sexual side presumably became less central. As the younger, more promiscuous partner, Bacon may well have had other affairs during this time, but it is clear that he depended on Hall's support – emotional, moral, and financial – and remained lastingly grateful to him.

Eric Hall would probably have remained in decent obscurity had he not fallen so conspicuously – and in some ways disastrously – in love with Francis Bacon. His life up until that point appears to have been a model of respectability. After Malvern and Oxford, he had served in the First World War, then worked as a banker and a director of Peter Jones, the department store; later he became a Justice of the Peace and a member of the London County Council, showing a strong interest in education and the arts. But his outwardly staid life was turned upside down by his passion for the young, charming and feckless painter. To judge from Bacon's story about the two of them going down to visit Hall's son at Eton, their affair appears to have been anything but discreet; it certainly destroyed Hall's marriage. The records show that from 1930 to 1946 Hall lived with his family and a maid of all work in Chelsea. But from 1947 Hall and, curiously, his son Ivan were recorded on the electoral register as living at 7 Cromwell Place, South Kensington, the house where Bacon had been living and working since 1943.

Hall's domestic move caused havoc. Bacon remembered much later (though still with some embarrassment) the threatening letters Hall's wife sent him, as well as Hall's own father calling round at Cromwell Place and remonstrating with the young painter. Bacon denied any responsibility at the time, but he was clearly gratified by this expression of his lover's commitment towards him. 'For some reason, I don't know why, he thought he was fond of me,' Bacon would

recall, with significant understatement. 'And of course when you're young, you think much more about your own enjoyment than the harm you might be doing.'

The real victim of the affair, in fact, was Hall's son, Ivan, who became severely deranged, and later blamed Bacon for his mental condition. Bacon himself recalled the episode with more guilt than mirth: 'I can see now that the whole thing must have looked very odd. After Eric died, I don't know whether it was really because of his friendship with me, but the son went completely mad. He used to come round to where I lived and shake his hands at me and shout "It's because of you I'm like this!" Then later when he was in a hotel somewhere he jumped out on a woman in the corridor and broke her arm. After that they put him in one of those homes. Ivan appears in 1953 as a certified patient at Holloway Sanatorium, Virginia Water; unlike Hall's other dependants, no provision was made for him in his father's will.

Eric Hall was one of several older men who fulfilled the role of substitute father in Bacon's early life. In quite different ways, the painter Graham Sutherland and the post-war Director of the Tate Gallery. John Rothenstein, were also instrumental in helping the inexperienced autodidact find his way in the art world, although it is clear that the moment Bacon had grasped a situation his selfreliance took over.8 In an art-historical sense, Van Gogh and Velázquez were to become important father figures to Bacon, too. But Hall's influence appears to have been particularly beneficial in an intimate sense, exercising a healing effect on the traumatized younger man through his civilized kindness and encouragement – qualities which had been so conspicuously lacking in the artist's own father. Although he was often surrounded by people older than himself, Bacon had already begun to impose his own wilful and chaotic style of life on those he came into contact with, more by his natural exuberance than by design. However filled with high drama his pictures were, Bacon's life during this period constantly teetered on the edge of high farce. With his utter lack of regard for convention and his unrestrained flambovance, Bacon had turned his living quarters in Cromwell Place into one of the most bizarre domestic arrangements in London.

As we have seen, Jessie Lightfoot, the Bacon family's nanny, had been a fixture in Francis's life for quite some time before he met Eric Hall. Having moved in shortly after his return to London from Paris in 1928, she followed him through a number of rented rooms and

flats, advising him on his choice of lovers and helping out with a little shop-lifting when Francis's passing 'companions' did not pay sufficiently well. Life was not made any simpler by the young man's passion for gambling, since gaming debts proved far harder to avoid than rent arrears; but Nanny Lightfoot was as resilient and quick-witted as her former charge. They made a redoubtable team, and this relationship, in some ways the most crucial in Bacon's life, was still very much alive when they moved to Cromwell Place. Thus, for several years, Bacon was surrounded by an ideal re-creation of his family: an older lover, who advantageously replaced his father, and his old nanny, who seems from the beginning to have replaced his mother.

For an ageing family retainer whose eyesight had begun to fail, sharing the chaos and countless shifts in fortune on which the artist thrived can hardly have been a bed of roses. Yet Jessie appears to have relished the chance to play an extended role in life: taking care of Francis, pilfering a few necessities, and alarming the friends who drifted through with her enthusiasm for capital punishment. She also had a chance to shine (which Bacon, who occupied the limelight effortlessly, gave only to the people he truly liked) during the gaming parties which, with Eric Hall's help, were organized regularly at Cromwell Place. After taking hats and coats, she made sure everyone had plenty to eat and drink, cheerfully augmenting the house's takings with her tips. She also kept the flat's lavatory locked and had to be prevailed on whenever somebody had need of it. Gambling was illegal at this time and, if detected, severely punished, Bacon's precaution was to keep four lookouts on the pavement outside dressed as house painters complete with ladders and buckets.9 Not only did he and Hall escape arrest, they apparently made a financial success of the whole venture. There were people with money longing for a flutter, and the studio at Cromwell Place, with its blend of faded Edwardian grandeur and bohemian licence, proved an ideal haven from the dangerous dreariness of war. During a good run at the clandestine casino, according to one eye witness, Cromwell Place would fill up with Daimlers and other substantial limousines. 10

Michael Wishart, painter, wit and close friend of Bacon's, gives in his autobiography a tantalizing evocation of life in Bacon's studio just after the war. Wishart had met Bacon by chance in a Soho pub and had later dropped in to see him in Cromwell Place.

I had the impression he was very poor at the time, but he somehow

managed to offer his guests enormous dry Martinis in brimfull Waterford tumblers. (He gave me his great collection of Waterford glass for a wedding present.) The dowdy chintz and velvet sofas and divans with which the cavernous room was sparsely furnished gave it an air of diminished grandeur, a certain forlorn sense of Edwardian splendour in retreat. Later I came to realise that this atmosphere reflected the touchand-go richesse and weary glamour of those hotels in and around Monte Carlo where Francis had spent so much time during a period of disillusion and self-doubt during which he painted only sporadically. He was happier among the ghostly clients of the casinos, whose lifestyles, conditioned by the crazy whim of a little ball, veer from extravagant opulence to abject poverty. The glimmer of two vast Waterford chandeliers produced the mysterious illumination of the room.

Francis, having invited me to supper, refilled my tumbler with warm Martini and went to the kitchen, leaving me standing in the flickering stove-light with a heavy glass. In his absence I inspected the room. Upon the dais in the shadows stood an enormous easel. There were only three paintings, uniform in size, already framed and stacked against a wall. This was the triptych *Studies for Figures at the Base of a Crucifixion*. ¹¹

Looking round the huge studio as he ate 'a delicious dish of spaghetti cooked with garlic and walnuts', conjured by Bacon out of the gastronomic wasteland of post-war London, Wishart noticed that the bookcases contained only Eliot, Pound and – thanks to Bacon's inspired research at the nearby Victoria and Albert Museum – a collection of Muybridge's infinitely suggestive photographs.

Wishart's memoir, peopled by characters such as 'Sod' Johnson, an ageing nightclub hostess also known as the 'buggers' Vera Lynn', and 'Granny', an eminent stockbroker with a secret life in Soho, gives a vivid picture of the extravagant whimsy of bohemian London in the immediate post-war period. Bacon introduced the bisexual Wishart to Anne Dunn, daughter of the Canadian-born magnate Sir James Dunn. The marriage did not last, but it was given a resounding send-off in Bacon's studio later extolled as the 'first real party since the war'. As the following extract from Wishart suggests, Bacon's life was far from being confined to the *Sturm und Drang* of crucifixions and screaming popes. In the background there was plenty of carrying-on, with champagne, laughter and elegant frivolity:

We bought two hundred bottles of Bollinger for two hundred people,

and soon had to send out for more, as our gate-crashers snowballed. Francis astonished everyone by painting his two large chandeliers crimson, and his face a more delicate colour. I hired a hundred gold chairs and a piano. For three nights and two days we danced. We had two very good pianists. One was the painter Ruskin Spear, the other our stockbroker friend Granny Blackett. We knew Granny from the nightclubs where he liked to improvise and sing, in a dated Cowardesque voice, his parodies such as

'You stepped out of a train With your tiara on And your mascara on...'

Many of the guests in Bacon's studio knew each other from their visits to the Gargoyle Club, which was London's nearest equivalent to the nightclubs of Saint-Germain-des-Prés in Paris. But this was very much an English establishment, and it attracted an easy-going medley of wayward aristocrats, intellectuals, artists, hard-drinking society beauties, and the inevitable host of 'characters'. The original premises in Soho had been designed by Matisse, with antique mirrors cut into thousands of square wall tiles and an impressive gold and silver staircase sweeping down into the club's main room. For Bacon, who spent a large part of his life in bars and drinking clubs of every description, the Gargoyle provided a regular port of call on his nightly round. What fascinated him was not only the mix of people to be found there, but their uninhibited behaviour; the club had been founded as 'a chic nightclub for dancing ... but also as an avantgarde place where people can express themselves freely in whatever manner they please'. 13 After being alone in the studio, Bacon loved to get out and observe others, particularly when they were in the grip of intense emotion or undergoing a crisis; he would often sit near a mirror so that he could watch discreetly what he called 'people carrying on'. There was a detached amusement but also compassion in this obsessive interest; and if the artist knew and liked the people concerned, he would be the first to offer every kind of help, without counting the often considerable cost – in time, money or patience – to himself. The free-and-easy atmosphere of the Gargovle encouraged people to give vent to their passions and their jealousies. Sexual jealousy intrigued Bacon, and nothing absorbed his attention more than a couple consumed by a bitter lovers' quarrel. He himself came to know jealousy's sting well, describing it as an 'illness so ghastly I

wouldn't wish it on my worst enemy'; and one of the reasons he returned regularly to Proust was his profound insight into this most corrosive of emotions. The Gargoyle provided what amounted to a nightly performance of people acting out their private lives in public, with famous spats that would be carried over with renewed vehemence from one evening to the next, like a play performed in instalments. The Gargoyle was, Bacon recalled nostalgically, 'a place made for rows'. With a membership list that reads like a Who's Who of London's postwar intelligentsia, and visits by famous foreigners such as Jean-Paul Sartre and Simone de Beauvoir, it was irresistible for a painter of modern life. 15

In the midst of the most seriously pursued frivolity, the process of image-making continued in Bacon's mind as an instinctive part of his being. Often it was not a conscious phenomenon at all: the artist himself frequently likened it to day-dreaming, with one image after another forming and dissolving. Having had many of his attitudes defined by his early contact with surrealism, Bacon paid the greatest attention to whatever promptings might come from his unconscious, which he regarded as a 'pool' from which the most unexpected images might surface like monsters from the deep. A painter in search of something new had to be free enough to allow everything in, however grotesque or absurd it might seem to the conscious mind, Bacon believed: only then might the conditions favour the emergence of a truly inventive image, rising from the unknown with what the artist called 'all the foam of its freshness' still clinging to it.

The war years had been a period of doubt and disillusionment for Bacon. However much the curious freedom of living under the threat of annihilation had exhilarated him, he had been regularly confronted by his failure to break through as a painter. He had always known that he was talented; even in his first, untutored attempts at oil painting, a natural gift was clearly apparent. But between 1937 and 1944, Bacon's highly developed critical faculties had always got the better of his creative spontaneity. Barely had an image begun to form than he saw its shortcomings; and because he instinctively expected only the very best from himself, hardly any of these early canvases survived. In deep frustration the artist tried to turn his back on painting and to lose himself in love affairs, gambling and drink. Yet the need to paint did not go away. After his father's death, when he had re-created a family of his own choosing at Cromwell Place,

certain inhibitions which had hitherto hemmed him in receded dramatically. Possibly he had inherited from his father the sense of being descended from a long line of distinguished ancestors, and the pressure to conform (even while, as a homosexual, allowing the line to die out) was at first too powerful to oppose and overthrow. But the artist possessed in unusual measure the resourcefulness and determination of his Bacon and his Firth forebears. He still needed to find out how to turn those qualities around so as to defy every convention he had been brought up to respect. That volte-face took a significant time even for this most rebellious of spirits; and, with the disappointments and the self-criticism, it helps explain the long, fallow interlude between Bacon's forceful début of the early Thirties and his triumphant return, a whole decade later, in 1944.

When the breakthrough was achieved, Bacon had not exhibited a single work for seven years. Rumours of the new triptych circulated quickly, nevertheless, and in April 1945, with the end of the war a mere month away, the artist was invited to exhibit both the *Three Studies* and his subsequent picture, *Figure in a Landscape*, at the prestigious Lefevre Gallery, then situated on New Bond Street, in an exhibition devoted to contemporary English painting. John Russell, who went to the exhibition, vividly describes the impact of the triptych:

Their anatomy was half-human, half-animal, and they were confined in a low-ceilinged, windowless and oddly proportioned space ... They caused a total consternation. We had no name for them, and no name for what we felt about them. They were regarded as freaks, monsters irrelevant to the concerns of the day, and the product of an imagination so eccentric as not to count in any possible permanent way. They were spectres at what we all hoped was going to be a feast, and most people hoped they would just quietly be put away.¹⁷

As Russell suggests, visitors and even critics were so unnerved by the *Three Studies* that they fled – a reaction that would have pleased Bacon more than praise. It confirmed his capacity to *disturb*, and having drunk deep at the fount of surrealism as an aspiring young painter Bacon knew that truly original art was bound to offend, the more deeply the better. Many years later, towards the end of his career, Bacon was delighted, for instance, to hear that a visitor to the Centre Pompidou in Paris had closed her eyes and crossed herself when confronted by his *Study of the Human Body* (1982), a truncated

male form with prominent genitals and cricket pads emerging from a hot orange background. Much the same reaction was elicited at the Lefevre show from the reviewer for *Apollo* magazine, who, signing himself as 'Perspex', recounts:

... I, I must confess, was so shocked and disturbed by the Surrealism of Francis Bacon that I was glad to escape from this exhibition, which I had anyway entered prematurely, unguided therefore by a catalogue. Perhaps it was the red [sic] background in three of the pictures that made me think of *entrails*, of an anatomy or a vivisection and feel squeamish. I don't know; but there it is.¹⁸

Raymond Mortimer, later an eminent literary critic, gave a more sympathetic review in the *New Statesman*:

Three Studies for Figures at the Base of a Crucifixion seem derived from Picasso's Crucifixion, but further distorted, with ostrich necks and button heads protruding from bags – the whole effect gloomily phallic. (Bosch without the humour.) These objects are perched on stools, and depicted as if they were sculpture, as in the Picassos of 1930. The Figure in a Landscape is no more engaging in form, but here the colour is more varied and the paint a beautiful mosaic. I have no doubt of Mr Bacon's uncommon gifts, but these pictures expressing his sense of the atrocious world into which we have survived seem to me symbols of outrage rather than works of art. If Peace redresses him, he may delight as he now dismays. 19

Although he trailed conspicuously behind the other painters at the Lefevre in the critical opinion of the time, Bacon had good reason to feel that his career as an artist was well launched, albeit at the relatively late age of thirty-five. Eric Hall was on hand to buy the *Three Studies*, and the *Figure in a Landscape* went to another faithful supporter, the artist's cousin Diana Watson; but both paintings were to find their way into the Tate Gallery by the early 1950s. More significantly, he had paid, as it were, his art-historical dues: the *Three Studies* exactly fulfilled the requirements of the traditional 'masterpiece' in which the apprentice absorbs the style of the master (in this case, primarily Picasso) while establishing a style unmistakably his own.

With the subsequent picture, Bacon demonstrated the distance he had put between himself and Picasso's potent spell, applying his genius to preoccupations which were to remain with him for the rest

of his career. Figure in a Landscape was triggered off by a snapshot of Eric Hall dozing in a deck chair in Hyde Park. This homely sight became cross-fertilized (inexplicably and enigmatically enough) in Bacon's imagination with the news photos of dictators – father figures of another kind – haranguing the masses through microphones. In a movement of pure, elliptical brilliance, Bacon does away with the figure, retaining only its clasped hands and part of a well-cut doublebreasted suit (which he coloured a perfect flannel grev by scooping dust off his studio floor and fixing it). This is the first example of Bacon's masterly shorthand: 'the smile without the cat', in Lewis Carroll's phrase, or 'the sensation without the boredom of its conveyance', as Bacon put it, paraphrasing Paul Valéry. The suit gapes like an empty parenthesis, a sinister surrealist pun that any statesman could don before addressing the people. The void left by the figure recedes into a charred landscape, a wasteland scribble of empty words.

Towards Other Shores 1946–50

I saw him open his mouth wide - it gave him a weirdly voracious aspect, as though he wanted to swallow all the air, all the earth, all the men before him.

Joseph Conrad, Heart of Darkness, 1902

Britain emerged from the war shaken to its roots. Fear of death and destruction gave way to the pettier anxieties of austerity and privation; how to spin out the days with a little powdered egg, a ration of paraffin for the stove and a coat that had gone at the elbows. The mood was one of deep disillusionment in what one of Bacon's reviewers, Raymond Mortimer, called 'the atrocious world into which we have survived'. For a couple of decades thereafter Bacon was credited with a sense of outrage at the war and its aftermath before it became apparent that the origins of his outrage were both more private and more metaphysical. Like everybody who lived through it Bacon had been affected by the war, but unlike most people he actually drew strength from it. Now, with his disdain for taking anything too seriously and the resourcefulness he always showed in extreme situations, he came triumphantly into his own, his colourful and eccentric personality standing out in the grey post-war world.

From the mid-1940s to the beginning of the 1950s, Bacon's life and career progressed rapidly until the ending of his two closest relationships forced him, in 1951, to abandon the studio at Cromwell Place and the whole idiosyncratic way of life he had fashioned there. It was a crucial period during which he came to terms with the deep-seated conflict between what he was expected to be by birth and

what in reality he was. 'Only by going too far', a favourite phrase of Bacon's ran, 'will you get anywhere at all.' If he was going to be a misfit, a freak of nature, a monster of the perverse and macabre, he would do so with dedicated panache. If he was to rebel against a powerful system, he would rebel with like power. And in painting he had found the most telling instrument of rebellion, at a time when on the art scene all the sons had risen against their fathers. By 1946, with his own father dead, and his first achievements as an artist recognized, Bacon could feel for the first time in his life that he had found his direction.

Shaky and intermittent as his first efforts as a painter had been, Bacon now experienced with great gusto the world opening up around him. In a series of inspired accidents, his *Painting 1946* was about to materialize, confirming his presence as a disturbing iconoclast in the generally mild-mannered English art world. Bacon was to follow this with a series of *Heads*, brought together in a one-man show in 1949, that were to establish his mastery of oil paint and his uncanny ability to provoke chance effects within the infinitely malleable medium. The following year, he rounded the period off with a *Fragment of a Crucifixion*, which showed that his power to shock was in no way diminished by an increasingly sophisticated technique: it had simply become more insidious.

As Bacon's reputation increased, so did his contacts in the art world. His friendship with the painter Graham Sutherland, whom he had known since they first exhibited together at Agnew's in 1937, flourished during the war and throughout the following decade. Considered by several leading pundits of the time to be England's most original artist, Sutherland enjoyed a prestige far beyond anything that Bacon had known; and he was ideally placed to bring his younger friend's work to the attention of the key members of the English art establishment, notably John Rothenstein at the Tate (of which Sutherland became a trustee) and Kenneth Clark at the National Gallery. 'I want you to meet this fantastic painter, Francis Bacon.' Sutherland would announce to anyone whose opinion he respected. 'He's like a cross between Vuillard and Picasso.' Although it took time to materialize. Rothenstein's support was to prove crucial to Bacon's career; it would culminate, in 1962, with a first full retrospective of his work. The contact with Clark proved less fruitful. At Sutherland's prompting, the influential Director of the National Gallery visited Bacon's Cromwell Place studio around the time the

artist was working on *Painting 1946*. After scrutinizing it, Clark remarked: 'Interesting, yes. What extraordinary times we live in,' and departed. Stung by this apparent indifference, Bacon turned to Sutherland, who had been urging him to get his work better known, and said: 'You see, you're surrounded by cretins.' Nevertheless, that evening, when Clark joined Sutherland for dinner, he said: 'You and I may be in a minority of two, but we may still be right in thinking that Francis Bacon has genius.'²

It was also in large part thanks to Sutherland that Bacon found his first committed art dealer in Erica Brausen, who, having founded the Hanover Gallery in 1947, went on to make it London's leading showcase for contemporary art. As a result, Bacon's work slowly began to attract a few serious collectors, both in England and America. At the same time, with more group exhibitions containing a picture or two by him, his name became better-known – at least in London's artistic and literary circles. His shows were regularly reviewed in the major newspapers. Kenneth Clark singled him out in a survey of contemporary British painting as the 'interpreter of our contemporary nightmare'; and in 1949 a brilliant essay-length analysis of his work by Robert Melville appeared in the last issue of Horizon, which Cyril Connolly had edited with great flair since the beginning of the war. The magazine reproduced seven paintings, and it was Bacon's 'horrorfretted canvases' which Connolly had in mind when he wrote, in a prophetic passage in his last Horizon editorial: '... from now on an artist will be judged only by the resonance of his solitude or the quality of his despair.'3

Scantily documented though this period of Bacon's life remains (compared to other twentieth-century artists of like stature), a new dynamism and drive were now perceptible in everything he undertook. The absolute beginner, full of self-doubt and awkwardness, had gone for ever. 'At one point in my life,' Bacon recalled, 'I realized it was ridiculous to be shy once you had got to a certain age. I had been so shy, what with my pudding face and the way I'd been brought up, that I couldn't even bring myself to go into a shop and ask for anything. Then I thought that's mad, there's no point in being shy – even if you feel, as I expect most of us feel when we're young, all this talent simply welling up inside you! And I really began to try and change the way I was.' By now the transformation was well under way, mainly because the artist had established the supportive 'family' that enabled him to channel his energies into his work.

The ground-floor flat in Cromwell Place was centred round the huge, vaulted studio which had been built out into the mews behind.4 Structurally, the studio had not changed since Millais had painted there in the 1860s, but there was no trace of the rich tapestries and heavy mahogany furniture with which the successful Victorian painter had embellished it.5 Uncompromisingly modern, Bacon had emptied the cavernous space and put in only the things essential to his work and a couple of worn velvet sofas. The atmosphere was congenially unconventional and, as the painter began to hit his stride, spectacularly chaotic – a far cry from the pristine Bauhaus order of the decorator's studio in Queensberry Mews West. Graham Sutherland and his wife Kathleen were often invited for dinner and as well as the outstanding food, wine and talk they remembered the studio's liberating element of confusion: 'the salad bowl was likely to have paint on it and the painting to have salad dressing on it.'6 Bacon loved the faded grandeur of the studio, which more than any of his subsequent spaces, reflected his own neurotic version of his father's love of grand old country houses. For all the passionate turbulence and disruptions of his life. Bacon became lastingly attached to certain places, and in later life he frequently rued his impetuous decision to leave Cromwell Place.

Everyone who met Bacon at this time was struck by his exuberant charm. Still boyish-looking in his mid-thirties, Bacon had a very distinct physical presence. Of medium height, with intense, pale blue eves and thick, swept-back reddish fair hair (when it was not dyed), he walked with a springily weaving step, as if the ground rolled beneath his feet like the deck of a ship at sea. He was rarely still in conversation, moving to and fro, with his hands outstretched to make a point, and at times even pirouetting if he felt he had made a palpable hit. He benefited from an ox-like constitution, and although he never exercised he remained remarkably fit and agile. Bacon himself claimed that he walked miles every day, ceaselessly going up to the canvas to paint then retreating to judge the effect; and even in old age he rarely seemed to tire when sauntering through a city or being obliged to stand for hours. A hint of the artist's strength was given by his powerfully thick white forearms, which he kept coquettishly on display by rolling up his sleeves. If anyone remarked on the alabaster beauty of his arms, Bacon would swell with pleasure and sometimes archly retort that his legs were even better. Manifestly less attractive were his hands: broad and fleshy, with long, strong fingers, they gave an impression of crude, even sinister force.

Outside the studio, Bacon dressed immaculately. Even when he wore a sweater with jeans and a leather jacket, the clothes were of the best quality; and his suits impressed many of his contemporaries by their expert tailoring. A photograph taken around this time shows him sitting in his cousin Diana Watson's garden but attired like a young banker in a dark double-breasted jacket. The writer Bryan Robertson, who enjoyed several drunken lunches with the artist during this period, remembers that he was unnerved by Bacon's appearance – the combination of lipstick, carefully dyed hair and perfectly cut suits – when he first saw him at the Lefevre Gallery. Michael Wishart was also struck by the cosmetic 'alchemy' Bacon practised, but he was more lastingly impressed by what he called his 'X-ray eyes'.

A curious hybrid emerges: half painted dandy, half steely survivor, a boy who clung to his nanny, and a boy who could take whatever life threw at him. On the sketchy evidence we have, he was already determined and uncompromising, and he had been himself, inescapably, from the start. There were many fully developed sides to Bacon by now: the wit and poseur, the charmer and socialite, the drinker and gambler, the seducer and whore, the careerist and marriage-breaker, the autodidact and image-maker; and when none of those worked, the spendthrift and drifter who got by, by whatever means.

The mass of contradictions could be held together only by the unifying power of art. From what Bacon later described as 'a series of accidents mounting on top of each other', a haunting new image, *Painting 1946*, emerged from that multiple personality. Fifty years on, this powerful icon of the mid-twentieth century, which in many ways stands to post-war Europe as *Guernica* did to a world on the eve of self-destruction, still radiates unspecified threat and a nameless evil. Coming on the heels of the *Three Studies*, it confronts us once again with a scene of concentrated gruesomeness which, though devoid of any ostensible meaning, cries out urgently, like an oracle, to be interpreted.

Everything in this ghoulish imagining conspires to alarm, from the crucified carcass to the bloodied jaws beneath the black umbrella and the insidious opulence of the colouring; but no cause for the disquiet can be found, and the panic remains hermetically sealed in. There is a mood of generalized evil reminiscent of the atmosphere Conrad

builds up towards the end of *Heart of Darkness*, one of the few 'narratives' Bacon admitted into his exclusive pantheon. On one level, it is as though the contradictions of the artist himself have come through, diverted and amplified, but not resolved, in the image. A conflict is established which, on a deeper level, captures the conflict which Bacon perceived at the heart of human existence: the picture demands a solution as insistently as a murder mystery, but no leads, either symbolic or narrative, are forthcoming. The painting exactly reflects Bacon's view of life as an accident, a spasm of brutality and suffering which cannot be explained because it has no meaning.

Painting 1946 remained one of Bacon's own favourite works, not least because it came about in a singularly unpremeditated – or what the Surrealists called 'automatic' – fashion. The artist was particularly preoccupied at this period with how he might combine surrealist techniques of free association with the formal grandeur of a Titian or a Velázquez. It seems likely that Bacon had got himself into a trance-like state, induced by alcohol and lack of sleep (as he admitted to doing when he worked on the Three Studies for a Crucifixion in 1962), in order to free himself from the strictures of his hyperactive critical faculties. He recalled later that he had moved almost unconsciously from roughing out a monkey in long grass to doing a bird swooping down on a field before the random paint marks led him to an image that ended as the headless mouth beneath the umbrella.

This haunting fragment of a face had probably been inspired by the countless news photos Bacon had seen of dictators in midharangue, though the massive jaw and bull neck of this figure bring Mussolini specifically to mind. One can only speculate why the artist placed his figure against what he called 'an armchair of meat', beyond the fact that dictator figures and sides of meat both fascinated him; he himself recalled how he had been drawn to butchers' shops as a boy, and later he allowed himself to be photographed, stripped to the waist, between two sides of beef – in an obvious reference to *Painting 1946*. A further instance of the pervasive effect of photographs on Bacon's imagination is seen in the drawn blinds, taken from a famous shot of Hitler's bunker. The painter was to use them time and again to intensify the sensation of a hermetically sealed space in which his figures were trapped.

The umbrella also serves as a space-defining device: it had already appeared in the slightly earlier *Figure Study II* and in a picture called *Study for Man with Microphones*, which Bacon reworked over a period

of two years and then abandoned. It has been noted that in Ford Madox Brown's famous painting of departing emigrants, *The Last of England*, the umbrella plays much the same role as a means of centring attention. ¹⁰ However improbable this may sound as a potential source for a Bacon, one should not forget that the artist looked at everything and that his imagination could be touched off by the most unlikely things. ¹¹ It is also worth recalling how highly charged an object the umbrella was for the Surrealists.

Particularly revealing in this context is Freud's statement in The Interpretation of Dreams that all 'elongated objects', such as umbrellas, may signify the male organ, with an open umbrella denoting an erection. It is tempting to speculate to what degree the dictator figure with its open mouth (which has obvious sexual connotations) was still associated in Bacon's half-conscious imaginings with his own father; and to what extent the opened umbrella was an expression of the sexual attraction he admitted he had felt towards him. (Although he never expressed much interest or confidence in psychoanalysis, Bacon was fascinated by Freud's research and greatly admired his writings; he may well have been led to Freud by the frequent references to his work in the surrealist magazines.) Whatever the obscure object of desire, there can be no doubt that a strong current of eroticism runs through this painting - as indeed through most of Bacon's art – and it is heightened by the juxtaposition of dead meat and desperately voracious, living flesh. In this setting, filled with what Georges Bataille called the 'lugubrious grandeur that characterizes the places where blood flows', the confrontation between life and death, eros and thanatos, has been orchestrated with maximum dramatic intensity. 12 Indeed, as Bacon's critics were not slow to point out, it teetered on the edge of Grand Guignol. In retrospect, one is more aware perhaps of the risks taken in this enormously ambitious composition, which incorporates such apparently irreconcilable elements as festooned carcasses (inspired by Bacon's wanderings through Harrods' Food Hall), ranting dictators, open umbrellas and tubular furniture drawn directly from the artist's own earlier designs. Like the Greek tragedy which had impressed Bacon so deeply, Painting 1946 comes close to melodrama yet rises above it by the scale of its conviction and imaginative power.

The new painting so surprised and impressed Graham Sutherland on one of his visits to Cromwell Place that he urged Erica Brausen to get in touch with Bacon right away. Dealer and artist met (in true Baconian style) over drinks at the Ritz in the summer of 1946, and they got on famously. As a result Brausen was invited to the studio to see Painting 1946, which she bought without more ado. This marked a turning point in the artist's career: the picture was exhibited at the Redfern Gallery for a few weeks, then included in a survey of twentieth-century art at the Musée d'Art Moderne in Paris at the end of the year. But if Brausen was to prove crucial to Bacon, the reverse was also true, since neither of them was yet properly established in the London art world. Enterprising as she was, Brausen needed a little more time for her talents to be recognized. She had left her native Düsseldorf in the early 1930s and settled in Paris, where her life revolved around the galleries and the artist friends she made there. Fired by her enthusiasm for Miró, she then left for Majorca, where she opened a bar much frequented by artists and writers, an experience, as Bacon surely pointed out, which prepared her admirably for running a gallery. Just as war was about to break out, she pulled up stakes and arrived in London. During the war, Brausen organized a few small shows in artists' studios and worked for a while at the Redfern Gallery. Once the war was over and she had secured the support of the wealthy American-born collector Arthur Ieffress, she decided to open her own gallery, in St George Street, off Hanover Square. Starting off with a solo exhibition by Graham Sutherland, she rapidly established the Hanover Gallery as one of the few venues in England which concentrated on contemporary art from home and abroad.

Brausen's cosmopolitan outlook, as well as her unconditional lesbianism, helped cement the relationship which Bacon was about to begin with her. It also helped that she had given him £200 for his painting – a considerable sum for a virtually unknown artist. (During the same period, for example, Brausen paid £350 for a Juan Gris Composition, and £200 for twelve watercolours by the far more established Sutherland.) Two years later, Alfred Barr displayed the same qualities of perception and daring as Brausen by acquiring the large livid composition for £240, on behalf of the Museum of Modern Art in New York. The mere fact of having a work in the world's most important collection of twentieth-century art went a long way towards establishing Bacon internationally, and it encouraged several important American collectors to buy his paintings later on. Even before this notable coup, Brausen had shown how faithful and effective she could be as the artist's representative; the relationship

between them — a volatile mixture of real friendship, possessiveness and ambition — was to last for the following thirteen years. Meanwhile, the artist himself seems to have had only one thought after selling his new painting to the Hanover Gallery: to use the proceeds to escape the drabness and privations of post-war London and enjoy himself in a location more to his taste. By early autumn 1946, within a fortnight of the sale, Bacon had left London *en route* for Monte Carlo.

The French Riviera had been virtually invented by the English upper classes seeking to escape the worst rigours of their winter, and in the Edwardian era into which Bacon had been born 'Monte' represented the summit of elegance, luxury and frivolity. After the discomfort of London, the South of France would have seemed especially alluring. The artist suffered intensely from the damp cold, which tended to aggravate his asthma; and whenever he could, he kept his studio heated to a hothouse temperature. Similarly, although he was able to endure the most spartan regimen, Bacon was by nature a man of strong appetites, and the continuous scarcity of proper food tormented him. The eagerness with which the English looked forward to returning to the sensual delights of France found its most eloquent spokesman in Cyril Connolly, who, like Bacon, made a beeline for the South of France at the first possible opportunity after the war.

In November 1946 Bacon went up to Paris to see his recent *Painting*, at the Musée d'Art Moderne. Nearly twenty years had gone by since he had arrived, full of ambition and self-doubt, in the French capital. Much later, at the time of his retrospective at the Grand Palais, he admitted that if the French liked what he had painted, that would be for him the most meaningful recognition. When he returned to Monte Carlo, Bacon thought of looking for 'a large room or studio' in Paris which he might use occasionally, and he wrote to Graham Sutherland suggesting that, if he found one, they might take turns working there; he also told Sutherland that he did not want to return 'to England at all for a long time'.¹³

As it turned out, Bacon did not feel the same magnetic pull to post-war Paris as he did to the South of France, where he would spend a considerable part of each year until 1950. For all his repeated attempts to paint there, however, Monte Carlo proved unconducive to work: the light was too strong, and there were too many distractions. In fact Bacon painted nothing throughout 1947, and he

had to return to his Cromwell Place studio before he could do the work he wanted. He began his series of *Heads* in 1948, mainly because Erica Brausen, who had advanced him money, was urging him to get a body of paintings ready for a show; and several of the *Heads* were finished under pressure to make the deadline for the exhibition, which opened at the Hanover Gallery in November 1949.

London remained the place to paint - indeed, throughout his life, Bacon never worked successfully anywhere else - but the French Riviera, with its climate, casinos and exotic mix of people, was clearly the place to have fun. Eric Hall usually accompanied Bacon, and they spent their days, in Bacon's words, 'drifting from luxury hotel to luxury hotel, eating and drinking too much'. In those years, when sterling went a long way abroad, stopping at the Carlton in Cannes, the Negresco in Nice and the Hôtel de Paris in Monte Carlo would not have seemed as extravagant for a youngish painter and his comfortably off companion, paying in pounds, as it would today. Used as he was to comfortless studios. Bacon nevertheless had a pronounced taste for luxury, and he had never forgotten the opulent apartment he had occupied with his father's virile friend at the Adlon in Berlin. What he enjoyed most was going from one extreme to another: from dismal rented rooms and seedy drinking clubs to tasting a rare champagne as he moved stealthily between the roulette tables placing his bets to left and right.

Self-indulgence, on however spectacular a scale, rarely clouded Bacon's hawk-eyed observation of everything that was going on around him. He was particularly fascinated by people who had enough money to live as they wanted: by being free to satisfy their desires and whims, he felt, they showed their real nature - their 'instincts' - more clearly. In the years just after the war, the Côte d'Azur formed a perfect balcony from which to view the antics of rich drifters and errant heiresses as well as a range of tricksters, gigolos, whores and fair-weather men. For hours on end, sitting in the smart hotels and cafés, Bacon would watch them all 'carry on'. 'The barmen in those places were fascinating,' he recalled. 'They were really like nursemaids. People would come in and draw up a seat and pour their life stories out. And the barmen would keep filling up their glasses and telling them what to do. It was simply mad, and after a while the boredom was so extraordinary you simply sat there and couldn't believe it. And then I remember one woman got so bored she just went up to her room and threw her dog out of the

window. Well, it landed on that thing, the awning, below, and somebody had to be sent to rescue it. Everyone loved that, naturally. It gave them something new to talk about and relieved the boredom, just for a moment.'

Gambling, of course, gave Bacon an inexhaustible source of excitement in Monte Carlo. He loved the Belle Epoque casino with its succession of large plush salons and its magnificent views over the Mediterranean and the mountains leading towards the Italian border: and he remembered very vividly watching from its bay windows as a forest fire raged high into the hills above the town. Although he had gambled on and off from youth, his passion for high stakes and the atmosphere generated by fortunes being made and lost can be traced to Monte Carlo, 'You can't understand the tremendous draw gambling has unless you've been in that kind of position where you terribly need money and you can manage to get it by gambling,' he once explained. 'It can really get a hold of you when you need the money and win. Of course you spend the rest of the time losing it again and God knows how much more. But at those moments there's this feeling you get about being able to control the way your life goes.'

Bacon enjoyed himself so thoroughly in the easy-come, easy-go ambiance of Monte Carlo that this remained one of the periods of his life that he talked about most spontaneously. He once gave me a detailed picture of the kind of life he led there:

I had a really marvellous win at one point. I was playing on three different tables and I kept thinking I could hear the numbers called out before they came up — as if the croupiers were actually calling them out. I had very little money and I was playing for small stakes. But by the time I'd finished I'd got sixteen hundred pounds, which was a very great deal for me then. And I went out and took a villa and stocked it with food and drink and invited a lot of people to come and live there ... I adore the atmosphere of Monte Carlo. It has a kind of grandeur, even if you might call it a grandeur of futility. There's something so beautiful about the view you get from the casino when you look out on to the bay and the curve of the hills behind. I love that kind of landscape. That, and just desert. I love the feeling of all that space with nothing in it. It sounds ridiculous, liking a landscape from behind a window, but I actually can't stand the countryside. After a day or two, I long for streets and people and just to be able to walk and see them.

Those places like Monte Carlo fascinate me too because of all the odd people who seem to be able to exist there and nowhere else. You know. the curious kinds of doctors with their promises of rejuvenating you who at that time I suppose could only practise in those sorts of places, and all the incredible old women who queue up every morning for the casino to open ... The evening I had that marvellous run of luck at the casino, a very handsome man was standing opposite me at one of the tables, just watching everything. Well, he came back with me to the villa I'd taken. And we were standing outside one night looking down at the sea and he said, he had some foreign accent: 'That eez my vacht over zere,' and of course I knew he didn't have a vacht and I said, 'That's not your yacht,' and he said: 'Perhaps it eezn't zat one, it must be over zere somevere ...' Then later I said to him: 'Why don't you go into the films with those marvellous looks of yours?' And he looked very serious for a moment and said: 'I vill tink about it.' Anyway, the next morning he disappeared. And a couple of hours later, the whole of the Monte Carlo police were in the villa wanting to know about him. It turned out he'd worked his way all round the Riviera, from casino to casino, as a confidence trickster, making people pay dearly for their fun, and probably everything else besides.

There was no mention of such escapades when Bacon wrote occasional progress reports to his new-found dealer in London. Most of his letters were appeals for funds to be advanced on pictures not yet painted. Although Monte Carlo was not proving conducive to work, it had become too alluring to leave. After the grey dampness of London. the painter was constantly amazed by the light, which often had an iridescent quality throughout the year. After staying in a succession of hotels (notably the Hôtel de Ré) and flats, the artist settled in the large villa. La Frontalière, situated in the hills above the town; both Eric Hall and Nanny Lightfoot came to stay with him there. Shortly after moving in. Bacon wrote what for him was a relatively discursive letter. Dated 1949 and addressed to 'Dearest Erica', it says: 'I have found a villa with what I hope will be a wonderful room to work in. It is at the top of the house with windows all around and far more sensational views than the Château de Madrid. There are plenty of rooms and bathrooms so do come and stay if you feel like it ... I feel I will be able to work rapidly and a lot ... My love to you all. Do tell Arthur I have not been able to track down the movements of the Fleet yet. I do hope you are feeling better. It is wonderful here terribly

expensive and the days hot and trembling like the middle of summer. Much love Francis.' The reference to the Fleet was for the benefit of Arthur Jeffress, Brausen's financial partner at the Hanover Gallery, who had a penchant for the lower ranks in uniform.

It is to Jeffress that Bacon's only other known letter from Monte Carlo is addressed. Characteristically, its main purpose is to thank him for having advanced the substantial sum of £200 against unsold work. Having this and no doubt future credit in mind, the artist strikes an upbeat note: 'I am at the moment working on some heads which I like better than any I have done before. I hope you and Erica will like them.' Bacon goes on to say that he will bring the paintings over to London 'in November or December': he also asks what dates the gallery has in mind for his exhibition, saving that as far as he is concerned the later it takes place the better it would be for him. 14 In the event, the Hanover's first exhibition of his work, which included six Heads, ran from 8 November to 10 December 1949, and Bacon painted virtually the whole show in London in the weeks leading up to the opening. The plea not to be put under pressure to produce was to become a constant refrain from the artist to his gallery, but it did not prevent the Hanover from holding shows of his work every year but one between 1949 and 1959. Although the gallery needed regularly to recoup the funds they had advanced, this frequency displeased Bacon and no doubt contributed to his eventual break with the Hanover.

The extended stays on the Côte d'Azur were among Bacon's happiest and least troubled times, and for the rest of his life he returned regularly to his old haunts there (or what remained of them) and periodically toyed with the idea, when well into his seventies, of renting an apartment somewhere along the coast so as to miss the worst of the London winter. Several of his near-contemporaries remember seeing him there during the late 1940s. Elsbeth Juda, the photographer and painter, recalls the excitement of spending the last few days of 1949 with her husband Hans gambling at the Monte Carlo casino, then joining the Sutherlands at a sumptuous dinner hosted by Bacon, who had been the only one not to lose at the tables. Much of the time, however, he did lose, as Michael Wishart remembers: 'He adored both cards and roulette, often playing at several tables simultaneously, displaying the committed masochism of Dostoevsky, who claimed that the real thrill of involvement only began when he had pawned his wife's jewels and was staking the

proceeds. Francis failed to convince me that there was a deep satisfaction in being completely "cleaned out". '15 Other forms of satisfaction were also hotly pursued, as Bryan Robertson suggests in an evocative reminiscence of the period: 'Francis arrived and told me how to rent his favourite villa on the heights above Monaco which he had taken for many winters as a place for himself and his old nurse. Francis painted all day, gambled all night, and the nurse knitted in the sun. That involuntary revelation of Francis's kindness touched me, and the villa turned out to be delightful, secluded and spacious. It was amusing to find that the furnishings included the most comprehensive library of literature on sexual perversions imaginable, which added a certain zing to hot afternoon siestas, as well as a cupboard off my own bedroom filled with intensely alarming images on canvas left by Francis in various stages of abandonment.'16 Nevertheless, however alluring the pleasures of the place. Bacon already knew that he could not work satisfactorily abroad. He was to make several other attempts to paint in places where the atmosphere attracted him - notably Tangier, and later Paris - but in every case, when the time came to concentrate on producing new work for an exhibition, he seemed fated to return home.

Bacon's important friendship with Graham Sutherland is well documented in letters which the young painter wrote from the South of France.¹⁷ The correspondence gets under way once Bacon is installed in Monte Carlo. 'I don't know if you would like this place or not,' he writes. 'I love the light, and go to the casino in the evening after working, and it is really quite pleasant to feel so isolated ... Nobody here is at all interested in ART, which is perhaps a comfort. I think you might really love working here,' he continues, adding: 'I do want to thank you Graham for all you have done for me. I know I should not have been able to sell anything if you had not been good enough to mention my work to other people.' Later, Bacon makes a more direct attempt to lure the Sutherlands away from the drabness of post-war England: '... it would be so lovely if you and Kathy felt like working here, and I always feel with a little clever manipulation the casino would buy our pictures ... The weather is so lovely and sometimes the colour is wonderful, with a gorgeous pearly haze over things that Renoir tried to catch ...' In the end, the Sutherlands not only visited Bacon in his new paradise in 1947 but later also acquired a house, built by the designer Eileen Gray, near by at Menton.

In between plans to find a studio in Paris, Bacon talks about painting, both his own (tentatively), Sutherland's (flatteringly) and the work (unflatteringly) of others: 'I saw the Balthus things in Paris, but they are no good. He is trying to get the tenderness which we would all love to get for a change, but it can't be done that way, it can only come as a technical thing, or at least I feel that. I feel more and more that nothing matters or will happen until someone makes a new technical synthesis that can carry over from the sensation to our nervous system. The thing I was very shocked by when I saw our things at Unesco, your three and mine, was the boring lack of reality, the lack of immediacy which we have so often talked about. I think it is also why so many Picassos are beginning to look iaded now. It is the terrible decoration we are all contaminated by now ...' Bacon then goes on to mention his first attempts at painting his own version of Velázquez's portrait of Pope Innocent X - the theme which began to preoccupy him in 1950 and to which he returned, intermittently, for the following ten years: 'I don't know how the copy of the Velázquez will turn out. I have practically finished one, and am going to start on a portrait I want to do, but it is thrilling to paint from a picture which really excites you. I'm sick to death of everything I've done in the past, but continue to think like a child or a fool that I'm on the edge of doing a good painting."

There can be no doubt that Bacon was alive not only to the older artist's mastery of technique but also to his influence and contacts in the English art world. Similarly, Sutherland was genuinely struck by the power of Bacon's imagery as well as by his untrammelled way of life. It was an attraction of opposites. Bacon's risk-taking promiscuity (in art and sex alike), his volubly expressed atheism and his deeprooted desire to flout all convention contrasted markedly with Sutherland's well-mannered reticence, ordered existence and attachment to marriage and the Catholic faith (he had converted as a young man). While Sutherland could take vicarious pleasure in Bacon's chaotic drinking, gaming and screwing, the younger man was by no means indifferent to a domestic stability that he himself could never achieve; indeed, at most periods of his life, Bacon's close friends included several securely married couples. It is also probable that Sutherland's faith, which Bacon would have constantly attempted to undermine, also proved an attraction. (Roy de Maistre, it is worth remembering, was a practising Catholic, and Eric Hall grew increasingly religious in his last years.)

A great deal of the shared pleasure, however, came from their conversations, which ranged from gossip about mutual friends and the art world to discussions of their own work and aims. Sutherland appears to have been first struck by Bacon when he read Herbert Read's book Art Now. The most heavily thumbed page in his paintspattered studio copy was the reproduction Read had included of Bacon's 1933 Crucifixion. 18 For a brief period after the war, both painters were perceived as creating a similar climate of impending doom. Although more muted, the coiled malevolence and razor spikes of Sutherland's organic forms looked like the landscape that Baconian man might discover if he ever escaped from his cell-like surrounds. There was undoubtedly a mutual influence, with Bacon particularly interested in Sutherland's technical skill; being self-taught, the younger painter still felt he needed professional guidance. Sutherland was manifestly drawn to Bacon's subject matter and style, and notably his adaptations of Picasso and Grünewald. The Crucifixion and The Deposition painted by Sutherland in 1946 are among the works that testify to Bacon's impact. But the degree of intensity and invention proved quite dissimilar; the younger painter, reckless in painting as in everything else, always went further, taking greater risks. Perhaps it would not be entirely unfair to describe Bacon as the Dostoevsky or Kafka of painting, while Sutherland was its Graham Greene.

Although he came to denigrate Sutherland's pictures, likening his later portraits to covers of *Time* magazine, Bacon professed to admire Sutherland's Crucifixion. Bacon saw it reproduced in a copy of Picture Post, and wrote to Sutherland saying he found it 'most awfully good' and that the colour 'sounded' very exciting. 19 For his part, as we have seen, Sutherland was sufficiently under Bacon's spell to agree (after a particularly convivial lunch at the White Tower in London) to follow his example and try life on the Côte d'Azur. As Bacon's star rose in the firmament of international art and Sutherland's began to set, the friendship cooled. Matters were not improved by Bacon's acerbic comments on the portraits Sutherland had begun to paint of personalities such as Somerset Maugham; at the same time, it should be said that Bacon rarely bothered to criticize anyone whose work had not, at some point, for one reason or another, aroused his interest. Bacon benefited more lastingly from the relationship in that the introduction he had through Sutherland to John Rothenstein led a few years later to a retrospective at the Tate. Sutherland, on the

other hand, began from the early 1950s onwards to be compared unfavourably with Bacon. In a review published in 1952, for instance, Nevile Wallis actually lists Sutherland's debts to Bacon: 'the horizontal and vertical construction lines, the adumbrated features, and long cast shadows ...'. ²⁰ While Bacon went on to attract worldwide recognition, Sutherland's art never received its full due except in Italy, where his reputation still stands highest to this day.

At the end of the 1940s, however, the two painters were still at the peak of their relationship, and Sutherland would not have missed Bacon's first exhibition at the Hanover (Sutherland himself had shown there the previous year). Having found the Mediterranean sunlight too fierce, and having destroyed or simply abandoned numerous canvases painted during his Monte Carlo sojourns, Bacon had been faced by the necessity of producing a sufficient body of work to fill the Hanover's ground-floor space; in point of fact, he appears to have done - or, rather, kept - nothing between Painting 1946 and the first Head, dated 1948 and the sole work catalogued for that year. (It is interesting to note that in the Time review of the 1949 Hanover Gallery exhibition, the artist is said to have destroyed 700 paintings; though certainly exaggerated, the figure indicates how unhesitatingly Bacon got rid of anything he reckoned less than his best.) The artist later claimed that images tended to drop into his mind in sequences, like a series of photos or a film broken up into stills. Being obliged to produce a number of images within a short space of time would also have encouraged the artist to work in a series, with one picture springing out of another.

However precipitate they may have been in the making, the six *Heads* that formed the core of the show are first and foremost brilliant pictorial inventions. As always in Bacon's most successful images, it is difficult to disentangle the various sources they have drawn on, although the thrown-back open mouth of *Head I* is astonishingly reminiscent of a Grünewald sketch of a screaming man.²¹ But Bacon 'looked at everything'; and there may well be as much news photo as Old Master in this haunting hybrid, along with some skilfully manipulated chance movements of the brush. The clotted, grainy paint dragged over the unprimed canvas sets up a visual discomfort similar to the scrape of fingernails on fabric, so that the nerves are immediately alerted to something unusual, something sinisterly unpleasant, before the image has spelt itself out in the brain. But now there are no sides of meat, no bandages or blood, no umbrellas

or other props; simply a glimpse of mankind reduced to basic instinct, the mouth gibbering in fear or opened in attack, with the rest of the senses (and often, literally, the rest of the head) obliterated. The pictures were vividly analysed, as if caught in movement, by Lawrence Gowing, many years after he had first seen them at the show:

Bacon's world was ... centred on the irreducible human fact - the human head. There was nothing else in the next six pictures but the abject physical reality, the unutterable misery of the knob that terminates a human being ... First it is bent back in agony; the chattering teeth, like the teeth of a hunted rodent, break loose in their cavity. The medium of vision, the granular paint, begins to powder down like snow at night. It drifts against the form and loads the canvas; the flesh glitters with a greedy meanness. The paint is now streaming down in a cascade. It makes a curtain of light, which is at once behind the figure and in front of it; the streams of paint only have to thicken a little to constitute the solidity of flesh. The curtain sways – it must be fastened, pinned together with a safety pin as the flesh has been pinned ... In the fourth of the series the curtains part and the human subject is seen passing between them, unless it is they that are passing through him, making him as much a product of the light as they, yet discovering him at the same time to be all too fleshy and animal. He is compared to the little monkey who is nestling against him, with the same chattering rodent teeth and greedy look. The light splashes down on man and ape alike. They are as solid and as spectral as each other. As bestial and as human ...²²

The series showed that Bacon no longer needed sensational subject-matter to create the intense emotion he wanted his images to transmit. He had found a simpler, more effective means, which he was to develop and refine for the rest of his life. All he required, he had discovered in one fell swoop, was a face or figure, in a vestigial setting, a cage or a parted curtain. The rest, the most essential, lay in the manipulation of the infinitely suggestive medium of oil paint. Here the connoisseur of human appearance began to come into his inimitable own. From these pictures on, all human movement and expression was to become his province: the lover in bed, the drinkers at the bar, the bodies colliding on the football pitch. Looking at animals, in photographic studies and later in the South African wildlife parks, trained him to spot and express more accurately the instinct in man. It was only that instinct, man stripped to his

animality, that Bacon wanted to capture. The rest was a gloss of civilization, hiding the snarl of rage and the bellow of fear which lurked undiminished in every human being.

Characteristically, Bacon himself made no claims and offered no explanations for his Heads. They were not intended to have a precise meaning, he was reported as saying in the review published in Time magazine: 'They are just an attempt to make a certain type of feeling visual ... Painting is the pattern of one's nervous system being projected on the canvas.' He was slightly more forthcoming about technique, making the much-quoted assertion that 'One of the problems is to paint like Velázquez but with the texture of a hippopotamus skin'.23 This formula, which may in fact have been misquoted, stood for an ambition Bacon cherished at the time: to achieve a tonal subtlety inspired by the Spanish master that nevertheless had the rough, grainy immediacy of a news photo. The first three Heads are characterized by a conscious striving for a dry, dragged, granular effect, as if the oil in his paint had been absorbed by the addition of sand or some other substance (in the catalogue the medium of the first Head is given as oil and tempera on board; all the others as oil on canvas, a formula Bacon never departed from again, except to add touches of pastel). What he wanted was to re-create the shock he himself had felt on seeing certain news images, such as those that made Picture Post and later Paris Match (both magazines the artist admired) so popular and famous. But he wanted the candid-camera immediacy to endure, enshrined in oil, like a portrait in the grand European manner.

As if in some accelerated evolutionary process, the snarling rodentish snout of the first *Head* becomes a recognizable man, spectral and bewildered, before arriving at what should be a higher form, in *Head VI*, which is recognizably dignified by the vestments of the Church. But this *Head* is again no more than an open-mouthed scream: above the satin-caped shoulders, where calm authority should radiate from beneath a skullcap, there is a blank made more empty by a dangling tassel, as if blinds were about to be pulled down to eclipse the screaming papal head. This was the first of Bacon's variations on Velázquez's portrait of Pope Innocent X, and of all the images in the show it was the one which shocked visitors most, as Lawrence Gowing recalled: 'It was an outrage, a disloyalty to the existential principle, a mimic capitulation to tradition, a profane pietism, like invented intellectual snobbery, a surrender also to tonal

painting, which earnestly progressive painters have never forgiven. It was everything unpardonable. The paradoxical appearance at once of pastiche and iconoclasm was indeed one of Bacon's most original strokes.'²⁴

Critical reaction was for the most part correspondingly confused, with reviewers forced to concede a certain pictorial mastery or even beauty while deploring the paintings' subject-matter and implications. The short notice in *The Times* is a characteristic example:

Mr Francis Bacon is a very capable artist ... But the subjects of his pictures are so extraordinary, and, indeed, so extremely repellent, that it is scarcely possible to consider anything else. His themes are as vivid and as meaningless as a nightmare ... Perhaps the nastiest of his ideas is what seems to be some sort of visceral specimen, a pale and flabby bag of flesh ... But much more frightening are his realistic figures behind half-transparent curtains – there are several showing a huge and brutal man with his mouth wide open as if shouting at the top of his voice – for these leave the most vivid impression that there is some act of frightful violence and cruelty being committed half out of sight. All this could no doubt be dismissed as the nonsense it sounds like if Mr Bacon had not used considerable power of imagination and pictorial skill, thereby producing something which it is impossible not to think worse than nonsense, as *Head II*, which appears to be a mutilated corpse, most certainly is.²⁵

The Observer critic made the point more subtly:

The recent paintings, however, horrifying though they are, clearly cannot be ignored. Technically they are superb, and the masterly handling of large areas of pearly grey, flushed with a sudden pink or green, only makes me regret the more that the artist's gift should have been brought to subjects so esoteric.²⁶

But Bacon already had a powerful supporter. Wyndham Lewis, arch-modernist, iconoclast and one of the most perceptive minds in England, had singled him out six months before the exhibition opened as 'among the most original of the young'.²⁷ In his regular column in the *Listener*, Lewis expanded on this view:

Of the younger painters none actually *paints* so beautifully as Francis Bacon. I have seen painting of his that reminded me of Velázquez and like that master he is fond of blacks. Liquid whitish accents are delicately

dropped on sable ground, like blobs of mucus – or else there is the cold white glitter of an eyeball, or of an eye distended with despairing insult behind a shouting mouth, distended also to hurl insults. Otherwise it is a baleful regard from the mask of a decayed clubman or business executive – so decayed that usually part of the head is rotting away into space. But black is his pictorial element. These faces come out of the blackness to glare or to shout. I must not attempt to describe these amazing pictures – the shouting creatures in glass cases, these dissolving ganglia the size of a small fist in which one can always discern the shouting mouth, the wild distended eye ... Bacon is one of the most powerful artists in Europe today and he is perfectly in tune with his time. Not like his namesake 'the brightest, wisest of mankind', he is, on the other hand, one of the darkest and most possessed.²⁸

The 1949 exhibition marked a watershed in Bacon's career. With this first, truly professional one-man show, he had become less the outsider with an occasional image of horrifying brilliance and more a force to be reckoned with on the contemporary scene. His new position was amply reflected in the prices put on his paintings, which ranged from £125 to £400. During the show, the Hanover's upper floor was hung with recent watercolours by Robert Ironside, whose prices – to give a point of comparison – were round £25. Brausen and her colleagues were clearly doing an excellent job, ensuring that the pictures were brought to the attention of the most influential members of the art world not only in Britain, but in Europe and America: indeed. Bacon's work soon began to attract as much attention abroad as it did at home. But while his career was at last on a firm footing, his agreeably protected, carefree existence was about to be shattered, with a whole, cherished phase of his life vanishing, traumatically, for ever.

Hounded by Furies 1950–54

Where are you damn'd?
In hell.
How comes it then that thou art out of hell?
Why, this is hell, nor am I out of it.
Christopher Marlowe. Dr Faustus. 1604

Francis Bacon entered the 1950s with much the same outlook and virtually the same physical appearance as he had begun the previous decade. His attitude to life, which deepened with time but did not alter, was based on an unyielding conviction of its futility. 'We come from nothing and go to nothing' was his most constant refrain and the bedrock of his belief. It was said in varying tones of voice: gently. almost tenderly, suggested to a new acquaintance, or delivered tutta forza to a line-up of regulars at the bar of a favourite haunt, 'In the brief interval between, we can simply drift and try to find ourselves.' the painter would add with a flourish, or lift his glass and propose to the surrounding sea of drinkers with perfectly pitched irony: 'Since the whole thing is such a charade, we might as well be brilliant.' But his lack of belief and essential pessimism in no way diminished his relish for the promise, however hollow or meaningless, of each new day. On the contrary, the prospect of total annihilation appeared to sharpen his appetite not only for pleasure but for every aspect, however banal, of what he called 'conscious existence'.

But age itself brought about an inevitable change. Bacon had turned forty as his first big show at the Hanover opened in November 1949. No signs of the onset of middle age could be detected in his way of life, which was still very much that of a wayward, reckless adolescent, which few people of forty have the energy and devilry to keep going. Bacon in fact retained aspects of adolescence, with its echoes of Rimbaud and Raymond Radiguet (and, more insidiously, of Dorian Gray), until his death: his youthfulness was an indispensable factor in his creative drive. Yet age worms its way into the most resolutely held youth, and it is worth noting that, however lithe and unmarked Bacon appears in photographs of this period, his eyes are those of a man who has lived his forty years to the full.

Around 1950 the delicate balance the artist had set up in his life between roaring rebel – atheist, homosexual, drinker, drifter, gambler – and deeply wounded, artistically gifted son no longer satisfied his needs. Vital and healing as the relationship with his two chosen 'parents' had been over the previous decade, its limitations became more clearly marked as the mature man began to emerge. Francis's real father had been dead for ten years. Eddy Bacon's presence extended well beyond the grave, but the son had to some extent freed himself from its shadow by bringing out a succession of *Heads* howling their rage and pain. The success of these pictures emboldened him aesthetically and emotionally over the next few years to confront the image of paternal authority *par excellence*, the Pope, and execute a magnificent series of paraphrases – or parodies – of Velázquez's portrait of Innocent X; rarely can a father figure have been pilloried and rejected with such ferocity.

In fact Francis rejected all father figures, in life if not in art, around this date. In 1950, although Jessie Lightfoot is still listed, Eric Hall no longer appears on the electoral register among the residents of Cromwell Place. Exactly how the relationship ended is a matter of conjecture, but it seems likely that the artist tired of it. The sexual attraction, for Bacon at least, may have waned quite early on. One suspects that he enjoyed Hall's encouragement and protectiveness as well as the relative luxury of their life together. These advantages had dwindled, along with Hall's fortune, which had been seriously depleted by his – and especially his impetuous companion's – obsessive forays into the Monte Carlo casino. As Bacon gained a more secure footing in the art world and began to earn a certain amount of money for himself, Hall may have begun to seem more like an impediment to his full enjoyment of life. The older man may well have accepted his young friend's promiscuity, but his constant presence would certainly have made it difficult for Francis to begin

another 'serious' affair. This nevertheless happened when the artist met Peter Lacy, the one man in his life who satisfied on every level his overriding, masochistic needs; and it was Bacon's infatuation with Lacy that finally finished off the old protector—protégé liaison which he had needed as a young man — and found he needed no longer.

"There it is," Bacon often said once he had recounted episodes from his past. 'I decided when I was very young that I would have this extraordinary life, going everywhere and meeting everyone. But of course,' he would add, not unguiltily, 'I used everybody along the way.' He may well have had Hall in mind, because although the break between them did not destroy their very real affection for each other, it did leave Hall in an appalling situation. For love of Francis, he had abandoned wife and family, and in the process he had set off or at least accelerated the mental instability of his son, Ivan; he had squandered much of his inheritance, as his will makes plain; and when Francis left him he had nowhere to go. Eventually he moved into the Bath Club.¹ There, pottering about the library and the smoking room, Hall was to live in comfort but also in a solitude haunted by feelings of loss until his death.

For a brief moment Hall resurfaces in Bacon's life as the benevolent supporter he had always been. The Hanover Gallery's records show that, on New Year's Eve 1952, he purchased the artist's Dog (1952) for £275, leaving instructions for it to be delivered to the Tate Gallery. The bequest created a minor fracas, since Hall's generous offer went totally disregarded - which reflects Bacon's rating at the time - until the donor put pressure on the Gallery and duly received an apology from its director. Sir John Rothenstein.² This elegant act of patronage was repeated, with far greater implications, when Hall presented Bacon's Three Studies for Figures at the Base of a Crucifixion to the Tate the following year. Thereafter Bacon's eminently urbane, civilized lover vanishes from view until the announcement of his death, at the age of sixty-eight, in 1959. The remains of his fortune, some £50,000, were divided between his daughter and his grandchildren. with a small sum set aside for his wife. In the obituaries, two characteristics of his later life are underlined, his fortitude and his religious commitment, the latter having been easier to foster, one imagines, after his break with the zealously atheistic Bacon. 'He was a good companion, always eager to see the best in everyone, and bore courageously trials which might have daunted others,' the Times obituary pointed out (presumably in reference to his son's condition), while ending on the evocative note: 'Of late he could often be seen in the afternoons walking to evensong at Westminster Abbey.'³ Ruthless and even cruel though he could be, Bacon never forgot the kindness of others. He knew the sacrifices Hall had made to live with him, and the extent to which he had benefited from the older man. The caustic or flippant way he referred to the end of their affair did not preclude a deep remorse. But soon his life was to be shattered by a far greater pain, possibly the greatest loss he ever experienced.

Bacon's relationship with Jessie Lightfoot had been all-accepting: he of her growing frailty, her lack of education and her manifold oddities; she of his apparent fecklessness, his instability, his godless amorality. It was a union of eccentrics, based on an absolute, instinctive trust which had begun at Francis's birth. So when Jessie Lightfoot died of heart failure at Cromwell Place on 31 April 1951, aged eighty, Bacon's world fell apart.

His distress made it impossible for him to continue living in the old studio he had shared with Nanny and Hall. The portrait painter Robert Buhler, who was teaching at the Royal College of Art (at that time located just around the corner on Exhibition Road), leapt at the opportunity of living at such a convenient and prestigious address; all the more so since Bacon was almost masochistically accommodating when it came to business transactions, and usually accepted the most disadvantageous terms.⁴ In any case, Francis had to escape from the place where his closest, oldest companion had died.

For several years thereafter, Bacon lived a kind of self-imposed exile, constantly on the move from one rented room to another – as if pursued, like Orestes, by avenging Furies. He had not been in London at the time of Jessie's death: Michael Wishart recalls that they had been gambling together in Nice and that, when the news came through, 'Francis looked as if he wanted to die'. 5 Was his grief compounded by guilt that he had let her die alone? Certainly the impulse to give up Cromwell Place and live like an urban nomad could be seen as a form of punishment – all the more so since, despite his frequent moves, the artist rarely strayed far from the immediate area and the memories it was bound to evoke.

After a stint at Carlyle Studios, a group of purpose-built ateliers behind the King's Road, Bacon moved to 6 Beaufort Gardens, also in Chelsea. He then rented a cottage at Hurst, near Henley-on-Thames, before returning to the Chelsea area, living first beside the river at 9

Apollo Place, then taking a room almost opposite his old studio on the first floor of 19 Cromwell Road. During this period, he worked in a studio at the Royal College of Art lent him by his friend Rodrigo Moynihan. After several extended stays outside London at Henley and many trips abroad, notably to South Africa and Tangier, Bacon was then lent a studio in Mallord Street, off the King's Road; but he found the light let in by an opening overhead wavered too much for him to work satisfactorily there. He eventually came to roost, in semipermanent fashion, in 1955, when he began sharing a flat with two friends. Peter Pollock and Paul Danguah, at 9 Overstrand Mansions, Prince of Wales Drive, Battersea. The sombre red-brick mansion blocks overlooking Battersea Park offer no clue in themselves as to why Bacon found six years' respite from his wanderings there. They have none of the seedy charm or decayed grandeur of the buildings to which he usually gravitated. It is true that during these years he was spending long periods in Tangier, where he rented a place of his own; but the real reason for his staying so long lay in the easy camaraderie and tolerant understanding of the other two men, who were bright, fun-loving and at ease with their homosexuality.

Significantly enough, Bacon had begun to re-establish contact with his own mother very shortly before Jessie died. After her husband's death, Winnie had left war-scarred England for South Africa, while both her daughters. Ianthe and Winnie, were to settle in what was then called Southern Rhodesia. Francis had always been closer to the maternal side of his family, and he admired the personal freedom his mother displayed in marrying again and creating her life anew. By sailing out in November 1950 and not returning until the following spring (shortly before Jessie's death), the artist managed to miss a whole London winter; his asthma became noticeably less acute in a climate like South Africa's. He enjoyed himself from the moment the SS Kenya Castle steamed out of port. Travelling with him was a new companion, Robert Heber-Percy, who had offered to pay for the trip and had taken a first-class cabin for himself and given Bacon a berth in steerage. The relationship was clearly doomed from the start, but Bacon was characteristically determined to change the situation in his favour. 'All the stewards and people on those sorts of boats are always queer,' he later commented, 'and I have to say it was much more fun to be in steerage than anywhere else.'

Although he continued to remember his mother as solely preoccupied by her own interests, Bacon was pleased to find that their

relationship improved effortlessly. With the tyrannical father no longer present to control and forbid, mother and son were able to find common ground right away in their love of lavish entertainment. Once she had settled into her new life in the town of Louis Trichardt, not far from the border with Southern Rhodesia, the artist's mother cultivated the air of a grande dame by giving parties that were considered unusually sophisticated. This did not endear her to the local hostesses, especially as she got on visibly better with the men, who loved her parties, than with women. In this context, having her son to stay with her proved a boon.⁶ Not only did he bring the glamour of burgeoning artistic success from London, he also knew how to make parties go with a swing. Beyond the constant socializing and drinking, there was not much in the colonial lifestyle, recently embraced by droves of war-weary Europeans, that Bacon found attractive, although he was intrigued by the number of servants and the idle luxury of some families. 'Most of the people I met through my mother were drunk from morning till night,' he remembered. 'The champagne used to start very early on, and there was one woman who couldn't think what to do with herself so she'd put pinball machines all through her house to play on.' But he also remained uncomfortably aware of the artificiality of the social and political structure, which was not without parallels to the situation that he had known in Ireland as a boy.

What fascinated Bacon about South Africa - and what partly caused him to return there the following year - was the landscape and the wildlife. Confirmed city-dweller that he was, with a positive dislike of 'cosy', intimate countryside, the huge horizons and the scale of Africa excited him. The dry heat of the place made him feel unusually well and receptive ('I feel twenty years younger.' he told Erica Brausen). Whenever he could find someone to drive him, he took a camera out into the bush and photographed the magnificent, untouched nature. His imagination was stirred most of all by the extraordinarily sculptural, dried-out river beds and the mysterious screens of long grass – particularly when they parted to reveal a wild animal. 'I felt and memorized', Bacon said, 'the excitement of seeing animals move through the long grass.'7 His sister Ianthe had married and gone to live on a vast farm near the border of Southern Rhodesia and South Africa, within easy distance of her mother. When Bacon staved with her he had ample opportunity to watch animals against the landscape; and he loved the experience so much that he even considered for a while the possibility of settling there himself. He also visited the various nature reserves, such as Kruger Park, and became so enthralled by the sight of an elephant slowly wading across the river, under the boundless African sky, that he made a painting of it on his return to London.

Bacon's relationship with his travelling companion. Heber-Percy. had been short-lived. Quarrels had already erupted on the journey out, and one flare-up had ended with all Bacon's clothes being pushed through the porthole. Luckily, the friendly stewards were on hand to cobble together a basic wardrobe. A later row on terra firma proved final, and, in the artist's camp phrase, the two of them 'parted on the banks of the Limpopo'. This separation allowed Bacon to be more attentive to the local men; and he soon proved susceptible to very masculine figures in uniform: 'the Rhodesian police', he remarks in one letter, 'are too sexy for words - starched shorts and highly polished leggings.' While freer after the final quarrel, Bacon was also much poorer. Writing care of Thomas Cook in the Rhodesian capital. Salisbury (the present-day Harare) on 22 February 1951, Bacon immediately sent off an airmail letter to 'Dearest Erica' requesting funds. The African landscape, he tells her, is 'too marvellous, like a continuous Renoir'. He pauses to assure his dealer that 'now that I have got shot of Robert the work has started terribly well I am going to try and do a set of 3 quickly' before cutting to the chase: 'Could the gallery possibly advance me £50 as now that I have left Robert I have practically no money.' He told Brausen that he hoped to find a cargo boat at Beira in Mozambique to take him up the east coast, then into the Red Sea, where he wanted to disembark at Port Sudan. make his way to Thebes and see the great monuments at Luxor and Karnak, then rejoin the boat at Alexandria en route for Marseilles. In the event, he certainly managed to reach Cairo, where he spent a couple of days, and the monuments and sculpture he saw confirmed his belief that Egyptian art was the highest form of visual expression ever achieved by man. From then on, the enigmatic power of that ancient culture, personified in the artist's memory by the Sphinx, remained the essential touchstone at every point in his own artistic development.

On his return to London after the second trip to South Africa in 1952, the artist found himself owing a considerable amount to his gallery without having any new paintings to clear the debt. As usual,

although he had been excited by Africa and pleased by the new alliance with his mother (which he continued to foster until her death nearly twenty years later). Bacon had found it difficult to work abroad. The pressure was now squarely on him to produce a body of work which the Hanover Gallery could mount as a new show. The artist's life had become more chaotic and precarious than ever, with his whole outlook intermittently darkened by the memory of Jessie. He had taken every opportunity – frequent trips abroad, manic changes of address, a range of lovers – to block out the sense of loss; but the forays into frivolousness and promiscuity did more to heighten than soothe Bacon's sense of the tragic in life – and, notably, in his life. Yet his very real grief at Jessie's death did not hinder his creativity; it goaded it into action. If vitality and sensuousness course through Bacon's paintings, giving them their extraordinary immediate impact, they are nevertheless the offspring of a darkly pessimistic mind. Indeed, Bacon painted his most haunting images when his own life was most deeply touched with pain and despair. Some of his greatest paintings were to be posthumous portraits of people he had loved. And while he scorned all transcendental belief, he nevertheless came to admit that certain of his portraits were painted out of a desire to bring their sitters back from the dead.8

Not long after Jessie's death, Bacon embarked on some of the most audacious pictures he ever attempted. The image of the Pope as the ultimate authority figure, and more specifically Velázquez's hauntingly modern portrait of Innocent X, had become an obsession with the artist. He kept various reproductions of the painting to hand and pinned one in pride of place on his studio wall (between a news photo of Goebbels and Nadar's portrait of Baudelaire). The image touched a deep division in him: the fascination with a man set above all others, the Supreme Pontiff, coupled with a fanatical admiration for the skill of Velázquez's rendering, on the one hand; and on the other, the desire to tear away the pomp and pretence of high office, revealing what Bacon believed to be a self-protective illusion at the core of all religious belief. Surely, in this image that rooted itself so strongly in his imagination, there was also a distinct echo of his feelings for his father: a natural inclination to admire, tinged with sexual desire, and a longing to disrupt and dismantle a symbol of tyranny. However much he pretended to ignore certain obvious implications, Bacon was not unaware that in Italian the word for Pope, il Papa, is the word for father as well. Much later he claimed

that he 'regretted' having painted his variations on the Velázquez portrait, that it had been 'stupid', since the original painting was so perfect. But, significantly, he added that it was something he had felt compelled to do: the image had 'overcome' and 'overwhelmed' him.

Once again, it is legitimate to ask why the outspokenly atheistic artist would be drawn to such an overtly religious subject as the Pope. Certainly, in terms of pure iconoclasm, the choice is very telling. In paraphrasing the Velázquez portrait, Bacon strikes not only at the highest personification of spiritual power, but also at the grandeur of the Western tradition of art. Two faiths are contested at one stroke. The surrealist spirit of derision is taken to extremes in this double act of irreverence which would surely have won the admiration of Buñuel or Duchamp (at one level, Bacon's scream on the Pope comes close to Duchamp's moustache on the Mona Lisa). Bacon himself dismissed any attempt to explain this troubling new series of images. There was, he insisted, nothing to explain. He had been drawn to the Velázquez painting by the beauty of its colour; he was haunted by its perfection, by what he considered the greatest portrait ever made – that was all. The refusal to give reasons, obdurately maintained, was taken up by the claque which had already formed around the openhanded artist as he went his convivial way around the bars, clubs and restaurants; there was nothing to explain. Slowly, an effective barrier of non-elucidation grew up around the oeuvre. It issued regularly from the artist, resounded through statement and interview, influencing dealer and collector, curator and critic alike. This process continued its crescendo throughout Bacon's career, and it illuminates, from the wings as it were, the artist's abundant natural capacity to foster belief and control opinion.

It is not difficult to sympathize with Bacon's attitude. His imagination excelled at blending the most disparate elements, his technique lay in coaxing oil paint into the most provocative ambiguity: thus an analysis that seemed bent on reducing the process to its individual parts was to be held at bay at all costs. As time went on and he became increasingly famous, the artist revealed himself correspondingly as master at covering his tracks, creating diversions, cleverly contradicting himself, in order to preserve the mystery of his images. And here we arrive at one of the most fascinating paradoxes of all. With his insistence on material reality, his fierce denial of any spiritual dimension in life and his militant nihilism, Bacon strove to impart to his images, and by all possible means conserve in them, a mystery

that went far beyond any rational explanation. It is as though Bacon were doomed to officiate as a religious artist in a world where he and his public had lost all faith. A fetishistic force appears to draw him back repeatedly to religious themes all through the earlier part of his artistic development, as if he had to make a belief out of his non-belief, using the structures of established religion to proclaim his distance from them. And even when Bacon had entered the latter part of his career, when his imagery was manifestly secular, he was still at pains to create pictures that could not be explained – and that he hoped would, in a very real sense, surpass all understanding.

Head VI of 1949 had been Bacon's first surviving attempt at the Pope theme. He returned to it in the course of 1950 and painted three large pictures inspired by the Velázquez portrait for the exhibition at the Hanover Gallery due to open in the autumn of that year. In the event, although the gallery advertised the show as 'Francis Bacon: Three Studies from the Painting of Innocent X by Velázquez', none were shown because Bacon destroyed them before the opening. It was in this exhibition, nevertheless, that the artist first brought to public attention his 1950 Fragment of a Crucifixion - an inert animal body hanging over a T-shaped cross from whose central shaft a screaming, bloodied Fury emerges, while behind runs a strip of blue sea with diminutive cars and people going by. When Bacon returned to his obsession with the papal figure, in 1951, his sources clearly included a photograph of Pope Pius XII being borne through the Vatican above the heads of the crowd on a sedia gestatoria. (Bacon kept this photo pinned to his studio wall amongst Muybridge studies, a shot of Hitler and some X-ray positionings.) As the series progressed and the Pope becomes increasingly agitated, a more daring conflation of images emerges, with the Supreme Pontiff bending forward on his delicately painted throne to unleash a bestial scream. The parallels with Nazi leaders and other tyrants in full rant are obvious. Gradually, as Bacon returned obsessively to depicting the scream in anonymous figures seated alone in sealed rooms, this impressive venting of emotion was taken by the critics to signify the oppressed as much as the oppressors; and from there it was only a short step, in the angstridden years of the Cold War, to seeing Bacon's figures unequivocally as dramatic expressions of the guilt, unease and solitude of modern man.

One sign of a powerful work of art is the range of associations it sets in train, some of which have never even occurred to the work's

creator. Curiously, while references were later made to unknown political prisoners and to Eichmann, to Kafka and Sartre, the obvious erotic element in the screaming figures seems not to have been recognized – no doubt because the subject was still taboo, especially when it involved a figure as elevated as the Pope. Yet there can be little doubt that Bacon's interest in the open mouth was due in large part to its sexual suggestiveness; and that the cry itself is an example of pure ambiguity, betokening rage, pain, fear or the pleasure of release without the slightest degree of differentiation. It is this enigmatic combination which fascinated the sado-masochistic artist. It was the one moment at which human nature could be perceived wholly naked, undisguised by civilized restraint; the spasm that made man indistinguishable from beast. For Bacon, whose genius dictated the shortest way to the heart of existence, the cry was the one indisputable moment of truth.

Beside his men shrieking in pain, roaring in pleasure, trapped in the darkness of their cages or the gilded confines of their pomp, Bacon's animals appear relatively well-mannered, almost genteel. After his second trip to South Africa, he had been expected to produce the contents of a new show for the Hanover. Africa had provided a respite from the feelings of loss and guilt that had turned London into a place of brief stays and short lets. But as a subject it could not inspire what the *Times* review of the show called the artist's 'appalling imagination' as intensely as the open-mouthed spasms of lone men in their rooms. Among the paintings of the 'dark continent' there are nevertheless wonderful evocations of a landscape reduced to a chaos of jungle grass and harsh blue sky.

For the previous few years, alongside his own amateur attempts with a camera, Bacon had been studying the photographic experiments of Eadweard Muybridge, whose works, such as *Animals in Motion* and *The Human Figure in Motion*, he had first discovered and consulted at the Victoria and Albert Museum. These detailed photographic analyses of movement remained a fertile source of ideas for Bacon for most of his long career; but in 1952–53 it was above all Muybridge's series of freeze photographs of dogs in movement that worked on his imagination, leading him to paint three studies on the theme. The sly-looking curs are not as impressive as Bacon's ferocious monkeys, yet the pictures perfectly illustrate the artist's ability to combine disparate sources. In one, the Muybridge-influenced dog stands on a formal flower-bed behind which runs a coastal road

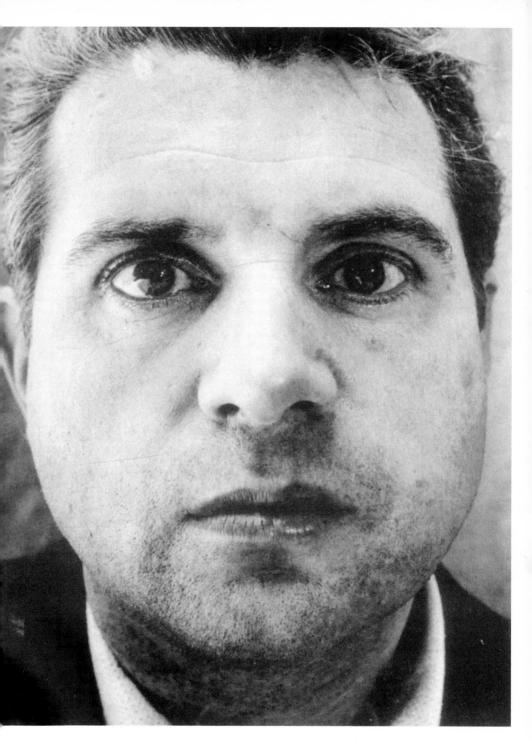

Francis Bacon, photographed by John Deakin, 1952.

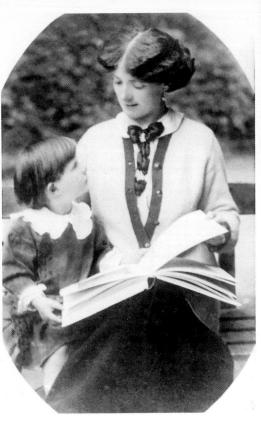

Francis and his mother, 1912.

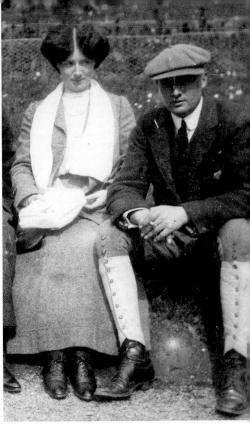

Winifred and Edward Bacon, the artist's parents, c.1910.

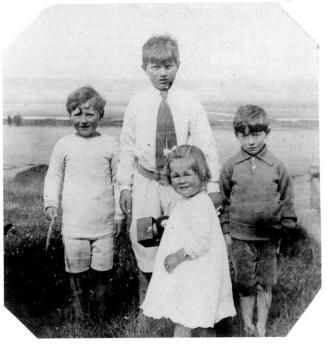

Francis (middle) with his younger brother Edward (left) and their Firth cousins.

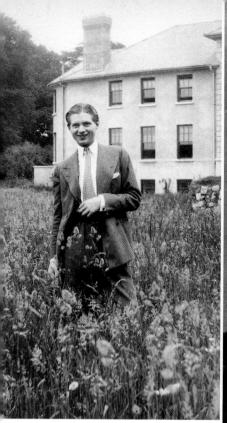

rancis Bacon at Cannycourt House, reland.

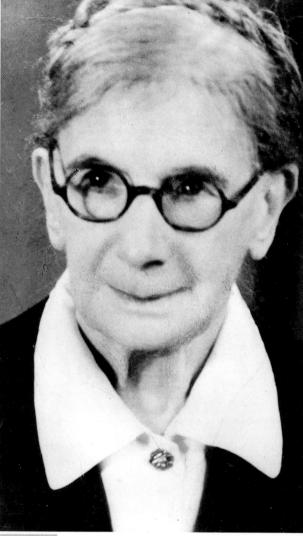

Jessie Lightfoot, the family nanny who lived with Bacon until her death in 1951.

Francis Bacon, aged 16, before he left for Berlin.

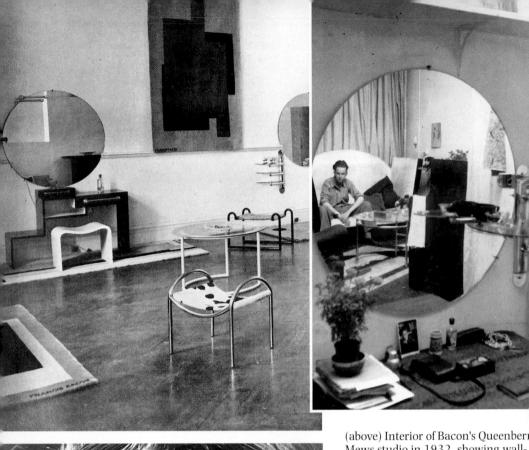

(above) Interior of Bacon's Queenbern Mews studio in 1932, showing wallbracket, rug, table and sofa designed by him and left there.

(above, left) Furniture and rugs designed by Bacon, photographed in 1930 for *The Studio* magazine.

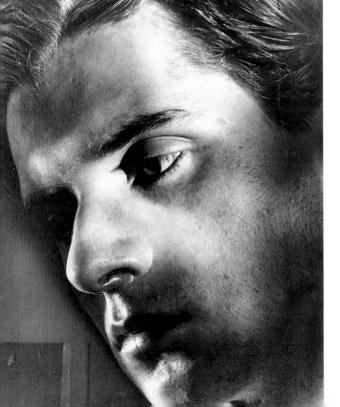

Bacon photographed by Helmar Lerski, Berlin, 1927.

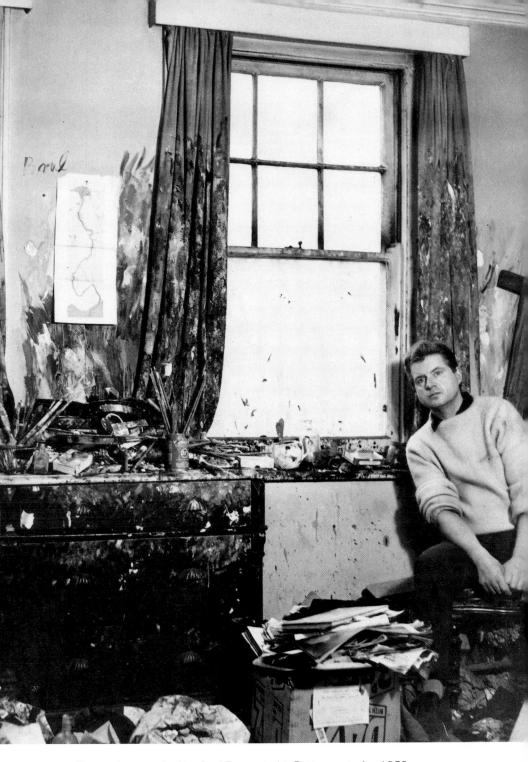

Bacon photographed by Cecil Beaton in his Battersea studio, 1959.

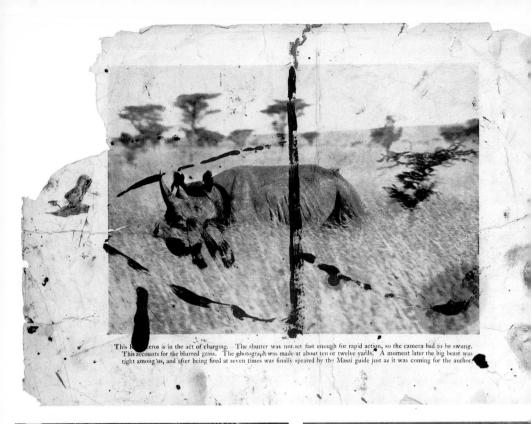

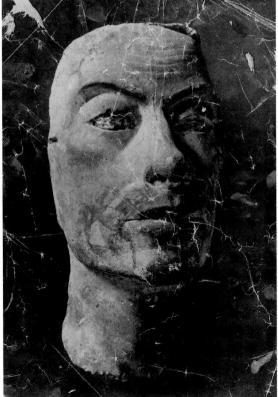

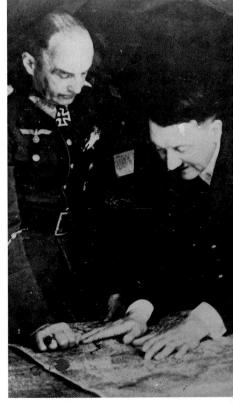

Working documents from Bacon's studio showing (clockwise from top left) a charging rhinoceros, a corrida, a male patient during a fit of hysteria, men wrestling by Muybridge, Hitler during the French campaign, and an Egyptian death mask.

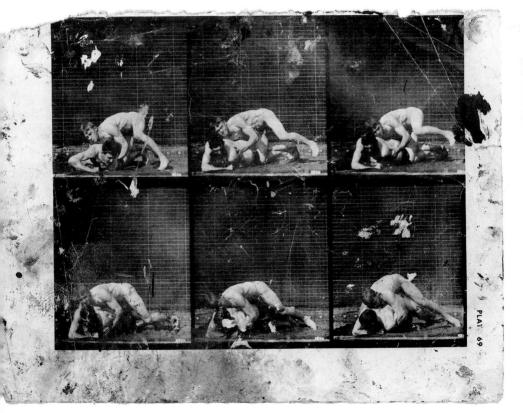

Lovers and models:

(this page, clockwise from top), George Dyer in the studio, Peter Lacy, and Bacon with Dyer in Soho.

(opposite page, clockwise from top left) Lucian Freud, Muriel Belcher and Henrietta Moraes were also among the artist's favourite subjects.

All photographs by John Deakin.

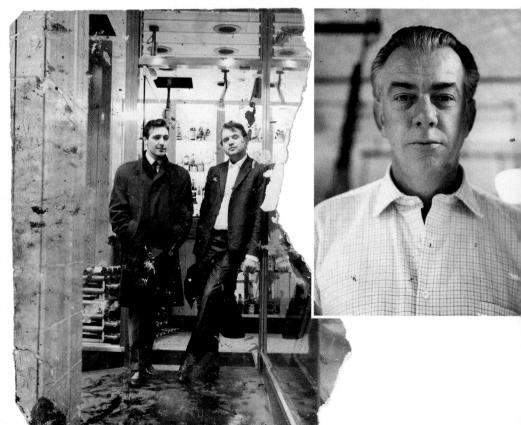

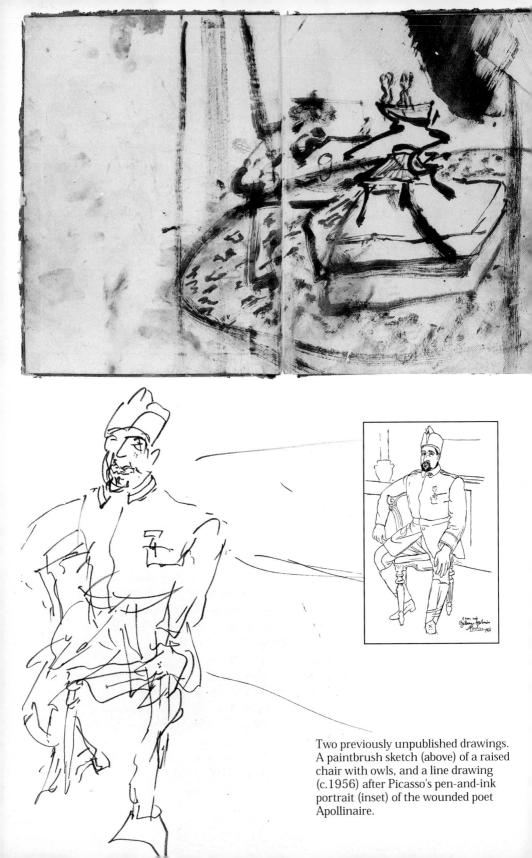

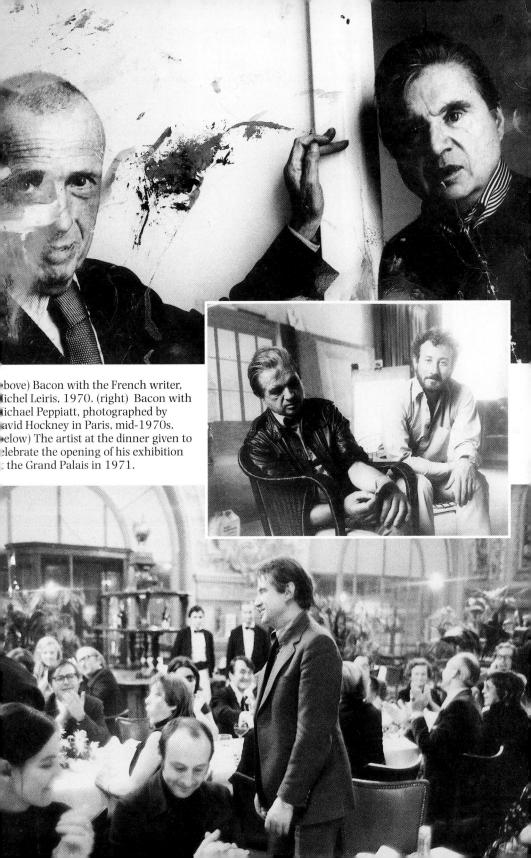

Bacon photographed in his Reece Mews studio by Jesse Fernandez, c.1980.

with palm trees derived from postcards of Monte Carlo (the same background as Bacon used in *Fragment of a Crucifixion*); in another, the background has been partly inspired by the stadium the Nazis built at the Nuremberg rally; and a third, showing a dog on a leash, clearly refers to Giacomo Balla's famous Futurist masterpiece, *Dynamism of a Dog on a Leash* (1912), which had been exhibited in the summer of 1952 at the Tate Gallery.

The role played by photography in the genesis of Bacon's images and in the artist's whole approach to painting cannot be overemphasized. For Bacon, the invention of photography had altogether redefined the scope and function of art, taking away, for instance, painting's use as a factual record; with the boundaries of his activity radically reduced in this way, the artist was obliged to invent more deeply within a smaller sphere. Bacon himself spelt out the dilemma that faced the twentieth-century artist on several occasions. 'One thing which has never been fully worked out', he wrote in one of his rare 'artist's statements', 'is how photography has completely altered figurative painting. I think Velázquez believed he was recording the court at that time and certain people at that time. But a really good artist today would be forced to make a game of the same situation. He knows that particular thing could be recorded on film, so this side of his activity has been taken over by something else.'11 Although photography had narrowed a painter's possibilities, it had also created new reservoirs of visual suggestions and effects for him to draw on. Photographs could become. Bacon said, 'not only points of reference but also often triggers of ideas'. He remained particularly receptive to those 'triggers', ransacking the whole history of photography from Muybridge and Marey, Julia Margaret Cameron and Nadar, right up to contemporaries such as John Deakin who took portrait photographs specifically for Bacon to work from. 12

During the early part of his career, Bacon produced (or at least preserved) a relatively small body of paintings. From the war years, only a handful of canvases remain; from 1947 there is nothing at all, and from 1948 only one. Then in 1949 — when he completed seven pictures — the rhythm of his output begins to change. Having discovered that working in series suited his creative temperament, Bacon became much more prolific. In the course of 1952 and 1953, for instance, he came up with no fewer than forty pictures, many of them variations on a theme; and given his habit of destroying a great deal, he must actually have painted many more. There were other

reasons for this sudden acceleration. After years of self-doubt and sporadic experimentation, Bacon had clearly hit his stride. As he approached his mid-forties, he could lay claim to a new kind of independence. However tortured and stormy his relationship with Peter Lacy was to prove, he was no longer the 'son' that he had been in his previous close attachments. He was coming to terms with the complex demands of his sado-masochism, provoking yet harnessing the extremes of sexual behaviour and – since Bacon was an artist above all else – allowing their excesses to flow into the grain of his paintings.

Although he would still have found it difficult to finance his expensive nightly round of eating, drinking and gambling, Bacon was also closer to financial independence than he had ever been before. Modest though they seem now, the prices that he and his dealer put on his work were, from the start, at the high end of the relatively small market for contemporary art. It is amusing to note that this did not create an overly solemn atmosphere at the Hanover Gallery, where Bacon's pictures were occasionally identified in their records with such off-the-cuff titles as Old Screamer. By the mid-1950s, when Robert and Lisa Sainsbury began to collect them, the paintings were selling regularly for £300-£400, and in 1957 the Hanover's day books list the sale of a Study for Van Gogh at £600.13 Since Brausen seems to have worked on a slender profit margin (making a mere £40 on the sale of Painting 1946 to the Museum of Modern Art in 1948), Bacon could already be counted among the very few experimental artists in England who made any kind of basic living from their work.

Similarly, Bacon was beginning to attract serious attention in the press, where his work had the admiring support of several influential art critics. Wyndham Lewis had long been won to his cause, and Nevile Wallis, the art critic on the *Observer*, regularly gave him encouraging reviews. Robert Melville had written a couple of remarkably perceptive essays on Bacon's uncanny power to disturb and excite. In a text published in *World Review* in January 1951, Melville wrote:

Bacon is unquestionably the greatest painter of flesh since Renoir but the intense beauty of the colour and texture of his flesh painting is at the same time horrifying, for it discovers a kind of equation between the bloom and elasticity of sensitive tissue and the fever and iridescence of carrion. He is the painter of flesh considered as a communal substance; as the guinea-pig of the senses, the trap of the spirit, the stuff of which murderers cannot get rid, the legitimate prey of pain and disease, of ecstasies and torments; obscenely immortal in renewal. ¹⁴

The ranks of Bacon's supporters were strengthened when David Sylvester, in *The Listener*, and John Russell, who became the *Sunday Times* critic, began reviewing his work regularly from 1952 on. Both men came forward as staunch defenders of the integrity of Bacon's vision at a period when the discomfiture he provoked was still routinely dismissed as deliberate Grand Guignol. Both later published a book: Russell the first monograph, and Sylvester his widely quoted interviews with the artist. British *Vogue* ran a feature on 'Painters and Pictures', with Bacon's *Pope I* taking pride of place with a full-page illustration. The painter is described as a 'collateral descendant of the Elizabethan philosopher' and as the only one of the ten artists *Vogue* approached who refused adamantly to be photographed – as if the creator of such horrendous images had insisted, like a criminal, on hiding his face from the public. Even though Bacon was still on the threshold of his career, his myth was already established.¹⁵

The peintre maudit aura which clung to the artist was partly fuelled by stories of his wild and ill-fated homosexual love affairs. Bacon himself certainly tended to see them in that light, and he claimed that his private life had consisted of one disaster after another. Of all the disasters, he considered the most wounding was his relationship with Peter Lacy. They had met in the Colony Room, a newly opened Soho drinking club, and, as Bacon described it, their mutual attraction was anomalous from the start. 'I'd known lots of people before but. even though I was over forty when I met Peter, I'd never really fallen in love with anyone until then. What Peter really liked was young boys. He was actually younger than me, but he didn't seem to realize it. It was a kind of mistake that he went with me at all. Of course, it was the most total disaster from the start. Being in love in that extreme way - being totally, physically obsessed by someone - is like having some dreadful disease. I wouldn't wish it on my worst enemy. He was marvellous-looking, you see. He had this extraordinary physique – even his calves were beautiful. And he could be wonderful company. He played the piano marvellously and he had a real kind of natural wit, coming up with one amusing remark after another, just like that – unlike those dreadful bores who plan from morning to night what they're going to say.'

The relationship was already under way by 1952, the date of Bacon's painting House in Barbados. This small picture was based on a photograph of the house Lacy owned on the island, and Bacon had been asked to copy it as faithfully as he could. The exquisite little composition seems to tell as much about Bacon's ability to render a scene with total naturalism as about his infatuation with Lacy strong enough, apparently, to cause him to paint something quite out of character. In point of fact, Bacon asked a close friend, the painter Denis Wirth-Miller, to help him on this unusual commission. Lacy had the advantage, like Eric Hall before him, of inherited money, which allowed him for most of his life not to work. Because of this, according to Bacon, 'he felt the futility of life all the more clearly'. Lacy had also been a fighter pilot during the war, taking part in the Battle of Britain: and afterwards he became a test pilot for a while. 'All these things obviously shatter your nerves,' Bacon reflected, long after Lacy's death. 'I must say, most of the time Peter was terribly neurotic, even hysterical.'

Part of the most intense period of their relationship (which Bacon characterized as 'four years of continuous horror, with nothing but violent rows') was lived - again uncharacteristically for the artist in the country. From 1952 to 1956 Lacy, recorded in the local electoral register as Peter James Gerald Lacy, rented a house called Long Cottage in the Berkshire village of Hurst, not far from Henleyon-Thames. Bacon recalled his invitation to come and live with him there: 'Of course, he hated my painting right from the beginning, and he said, "You can leave your painting and come and live with me." And I said: "What does living with you mean?" And he said: "Well, you could live in a corner of my cottage on straw. You could sleep and shit there." He wanted to have me chained to the wall. Peter was very kinky in all sorts of ways. He liked to have people watching as we had sex. And then he liked to have someone bugger me, then bugger me himself right after. But he was so neurotic that living together would never have worked. In any case, it so happened that I wanted to go on painting.' Even if Bacon did not accept the invitation to move in, he was a frequent visitor, and he even managed to get some work done by setting up a makeshift studio in a conservatory. One old inhabitant of Hurst remembers the two of them very clearly, describing them as 'very good friends indeed', who could often be found dropping into their local pub, the Jolly, for a drink.

Bacon's need to paint, then, had proved even stronger than his obsessive passion for Lacy. In 1953, between frequent visits to Hurst and a move from Beaufort Gardens to another set of temporary digs not far away at 9 Apollo Place, Bacon completed twenty-one paintings, the most he had ever painted in a year; no doubt he discarded many more, since during this period he was in a highly self-critical, destructive frame of mind. In the latter half of the year, however, Bacon knew that pictures were needed to make up two new exhibitions planned for the autumn – one at Durlacher Bros in New York, his first one-man exhibition abroad, and the other at the Beaux-Arts Gallery in London – and he painted with the single-minded urgency he had shown for his previous shows at the Hanover.

Realizing that he could no longer go on destroying work in progress. Bacon cast around for a new subject. His friend and supporter David Sylvester, who was living at the time in the same house in Apollo Place, had an imposing presence that caught the painter's interest. Sylvester sat for what was to be his portrait on some four occasions; but Bacon's obsession with the Pope theme took over, and Study for Portrait became the first in the series of eight fully recognizable pontiffs - caught as if in successive frames on a film. This was the longest series Bacon had ever undertaken, and it confirmed his bent for working in variations on a theme, a practice that came naturally to someone of his strongly obsessive temperament. The first portrait remains the most precisely descriptive, with its steady, mournful gaze: and as the series continues, so the portraits grow freer until the figure radiates a kind of wild hysteria. In this respect, it is tempting to think that as Bacon worked he transposed some of his feelings about his alarmingly neurotic lover, Peter Lacy, whose surface calm would suddenly erupt into uncontrollable rage. Certainly, as the series progresses, there remains of papal dignity only the vestments and the throne's gold finials; in its place one finds a puppet contorted by fear and fury, writhing against a dark ground articulated by white lines to suggest receding space.

When questioned about this series, Bacon replied, jocularly enough, that he had nothing against Popes, and that he merely 'wanted an excuse to use those colours, and you can't give ordinary clothes that purple colour without getting into a sort of false fauve manner'. In retrospect, this sounds deliberately disingenuous, as if the artist wanted to avoid any explanation. It may be that he himself did not

know why he was so obsessively drawn towards depictions of the Pope, but it indubitably went beyond the attraction of a particular colour.

In the Pope, one might say, the two most important elements in life for Bacon, the erotic and the aesthetic, were intertwined, and it seems reasonable to suppose that is why he was drawn to the theme so repeatedly and why it gave rise to some of his greatest images, such as the magnificent Study of a screaming Pope done after the Velázquez portrait in that same productive year, 1953. In this picture, the pleated curtains of the backdrop are made to fall through the Pope's face, as if its flesh hung in folds: this is a peculiarly Baconian conceit, like the use of safety-pins and blind tassels or, later, lightbulbs and arrows. It was a device Bacon employed in several pictures, and it may have been suggested to him originally by the transparent curtain Titian introduced to veil his portrait (1561-62) of Cardinal Filippo Archinto. Bacon's fondness for these devices grew rather mannered and predictable in some of his later work, but here they have a mesmerizing power, instilling the images with the kind of potency usually associated with religious icons or fetishistic idols.

Of the thirteen Bacon paintings that went on show at Durlacher Bros, on 57th Street in New York, most had been executed within weeks of being shipped to America. Given the cultural climate of the time, the reaction to the first glimpse of these unquestionably disquieting images en masse was remarkably perceptive. The work was discussed at length by some of America's most sophisticated reviewers. including James Thrall Soby (who bought the magnificent shrieking Baboon of 1953) and Sam Hunter, who had taken the invaluable photographs of the reproductions Bacon kept pinned on his studio wall. Time also gave the show a notice under the heading 'Snapshots from Hell', and an even more palpable token of the show's success was the number of works that found favour with American collectors. notably Seymour Knox, who presented Man with Dog (1953) to the Albright-Knox Art Gallery in Buffalo, and William Burden and his wife, who gave Study for Portrait VII to the Museum of Modern Art in New York.

Bacon was in close touch with everything that happened in the London art world, and he was well aware that being invited to show at the Beaux-Arts Gallery, which was run by Helen Lessore, carried a definite cachet. Lessore had in fact bought enough Bacons to enable her, in November 1953, to put on a small show of his most recent

work, though Erica Brausen remained his main dealer and even attempted to buy the paintings back before the exhibition opened. The Beaux-Arts was to play a central role in the development of postwar figurative painting in Britain, thanks to Lessore's discernment and dedication to art (she was herself a painter) as well as the unique atmosphere she had created there. The space itself, a converted coachhouse off Bond Street, had an intensely private, almost shrine-like feel quite unlike other galleries. 'You came off the street up a dark staircase and straight into the upstairs gallery.' Andrew Forge, then a young art critic, recalls. 'It was like entering an attic. The first things you saw were floor-boards and a floor-level view of the pictures ... Through the top gallery you came to a balcony hanging out over the large gallery below, just as it might over the squash court which the lower space resembled. On the balcony to the right was Helen Lessore's desk and she was almost always there, pale, beaked, a melancholy bird. To your left, a precipitous iron staircase took you down into the large gallery ... More than anything else it was like a studio, an atelier de peintre spruced up for visitors and it was this that the gallery itself seemed nearer to the painting end of pictures than to the merchandising end - that gave it its inimitable, irreplaceable quality.'17

Lessore championed figurative art during the period when it reached its lowest ebb in public esteem, from the early 1950s through to the mid-1960s. Michael Andrews, Raymond Mason, Frank Auerbach and Leon Kossoff all showed their work at her gallery. For those and other younger artists, Bacon had the status of a trailblazer, a lone genius who knew instinctively that in the long run art could not cut loose from its tradition but only – which was far more difficult – renew it in a way which would be compelling to a contemporary sensibility. For them, his painting and the demands he made on himself served as a model, in much the same way as, on the other side of the Channel, Giacometti represented in the fullest sense what an artist should be.

Like Giacometti, Bacon impressed many of the people who discussed aesthetic issues with him by his ability to formulate in memorable phrases his own perceptive and highly personal credo. During this period, at the request of John Rothenstein, the artist agreed to write one of his rare statements, ostensibly as a tribute to the English painter Matthew Smith, whose Fauve-inspired freedom with colour Bacon admired. Perhaps inevitably, the text is more about Bacon's

thoughts on art than about Smith, so it is worth quoting in full:

Because I very much admire Matthew Smith, I am delighted to have been asked to write something about him, although I know I will not be able to do him justice. He seems to me to be one of the very few English painters since Constable and Turner to be concerned with painting – that is, with attempting to make idea and technique inseparable. Painting in this sense tends towards a complete interlocking of image and paint, so that the image is the paint and vice versa. Here the brush-stroke creates the form and does not merely fill it in. Consequently, every movement of the brush on the canvas alters the shape and implications of the image. That is why real painting is a mysterious and continuous struggle with chance – mysterious because the very substance of the paint, when used in this way, can make such a direct assault upon the nervous system; continuous because the medium is so fluid and subtle that every change that is made loses what is already there in the hope of making a fresh gain.

I think that painting today is pure intuition and luck and taking advantage of what happens when you splash the stuff down, and in this game of chance Matthew Smith seems to have the gods on his side.¹⁸

Bacon at the Beaux-Arts with a handful of brand-new works notably Sphinx I and Three Studies of the Human Head - might have seemed an unmissable occasion. Yet the English, with their seasoned capacity for ignoring a truly original talent in their midst, made considerably less of the show than the American public had done a few weeks previously. It was reviewed mainly by critics not won over to the Bacon cause, and the general response was one of mild disgust compounded with blank incomprehension at the notion that art might disturb. Bacon never truly suited contemporary English taste, even after his talent had been internationally recognized. In Elizabethan or Jacobean England, he would have taken his place quite naturally beside a Marlowe or a Webster. But under Elizabeth II, who had ascended the throne the year before, the prevailing tendency was to disregard the anxiety of existence, and certainly not to look to art for a reminder of it. In France and more generally in the Latin countries of Europe, metaphysical disquiet had evolved instead into the art and philosophy of existentialism. Once again, Bacon was to show himself more European than British, and instinctively in tune with the new thinking on the Continent, as if his early contact with

Berlin and Paris had left him with especially sensitive antennae.

Correspondingly, Bacon's work found spontaneous and widespread support abroad, above all in Italy and France. It was in Italy, for instance, that some of the most important early collections of his paintings were formed, notably the one put together by the film producer Carlo Ponti. 19 The first opportunity for a truly international audience to see a representative choice of his work came at the Venice Biennale in 1954, when Bacon was invited to exhibit in the British pavilion alongside his friend Lucian Freud and the abstract painter Ben Nicholson. Two early works lent by the Tate - the Three Studies of 1945 and Figure in a Landscape of 1946 - were complemented by a couple of Studies after Velázquez and some very recent work, including Three Studies of the Human Head and Sphinx, painted earlier in the year. The selection, which was presented with an introductory text by David Sylvester, amounted to Bacon's first small retrospective. The artist himself was in Italy that year, but he did not visit his own show. For most of the time, he stayed in Rome, making trips out to Ostia on the coast and further south to Naples - which he found even more exciting than the Eternal City. Although he might easily have gone to the Palazzo Doria Pamphili to see the Velázquez portrait which had fascinated him for so long, he deliberately avoided doing so, partly because the reproductions he used had already served him so well and also because he felt superstitious about what a direct confrontation with the real thing might tell him. It was by *not* seeing it, perhaps, that he might continue his variations on the masterpiece he revered. He was moreover deeply distraught: the relationship with Peter Lacy distressed him as much as it obsessed him, and to try and calm his agitation he spent hours wandering aimlessly round the incense-laden gloom of St Peter's.

It was the 'illness I wouldn't wish on my worst enemy', the agony of being deeply and unhappily in love. 'It was like that song,' Bacon said, more light-heartedly, many years after Lacy's death. 'I couldn't live with him, and I couldn't live without him.' This was a far cry from the calm, benevolent presence which Eric Hall had provided. For much of 1954 Bacon had been living either with or close to Lacy at Henley-on-Thames, a place which he later characterized as 'just one luxury pub after another'; they were both drinking with a vengeance, and the alcohol helped fuel their violent rows. Bacon's agitation is clear from a further bout of changing addresses. He moved early in the year from his furnished room at 19 Cromwell

Road to the Imperial Hotel at Henley. Then he travelled to Italy. But a few months later, he was back at Henley, even though in a letter to Erica Brausen from Rome he had written that he wanted to return to London. 'I am so sick', he said, 'of never having a permanent place.' He wrote again to Brausen, while still at the Imperial, and although he does not mention his difficulties with Lacy, the whole tone of the letter betrays his despondency:

My dear Erica

I am not able to finish my paintings at the moment so will you please put off the exhibition. I am terribly sorry about this but as you know these things happen with work. I will let you have the paintings as soon as I possibly can but please do not have a show of the things you have got in the gallery of mine. I think it would be a great mistake to show them both for you and for me. As you know I want to replace most of them when I can. Also there have been too many shows of mine. I am desperate and completely broke and am going to try and get a job for a time. I am terribly sorry about this but will let you have the pictures as soon as possible, I hope before the end of the year. Please forgive me but I cannot finish the work at the moment.

Best love Francis

However unguarded or adventurous he had been before, Bacon had never allowed his private life to interfere with his work. He liked to push his relationships to the edge and welcomed an element of risk or danger while remaining just in control himself. In that way he could enjoy himself fully yet still concentrate on his work. But he had fallen in love with Peter Lacy in large part because the latter knew exactly how to dominate and hurt him. Ill used and furiously jealous, Bacon no longer had the upper hand, and this predicament undermined his very strong sense of his own identity. There were to be several more 'years of continuous horror' before he managed to break free.

Truth Told by a Lie 1954–58

I want my paintings to be inaccurate and anomalous in such a way that they become lies, if you like, but lies that are more truthful than the literal truth.

Vincent Van Gogh, Letters, 1912

Once Peter Lacy had moved to Tangier in the mid-1950s, Morocco supplanted the South of France as Bacon's favourite place of gilded exile. The city was then in its last, full-blown phase as an 'international zone' famed for turning a blind eye towards almost all forms of deviancy. But however potent Tangier's mix of the exotic and the seedy proved to be, the artist always returned after a while to London. Criticize London as he often did for its dampness and dullness, its poor food and restrictive attitudes towards the pleasures of the flesh, Bacon developed a sixth sense for the sprawling metropolis. Having stalked it night after night in pursuit of illicit sex, out-of-hours drinking and gambling wherever there was a game to be found, he had an intimate knowledge of the city's most secret geography, from the hidden club and basement casino to the most furtive pick-up place. Even when Soho closed for a few hours around daybreak, Bacon could always be counted on, blind drunk or not, to plunge down short cuts, up stairs and across landings to find the one last bar in the whole West End that would serve a drink, or an isolated shack known only to cab-drivers that dispensed thick sandwiches and scalding tea.

This was not the only thing that bound Bacon to London, of course. His needs and his amusements – his very appetite for life –

kept him out late on a quasi-permanent basis, and he acquired this kind of nocturnal expertise wherever he put up for more than a few days. But he never got to know another city, in all its shifts of mood and the diversity of its inhabitants, with the same kind of unreflecting intimacy. Any evening might take him from a Knightsbridge drawing room to an East End pub, from upper-class hostesses and art collectors to the roughest of trade in a Soho alley. His easy manner when mixing with all kinds and classes of people in London could not have been approximated elsewhere; his keen sense of the nuance in a word or gesture was peculiarly English. It was also this fluency in the unwritten codes that made London home, allowing the artist to forget his surroundings when necessary and concentrate on the new image taking shape in his mind and the ways he might transfer it to canvas.

A further reason for Bacon's attachment to London, which grew the more he tried, always unsuccessfully, to live and work elsewhere, was the satisfaction he derived from being able to fall in with a range of old and new friends at a moment's notice. If he had not arranged to meet someone in particular, he had only to drop into a pub or two to find congenial company. London was made up of different pockets and strata of friends for Bacon, and he particularly enjoyed the freedom of moving from one area to another. It was not just a case of dining with a duke before being beaten by a bruiser, though Bacon certainly relished that kind of contrast, but of constant change, of slipping from the familiar to the unknown and back again as if nothing had happened. Often, when he had spent a long evening wining and dining some close friends, he would let them return tipsily home while he himself went on to more serious drinking in the clubs before trying his luck at the tables, and returning - mostly legless and fleeced - to the studio around dawn. He found the energy for these nightly marathons not so much because he did not need to sleep as because he did not want to sleep. He was also always interested in meeting someone new – usually, but not necessarily, as a possible sexual partner – whose looks or intelligence or knowledge of a field (such as medical research, which deeply interested him) might, as he put it with mock world-weariness, 'relieve the boredom just for an instant'.

With its intricate maze of old haunts, London offered Bacon every sort of encounter. Apart from his lovers and his professional contacts, he tended to cultivate two kinds of friends. One group was the flotsam of the bars and clubs he frequented, the 'characters' with whom he could share a drink and a laugh; the other consisted of more dedicated people, usually other artists or writers, with whom he enjoyed talking about art and ideas. Some of Bacon's closest friends belonged, as he did himself, to both categories, and the place to which they all naturally gravitated was Soho. As London's off-limits area, Soho stood out in garish contrast to the grevness of a city still in the grip of post-war austerity. It owed its particular flavour to the puritanical notion that sexual licence became less threatening within an artistic Bohemia, and more acceptable with a Continental overlay of Cypriot restaurant. French pâtisserie and Italian barber. In the 1950s Soho came into its own as the only playground in the capital, where jazz clubs and coffee bars suddenly proliferated, turning the area into a place of pilgrimage for several generations of young people. Soho also had street markets selling produce not found elsewhere in London, as well as small shops specializing in Italian and French delicacies rarely found in any British household. The same licence and touch of the exotic extended to sex, with 'models' offering particular 'services' in rented rooms and clubs that catered for unusual tastes. Even some of the pubs favoured a particular clientele: the Golden Lion in Dean Street was mainly a homosexual port of call, while a few doors along the York Minster, the 'French pub' run by the impressively mustachioed Gaston Berlemont, was distinctly cosmopolitan and as close to being an intellectuals' meeting place as a pub could be.

Both these latter establishments were among Bacon's regular haunts, and the surest, simplest way of meeting him (as a growing number of admirers and hangers-on set out to do) was to take a stance at the bar of the French and bide one's time. Once he had done his morning's work in the studio, Bacon would arrive around noon in Soho, have a few glasses of white wine, then move on for lunch, with a group of friends (plus the lucky admirer or hanger-on) to Wheeler's, his favourite fish restaurant, around the corner in Old Compton Street. However hard Bacon was drinking, he made a point of eating well; in addition to being one of the few places in London to provide fresh fish. Wheeler's had the advantage that the artist was allowed to run up a bill there until he sold a picture and had the funds to pay. Since Bacon often arrived with large parties and always insisted on being host, and since oysters, sole and Chablis never come cheap, the bills rocketed. But as he was a very big spender and always eventually settled, the management greeted him with open arms; and Bacon, who adored being the centre of attention, held court at Wheeler's, becoming its undisputed star and charming the staff down to the last scullion with his exhilarating mix of laughter and large tips. The pulse of the plain dining room automatically shot up whenever he swept in, as often as not at the head of a collection of unusual-looking companions. A famous group portrait by the *Vogue* photographer and incorrigible Soho scallywag, John Deakin, shows Bacon raising a champagne glass while entertaining four other painters, Timothy Behrens, Lucian Freud, Frank Auerbach and Michael Andrews, at two tables along the wall. Occasionally Bacon's guests would include some drunken bruisers or East End toughs, and their unrestrained behaviour as they dispatched bottle after bottle of wine, under Bacon's amused, provocative gaze, sometimes outraged but usually fascinated the other staid, middle-class customers.

Wheeler's became the ultimate club for Bacon, a place where he knew everyone, could sign for meals and cash a cheque. Largely because of his magnetic presence, it regularly attracted other painters and intellectuals when they were sufficiently in funds, and Bacon adored the congeniality of eating and drinking amongst a large number of friends; the love of entertaining that he had inherited from his grandmother and mother found a natural outlet in the spontaneous banquets that he offered to a wide range of close companions and passing acquaintances there. But vital as the restaurant was to his daily round, it never acquired quite the importance of what, for over forty years, was his true home in Soho: the drinking club in Dean Street known as the Colony Room or, simply, Muriel's, after its legendary owner, Muriel Belcher.

Bacon had been very much a founding member of the Colony. He had wandered into the new club, on the day after its opening in 1948, and struck up a lively relationship with Muriel, who was to become a cherished friend and later the subject of several portraits. Muriel herself was a natural club-owner, both shrewd and convivial. In more than one respect, she resembled Evelyn Waugh's proprietress in *Vile Bodies*, Lottie Crump. Her parents were Portuguese Jews who owned the Alexandra Theatre in Birmingham, and she herself had already run a club called the Music Box near Leicester Square during the war. She was no intellectual but with her ample mother wit she immediately realized that Francis – thenceforth referred to as 'daughter' – would be an invaluable ally in building up her clientele. The artist was duly allocated £10 a week and free drinks for bringing in as many open-handed punters as he could. The arrangement

suited both of them very well and lasted for several years, until the Colony no longer needed new members and Bacon could afford to buy not only his own drinks but everyone else's.

Colin MacInnes, the ablest chronicler of Soho, caught the seedy lure of Muriel's (which he called Mabel's) in *England, Half English*:

To sit in Mabel's, with the curtains drawn at 4pm on a sunny afternoon, sipping expensive poison and gossiping one's life away, has the futile fascination of forbidden fruit: the heady intoxication of a bogus Baudelairian evil. As the gins slip down your throat, and the dim electrics shine on the potted plants and on Mabel's lurid colour scheme of emerald green and gold, you feel like the fish in the tank above the cash-register – swimming aimlessly among artificial water weeds, mindless in warm water.²

A smallish, dingy room reached by an evil-smelling staircase flanked by dustbins, the Colony depended entirely on the hilariously unconventional atmosphere created by Muriel and a handful of key habitués. 'It was a place', Bacon put it, 'where people could go and lose their inhibitions' – but only, it must be said, those whom Muriel had accepted. Many would-be members were turned away with a choice obscenity followed by a look of fine hauteur from the owner. who invariably sat, regally erect, on a stool by the bar, delicately whisking the bubbles out of her champagne. Because they had passed the test of Muriel's scrutiny members felt they were somehow inviolate, especially when a big spender like Bacon had ordered champagne for the entire assembly. ('Champagne for my real friends.' Bacon would propose as the barman topped up all the eagerly extended glasses, 'real pain for my sham friends.') Rowdy as the members often grew, grouped three deep at the bar and suddenly taking sides in a violent argument. Muriel always managed to keep a certain order: no one wished to cross her or become the butt of one of her foul-mouthed insults. 'Not a vision of loveliness tonight, is she?' she would say, fixing an offender with her imperious stare: and, as the hapless client dropped his eyes: 'To think she's had more pricks, dear, than most of us have had hot dinners.' Muriel's obscene banter set the tone from the start: 'You must remember me, dear,' she would announce to an unsuspecting newcomer, 'sucking cocks in rented rooms.' Regulars were referred to as 'Mary' or, less affectionately, as 'Cunty', these epithets being delivered with deadpan aplomb by Muriel, whose noble features and severe black dress gave

her the air of a distinguished ballerina in retirement. She had a keen eye for both the talents and the foibles of her favourite members; she also gave camp talk a whole new dimension one afternoon by alluding to the Führer as 'Miss Hitler'.

It was in this atmosphere, seedy par excellence but witty and also oddly compassionate, that Bacon whiled away whole afternoons, leaving the shabby premises only to absorb some seafood at Wheeler's. then returning to drink with a new circle of friends until far into the night. For him, apart from the fact that he liked a certain routine in his amusements, the advantage was that he would see many of his closest friends at Muriel's. One was the younger artist Lucian Freud. whom Bacon had painted – his first portrait of an identified person – in 1951, using a snapshot of Franz Kafka (shown leaning against a column, and casting a strong shadow) as his point of departure.³ Freud was to return the compliment the following year by painting a strikingly intense head of Bacon. The affinity between the two deeply committed figurative painters was no doubt strengthened by the fact that abstraction was being progressively hailed at the time as the only inventive mode of painting; but their friendship throve on an appreciation of each other's quick wit and vitality. Like Bacon. Freud had an endless curiosity about other people and the 'human comedy' in general: the two artists had no problem in abandoning a discussion about poetry – of which they were both perceptive readers – to regale each other with choice bits of gossip about their friends and acquaintances. The close friendship between these two powerful personalities, each conscious of his own and the other's uniqueness. was sufficiently well grounded to flourish for another twenty years, during which it proved an invaluable source of encouragement and amusement to them both. The rapport between the two painters is subtly suggested in Michael Andrews's celebrated painting The Colony Room. Bacon, seated at the bar with his back to the viewer (but still instantly recognizable) addresses himself to an attentive Freud, while other Soho characters mill around and a pale-faced Muriel hovers ghost-like beside the bar.4

A character not included in this composition but who could be counted on to turn up unfailingly either at Wheeler's or at Muriel's was the painter Johnny Minton, an archetypal Fifties figure whose mournfully sensitive face, gangling physique and wild eccentricities came to be regarded as an essential part of the Soho landscape. Minton had asked Bacon to take over his post as tutor at the Royal

College of Art for a term in 1950. Bacon agreed to stand in for him, on condition that he did no formal teaching – since he was convinced that art could not be taught; meanwhile, he said, he would be on hand to talk to the students. In return, Bacon was provided with a studio – for which he later insisted on paying, with almost excessive punctilio, by presenting the college with a large painting.⁵ His reputation, which already stood high with the students, seems to have been enhanced by his well-known views on the uselessness of art schools. Uncharacteristically, he agreed to give a talk about painting while he was there; and some of the phrases he used (notably 'what modern man needs is a kind of shorthand') became articles of faith for some of his young listeners.⁶

The friendship between Bacon and Minton, both homosexual and both flamboyant, became increasingly strained as Minton's star in the art world began to dip and Bacon's to rise spectacularly. Since they each craved the limelight, they would frequently be found holding court at opposite ends of Muriel's (which Minton once compared to 'being in an enormous bed, with drinks'), vying with each other in rounds bought and general outrageousness; one such competition ended with Bacon slowly pouring a bottle of champagne over Minton's head. Minton later lampooned Bacon as 'Ferdinand Delicious' in a sketch he wrote:

'Have some champers,' said Ferdinand Delicious, 'magical champers. I'm simply going to Monte to make a fortune. I simply am. Have you ever been to the Casino? All that soft red plush, darlings, it's just like being back with Mum, but *just*.' He drew a forefinger across the bar tracing a complicated pattern of events. 'You must all come but you *must*, we'll all go and simply destroy one another.'⁷

Minton was not of course the only painter to resent Bacon's apparently irresistible ascension. Less light-hearted was the verdict of another, more astringent and gifted homosexual painter, Keith Vaughan, who charged Bacon with a 'lack of permanent, formal, classical values, a sort of deliberate spiv-existentialist outlook on painting', and held that the artist's later portraits of Lucian Freud 'hit a new low in banality'. Minton himself mostly avoided direct confrontation with Bacon, sensing the latter's ferocious sense of purpose and confidence. Doubts about his own talent led to self-destructive drinking, deep depressions and, eventually, suicide, at the age of thirty-nine. Minton may be regarded now less as a truly

creative artist than as an endearing embodiment of the period, when painting in England suffered from - and reflected - a sense of postwar, provincial isolation.

Artists like these or Rodrigo Moynihan and Robert Buhler, writers such as Cyril Connolly and Stephen Spender, journalists and photographers like Daniel Farson and John Deakin, all came into Bacon's orbit regularly in the mid-Fifties. So did several of the women who meant most to him, such as Sonia Brownell, who had been Connolly's assistant on *Horizon* magazine before marrying George Orwell; or Isabel Rawsthorne and Henrietta Moraes, who became the subjects of some of Bacon's most impressive portraits. They tended to come across each other at parties given by Ann Fleming, whose stylishness Bacon admired, or boozy, argumentative lunches at the Royal College of Art, where not only Minton, but Moynihan and Buhler, taught; but somehow, because of the licensing laws imposed on pubs and the area's concentration of restaurants and after-hours clubs, most escapades began, continued and ended in Soho.

The people who accompanied Bacon on his nightly tour of the bars and gambling dens did not usually do much the following day except nurse a monumental hangover and try, confusedly, to piece together the sequence of events. Even a seasoned boozer like John Deakin, who became the quintessence of bohemian Soho, would lie low for a day or so after a Baconian session before popping up like a genie in the Golden Lion, penniless and impenitent, archly narrating anecdotes of what had recently befallen him ('Imagine the churl's impudence, my dear,' he might say, rolling his spaniel eyes to heaven, 'making a pass at me, the Mona Lisa of Paddington!'). Between bouts of drunken clowning, Deakin not only took the most striking photographs but made perceptive comments. Talking about a close-up portrait he had taken of Bacon around 1950. Deakin remarked: 'I like my picture of Francis Bacon enormously, perhaps because I like him so much, and admire his strange, tormented painting. He's an odd one, wonderfully tender and generous by nature, yet with curious streaks of cruelty, especially to his friends.'10

A few of Bacon's regular drinking partners turned the Soho boozing into a way of life. Jeffrey Bernard even became famous for it, drawing wittily on his experiences for his 'Low Life' column in the *Spectator*. 'Jeff's *modus vivendi*,' as George Melly wrote, 'is truly ingenious. He pays for his formidable intake of drinks by writing, very funnily, about the disastrous effect the drinks have on him.' But Bacon

himself would generally be back in the studio a couple of hours after the bacchanalia, wrestling with a new image. 'I often like working with a hangover,' was all he would say about this unusual performance, 'because my mind is crackling with energy and I can think very clearly.' Certainly, neither dissipation nor the tempestuousness of his love life seemed to stop Bacon from working. On the contrary, his love life inspired at this period two of the most evocative images of sexual coupling ever made - Two Figures and Two Figures in the Grass: indeed, Erica Brausen, herself no prude, found the former so evocative that she felt compelled to hang it out of the way, in an upstairs corner in her gallery, for fear of the scandal it might cause. Drawn from a Muybridge photograph of two wrestlers, both pictures convey with uncanny immediacy the spasm and the melting of flesh. They are among Bacon's most beautifully painted works and are virtually devoid of any of his usual compositional supports, apart from the tubular structure in the former and the amazing conceit, in the latter, of a field of grass transposed to an interior hung with pleated curtains. As a 'shorthand' of erotic obsession, they surely have no equal in this century outside Picasso's brilliant variations on this most demanding and hazardous of themes.

Despite the havoc which the love affair with Lacy had funnelled into his life, Bacon was at the height of his creative powers, producing some of his most haunting images. A photograph of Bacon at this time, taken by Douglas Glass in 1957 in the small studio in Overstrand Mansions, Battersea, shows an agile, youthful-looking man in his forty-eighth year: he is slim, with a full, unlined face and a vigorous shock of hair. He sits back in a chair, his eyes downcast (a look Bacon assumed frequently in photographs, but rarely in life), as if reflecting in a petulant, James Dean kind of way. He is wearing a crew-neck sweater, denim trousers with the bottoms turned up and smart, crepe-soled ankle boots - the kind of stealthy footwear he favoured for years. The sleeves of his sweater have been pushed up, characteristically, to reveal his strong white hairless arms. The prominently displayed wristwatch - another Bacon fetish that appears, like the shoes, in his later paintings – is clearly an expensive one. Inordinately vain of his appearance as he could be, frequently preening in a pocket mirror and very aware of which clothes suited him best, he never wore any kind of ring or bracelet, and even ridiculed men who did; but the expensive wristwatch was a sign that

he had money, and he sported it as a lure in the complex game of casual pick-ups.

Although the artist is immaculate, with his hair expertly teased out into a 'Tony Curtis' and his clothes fresh, the studio has the look of extreme chaos that was to mark all Bacon's subsequent working spaces. In sharp contrast to the pristine order of his first, decorator's studio in Queensberry Mews, this interior shows an almost wilful mess of books, brushes and paper strewn over the floor, with paint spattered over the broken furniture and climbing in random swipes up the wall. This kind of spectacular disorder reached a climax in the Reece Mews studio where the artist worked for the last thirty vears of his life; he claimed that he worked best in that kind of visually fascinating chaos because it suggested images to him. It is also true that, just as he was always conscious of his appearance and how he 'presented' himself. Bacon was constantly aware of the legend growing up around him. From the late nineteenth century on, artists had used photographs, especially those which showed them in their studios, as a way of getting their work better known; nobody used them to greater effect than Picasso, a fact that would not have been lost on Bacon. To a certain degree, like all successful professionals. he created and manipulated the public image of himself and, by extension, of his studio. Most of Bacon's picture-making took place. of course, in his imagination, and then in the hazardous, hit-or-miss techniques he used applying oil paint to canvas. The studio and its contents are fascinating to the art historian because they contain a variety of clues to the genesis of a work. For the artist himself the thick strew of documents on the floor may have fostered a sympathetic working atmosphere – a liberating confusion of paint and photos, art books and pigment-soaked rags, caked brushes and old shoes. But it is less likely that the exhilarating mess actually 'suggested images' to him than that the wild disorder reinforced a certain notion of the randomness and spontaneity of his creative process that Bacon wanted to project. The confusion in the studio, like the 'confusion' of vision on the canvas, was willed. Bacon was, in Rimbaud's phrase, 'absolument moderne', completely in touch with his time, and he knew that art could be created only if the confusion of modern man came through. But underlying the chaos - the jumbled carpet of images on the studio floor, the disintegration of form on the canvas – was a deeper desire for order.

At another level the studio chaos suited the legend that was

forming around the artist, partly at his instigation, partly beyond his control. Although Bacon had come from an upper-class background and had shown himself adept at making his way through society from the start, he deliberately cast himself as an inspired misfit from the wilds of an Irish stud farm. He identified himself with Rimbaud, Lautréamont, Van Gogh and other heroes in the surrealist pantheon: a brute creative force that had burst into the hidebound salons of culture and shaken them by sheer originality.

Signs of Bacon's growing recognition by the more progressive art establishment came when the Institute of Contemporary Arts, recently founded by the English surrealist painter and writer Roland Penrose, put on an exhibition of his work in January 1955, with a catalogue introduction by Max Clarac-Sérou, the French poet who later ran the prestigious Galerie du Dragon just off the boulevard Saint-Germain in Paris. By the standards of the time, more modest as regards contemporary art shows than our own, it amounted to a minor retrospective, for even though it consisted of no more than fourteen works, it covered the span of Bacon's development from before the war (Figures in a Garden, 1936) through Painting 1946 to several recent works exhibited for the first time. One of the artist's most provocative works. Two Figures in the Grass, discussed above, so disturbed some visitors that they called the police in to make a report for obscenity. 'But they're just wrestling in the grass.' the constable in question concluded. Figure with Meat, which shows an openmouthed pope seated against a background of two sides of beef, was accused of 'sensationalism': and even David Sylvester suggested in his review of the show that 'many of the things that make [Bacon] exciting today may render him laughable for future generations'. 12 Undeterred, Bacon later allowed himself to be photographed for *Vogue*, stripped to the waist and sandwiched between two such sides of meat.

Bacon's increasingly evident influence over Sutherland and many young painters was also commented on in the press. One reviewer pointed out that very few British artists could lay claim, like Bacon, to an international reputation. This was confirmed in the same year when four of his paintings were included in a show entitled 'The New Decade: 22 European Painters and Sculptors' which opened at the Museum of Modern Art in New York. The artist produced a statement for the catalogue of this exhibition which contains the arresting and now famous avowal: 'I would like my pictures to look as if a human being had passed between them, like a snail, leaving

a trail of the human presence and memory trace of past events, as the snail leaves its slime.' The following year, 1956, six of his works were selected for another exhibition at MoMA, 'Masters of British Painting 1800–1950'. What meant most to Bacon, however, was his first one-man show in Paris, which took place at the Galerie Rive Droite early in 1957. The artist clearly lent his full support to the event: it offered the French public a choice of twenty-one paintings, his largest show thus far, and the catalogue contained texts by Roland Penrose and David Sylvester, both of whom were known to the Paris art world. Lastly, in 1958, following Bacon's earlier success at the Venice Biennale, his work went on tour in Italy.¹³

Back home, Bacon continued to exhibit at regular intervals at the Hanover. Throughout the mid-1950s he concentrated on single figures caught, often open-mouthed or as if blurred by sudden movement, in anonymous spaces. The mood was detached, even clinical, as if the artist were analysing and recording manifestations of hysteria; and the palette was correspondingly cold and sombre, with a predominance of cobalt blue and ghostly whites. In 1954 he painted no fewer than seven versions on the theme *Man in Blue*, the original subject being a man Bacon had met – and no doubt become attracted to – while staying at the Imperial Hotel at Henley. Given his proximity to Peter Lacy and the latter's capacity for bouts of hysterical rage (during which he would destroy everything within reach), the underlying source of inspiration was also no doubt the artist's troubled, and troubling, lover.

Calmer, but no less disquieting, were the heads Bacon went on to paint from the life mask of William Blake. The idea for the series came about in an uncharacteristic fashion. A composer called Gerard Schurmann had set a number of Blake's poems to music and asked Bacon if he would design an image for the cover of his song cycle. Bacon, who was a great admirer of Blake's poetry and individualism while detesting his painting, was sufficiently intrigued to accompany Schurmann to the National Portrait Gallery to see a plaster cast of the life mask J. S. Deville had made of Blake in 1823, four years before the poet's death. Bacon took some photographs of the cast away with him and went back to see it several times. Over the following year he completed numerous versions of the head, of which five have survived. Painted against a dark ground (as in the photograph), the heads are a perfect example of Bacon's ability to communicate with a minimum of means. With eyes shut and mouth

closed in a determined down-turn, they float against the void like unearthly sculptures, impalpable yet expressive of a force as concentrated as a clenched fist. In Bacon's masterly versions, they appear to have gone over into death while leaving their living presence like a phosphorescence on the canvas.

During this period, references to Bacon and anecdotes about him began to surface in private papers, diaries and letters. Stephen Spender records in his journal a dinner party he and his wife gave for Wystan Auden in June 1955 at which Bacon was a guest; Bacon and Auden disliked each other almost on sight, and the evening ended with an argument flaring up between them. ¹⁵ A quite different account of the increasingly successful painter's effect on other people crops up in the diary of the artist Keith Vaughan. In his entry for 27 January 1955, Vaughan recounts a curious instance of Bacon's charisma:

Interesting account this morning from Dennis Williams of the time he lived and worked in a small room adjoining Francis Bacon's studio; idolizing Francis at the time, longing to be of service to him and ending by becoming so wholly enslaved to his personality that he was incapable of any independent action.

'There was nothing I could do. He would lie in bed in the morning. purple in the face, looking ill - terrible - unable to move until he had taken enough pills, but talking all the time about the paintings he had dreamed of. If I offered him a cup of tea he wouldn't drink it. He just didn't see me. I could have been anyone else and he wouldn't have noticed. I was in his studio one day and he came in with a suit which had just come from the cleaners. He laid it down on a large table in the middle of the room which was thick with paint, cotton wool, bits of dirty paper. He laid the suit down on the top and said he had to go out for a moment. As the suit had just come from the cleaners I picked it up and put it on a hanger and hung it out of the way by the wall. My only reason for doing this was that I thought it would be helpful a small thing - but something that he was incapable of doing for himself. Directly he came back into the room, without saying a word, he went over to the wall, took the suit down and laid it again in the paint on the table. I felt absolutely shattered, as though my personality had been wiped out.'16

An unexpected sign that Bacon's work had begun to be noticed by the senior cultural establishment came when Evelyn Waugh, writing from Combe Florey in 1956, asked his agent whether he could get permission to reproduce a Bacon painting on the cover of a forth-coming book. It would be out of the question of course to commission one,' Waugh adds tartly, 'but he might let us have "serial rights" of an existing horror.' Alfred Barr, the far-sighted founder-director of the Museum of Modern Art in New York, wrote to Erica Brausen in 1957 urging her 'to document thoroughly the work of England's most interesting painter'. There is also an amusing anecdote about Bacon around this period told by Kingsley Amis in his *Memoirs*, where the writer describes the artist making a sly attempt to pick him up; but according to Bacon the incident never happened. 19

As Bacon's reputation in the art world grew, so did the market for his pictures. Sales at the Hanover were brisk in the late 1950s as dealers, museums and private collectors all became interested in acquiring Bacon's work. The Arts Council and the Carnegie Institute were among the buyers, as were a number of key dealers such as Richard Feigen of Chicago and Eric Estorick of London. Prices were around the £400–£500 mark, and by 1961 (at which time the Hanover no longer represented Bacon) remaining works in the gallery's stock were being estimated at up to £1500. There were also a few committed private collectors, notably Joseph Hirshhorn and Robert and Lisa Sainsbury, who were to build up a significant collection of Bacons; both these wealthy entrepreneurs eventually founded museums where the works are displayed.²⁰

Throughout his life Bacon remained fascinated by very rich people — a category to which, increasingly, all the major collectors of his work belonged. Although he himself was much more inclined to spend rather than accumulate money, he admired those who had the knack of keeping it and increasing it, even if he was often scathing about their 'meanness' and would fume at a wealthy person doing something on the cheap. Once after spending the evening at the house of a rich woman, he came away truly indignant that she had plastic rather than real flowers; 'the whole point about flowers,' he expostulated, 'is that they *die*.' Similarly he always made a point of paying for meals at restaurants, even when the company included people with considerable fortunes, so that he could order the expensive vintages he enjoyed; later it amused him as a host to choose an exorbitantly priced wine while some far wealthier guest anxiously attempted to dissuade him.

With the Sainsburys, Bacon developed a close relationship which led to his painting one portrait of Robert and some eight studies of Lisa, of which the artist destroyed all but three. The portrait of the husband was specifically commissioned by the wife, who had been deeply impressed by Bacon's 1953 show at the Hanover. All the portraits of Lisa, to whom the artist felt closer, were done spontaneously during or after regular sessions of sitting to the artist in his little chaotic studio in Battersea. The first surviving study, entitled *Sketch for a Portrait of Lisa* (1955), is especially fine; it is worth pointing out that, although some of his most expressive works were to be of women, this was Bacon's first female portrait, and also that he still worked directly from certain models rather than exclusively from photographs of them, as he insisted on doing later on (to avoid, as he said, inflicting on them in their presence the injury which he did to them in paint).

It was around this date, too, that he painted his first identified Self Portrait, another subject that was to occupy him increasingly as he got older. More significantly, he also produced Study for the Nurse in the Film 'Battleship Potemkin' and his variations on a portrait of Van Gogh during this exceptionally creative period. As previously mentioned. Bacon had first seen Eisenstein's masterpiece very early on, possibly during his stay in Berlin, when the film was released after having been banned. The concentration of horror in the Odessa Steps sequence, bringing into sharp focus a whole world falling apart. had transfixed Bacon so much that he returned to see the film many times. The nurse's scream blended with the Poussin cry and the hand-coloured medical photos of mouth diseases in his imagination, prompting him to reinterpret both the distended mouth and the violently shattered glasses repeatedly, and with such force in this fulllength study that the head altogether dominates the sombrely coloured composition. With his own beloved nanny (who wore similar glasses) not long dead, Bacon would have been especially moved by the image of the tragic separation between the abandoned infant and the dying nurse.

Van Gogh was also to become a prime source of inspiration. For someone of such rigorously exclusive tastes, Bacon liked a comparatively wide range of nineteenth-century art; and he especially admired Ingres, Manet and Degas. But Van Gogh's ability to convey raw emotion had always touched him more deeply, even, as he put it, 'when I was young and Cézanne had become the god'. He was drawn above all to the early work, which he found especially 'poignant'. He was fascinated, too, by Van Gogh's letters, which he

kept by his bedside and constantly reread, finding many of his own convictions as an artist reflected in such modern insights as 'real painters do not paint things as they are ... They paint them as they themselves feel them to be.' The earliest manifestation of Van Gogh's importance for Bacon came during the painting of Head in 1951, which started out as a pope but turned, as if of its own accord. into a portrait of the Dutch artist. Characteristically enough, Bacon's interest in Van Gogh was quickened by seeing Vincente Minelli's Lust for Life, in which Kirk Douglas plays Van Gogh to Anthony Quinn's Gauguin, and he returned to the theme less obliquely in 1956 with the first Study for Portrait of Van Gogh. This picture was inspired directly by The Painter on his Way to Work of 1888 (which was destroyed during the Second World War, and therefore existed only in reproduction). It shows Van Gogh, weighed down by outdoor painting equipment, making his way 'like a phantom of the road' (in Bacon's phrase) towards a motif in the fields of Provence; though a late work, it had moved the English painter deeply, echoing his own sense of struggle and isolation. Bacon's first version was relatively subdued, but the subsequent seven pictures on the theme are remarkable for their loose, rapid brushwork and explosion of colours. Suddenly Bacon's chill interior world of dark blue drapes and tubular structure spills out into an even more pitiless exterior where the light chars flesh and vegetation black. The pictures irresistibly call up a few lines from Yeats's poem 'The Second Coming', which Bacon loved to quote:

... somewhere in sands of the desert
A shape with lion body and the head of a man,
A gaze blank and pitiless as the sun,
Is moving its slow thighs, while all about it
Reel shadows of the indignant desert birds.

The frenzy that the *Van Gogh* portraits communicate perhaps stems to some extent from the fact that Bacon painted the first three under terrific pressure for his new show at the Hanover in March 1957; the subsequent two studies were in fact smuggled in with their paint still wet once the show had opened.²¹ But there is patently a deeperseated reason. However much Bacon liked to emphasize the randomness with which his paintings came about, he clearly felt a degree of identification with Van Gogh, in much the same way as, by his own admission, he had become 'obsessed' by the Velázquez Pope.

Van Gogh represented the ultimate outsider ('le suicidé de la société', as Artaud called him); and Bacon, distraught and trapped in the extreme alienation of an unhappy love affair, surely saw his own suffering reflected in the bowed figure trudging towards the strange isolation of making paintings in a field. Certainly, in Bacon's next three variations on the theme, the figure conveys such a weight of loneliness that it appears to be melting into its own shadow, which in its turn is swallowed by the harsh yellows and reds of the road. There is a despair close to madness emanating from this black wraith caught in a nightmare of quicksand paint and blinding colour.

Although he enjoyed being physically dominated, Bacon instinctively sought to have the upper hand in all his important relationships. He could be whipped and physically abused, but by his toughness and intelligence he kept ultimate control. With Peter Lacy, he had lost it spectacularly. He could withstand the violence and the rows, the scenes which ended with him being beaten up, his clothes destroyed and his paintings slashed; there were sides of it he positively relished. But he was kept, mentally as well as physically, in thrall: being less in love, Lacy seemed stronger and freer, and the pangs of sexual jealousy tormented Bacon as intensely as any Furies he had known. Naturally promiscuous but above all devoted to his own destruction, Lacy kept always slightly out of reach. The *folie à deux* raged within its own pain and degradation. By the time of the first *Van Gogh* portraits, it had reached an inevitable impasse. But when Lacy left for Tangier, that did not stop Bacon from following him.

Tangier acted like a magnet for homosexuals during the 1950s. While back home, in the wake of the notorious Montagu case, Scotland Yard was reported to be stepping up a campaign to 'rip the covers off all London's filth spots' and encouraging arrests for homosexual offences, the Moroccan port offered not only acceptance but widespread acquiescence in matters of sexual preference; there was also a huge number of brothels, some of them catering specifically for paedophiles. Arab men, moreover, were often unusually goodlooking and had a reputation for virility. Many British and American men who were understandably circumspect about their 'proclivities' in the ordinary course of their lives were able to cast off such restraints in Morocco, where sex between men was considered less consequential and binding than sex between man and woman. The sight of crowds of native men in brilliantly coloured jellabas strolling

hand in hand together through the town would have been particularly alluring to foreign homosexuals forced to hide their affections. The French presence in Morocco had also made the country more attractive to visitors from abroad: besides the souk, with its exotic wares and mysterious customs, there were European-style boulevards and hotels which had transformed Tangier into a kind of Arabian Nice. There were many reasons for a restless man to settle there, of which Truman Capote, himself at one time a resident of the city, lists a leading four: 'the easy availability of drugs, lustful adolescent prostitutes, tax loopholes, or because he is so undesirable no place north of Port Said would let him out of the airport or off the ship'.

In the mid to late 1950s, when Bacon was spending large parts of the year there. Tangier had a distinct expatriate hierarchy and modus vivendi. David Herbert, the younger son of the Earl of Pembroke, was a natural choice as the unofficial head of the British community. He had established himself in a picturesque house with an aviary, surrounded by a splendid garden, where he entertained all the passing grandees from the Windsors to Noël Coward; Ian Fleming, who had gone to Tangier to work on a book, put it in a nutshell: 'David is a sort of Queen Mum.' On the American side, there were several brilliant writers. Tennessee Williams lived in the luxury Hôtel Minzah and lamented to Bacon the lack of sexual faithfulness among the Moroccan boys he fell in love with. Paul Bowles, the city's most committed foreign resident, was to become the doven of the expatriate writers, although for the period that he was there, working on The Naked Lunch, William Burroughs had a scandalous reputation that attracted more attention. Other poets, notably Allen Ginsberg, followed Burroughs to Tangier, turning the city into a place of pilgrimage for the Beat Generation, where they hoped to glimpse the hallucinatory scenes which Burroughs paraded before their eyes:

Minarets, palms, mountains, jungle ... Hipsters with smooth copper-coloured faces lounge in doorways twisting shrunken heads on gold chains, their faces blank with an insect's unseeing calm. Behind them, through open doors, tables and booths and bars, and kitchens and baths, copulating couples on rows of brass beds, crisscross of a thousand hammocks, junkies typing up for a shot, opium smokers, hashish smokers, people eating talking bathing back into a haze of smoke and steam ...

The City is visited by epidemics of violence, and the untended dead

are eaten by vultures in the streets. Albinos blink in the sun. Boys sit in trees, languidly masturbate. People eaten by unknown diseases watch the passer-by with evil, knowing eyes.²²

Nevertheless 'Interzone' (as Burroughs called the city) did not take Bacon altogether by surprise. Apart from its powerful charge of North African exoticism, he saw it as a seedier, more decadent Monte Carlo. Around the writers and artists there revolved a similar if more raffish mixture of heiresses, criminals, socialites and drifters, whose lives interpenetrated as they made their daily round of the main bars. Preeminent among these, supposedly 'twinned' with Muriel's in London and the place which served as Bacon's own favourite hangout in Tangier, was Dean's Bar. Dean was a mellifluously spoken black man of mysterious origins who seemed born to run a bar, infusing his little lair with a mixture of improbability and shadiness which perfectly reflected the atmosphere of the city outside. Ian Fleming also made it his main port of call: 'My life has revolved round a place called Dean's Bar, a sort of mixture between Wiltons and the porter's lodge at White's,' he wrote in a letter to his wife, Ann. 'There's nothing but pansies, and I have been fresh meat for them,' he goes on racily, adding, 'Francis Bacon is due next week to live with his pansy pianist friend...'23

For Peter Lacy, Dean's had become a place of near enslavement: and it marked the beginning of his last, rapid decline. Whatever his means when Bacon first took up with him in the early 1950s, they had dwindled to the point where he was obliged to 'tinkle the ivories' in Dean's virtually day and night in order to eke out an existence in Tangier. Bacon always cast Lacy as someone rich enough not to have to work, possibly because it flattered him to think that he had been singled out by someone who had the means to pick and choose among the many lovers available. But the writer Rupert Croft-Cooke described a Handful of Dust situation in which Lacy was obliged to play night after night to pay back a debt to Dean which never decreased as, night after night, the pianist drank the bar dry. The piano was always 'four ranks deep in empty glasses. This cigarettescarred instrument produced an inspired stream of music which I had never known to end before seven in the morning, at which hour the performer would sway and his face collapse gravely into the keys with a faint but haunting discord.' Lacy himself 'had the face of a poet who has dropped in to remark that life after death is tolerable –

a calm, ageless face impossible to classify as either drunk or sober until the last gin went into reverse, usually about sunrise... 24

'Periodically Peter got very drunk,' David Herbert says, taking up the tale with exemplary understatement, 'and on one of his benders he took a knife and slashed three-quarters of the paintings that Francis had been working on the previous six months. Francis took it quite calmly; in fact he seemed almost pleased.' The British Consul-General in Tangier, Bryce Nairn, became worried because 'Francis was frequently found by the police beaten up in some street in Tangier in the early hours of the morning,' Herbert goes on. 'Bryce complained to the Chief of Police and asked to have more police on duty in the darker alleys of the town. A few weeks passed; the beatings continued. Then the Chief called on Bryce and said, "Pardon, Monsieur le Consul-Général, mais il n'y a rien à faire. Monsieur Bacon aime ça." '25 In a letter from Tangier, Bacon himself relates that Lacy and another friend 'set on me in the taxi and the taxi driver called the police', adding: 'Peter seems to be going a bit mad. I shall never be able to work with all this...'26

After putting up at several hotels, notably the Hôtel Cecil (which he gives as his address on two letters to Erica Brausen), Bacon wandered through a succession of rooms and small flats, much as he had done in London. From a makeshift studio on the sixth floor of boulevard Mohammed V, a big thoroughfare in the *ville nouvelle*, he tells Brausen he has just finished four paintings: 'I think they are the best things I have done. I am doing two series, one of the Pope with Owls quite different from the others and a serial portrait of a person in a room. I am very excited about it. I hope to come back with about 20 or 25 paintings early in October . . . I feel full of work and believe I may do a few really good paintings now.'

In the event, Bacon brought back very little from his lengthy stays in Tangier: he abandoned numerous works in progress, and either he or Peter Lacy destroyed most of the others.²⁷ He was fixated by his hopeless and destructive relationship with Lacy, which continued despite raging quarrels and their both having other affairs. With Lacy now penniless and chained to Dean's piano, Bacon desperately needed money to keep the two of them going, and the up-beat tone of his letters to Brausen often precedes an urgent request for funds (the loucheness of life in Tangier is nicely evoked when he asks for a cash transfer to be made to the account of a certain 'Auto Gears and Spare Parts Co.' in Gibraltar).

But although Bacon completed and kept few paintings in Tangier, the whole atmosphere and the luminosity of Morocco marked him deeply. There can be no doubt that the explosion of strong colours in the *Van Gogh* series is at least partly attributable to Bacon's experience of the North African light (just as Van Gogh's own palette took on a new intensity after his arrival in Arles). In *Van Gogh in a Landscape*, Bacon has actually used a view of the countryside outside Tangier, which impressed him so much that it later became the sole subject of a wonderfully mysterious painting called *Landscape near Malabata*, *Tangier*. Dated 1963 and painted in London, this picture in fact had a deeply personal importance for the artist: it was in that landscape that Peter Lacy had been buried.

Bacon always stood out by his sheer exuberance, a kind of manic bonhomie, wherever he was, and his presence did not go unnoticed by the gay luminaries of Tangier. Allen Ginsberg described Bacon at that time as having the look of an English schoolboy with the soul of a satyr, who 'wears sneakers & tight dungarees and black silk shirts & always looks like going to tennis ... and paints mad gorillas in grey hotel rooms drest in evening dress with deathly black umbrellas - said he would paint a big pornographic picture of me & Peter [Orlovsky]'. Ginsberg was at work trying to edit his former lover Burroughs's Naked Lunch into its final form, and he was particularly interested to know how Bacon completed a painting: 'He said he did it with a chance brushstroke that locked in the magic a fortuitous thing that he couldn't predict or orchestrate.'28 Bacon was offended when Ginsberg offered him a drink in a tin can retrieved from the garbage, and later waxed sarcastic about the Beats' bohemian ways being underpinned by a return ticket to America safely stowed away in the back pocket of their jeans. Ginsberg actually gave Bacon some photographs of himself and his current lover in bed, no doubt in connection with the 'pornographic picture'. Bacon's reaction later on was typically laconic: 'Those photos were terribly useful. The lovers weren't very interesting, but there was something about the way the mattress spilled over the metal spindles of the bed that was so despairing I decided to keep them and use them.' The ticking on which Bacon's nudes of the early 1960s are displayed derives, in fact, from these shots taken in a Tangier hotel.

Bill Burroughs, whom Bacon met originally through Paul Bowles, became a close friend. Bacon was intrigued by his radical stance, which he found all the more interesting given Burroughs' wealthy

origins; and he was genuinely interested in the American writer's use of the cut-up technique (in essence, a variation on the Surrealists' disruptive exercises with which Bacon was familiar). Ginsberg in fact believed that Bacon painted the way Burroughs wrote, but Burroughs succinctly corrected this: 'Bacon and I are at opposite ends of the spectrum. He likes middle-aged truck drivers and I like young boys. He sneers at immortality and I think it is the one thing of importance. Of course, we're associated because of our morbid subject matter.'29 Bacon had less contact with Paul Bowles, who mentions in his autobiography that he admired both the painter and his work, adding perceptively that he sensed in him 'a man about to burst from internal pressures'. Bacon actually preferred both the company and the writing of Bowles's wife, Jane; as a portraitist, he was also fascinated by the mobility of her features. In a recorded conversation with Burroughs he lamented the circumstances of Jane's death: 'She died in a madhouse in Malaga, it must have been the worst thing in the world. Looked after by nuns, can you imagine anything more horrible?'30 The remark takes on a particular poignancy in the light of the artist's own end in Madrid.

But Bacon's closest relationship in Tangier apart from Peter Lacy was with a young Moroccan artist called Ahmed Yacoubi, who had lived with Paul Bowles for several years. Yacoubi was still trying to find himself as a painter, and Bacon found his combination of virility and charm so attractive that he allowed Yacoubi — a very rare privilege — to come to his studio in the Casbah and watch how he worked. Bacon's generosity extended to getting his friend's paintings shown at the Hanover and also standing by him when he was held in prison for seducing a young German boy. Although Yacoubi was later acquitted, the case led to a general police crackdown, and a number of expatriate homosexuals left in alarm. 'Tangier is finished,' Burroughs announced in a letter to Ginsberg. 'The Arab dogs are upon us. Many a queen has been dragged shrieking from the parade, the Socco Chico, and lodged in the local box where sixty sons of Sodom now languish...'

The Tangier interlude and Bacon's affair with Lacy were to last for another couple of years. 'Peter had been very tough when I first knew him. He was really tough, tougher than me. Then he fell for this Moroccan boy, and after he went to Tangier he lost that toughness,' Bacon told me. 'I think it had something to do with Arab men. He had also always been the most terrible kind of drunk, but

by this time he was completely out of control. The boy had left him and so on. Anyway he said he never wanted to see me again - at one point he told me I had ruined his life by making him think about himself. Then one day he just telephoned and said, "From now on, consider me dead. Consider me dead!" And I was very upset, because I had been deeply fond of him. And then much later, for some reason. he sent this telegram asking me to go out and stay with him again in Tangier. It was all over between us, but like a fool I went. Peter wasn't there when I arrived. Of course, But there was this Arab boy. it sounds perfectly mad, but he was sitting up in a fig tree in the courtvard and he asked whether he could pick the figs. I said ves. certainly he could. And in the end he climbed in through the window. and he was terribly good-looking. Then Peter came back, I'm afraid, and found us both in bed, and he got so absolutely mad he went round and broke every single thing in the place. Even though there was nothing between us any more. I had to go out and try and spend the night on the beach. By that time Peter was drinking three bottles of whisky a day, which no one can take. He was killing himself with drink. He set out to do it, like a suicide, and I think in the end his pancreas simply exploded. Anyway, after that disastrous trip, I had no news of him until the day the exhibition of mine opened at the Tate and, along with all the other telegrams, I got this one saving he had just died.'

Recognition at Home: The Tate Retrospective 1958–63

There is no excellent beauty that hath not some strangeness in the proportion.

Sir Francis Bacon, 'Of Beauty', Essays (1625)

A picture is something which requires as much knavery, trickery, and deceit as the perpetration of a crime. Paint falsely, then add the accent of nature.

Attributed to Edgar Degas (1834–1917)

Abandoned or destroyed in great batches, both by the artist himself and by his sadistic lover, Bacon's surviving paintings nevertheless grew in number. However many had been slashed in bouts of despair or drunken rage, 150 canvases were in existence by the end of 1958. most of them safely in the hands of collectors. But for all his excitement about working in Tangier - where he arrived each time from London laden with canvas and paints – Bacon actually brought back just one completed picture. Now entitled simply Painting (1958). it was originally known as Pope with Owls and belonged to the series which Bacon mentioned in the letter to Erica Brausen as one of the score of paintings he hoped to give her on his return. The experience of North Africa remained central, however, transforming the artist's sense of colour, as if, almost literally, the space of his pictorial imagination had been flooded with violent light and stark contrast. It directly inspired two subsequent paintings, one of a Moroccan man in a jellaba carrying a child, and the Landscape near Malabata; but it also influenced Bacon in less immediately perceptible ways, deepening

and confirming his feelings about life and about human beings.

From adolescence, Bacon had had an undeniable taste for 'low' life. He also gravitated readily towards the opposite end of the scale. whether it consisted of high stakes in the private salons of the Monte Carlo casino or a sumptuous dinner in the grandest hotel. Much of what lay in between had no appeal for him, and he made every effort to divide the time he spent outside his studio in pursuit of one or the other extreme. This 'gilded gutter life', as he called it, had found its tempo primo in his late adolescence in Berlin, where the effortless descent from the four-poster bed at the Adlon to the seediest pick-up joint or 'cottage' impressed him for life. Clearly his frequentations were to a large extent dictated by his homosexuality, driving him often literally 'underground', to furtive gatherings down dark alleys. in basement bars, behind locked doors. Instead of deploring the clandestinity, he actively welcomed it; and much later, after the advent of Gay Liberation, he would complain that being a 'queer' had been 'really so much more interesting when it was illegal'.

This taste for low life led him to places which combined financial laxity with moral freedom, such as Monte Carlo and the 'international zone' of Tangier, and also to Soho and the East End of London. Even in Paris, he made for the bas fonds of Pigalle, where all those outside the law, whether gangsters, prostitutes or homosexuals, gathered as a matter of course. He was not drawn by nostalgie de la boue or the desire to slum: beyond the sexual drive, he was convinced that in these milieux people behaved 'closer to their own instincts', as he put it, and therefore that human existence could be seen more 'rawly'. without the 'veils' that overlaid the lives of most honest citizens. Certainly, in the bars and hotel rooms of Tangier, he had observed abundant displays of extreme behaviour and emotion, with his drunken lover, who whipped him and destroyed his work, or in the antics of other expatriates high on drugs or driven to despair by the guileless and guiltless infidelities of their Moroccan boyfriends. In numerous small rooms, under the dim light of Dean's or in the fetid airlessness of a pension in the medina, Bacon's image of the 'other', of the human animal, gained in depth. Although his own feelings were often intimately involved, the artist strove to maintain a surgeon's detachment, dissecting human features down to the bone. It was not. as far as he was concerned, in any way a 'negative' vision; the word would not have occurred to him. He watched - bodies bruised by brutal love-making, faces swollen in lust, twisted in fear, collapsed in

drink – and recorded what he saw, with the excitement of his own reawoken emotion but with no trace of moral judgement or sentimentality. He sought the centre of existence, the instant of truth, in the unguarded look and the spontaneous, unstoppable cry. These were the facts, and you got to them at close quarters, more quickly and more accurately, in places and situations of least restraint.

Nevertheless, in the wake of the great Van Gogh series and the disruptions caused by the tortured love affair with Peter Lacy, 1958 was singularly unproductive. A mere six canvases survive from that year, compared to a score produced the year before. Of the latter, two are identified as portraits of P. L.: the first shows Lacy naked and huddled on a sofa – an image of vulnerability Bacon reinterpreted several times over the next few years; in the second, the subject stares back dazed and confused from the picture's shallow space, the flesh of his face looking as if whipped into a chance likeness. However much he distorted a sitter's appearance, Bacon's ability to capture a likeness grew more impressive as he became more technically skilful later in his career. But here already the likeness is such that Lacy can be recognized as the model of several previous, unidentified portraits, notably the three variations on *Study for Figure* (1956–57), and the Study for Portrait IX (1957). Lacy's presence, both threatening and pathetic, domineering and defeated, spills over into many of Bacon's anonymous figure studies of this period. The whole range of his obsession with his lover is conveyed in the writhings of the paint. from fury and frustration to a deep tenderness.

While Bacon was steering his precarious course between his friends' flat in Battersea and rented rooms in Tangier, his dealer Erica Brausen continued to support him and further his career. Ever since his work had been exhibited at the Venice Biennale in 1954, Bacon had aroused a great deal of interest in Italy. Through the early months of 1958, he was given what amounted to his first travelling show. The exhibition, a small selection of canvases (only eight in all), opened on 23 January at the Galleria Galatea in Turin, with an introduction by the influential Italian critic Luigi Carluccio; from there it went to Milan, to the Galleria dell'Ariete on the fashionable via Sant' Andrea, and ended at L'Obelisco in Rome. Several Bacons entered private collections in Italy as a result of this modest tour. Meanwhile, the artist was also beginning to attract attention from academic circles, but his lifelong reluctance to provide biographical information was to prove a stumbling block even at this early date.

'We only wish we could give you some positive help in your researches on Francis Bacon,' Brausen replies in May 1958 to an enquiry from the University of Minnesota, 'but biographical data is almost impossible to obtain because the artist will not allow the publication of any personal details.'

Bacon's letters to Brausen from Tangier betray occasional exasperation with her handling of his affairs, above all with the number of shows she had arranged for him. 'I feel it is too soon to get the things ready by February,' he says in one note. 'I do want to have a good show this time and not a rushed affair like last time.' 'Do you think we could delay arranging exhibitions for a bit,' he asks in another, 'so that I can for once work in peace.' But nothing led Brausen to suspect that the artist whose reputation she had been steadfastly building for a dozen years was about to quit her gallery for good. She herself was absent from the Hanover at the time, and she learnt of the break in a letter dated 17 October 1958 from her assistant:

... Francis came in just now, obviously upset and in some trepidation, bringing with him a cheque to clear his account. It seems he had not wanted to reveal to you the true state of his financial affairs, which had come to such a pass that he decided to make an arrangement with the Marlborough. He said he would never have taken this step without consulting you but was up to the neck in personal debt to the extent of about £5000 from gambling etc. He felt you would never be able to take over such a liability and therefore had not spoken to you about it ... Obviously he has already signed up and received money. He knows that you will be distressed, as he is himself, but he says that his position was desperate and that he had no alternative ... I'm terribly sorry about Francis after all you have done for him all these years.²

Bacon had in fact received a statement of his account with the Hanover only a fortnight before the break. It confirmed that his debt to the gallery amounted to £1242 – roughly the equivalent of what he could expect to be paid for the contents of an entire new show. Bacon loathed the feeling of indebtedness, making a point of repaying any sum or favour with considerable interest as soon as he could; and as far as his big gambling losses were concerned, he would have had his arm firmly twisted to encourage a rapid settlement. Consequently, when the directors of Marlborough Fine Art offered to pay off his debts, he did not hesitate: on 16 October he signed a

contract with them, without any prior discussion with Erica Brausen. The news came as a double blow to Brausen, who felt she was losing both her 'star' artist and a close friend. Shortly afterwards, her disappointment turned to anger. 'I've looked after Mr Bacon's interests for more than ten years,' she told the press. 'I bought his first picture. Now he leaves a message with my secretary that he is taking his business elsewhere. I intend to sue him.' But since no written contract existed between them, she was powerless to attack him. Bacon gave other justifications for the break years afterwards. Brausen herself had never had any money, he said, and therefore depended on the financial support of her backers; but they had never liked his work, and the situation had become intolerable.³ The rift between them never healed; however, when they were both old and Bacon heard that Brausen could not afford some necessary medical treatment, he sent her £100.000.

Another, perhaps less easily avowed reason for joining a rival gallery was that Bacon had sensed that Marlborough Fine Art might be more soundly financed, more dynamic and hence better in the long term for his career. Although he claimed to be a 'total fool' in business, he showed a remarkable shrewdness when it came to making decisions that would affect his life profoundly. As with much that happened in the art world after the war, the founders of the Marlborough were two Jewish refugees, Frank Lloyd and Harry Fischer, both Viennese by birth, who had served together in the Pioneer Corps. They began by dealing in antiquarian books, then they bought and sold a complete set of Degas bronzes, which established them as a new force on Bond Street. Through the 1950s they continued to specialize mainly in nineteenth- and early twentiethcentury art, putting on notable exhibitions of Géricault, Courbet, Monet, Picasso and Juan Gris. By the early 1960s, when Bacon was given his first shows there, the Marlborough had become the agents for a variety of contemporary artists, including Henry Moore, Ben Nicholson and Graham Sutherland. In 1963, they opened a gallery on 57th Street in New York.

After his move to the Marlborough, many aspects of Bacon's life were to change, some rapidly and visibly, others more subtly. Joining an ambitious, internationally based organization, with its prestigious stock of modern masters and 'stable' of well-known contemporaries, rekindled his ambition and proved the best possible way of counteracting the erosion of a drawn-out, destructive love affair. In order to

put some real distance between himself and the dissolute, brawling life with Lacy in Tangier and concentrate once more on painting, Bacon took the uncharacteristic decision of shutting himself away in the most unlikely location: St Ives, the Cornish fishing village where numerous artists, from Ben Nicholson and Barbara Hepworth to Peter Lanyon and Patrick Heron, had set up their studios. For a person who was truly at home only in the anonymity of big cities and who detested not only the countryside but the least hint of an artists' community, living for several months in St Ives, however beautiful its light, seems like a deliberate act of penance.

Bacon himself never referred to his stay in Cornwall, although it lasted for some four months, from late September 1959 to mid-January 1960. It seems likely that his new gallery had firmly advocated and partly organized his stay, in the hope that he would return with a batch of paintings. The arrangements were certainly comfortable enough: Bacon lived in a large house owned by a hospitable homosexual where the other guests, the conversation and the quality of food made him feel as much at home as he ever could in a village. He also had one of the best rooms to paint, a short walk away, at 3 Porthmeor Studios. The row of studios, where Ben Nicholson and Patrick Heron also worked at one time, gave out directly on to the beach and the sea. The other painters resident in the village were abstract almost to a man, and they were suitably surprised to find Bacon, not only notoriously figurative but outspokenly disdainful of all forms of abstraction, suddenly plunged into their midst. A certain amount of banter ensued, with the abstract painters confidently predicting that the sparkling marine light would do Bacon's sense of colour a power of good. Much of the talk took place in the local pubs or at the house of Barbara Hepworth, whose strong personality and artistic achievement had made her a dominant force in the community. Bacon occasionally dropped in to drink whisky with Hepworth, who had a positive opinion of him as a man and an artist, despite their widely differing views.4 Little else is known about the St Ives interlude, the only real record being the relatively few paintings that survived. Of the twenty or more canvases which Bacon completed during his stay – a rate of production which implies unusually intense bouts of work - all but six were destroyed.

As on previous occasions, Bacon's creative energies had been

concentrated by the prospect of an important exhibition: a first show at the Marlborough had been scheduled for early spring 1960, and it was to consist entirely of new work. The drastic change of light from North Africa to Cornwall was immediately reflected in the artist's palette. Lying Figure (1959) was one of the first paintings he completed at St Ives, and the picture's background is made up of three thick bands of differing blues - aquamarine, indigo and cobalt that correspond to a wall, a couch (on which the nude figure lies) and a carpet. Earlier in the year, Bacon would have seen the exhibition of 'New American Painting' which opened at the Tate at the end of its European tour and created a considerable stir in the English art world, where there had been little opportunity to contemplate the full range of Abstract Expressionism. Bacon liked to dismiss all abstraction as essentially 'decorative', a pattern-making that could be pretty but never profound; and in more waspish moments he would refer to Jackson Pollock as 'that old lace maker' and compare de Kooning's Woman series to playing-cards. (De Kooning, on the other hand, had been struck early on by Painting 1946 at MoMA, and expressed warm admiration for Bacon.)

Such caustic utterances, however, did not prevent Bacon from responding to the Americans' achievements and turning them to his own purpose. The flat bands of colour in Lying Figure clearly denote that at some level the English painter had been struck by the huge Barnett Newman colour-field canvases he had seen, either at the show or in reproduction. He was also fully aware of the gestural spontaneity of de Kooning's brushwork, which may have encouraged him to be free to the point of apparent randomness in his own application of paint; from time to time, he certainly experimented with throwing paint on to the canvas and letting it drip. Bacon would not have bothered to criticize abstraction so frequently and with such acerbity if he had not felt to some degree challenged by it. He also understood that taking a figurative image to the verge - but just short - of abstraction gave it a mysterious and compelling tension. In this perspective, the admirably ferocious portrait of Muriel Belcher (1959), for instance, made out of what looks like an elliptical smearing of paint, inevitably recalls de Kooning's aggressively won freedom.

With the deadline of the Marlborough show fast approaching, Bacon stepped up his rate of production even further after returning to his

cluttered little Battersea studio in mid-January 1960. Most of the paintings were of single figures sitting or reclining, and many of them were set against the smooth, emerald-green ground which the artist had used as a backdrop for his head of Muriel Belcher. In the event, he managed to complete an impressive total of thirty-two works for the show, several of them still wet when they were hung for the opening on 23 March. The catalogue contained a fine photograph by Cecil Beaton of Bacon standing defiantly in the midst of several recent paintings and a perceptive text by Robert Melville. Reactions in the London press were sharply divided. While Stephen Spender, John Russell and the American-born painter R. B. Kitaj wrote enthusiastically in praise of Bacon, Eric Newton expressed his disgust ('Snails extracted from their shells and arrested half way through the process of metamorphosis into human beings would look rather like this') and Lawrence Alloway a measured contempt ('Much of Bacon's imagery, with or without Melville, is beginning to look corny now').5

Beaton produced a whole series of striking shots of Bacon, who looks a good deal younger than his fifty years, staring alertly back at the camera. But Beaton portrayed by Bacon – at the former's express request – turned out to be a far more testing affair. Beaton, who was clearly much marked by the experience, devotes a section of his autobiography to describing what happened. Despite its twittery tone, the account is worth quoting in part because no other full account of sitting to Bacon exists, and also because it shows how wounded even an experienced (albeit inordinately vain) admirer of Bacon could be when his own appearance underwent a Baconian distortion. Beaton begins by relating his admiration for the painter's physique: 'He appeared extraordinarily healthy with cherubic, apple-shiny cheeks, and the protruding lips were lubricated with an unusual amount of saliva. His hair was bleached by the sun and other aids. His figure was incredibly lithe for a person of his age and occupation. wonderfully muscular and solid. I was impressed by his "principal boy" legs, tightly encased in black jeans with high boots.' After a 'winter in Tangier where he had been too harassed and ill to paint'. Bacon began on the portrait 'with great zest, excitedly running backwards and forwards to the canvas with gazelle-springing leaps'. but what appeared at last on the canvas was a 'monster cripple – a nude figure, with no apparent head, but with four legs'. Even though the hoped-for portrait did not materialize, the sittings had enabled

Beaton to get a close look at the 'extraordinarily messy, modest drawing room studio', where he noticed 'among the rubbish of old discarded suede shoes, jerseys, and tins on the floor, one or two very costly art books on Egypt and Crete'.

Nothing daunted. Beaton pressed the artist to make a second attempt at a likeness. Surprisingly, Bacon agreed. During the sittings, Beaton recalled, 'Francis would sit down on an old chair from which the entrails were hanging ... His pose reminded me of a portrait of Degas. He curved his head sideways and looked at his canvas with a beautiful expression in his eyes. His plump, marble-like hands were covered with blue-green paint. He said he thought that painting portraits was the most interesting thing he could ever hope to do: "If only I can do them ... To get the essence without being positive about the factual shapes - that's the difficulty. It's so difficult it's almost impossible!"' Bacon felt the second portrait had come off very well. When Beaton was invited to look at it, however, his shock and disappointment knew no bounds. He was confronted by 'an enormous, coloured strip-cartoon of a completely bald, dreadfully aged - nay senile - businessman. The face was hardly recognizable as a face for it was disintegrating before your eyes, suffering from a severe case of elephantiasis: a swollen mass of raw meat and fatty tissues. The nose spread in many directions like a polyp but sagged finally over one cheek. The mouth looked like a painful boil about to burst ...' The situation was complicated by the fact that Beaton had actually agreed beforehand on a price for the portrait. His panic at the idea of having to live with an image that might 'give me "a turn for the worse" each time I saw it' was counterbalanced by the notion that he might sell it at a profit. But Bacon had sensed his dismay; he telephoned Beaton and in an ecstatic voice announced that, not wishing a friend to have something he did not like, he had destroyed the portrait. The incident, doubtless not the only one of its kind, helps explain why Bacon rarely agreed to paint a commissioned portrait in later life, and also why he felt less inhibited working from photographs rather than having the subject in the studio as he painted.

The Marlborough show had opened up a new circle of collectors for Bacon's work and confirmed his reputation as a powerful iconoclast, an outsider working within a tradition which he subverted, a wild, self-taught genius whose imagery excited as much disgust as admiration. For many young adults and students, Bacon was already

an established hero. Beaton remarked how he had been 'acclaimed by the vounger generation which, it seems, considers Picasso to be old-fashioned', and in his preface to the catalogue, Robert Melville described the artist, with an almost perceptible frisson, as 'satanically influential'. Bacon impressed many young people not only by the sexy savagery of his mysterious images, but perhaps even more by the extravagant freedom of his way of life and the legends of excess and eccentricity that had grown up around him. With all this renown and a suitably increased income from his new contract, he was, at the age of fifty, still without a place of his own. It was ten years since he had left the area around South Kensington that remained his natural habitat. With his old nanny long gone and Eric Hall having died in 1959, Bacon no longer felt constrained by his past life there. By the autumn of 1961, he had taken over a mews house that was literally a stone's throw away from his beloved old studio in Cromwell Place.

Anonymous and definitely on the dilapidated side when Bacon took it, the small house at 7 Reece Mews answered his requirements perfectly. Whenever a restless mood came over him, he would consider moving to something more spacious and practical, or to a more congenial atmosphere abroad with a climate that might soothe his chronic asthma. But although he made numerous attempts to change, buying several flats and houses in the process, he was to stay in the rented mews until he died. It was difficult for any visitor not intimately acquainted with Bacon's character and tastes to understand why he should have grown so attached to the place. Set in a small row of similar converted carriage houses overlooking a cobblestoned passage, it consisted basically of two rooms over a large garage (which Bacon. who never drove, left empty except for a few piles of mouldering books). The rooms were reached by a wooden staircase as steep as a ship's ladder that could be scaled only with the help of a rope handrail. For visitors who were welcome, the artist would leave the mews door ajar and stand with open arms at the top of the stairs; anyone else might knock in vain or be met by a baleful glare from the overhead window and the warning: 'I am not here!' Beyond the stairs there was a cluttered landing which led, on the left, to a bare and generally cheerless bed-sitting room; on the right to the small, chaotic studio, which increasingly few people were invited to enter; and straight ahead, to a galley-cum-bathroom, where, wedged in between the cooker and the bathtub, the artist would occasionally whip up a memorable dinner for a handful of friends.

Though less ramshackle than Alberto Giacometti's famous studio in the rue Hippolyte Maindron behind Montparnasse, Bacon's mews house had much the same magic: a banal space transformed by the presence of the artist and the significance of the images created there. After a few years, the rooms bore eloquent testimony to the way Bacon lived and worked, despite the stark ordinariness of the bare floorboards, naked lightbulbs and empty, whitewashed walls. The huge wall mirror smashed in a guarrel (Bacon had ducked to avoid a heavy ashtray hurled at his head) caught and fragmented you in a cobweb of reflections as you walked in; superficial, everyday appearances were taken apart, then left to wander uneasily into chance distortions. The trial paint marks rising up the studio walls in explosions of colour and the visual clutter of books and photos lying underfoot changed according to the painting in progress and provided a random index of sources consulted. Among the astonishing litter of empty tins, coagulated brushes and old, paint-soaked clothes, there was an occasional note of luxury: costly, paint-spattered catalogues raisonnés or a half-consumed case of fine wine, just as, in the living room, there was a Boulle commode. Otherwise the accommodation was spartan to the point of harshness, as if the artist were deliberately resisting the softening effects of ordinary comforts such as a rug or a shaded light. The more famous and wealthy Bacon became, the more incongruous his domestic arrangements appeared; the studio was manifestly too small, allowing him to work on only one million-pound painting at a time. But he had never wanted to work in a big space (sharing Leonardo's conviction that 'small rooms concentrate the mind'), and he was committed to the style he admired in Giacometti of the artist living in hermit-like poverty, apparently unchanged by success. The discrepancy between how Bacon lived at home and how he could afford to live also reflected his deep need to shock all comfortable expectations and remain subversive.

Outside the studio, Bacon led a life at the opposite extreme to this ascetic reclusion. No restaurant was too good, no wine too expensive for him and his friends (whom he captivated as much by his openhanded hospitality as by his charm and exuberance). He continued to move in vastly differing circles, weaving with expert assurance between his Soho haunts and the houses of certain London hostesses.

He saw more of Ann Fleming, who brought artists and politicians together at her parties and delighted her (mainly male) correspondents with observations about them afterwards. A couple of the letters in which she refers to Bacon provide an amusing sidelight on the period. To Evelyn Waugh she tells of a carbuncle that has appeared on her cheek, then bemoans the fact that she will have to spend the rest of her 'life with Bacon and Freud who consider that pox, boils, burns and blemishes add beauty and excitement to the human phiz'.⁷ At greater length, to the writer Patrick Leigh Fermor, she describes a 'grouse celebration' shared with Bacon, Cecil Beaton and the choreographer Frederick Ashton:

Francis was restless for he had a date with a Ted at Piccadilly Circus. I persuaded him to collect the Ted, though warned by Cecil that he was known to be equipped with bicycle chains and razor blades and though worshipped by masochistic Francis was a danger to normal mortals; it was therefore an anti-climax when Francis returned with an undergrown youth with most amateur sideburns and drainpipes – he was named 'Ron,' blushed when spoken to, a refined cockney accent and a lamblike disposition – I was most disappointed and refilled his glass assiduously hoping to promote rage, but it failed to persuade his most gentle disposition.⁸

It was at Ann Fleming's that Bacon got to know a whole segment of London society including such ubiquitous personalities as the poet Stephen Spender and the legal wizard Lord Goodman. who later defended the artist against charges of drug possession. These frequentations, with or without a Teddy boy in tow, certainly did no harm to Bacon's career. Early in 1961 he had already been given a sizeable retrospective, with a catalogue introduction by his erstwhile dealer Helen Lessore, at Nottingham University. Due partly to his increasing prominence in the British art world and partly to a growing friendship with John Rothenstein, a far more significant event was taking shape. Bacon had gone on record as saving that the only place where he would accept a large museum exhibition would be at the Tate, which owned the two works of his that had been given by Eric Hall: and Rothenstein seemed increasingly well disposed to the idea. He had admired Bacon's work since he first saw it in a group show at the Lefevre Gallery in 1946, and as he began to get to know the painter himself he was equally impressed by his character and way of life, with its mixture of discipline and freedom, gregariousness and sharp wit. In his memoirs, Rothenstein recalled Bacon's 'imperious dignity, especially when very drunk', as well as the no less characteristic waspishness, nicely captured in his account of an exchange between Bacon and Henry Moore:

Henry and Francis, in spite of their mutual liking and respect, sometimes treated each other with the aggressive caution of heavyweight boxers. The three of us went together one night to a big reception at the Savoy, and Francis, attracted by some galaxy or other which held no attraction for Henry, said, 'Let's go over there,' 'I think,' said Henry, 'that for a few minutes I'll stay where I am,' and Francis, whether in allusion to the sobriety of our friend's life or the consistency of his attitude as an artist I do not know, replied, 'Where you are is usually where you stay, isn't it, Henry?' and he strode off into the crowd.⁹

Over sedate dinners at the Athenaeum, Rothenstein's club, or during considerably less inhibited champagne-drinking sessions at Bacon's favourite haunts in Soho, the notion of a retrospective at the Tate began to emerge, with Fischer of the Marlborough skilfully liaising behind the scenes. Even with Rothenstein's full support, the project ran up against considerable opposition from the gallery's Trustees. One of them, John Witt, spelt out his objections very forcefully to Rothenstein in a letter dated 8 January 1962:

Even if Bacon did destroy some of his earlier work, I do not see how the Exhibition can be called retrospective when there are only ten pictures earlier than 1950. There are twenty-seven pictures dated 1960 and 1961 and of these twenty belong to the Marlborough or are listed as the 'property of artist' which can only be an indirect way of saying the same thing ... if we accept this Exhibition we shall I think be regarded by the public, both informed and uninformed, as having been taken for a ride by the clever Marlborough Gallery and have given them the use of our walls largely for their own purposes. ¹⁰

Objections that the retrospective would in fact be and be seen as a 'Dealer's Exhibition' were overruled, even if, as Rothenstein noted, the Trustees came to accept the proposal with 'a conspicuous lack of enthusiasm'. Having crossed this bridge, the Director had to confront what he feared might be all kinds of unforeseen difficulties with the artist himself. 'Several common friends and acquaintances warned me that Francis would be an extremely troublesome collaborator,'

Rothenstein recalls in his memoirs. 'One of them - someone who knew him far better than I - even declared that if any of his early works were shown Francis would come to the Gallery and destroy them.'

As things turned out, Bacon cooperated wholly. Rothenstein continues:

He was zealous in helping us to trace paintings lost sight of, and more surprisingly he imparted a considerable volume of information hitherto unpublished, speaking freely about his painting and his life in a series of conversations arranged to enable me to prepare my introduction to the catalogue. I appreciated his helpfulness in this respect, as he is apt to be guarded about giving biographical facts for publication – he had flatly refused, he told me, to meet an unusually perceptive American scholar-collector who was writing a book about him. But Francis did even more than afford us his utmost help; he painted pictures especially for the exhibition. Towards the end of March I received an urgent invitation to his studio to look at a new painting which he hoped that I would like sufficiently to include. A huge triptych (it is eighteen feet wide) stood across the studio like a wall of lurid orange, red and black: two Nazi-like figures with two butcher's carcases on the left panel, a crushed bleeding body on a shabby bed - an allusion, pointed though remote, to the Crucifixion.11

The triptych, which was included in the retrospective, became known as *Three Studies for a Crucifixion*. It is one of the most alarming and enigmatic of Bacon's paintings. Bacon admitted in various interviews that the three panels, painted under pressure in about a fortnight, were done while he was either very drunk or struggling to overcome a bad hangover; at times, he said, he had no idea what he was doing. There was no rational explanation for the two figures on the left-hand panel, he added; he had tried as far as possible to avoid story-telling. This was, with varying degrees of emphasis, the bare and unsatisfying account Bacon gave of one of his most important works. As noted earlier, Bacon referred to the whole theme of the Crucifixion as a kind of self-portrait conveying deeply personal truths. If this triptych – which the artist chose to call a *Crucifixion* – is regarded in the light of a self-portrait, it becomes peculiarly revealing about the man who painted it.

It is clear that in this, as in any other work, Bacon did not set out

to 'tell a story'. On the contrary, he was convinced that any 'narrative' content in painting – by which he meant anything 'that can be told through the brain before it makes an assault on the nervous system' – invariably weakened the enduring impact of an image. To some extent, however, the old adage that 'every picture tells a story' is true; and this particular triptych, with its burning colours, painted on the eve of the artist's most important show and following the break with his lover, comes with a particular urgency from the deepest levels of the artist's being.

With its intense alternation of red and black, living figures and cadavers, the picture's overall theme could be summed up at its simplest as life and death, or, perhaps more accurately, love and death. This was only the second time that Bacon had chosen to make a large painting in triptych form, which automatically stimulates a sense of narrative progression – all the more so as, in this case, the three panels 'read' quite naturally from left to right. The left-hand panel is one of the very rare instances in Bacon's work to present two separate figures of equal importance inhabiting the same pictorial space, which in itself implies some kind of relationship, or narrative. between them - unlike the coupled figures, which occur frequently and about whom, one might say, the story has already been told. The figure in red seems older and has taken up a seemingly indignant posture, with its arms akimbo; the other figure, dressed in what looks like a black bodystocking, with a hint of underclothes and garters beneath, is turned, as if in exit, towards a black panel set in the curved red wall. Once again we are reminded that Bacon's final break with his family had come about after his father had surprised him in the act of putting on his mother's underwear. Whether or not the memory of this traumatic rejection had been reawakened by the break with Lacy, it is probable that the scene refers to Bacon's expulsion from home; the older figure's face, with its hooded eyes and prominent lips, is not unlike a photograph of Eddy Bacon. 12 If such a 'story' escaped from Bacon, it may be precisely because he was not in control at all of what was happening. The middle panel shows a badly mutilated body, which could be taken simply as indicative of acute psychological or physical pain. But given the bed, with its well-documented Moroccan origins, and the frequent beatings Bacon took in Tangier, from Lacy and others, it may not be too fanciful to approach this image in terms of the artist's own extreme masochism: a self-portrait as victim. Indeed, there is a case for

approaching Bacon's entire vision of the flesh in sado-masochistic terms. And the last panel, with its acknowledged reference to Cimabue, whose Christ on the Cross Bacon had long admired (and also, perhaps, to photographs of Mussolini's inglorious public hanging upside down, like the crucified Peter), may be seen as a sublimation of personal pain in the most universally recognizable symbol of human suffering.

With its impressive dimensions and large planes of hot colour, the new triptych undoubtedly formed one of the climaxes of the Tate retrospective. Among the other new works included were the Six Studies for a Pope of 1961, in which the Supreme Pontiff is caught as if in private, running the gamut of emotion from hysteria to nervous collapse. The final choice of paintings – ninety-one in all – constituted somewhat under half of the artist's surviving work to date. After the noticeably fallow year of 1958, when he produced no more than six pictures, Bacon had one of his characteristic bursts of creativity in the run-up to the first Marlborough show and the Tate retrospective, completing nearly fifty surviving canvases over the following three years. As the Tate curators put together their list of works for eventual selection, they became aware of the large number of Bacon paintings that had found their way abroad - notably to Switzerland, Italy, Germany, France and the United States. In the event, many were shipped over especially for the retrospective - with the important exception of the MoMA's Painting 1946, considered too fragile to travel because parts of its impasto had begun to flake. The two largest collections in the world both turned out to be in England: one was in the hands of the Sainsburys, who by this time possessed eleven paintings; the other, much less well known one belonged to Jimmy and Brenda Bomford, who lived in Wiltshire with no fewer than nineteen, mostly early Bacons. The latter appear to have been dispersed shortly before the show, while the Sainsbury collection was represented in its entirety. The Marlborough lent a relatively modest number of works, thereby putting to rest earlier anxiety that the retrospective would serve a directly commercial end.

The catalogue carried an introduction by Rothenstein, who later recounted that when he initially read the text to Bacon he glanced up at the end to find the artist in tears: 'I *feel* like the artist you've described,' Rothenstein remembered the artist saying, 'it's an

experience I've never had before, partly, I think, because you've treated my art in such a matter-of-fact way.' In the same memoir, Rothenstein describes how self-possessed Bacon remained, although drunk, throughout the opening of his retrospective, arriving for the 'very formal' evening party dressed in the same clothes, a check shirt and jeans, that he had worn since the press conference in the morning. A friend who was accompanying Bacon remembers that neither of them had changed for the evening party and that, since they had no invitation, they were refused entry - which greatly amused the artist - until some officials recognized them. 13 'The exhibition was a resounding success,' Rothenstein concludes, 'attracting more praise than any exhibition by a British painter within my memory ... I sent a copy of the catalogue to Picasso, who acknowledged it with an admiring message. The Gallery was presently crowded not only by the general public, artists, and students, but by "teddy-boys" who came in unprecedented numbers,'14

News of Peter Lacy's death was among the telegrams that arrived to congratulate the artist on the opening day of his retrospective. Although their intimate relationship was long since over, Bacon had never come to terms with the self-destructive passion that had drawn him to Lacy nor with the latter's rejection of him. 'Consider me as dead,' Lacy had told him; and now that he was dead Bacon was inconsolable.¹⁵ He saw Lacy's death as a suicide, and he interpreted the fact that it had coincided with his opening as a deliberate extra punishment, as if he had to atone for the violence of his art in personal misfortune. The voracious, Fury-like shapes on an orange ground that dominated the first room of the exhibition, the artist was convinced, still pursued him.

In his grief, Bacon attempted several times to bring his dead friend back to a kind of life through the act of portraying him. In both named and unnamed portraits, Lacy seems to be struggling to surface through the damaging smears of paint that blind an eye or excise an ear. Painting from photographs but above all from memory, Bacon began in these intimate portraits to be able to suggest the mythical implications for which he had previously needed a recognizable, formal symbol such as the Crucifixion. For Bacon, Lacy himself had become part of the artist's own myth of guilt and retribution. He could recapture him at his most vital by foreseeing the death that would dissolve his appearance. He began to picture himself too,

in his first acknowledged self-portraits, in a last spasm of raging pink flesh and black shadow before dissolution. Indeed, from this point in his development, when portraits of people became so central to his work, each portrait was painted as if it might be the last.

Reactions in the press were as usual polarized, with Bacon being described alternately as the country's 'most important living painter' or a 'cheap sensationalist'. Several reviewers were scandalized by 'the most horrific exhibition ever seen in Britain'. but by now Bacon could count on the support of several of the most influential critics. 16 In a prominent article in the Sunday Times entitled 'Titian Crossed with Tussaud', John Russell gave the show unconditional praise. On the same day, London's other heavyweight Sunday newspaper, the Observer, published a lengthy 'profile' which showed the extent to which a Bacon legend had taken root: 'In a back-street behind Piccadilly,' it began in good Conan Doyle style, 'a man may sometimes be encountered wearing a huge pair of sunglasses, grey flannel coat, tight trousers, grey flannel shirt, and black tie. He walks rapidly into the darkness. He has cropped hair, a round puffy face, and he looks about 35 ... In this country he is about the only English painter who excites art students. Abroad, there is more interest in Bacon than in any other British artist.'17

After five weeks at the Tate, the exhibition was sent in modified form on what, for the art world of the period, was an ambitious European tour: it went first to Mannheim, then to Turin and Zurich, before ending at the Stedelijk in Amsterdam. Within months of the Dutch exhibition ending, the Marlborough combined commitment to their new artist with commercial flair by showing a selection of 'Recent Work' in their London gallery. Impressively enough, all but one of the thirteen works shown had been completed since the Tate retrospective. Bacon's posthumous homage to his ill-fated lover set the dominant tone: two full-length portraits (one of them placing the figure on the Moroccan bed), and – in one of the artist's earliest small triptychs – two beautiful heads flanking a clearly and poignantly distressed self-portrait.

There was, as the *Observer* profile had suggested, a distinct 'Bacon boom'. In the autumn of 1963, two further exhibitions opened in New York: at the Granville Gallery, and a fully fledged retrospective of sixty-five paintings at the Guggenheim Museum. Lawrence Alloway, the British critic who wielded considerable influence in the

New York art world, wrote the introduction to the Guggenheim catalogue; and the show, which later travelled to the Art Institute in Chicago, provoked widespread and not particularly favourable reactions – not unexpectedly, given the prevailing taste for abstraction in America in 1963. As one perceptive critic summed it up: 'Among painters there has been generally a warm disapprobation that has contrasted with the cold respect for Bacon in official quarters . . . In short, there is enough in Bacon to displease everybody.' ¹⁸

For his show at the Granville Gallery on Madison Avenue, Bacon had prepared a statement about painting and the human condition which showed how carefully and perceptively he thought about the questions which preoccupied him most. 19 During this year, another sign of his growing self-confidence as an artist whose work was receiving the highest forms of recognition and hence, inevitably, as a public figure, could be deduced from the number of interviews that he began to give. He talked at length to David Sylvester, in what was to become the first of a famous series of interviews, which served to define many aspects of the artist's thought and practice; as the interviews progressed, Bacon's persona changed radically from the self-taught original of his earlier career to a reflective and incisively articulate, mature painter.²⁰ He also talked to Stephen Spender, who had written a catalogue essay for the artist's travelling retrospective in Zurich and Amsterdam. But Bacon by no means hoarded his conversation for a handful of art world pundits. He loved the conviviality of chance encounters; and he would happily talk through the afternoon and late into the night whenever he found someone with whom he felt in sympathy and who kept pace with his drinking. While regularly shunning formal interviews with important publications, he might give unlimited time and hospitality to a student, as he did to me when I sought him out on behalf of a university magazine in the summer of 1963. In the interview which followed. Bacon outlined several of the themes uppermost in his mind at the time with provocative clarity:

We can try to enjoy life – and hope to go on exciting ourselves in different ways. What else is there? To find this excitement one should be allowed the greatest possible freedom in order to drift. Apart from that, we can watch our own decay in the interval that separates life from death . . . With Nietzsche I believe that man must remake himself.

We must woo the doctors and scientists in the attempt to renew and alter ourselves, but there will be a lapse of time before their religious hangover will allow them to act freely ... The division between the sexes has to a large extent been invented. Only a comparatively small number of people are active within this division. The rest are waiting for something to happen or be done to them. But society has attempted to make moral differences. We must have the freedom to drift and find ourselves again.

I have deliberately tried to twist myself, but I have not gone far enough. My paintings are, if you like, a record of this distortion. Photography has covered so much: in a painting that's even worth looking at, the image must be twisted if it is to make a renewed assault on the nervous system. That is the peculiar difficulty of figurative painting now. I attempt to recreate a particular experience with a greater poignancy in the desire to live through it again with a different kind of intensity. At the same time I try to retain the greatest possible tension between the original and the recreated experience. And then there is always the desire to make the game a little more complicated to give the tradition a new twist ... Abstract art is free fancy about nothing. Nothing comes from nothing. One needs the specific images to unlock the deeper sensations, and the mystery of accident and intuition to create the particular. Now I want to do portraits more than anything else, because they can be done in a way outside illustration. It is a gamble composed of luck, intuition and order. Real art is always ordered no matter how much has been given by chance.²¹

As his fame grew, Bacon nevertheless remained as accessible as famous artists like Picasso and Giacometti had been in Paris. Anyone who was intent on meeting him only had to chat to the barman or a familiar like John Deakin at the French or the Golden Lion in Soho to get an introduction. Bacon's vitality and charisma indeed brought to a London pub the excitement of spontaneous exchange that was then more associated with the famous cafés of Saint-Germain-des-Prés. But while the artist remained very much the same in his dealings with the world in general, his reputation and the aura surrounding his work began to lift into another sphere. As he expanded and refined his thoughts in published interviews and his critics followed suit, often exploring hints and references that he himself had thrown out, an impressive body of appreciation and theoretical interpretation began to form around his art. In this, the

Tate retrospective had clearly been the major watershed. As a result, within a couple of years Bacon had gone from being a brilliant outsider with no fixed address who occasionally stunned a small London audience to being a revered, successful artist of international stature.

PART THREE 1963-92

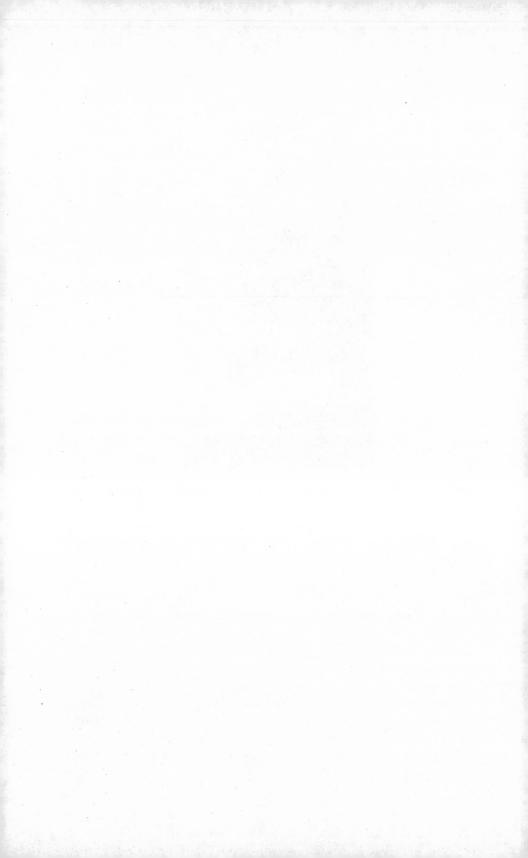

'A Brilliant Fool Like Me' 1963–69

Life is so meaningless we might as well try to make ourselves extraordinary.

Francis Bacon (in conversation)

Francis Bacon's reputation grew spectacularly during the 1960s, with the impetus given by the Tate retrospective accelerating throughout the decade. Not only was his work shown prominently every year in major museums and galleries across the world, but the public perception of him began to change subtly from morbid maverick to 'modern master'. The transformation was put in train by historically conceived group shows, such as 'Constable to Bacon' (1962) and 'Nineteenth and Twentieth Century Masters' (1966), and the publication of a massive catalogue raisonné as well as the first monograph on the artist by John Russell. Bacon also accepted two prizes: a Carnegie Award in Painting from the Pittsburgh International Exhibition, and the Rubens prize, worth around £1000, which he donated towards restoring art damaged by the floods in Florence (the partial destruction of the Cimabue Crucifixion had especially affected him). The artist was none the less keenly aware of the danger of public honours to an independent spirit. As Baudelaire, one of his favourite analysts of human behaviour, had warned, they 'encourage hypocrisy and freeze the spontaneous upsurge of a free heart'. Bacon himself, who later turned down all prizes and titles (he was offered the Order of Merit and the Companion of Honour), emphatically agreed, although he put it more archly: 'I've never wanted those things. Besides, they're so ageing.'

With this notoriety came more frequent references to him in the popular press. In 1967, for example, when he returned for the first time in twelve years to South Africa to see his mother and two sisters, Bacon was hailed as the 'genius of violence', the 'finest British painter of the present age' whose recent show at the Marlborough was reported to have brought him over £60,000. It was during the 1960s, too, that several films were made, on both the work and the man. The most riveting of these remains the no-holds-barred interview filmed in 1964 for Swiss television.² The film begins with the camera following Bacon round his Reece Mews studio like a hunter stalking its prey; but as the artist becomes progressively drunker and more unpredictable, he begins to send up and dominate the film completely. striking camp poses, turning suddenly serious and penetratingly precise, coiling the long microphone lead round his neck like a necklace, then, with his head thrown back in laughter, spinning like a dervish round the studio with the interviewer and cameraman struggling to follow. Outside the paintings themselves, there are very few records that communicate so vividly the demonic recklessness and delight in derision that surged through the artist as he appeared to abandon himself completely before the lens.

Bacon maintained this capricious, contradictory attitude towards his success, though in diminishing degrees, for the rest of his life. He played with success very much as he gambled, dropping his bets at several roulette tables at once, exhilarated to be on a winning streak and pushing his luck again and again to see how far it would go. Without a doubt he craved recognition. As a proud and vain man discreetly but deeply convinced of his superior artistic powers, he had suffered from spending the first half of his career in relative obscurity and need. Yet from the start he attempted to control his success, to accept it only on his own terms and, with abrupt disdain, to show it periodically the back of his hand. Nowhere did Bacon demonstrate his control as spectacularly as he did over money, the most obvious attribute of success. Although he needed considerable amounts of it to fuel his open-handed lifestyle, he spent everything he earned – and often more - with a voluptuous abandon that came close to scorn. Bacon actually turned his famous namesake's dictum, 'Riches are for spending', into a form of discipline. Money was something to spread around, thickly and quickly - at the gaming tables (where his losses could be crippling), on friends and lovers, in expensive restaurants, where he spent and tipped on a princely scale, and on endless rounds

of champagne (his weekly bills at Wheeler's and the Colony Room took on heroic proportions during this period). In this, as well as gratifying a naturally prodigal bent, the artist sought to control money before it controlled him.

Bacon also used money, and the other means at his disposal, to control the people around him. Virtually anyone who came into the artist's orbit would before long be either obviously or subtly indebted to him. At its most banal level, this meant that he enslaved legions of waiters and barmen by exceptionally large tips; in certain restaurants and hotels, the entire staff would vie in amiability for his attention.³ Similarly, since he insisted on being the host at virtually every meal, hordes of friends and acquaintances, including the very rich. became the recipients of his memorable largesse. Friends in need of money, whether it was to pay off gambling debts or for urgent medical treatment (Bacon himself made no 'moral' distinction), could turn confidently to him, knowing that he did not usually expect to be repaid. He was also prodigal with gifts, which over a lifetime included several houses and flats, and an impressive number of his own paintings. He was equally liberal with his time, spending countless hours visiting friends in hospital or trying to pull them through some crisis; and he was prompt to help with his influence, giving recommendations and valuable introductions, particularly to young people who were setting out. He himself rarely mentioned these countless acts of generosity; but the recipients generally remembered. and that left them delicately in thrall.

By the same token, Bacon went to great pains to avoid being indebted himself. Any gift or act of kindness to him was likely to be promptly repaid, often with astronomical interest. A workman who had put in a little extra time might be paid double, just as a staunch ally in the art world, whether dealer, critic or curator, might at some point receive the ultimate bounty of a picture. In this way, by enriching or helping to free his friends and allies, the artist quite literally changed their lives. But while he treated friends lavishly and regularly spoilt those to whom he was really attached, Bacon avoided pampering himself. Outside such extravagances as his gambling and entertaining, he practised a very personal form of austerity. While he dropped fortunes at roulette and insisted on his guests having the best view and every delicacy in restaurants, he himself would often walk home or take the Underground rather than choose the comfort of a cab. He might roll round the bars of Soho or Les Halles with a

great ball of large, scrunched-up banknotes (occasionally allowing a few to flutter to the floor under the fascinated gaze of other clients), drinking immoderately and generally drawing attention to himself, but alone in his spartan mews he rarely touched a drop and would make do with the simplest kind of food; he always insisted, when surrounded by champagne and oysters, or vodka and caviare, that what he really enjoyed was a boiled egg.

In point of fact, Bacon loved the extremes of waking in the grim discomfort of his living quarters and working in the studio's cramped chaos before appearing for dinner, impeccably groomed, in the hushed opulence of a grand hotel. What fascinated him, he often remarked, was the 'distance' between the two; staying long in either state would have seemed tedious. Like Picasso, he wanted 'to be rich enough to live like a poor person', without the restraints of bourgeois convention.

Not surprisingly, with fame and money added to his exuberant charm and gregarious generosity, Bacon had a prodigious number of well-wishers. Since he slept little, with a working day that began early and often finished at noon, the artist also appeared to have endless amounts of time at his disposal: he would have drinks in a pub, a long lunch, an afternoon in a succession of private clubs, then dinner, before going on to the Colony Room and perhaps a casino. It was a routine of relentless excess, day after day, and only the strongest constitution could have survived it, let alone enjoyed it. Because of his capacity for alcohol - which, as his doctor has confirmed. he metabolized unusually fast - Bacon cut a swathe through his companions, leaving some stranded in a surfeit of rich food and wine as he went on to drink others under the table. Being with Bacon for any length of time meant relishing such extravagance, topping an outstanding dinner accompanied by great claret with a late supper and more fabled vintages in a nightclub (if you drank only the best wine, Bacon was convinced, you didn't get a hangover). It also required an ability to ride the artist's sudden swings of mood – from sparkling geniality, for instance, to sodden aggressiveness - as the drink took over and suspicion darkened his mind. The closer the friends, the more likely targets they would be for these shafts of bitter rage.

A host of people filled the role of companion to Bacon on his odyssey round London. It was an epic voyage, full of unexpected discoveries and pitfalls, and for several decades it seemed it would continue for ever. The city's range of restaurants and nightspots

increased significantly during the 'Swinging Sixties', and the appetite for pleasure was all the keener for having been stifled by post-war austerity. Bacon, who could be seen as a notable one-man catalyst in this transformation, took full advantage of the new possibilities. He patronized several of the fashionable new Italian restaurants, such as La Terrazza in Soho, and his reputation as a crowd-puller (which kept them coming to the Colony Room) meant that big new nightclubs plied him with invitations. The huge numbers of friends and admirers. drifters and spongers that passed through Bacon's orbit were so varied in tastes and background that they could not always be mixed: and the artist, who liked to keep the various compartments of his life separate, tended to discourage certain close friends from one stratum getting together with those of another without his being present. The people with whom he spent most time divided roughly into art world bigwigs and intellectuals on the one hand, and Soho characters and 'rough trade' on the other, as well as a number of seasoned cronies. like Iohn Deakin or Jeffrey Bernard, who managed to straddle both ends of the spectrum.

Prominent in Bacon's social life through the 1960s was a highly strung intellectual hostess, known equally for her blonde beauty, her warm hospitality, her snobbishness and her sharp tongue. Born in India, Sonia Orwell (née Brownell) had conceived early on a passion for literature and the arts without herself having a significant creative talent. With her striking good looks and her enthusiasm, however, she soon established herself on the London literary scene as the editorial assistant on Cyril Connolly's Horizon; as the magazine drew to its close, she married one of its foremost contributors. George Orwell, who was already seriously ill with tuberculosis and who died shortly afterwards. Later she made a second marriage to Michael Pitt-Rivers, whose homosexuality had never been in doubt and who was prosecuted in the notorious 'Montagu affair'. With the financial independence and the social cachet that being Orwell's widow brought. Sonia was free to concentrate her considerable drive on what she did best: befriending and defending the writers and artists she admired and bringing them together at the dinner parties which she gave tirelessly, cooking abundant food and serving unlimited wine in her comfortable house, a short walk away from Reece Mews. in South Kensington.

Sonia had little in common with the other women, from Nanny

Lightfoot to Muriel Belcher and Isabel Rawsthorne, who played a significant role in Bacon's life; but he grew very attached to her. During the 1960s he began going regularly to her house, where he might dine with her and a small group of mutual friends, such as Lucian Freud and Stephen Spender. Although she was generally more at ease with homosexual than heterosexual men, Sonia stood palpably in awe of Bacon, which he enjoyed. He sensed the confusion and vulnerability that underlay her frequently aggressive behaviour, which was mostly directed at people she considered intellectual inferiors (she was, on the other hand, effusively appreciative of plumbers and electricians). He also felt in tune with her spontaneous generosity. Later, when he needed to convalesce after a serious operation, it was in Sonia's house that he stayed; and on very rare occasions, he allowed her to look after him in her bossy fashion - a kind of mothering which he normally detested and rejected violently. When Sonia herself was terminally ill and impoverished, Bacon showed her every kindness and settled all her bills.

With her wide circle of intellectual friends and her unflagging hospitality, Sonia created the closest thing to a literary salon that could exist in the London of the 1960s. Its vitality and success was favoured by another circumstance: the hostess's impressive ability to introduce leading lights from Paris, still the undisputed centre of the intellectual world. Through the philosopher Maurice Merleau-Ponty, with whom she had had a passionate affair, Sonia had encountered le tout-Paris of the arts and letters, and her parties created countless links and sympathies between the two capitals. This side of Sonia and her entertainments particularly interested Bacon, who got to know some of his closest French friends, notably the writer Michel Leiris and his art dealer wife, Louise (the daughter of Daniel-Henry Kahnweiler, Picasso's great dealer), at her soirées. Throughout the 1960s and well into the following decade, Sonia's house became the nearest thing the artist ever had to a 'normal' home – a refuge from the round of bars, restaurants and casinos which made up ninetenths of his existence outside the studio.

Another close woman friend who strengthened Bacon's ties with the Paris art world – which remained the one that counted most for him – was Isabel Rawsthorne. In many ways, Isabel was a far more natural ally for Francis, resembling him in her animal exuberance and the resolute sense of her individuality. She was also a more integral part of the art world than Sonia, being herself a painter and

set designer, and having been - an experience which particularly fascinated Bacon - a model and muse in the Paris art world of the 1930s. She had a magnetism and a mobility of expression that captivated Bacon, unusually alive as he was to the moods of a woman. Her face would assume a look of extreme indignation. followed by one of raucous good humour, and then a glance of seduction, all dropped like masks and as rapidly replaced. Because of her largesse, particularly as regards her own and other people's sexual pecadilloes, Bacon probably felt closer to her and to Muriel Belcher than to any other woman. Born the daughter of a master mariner. Isabel became the model and assistant of the sculptor Jacob Epstein before leaving to study in the life classes of the Grande Chaumière in Montparnasse. To pay her way in Paris, she posed for André Derain (whose portrait of her is in the Fitzwilliam Museum. Cambridge) and for several other artists, notably Giacometti, with whom she began a close, lifelong relationship.

Bacon himself had first come across Giacometti in person in a café during a trip to Paris, and he had approached him to say how much he admired his work. In fact, it was not his work alone — which, typically, Bacon liked only in part, far preferring the drawings to the sculpture — but Giacometti's attitude and way of life as an artist which the English painter admired. For any artist who had pursued the lonely path of figuration through the 1950s, as abstract art became the dominant mode, Giacometti's obsessive adherence to the figure and monk-like devotion to the demands of his artistic vision stood as a shining example. The Swiss-born sculptor's apparent indifference to success, and the fact that he chose to remain in his tiny, chaotic studio even when he could afford a luxury apartment, also made a deep impression on a younger generation of artists; for them, Giacometti gave the whole *métier* an aura of gritty, incorruptible grandeur.

Bacon had clearly been touched by Giacometti's 'existentialist' attitude to life and his apparent indifference to worldly success, and the comfortless chaos of his own studio no doubt derived in part from the older artist's photogenic little cave behind Montparnasse, filled with rubble and half-finished sculpture. There was an openness, a kind of fearless vulnerability, about the sculptor which would not have failed to impress Bacon (writing about Giacometti led Jean Genet to the beautifully phrased definition: 'Each man guards in himself his own particular wound, different in everyone . . .'). Most of all, however,

Bacon was conscious of Giacometti's artistic achievement: the need to take human appearance to the edge of dissolution by reducing it to its essence also lay at the heart of his own ambition as a maker of images. In his search for a solution to the long-standing problem of how to articulate the pictorial space around his figures, Bacon had clearly borrowed certain formal devices from Giacometti, notably the cage-like structures the Swiss artist had used in early sculptures (exhibited in London as part of the famous 1936 International Surrealist Exhibition). But he was also indebted to the overall reverberation of Giacometti's oeuvre which, like his own, had its roots in surrealism; and it was after seeing the Giacometti retrospective at the Tate in 1965 that Bacon began to think seriously about making sculpture himself. What he had in mind were flesh-coloured human figures that could be moved into different positions on a tubular steel framework. Having begun by trying out his sculptural ideas in various pictures, Bacon decided in the end that they would be best achieved in painting.4

Isabel Rawsthorne brought the two artists together on a couple of occasions when Giacometti was in London first to prepare, then to attend, his Tate retrospective, which opened in July 1965. Giacometti was sufficiently curious about Bacon's recent work, which the Marlborough was exhibiting at the same time, to slip out of his own opening and go to see half a dozen new portraits and Crucifixion 1965. There was genuine mutual attraction and admiration, but the limited amount of time they spent together and Giacometti's relatively early death in 1966 did not allow them to develop more than the beginnings of a friendship. Yet it counted a great deal for Bacon, who was especially impressed by what he called the sculptor's 'clarity' of thought and his ability to see both sides of a complex question at one and the same time.⁵ As an inveterate loner, Bacon seems to have felt closer to Giacometti than to any other famous living artist. The feeling may have been to some extent reciprocated by Giacometti, who on one occasion spent the entire night talking to Bacon as they dined then made the rounds of drinking clubs. Bacon, who by that time had begun his liaison with George Dyer, was particularly intrigued when Giacometti said to him, provocatively enough: 'When I'm in London, I feel homosexual.' Again according to Bacon, who was always quick to see the homosexual in his fellow-man, the sculptor took a visible shine to his new boyfriend - to the extent, at one point, of following him down to the lavatory - and suggested that George should come to Paris so that he could do his portrait. Bacon encouraged the idea and even tried to persuade George, who was barely literate, to learn some basic French. Dyer was visibly intrigued by the idea, but he lacked the necessary concentration; the project petered out, and not long afterwards Giacometti died.

'When I was young I needed extreme subject-matter for my paintings,' Bacon admitted, 'Then as I grew older I began to find my subject-matter in my own life.' During the 1960s the Furies, the dictators and the screaming Popes, the anonymous figures trapped in darkened rooms, gave way to portraits of living and identified beings: Muriel Belcher, Isabel Rawsthorne, Lucian Freud, George Dver and Henrietta Moraes (another model and a notable Soho character). It was a radical transition, marking a new stage in the artist's maturity. He had paid full tribute, however paradoxically, to mythology and the history of art in his work thus far: the Crucifixions and the variations on Velázquez were comparable, in the traditional hierarchy of artistic subjects, to 'history' paintings.⁶ Now, totally modern and never less than vauntingly ambitious, Bacon felt impelled to replace 'history' by portraiture at the top of the list. He was admirably equipped, and not only by a hawk-like eye for the infinite interplay of flesh and feeling. Prompted by a sense of inadequacy that stemmed from his initial lack of tuition, he had also gained an impressive mastery of technique – a virtuosity even, at times, reminiscent (however furiously Bacon would have rejected comparison) of the brayura brushwork of John Singer Sargent.

As a result, he was well prepared to bring his prodigious visual concentration wholly to bear on a handful of people whose physical presence warmed and intrigued him. He had observed them all, in some cases for years, with that intense, unwavering gaze — as penetrating as Picasso's *mirada fuerte*; he was perpetually fascinated by their changing expressions and the way a movement, a violent emotion or a trick of the light could suddenly distort their 'normal' appearance. They were his close friends, whom he saw on an almost daily basis: he had watched them in and out of love, drunk and sober, close up and across the street, in snapshots and in mirrors. He knew their faces better than they did themselves; he recalled and rehearsed the shadows cast as they laughed under barlight, the dark pools on the reddened flesh, then the head snapping back in a blur, as if in search of its old contours. He saw them in film sequence, always moving, and at times, almost unrecognizable from one instant

to the next. This was the mystery of their appearance, which he loved and which prompted him to try and capture them, tenderly, violently, erotically, in paint. When he painted them, he did so only from memory, from a distillation, occasionally referring to the sheaves of photographs, full face and in profile, which John Deakin had taken of them and which he kept lying around in the rubble on the studio floor.

Bacon was obsessed by appearance, his own most of all, and he believed that homosexuals possessed an unusually keen eye for the way people looked. 'Homosexuals become more and more impossible with age,' he remarked, 'because they are obsessed with the physique. They simply never stop looking at the body, all of it, the whole time, and pulling it to pieces. That's why if ever I've wanted to know what someone really looks like, I've always asked a queer. They're ruthless and precise.' Bacon's portraits — which, unlike Giacometti's, often uncannily resemble their subjects — prove his point abundantly. When Isabel Rawsthorne discussed the images Bacon had made of her, she stressed how 'fabulously accurate' they were.⁷

In catching the 'likeness' of his friends, Bacon also caught their dominant characteristics, which in turn, he hoped, would give the portraits greater universality as images of human beings not bound to specific circumstances. The imperious courage with which Isabel Rawsthorne emerges from the onslaught of paint, at times with a ruddied fury, at others as exquisite as Nefertiti, contrasts with George Dyer's confused vulnerability. It is interesting that the women Bacon portrays generally survive his attacks much better than the men; while Isabel and Muriel triumph and ascend into a surreal beauty, even the proverbially resilient Lucian Freud lies on occasion as if punch-drunk from the assault. To give 'all the pulsations of a person', in Bacon's beautiful phrase, was his guiding principle in portraying his friends. Without those drives and contradictions, which were in a sense the inner architecture of appearance, he believed, the portrait became banal, empty illustration.

The 'gallery' Bacon created of a few London personalities is in itself an unusual phenomenon in mid-twentieth-century art, when the portrait was considered so retrograde that it all but disappeared apart from 'society' portraiture. Here again, Giacometti, who had tirelessly drawn, painted and sculpted his own inner circle (above all, his brother and his wife), may have served as an example. Bacon had apparently been seeking a new direction in his art which would

correspond to the new direction his life had taken. In the wake of a successful retrospective, he was assured of an audience, an income and a certain public esteem; he had a fixed address and an efficient support system in the form of his gallery. However inapplicable the phrase seems to a person as scornful of security as Bacon, he had to some degree settled down. What is more, he took a manifest satisfaction in this respite from the tortured wanderings between his hopelessly alcoholic, self-destructive, sadistic lover in Tangier and the student-like precariousness of living with friends in Battersea. Having reached his mid-fifties and feeling at the peak of his creative powers. he needed a life that would allow him to work as far as possible without constant disruption. It would not last for very long, but during the latter half of the 1960s Bacon lived through one of the least tormented, not to say happiest and most fulfilling, periods of his life; and this new confidence was reflected in the spate of magnificent portraits he produced.

Later, at the height of his fame, Bacon did accept a couple of commissions for a portrait: he did a small triptych of Gianni Agnelli, for instance, and another of Mick Jagger. He was frequently approached by people who longed to be 'Baconized', but with a few exceptions – when the face and the personality really intrigued him – he declined to paint anybody he did not know really well. As the shock of Bacon's manner recedes and some of the rawness of its impact is absorbed into the perspective of art history, it should become increasingly apparent not only how much brilliance, but how much tolerance and tenderness passed into the portraits. The artist appears to have identified with Isabel Rawsthorne, for instance, whom he painted with obsessive frequency, both in full-length portraits and small-format heads. If a magnificent sense of dignity emanates from these studies, it is because the artist's affection is greater, but only just, than the destructive fury with which he dislocated and twisted her every feature. Bacon once said that he thought of real friendship as a state in which two people pulled each other to pieces – dissecting and criticizing mercilessly. This is the act of 'friendship' that Bacon perpetrates in the portraits: a pulling apart of the other until he gets to an irreducible truth - or 'fact', as he liked to call it, in a pseudoscientific fashion – about their appearance and their character.

Like Isabel Rawsthorne, Henrietta Moraes stood up with remarkable resilience to the experience of being flayed into a Bacon portrait. Again like Isabel, Henrietta had attracted Bacon's attention by her

vitality, her bursts of unconstrained laughter and her equally unconstrained behaviour: accordingly, she had passed through a succession of boarding schools until she landed in the more knowing and tolerant pastures of Soho. She began to model in art schools, and her ambition was to meet Lucian Freud and Francis Bacon. 'I knew that if I hung around the French pub long enough I'd get to know them - and I did,' Henrietta Moraes says. 'They were simply the most exciting people you could possibly be with. The more time I spent with Francis. the more I realized how much I had to learn from him. Then one day, he took me to one side and said, "I want to do portraits of my friends. Would you let me do you?"' John Deakin - whose grainy photographs, in full face and profile like police mug shots, had been commissioned by Bacon for a number of his portraits – was asked to take a series of photographs of Henrietta lying naked on a bed. 'So Deakin took the photographs,' Henrietta says. 'He was a horrible little man. He came round and told me to lie on the bed with my legs open. And he began taking the photos from the wrong end. I said. "Deakin, I don't think that's what Francis wants. I don't think that would interest him." "Oh no," said Deakin, "this is the way Francis wants it." But of course he didn't, so we had to start all over again. Later on I found Deakin selling copies of the first lot of photos to some sailors in Soho for ten shillings a time. I was furious, then I thought it was quite funny, but I made Deakin buy a few drinks first, which of course he hated doing.'8

Deakin's photographs of Bacon's sitters, sprawled on beds or pinioned against walls, show up their vulnerability very clearly. 'Being fatally drawn to the human race,' the photographer wrote in a rare statement, 'what I want to do when I photograph it is to make a revelation about it. So my sitters turn into my victims.' Bacon had a collection of Deakin's photographs (notably his portraits of Dylan Thomas, Richard Burton, Orson Welles and Picasso) and admired them unreservedly, going so far as to call them 'the best since Nadar and Julia Margaret Cameron'; and they served his purpose perfectly. above all when he had made them more his own by abandoning them on the studio floor to be trodden on and splattered with stray paint. The more familiar Bacon became with his friends' appearance, the more prolific he grew. By Henrietta Moraes's own reckoning, he painted over two dozen studies of her alone, in large and small format, including such dramatic portrayals as the celebrated Lying Figure with Hypodermic Syringe of 1963.

Of all Bacon's friends painted in this obsessive manner, the one rendered most often was his most recent and most intimate companion, George Dyer (his 'latest and greatest friend', as Oscar Wilde would have put it). George was already established as the new lover in Bacon's life by 1964, the date of the earliest known portrait of him. They had met in a pub in Soho, and it was Dyer, according to Bacon, who had made the first move. 'I was drinking with John Deakin, who had just done some photographs for me, and lots of others. George was down the far end of the bar and he came over and said, "You all seem to be having a good time. Can I buy you a drink?" And that's how I met him. I might never have noticed him otherwise.'

Had he not bought that round, George Dyer's life might have remained obscure and somewhat depressing; it might also conceivably have extended beyond the eight years which remained to him. Around thirty years old at this time, Dyer was of medium height, with a compact, athletic build and (belying a docile, inwardly tormented nature) the air of a man who could land a decisive punch. He looked fit and masculine, with regular features and close-cropped hair, and he dressed immaculately in white shirts, tightly knotted. sober ties and the most conservative business suits - the uniform of the more successful crooks, like the Kray twins, whom he feared and admired. Even when drunk, George took obsessive care with his appearance, flicking the slightest fragment of ash or dust off his wellpressed clothes. Most of the time, he was withdrawn and pale, with an anxious, strained expression; he had a speech impediment, and when he did talk the words came out in a stream of strangled, nasal sounds which took considerable patience and practice to understand. He had been brought up in the East End in a family steeped in petty crime; George himself told the story that he used to wake at night to find his mother stealthily going through his pockets. He drifted as a matter of course into a round of minor theft and spells at borstal. which escalated into bigger 'jobs' and prison. 'When I met him. George had spent more time in prison than out,' Bacon used to say, with jocular pride. 'I think in a way he was simply too nice to be a crook. Anyway, he was always being caught.'

Adrift and in need of a protector, George was attracted by Bacon's self-confidence and impressed by his success. Being the artist's 'friend' – George played down the homosexual connection – helped him forget his failure to make a mark in the criminal world; it also

provided him with enough money to keep himself and a variety of hangers-on more or less permanently drunk. Bacon enjoyed his role as protector, and in the beginning he made genuine attempts to improve George's bleak prospects by trying to interest him in something outside drinking and crime. The younger man's vulnerability and trusting nature endeared him to the artist, creating a relationship which, while tumultuous in its own way, was quite different from the masochistic passion he had felt for Peter Lacy. Above all, Bacon found George physically very attractive, and it was this – conjugated with the sharp swings of mood in their life together – that prompted him most strongly to make George the subject of so many portraits.

All the artist's big exhibitions of the late 1960s were dominated by the increasingly strange and compelling pictures of Dyer. In November 1966, the Galerie Maeght, the leading dealers in modern masters in Paris, put on an important show in their elegant premises on the Right Bank, with a catalogue preface by Michel Leiris – two signs that Bacon's achievement had been recognized at the highest level in France. The same show, with some variations and an English translation of the Leiris text by Sonia Orwell, went on to London. Finally, in 1968, there was a selection of 'Recent Paintings' – above all, some astonishingly inventive new portraits of Dyer – at the Marlborough-Gerson Gallery in New York, for which Lawrence Gowing wrote an impassioned essay entitled 'The Irrefutable Image'.

However great the liberties Bacon had taken in pulling apart and remaking the appearance of his other friends, with Dver he reached a maximum intensity, not only paint-pummelling his features into near-extinction but creating complex visual conceits, brilliant puns on the act of seeing, that were unlike anything he had attempted before. Thus, in Two Studies of George Dyer, the model is represented sitting beside a Bacon painting of himself - a portrait within a portrait. In another image, Dyer swings round to look at himself with such violence that his features are thrown into the mirror like a torn mask, leaving only the stump of a head behind on his shoulders; or, in the most disquieting image of all, he is shown accompanied by a statuette-sized likeness of himself, a chunky, portable George Dyer, while in place of his shadow lies a dog with a lolling pink tongue. These 'pigment-figments', as Gowing named them, were all the more disturbing for having been executed with the palpable confidence of an artist at the height of his imaginative and technical powers. The deformations were brought off with a bravura that took a mass of brushstrokes to the edge of non-sense, then held them there, underlining their triumphant precariousness with the black and green shadows of encroaching death, or flares of white pigment that sealed in the memory of sexual release. The extremes of existence were the constant theme of the portraits, in which Bacon invented his own ritual and mythology: the human 'fact' was all he needed if he could find the means to suspend it between tension and collapse, horror and fulfilment. With his small pantheon of friends and lovers, warriors of the bed and the bar, heroes perhaps of a minor age but ready of wit and remarkable of feature, he no longer needed the framework of Greek or Christian tragedy. He could enact his profound sense of the tragedy of life within the circle of his familiars. He could in fact enact it better by using the idiom of his own life, since he had no belief beyond.

In this perspective, it would be tempting to cast George Dyer as a modern-day Orestes, surrounded by simulacra of himself – in mirrors, in paint, in statuettes, in shadows - moving as inevitably as in ancient Greek drama towards his destiny, while the Cassandra of Isabel Rawsthorne delivers dark warnings; Bacon did in fact portray the two of them together in a diptych. But although no direct parallels can be drawn, the artist had surely aspired from his earliest reading of Greek tragedy to make pictures that would purge spectators of the emotions of pity and fear through vicarious participation in the drama portrayed. Although he did not believe in any form of afterlife. Bacon believed passionately in art's supreme function in this life to give substance and meaning to what he called the 'brief interlude between birth and the grave'. Only by expressing the chaos of emotions inside us, the artist held, was there any chance of coming to terms with the confusion. At an almost subconscious level, that is the subject of Bacon's entire work: in its colliding forms and clash of colour, the very pigment of his imagery re-enacts the struggle.

More than any other of the close friends represented in the spate of portraits produced in the late 1960s, Dyer came to feel inseparable from the effigies Bacon had created of him. They gave him a raison d'être, a stature even, that his failure to be anything else made all the more precious. Ill at ease as he often was in the intellectually and socially sophisticated circles which the artist frequented, he took unconcealed pride in being the acknowledged subject of so many works. Accordingly, Dyer never missed the opening of a new show, in London, Paris or New York, and he would lead visitors round an

exhibition expressly to point out which of the pictures were of him. With a certain canniness, he took on the role of the simple East Ender amazed by the extravagant foibles of the fashionable art world. He was above all impressed and bewildered by the prices for which the pictures changed hands — a world-record price for a painting by a British artist was paid for a Bacon *Pope* in 1970 — and he learnt how to amuse the artist's friends by expressing his incredulity, in nasally strangled Cockney, that such sums (in this case, £26,000) were paid for items he himself did not even pretend to appreciate. 'All that money an' I fink they're reely 'orrible,' he would conclude with choked pride.

Bacon particularly enjoyed this 'turn' of Dyer's. Apart from being very funny, it confirmed his suspicion that, however welcome, such prices – not to say all prices – paid for art were artificial. He liked the way his East End boyfriend, whom he fondly addressed as 'Sir George', overturned the conventions of the sophisticated world in which, thanks to his growing fame, he was spending more and more time. Having George there to give a dismissively uncomprehending snort during an involved aesthetic discussion or to grab the vintage wine from the haughty wine waiter and slosh it into his ever-empty glass pleased Bacon because he himself had an innate distrust of 'frills' and delighted in anything subversive. The artist himself made a point of draining every bottle; and if the *sommelier* tried respectfully to explain that he was drinking the dregs, Bacon would rear back in mock astonishment and say loudly: 'But I *love* the dregs. The *dregs* are what I prefer.'

The strain of trying to keep up with Bacon nevertheless began to tell on George, whose drinking became increasingly problematic. For a time, his alcoholic vulnerability brought out an almost paternal tenderness in Bacon, who would go to great trouble to ensure that his lover followed his own habit of always eating well even when he was drinking hard. But George would leave dish after dish untouched, white-faced and chain-smoking, withdrawn into the horrors of his hangover. 'The trouble is,' the rosy-faced artist would explain, champagne glass jauntily aloft, 'poor George doesn't seem to be able to keep anything down.' Then from the concerted efforts of an entire restaurant staff an unlikely delicacy arrived, such as eel broth, that even the most liverish constitution could absorb. For a time Bacon extended this mothering solicitousness to the Reece Mews studio, where his idea of a 'cure' for George centred around plain roast chicken, bread sauce and the finest claret.

George's charms were, almost inevitably, destined to wear thin. As Bacon gave him more than enough money to live on, Dyer relinquished even his unsuccessful attempts at crime and did virtually nothing beyond getting regularly and spectacularly drunk, often with the hangers-on in Soho who always materialized when you were in the money. During these binges, the hapless George could be seen trying to 'do a Bacon' by buying large rounds and sweeping his cronies off to an expensive lunch. Though reserved when sober, Dyer became excitably suspicious or garrulous and maudlin as the drink took over, repeating some incomprehensible formula - half threat, half disclosure - for hours on end. He made even greater demands on Bacon, who began to avoid him in order to work and keep some privacy. To put a distance between them, the artist offered him various places to live – a luxury studio, a place in the country – and some handsome financial settlements. But Dyer always came back, since the mere fact of being with Bacon gave him an identity which otherwise evaporated totally during his long, lonely benders. It was a need that Bacon felt less and less inclined to fulfil; meanwhile, his masochistic side found no satisfaction in a weak, imploring lover. The rows between them flared up more often and turned nastier. with the younger man breaking down the door to Bacon's studio and going on the rampage when he got inside. Dyer also threatened suicide and attempted it by overdosing on sleeping pills, but on those occasions - such as an ill-starred trip they took with John Deakin to Greece – Bacon succeeded in getting him to a stomach pump in time.

As Dyer saw himself slipping in every sense out of the picture, he dreamed up a desperate and feeble-minded form of revenge by tipping off the police that they would find some cannabis hidden in Bacon's studio. The police duly arrived with a search warrant and with two sniffer Alsatians; having sifted through the rubble on the studio floor, they came up with 2.1 grams of cannabis wrapped in silver foil. Bacon was charged, although he denied knowing anything about the drugs and protested that, as a chronic asthmatic, he was unable to smoke anything – although occasional photographs show him holding a cigarette. The situation would have been farcical but for its sinister implications. Worried by the charge of being in possession of 'dangerous' drugs – which, if it had stuck, would have debarred him from entering the United States and attending his shows there – and by what other lurid 'revelations' might surface during an acrimonious court case, Bacon turned to his solicitor, Lord Goodman (whom he

had got to know at Ann Fleming's parties and at the club-like dinners given by the artist's framer, Alfred Hecht). Goodman chose to go for trial and briefed a formidable QC, Basil Wigoder, to defend his client.

"Grudge" story in Francis Bacon drugs case ran the headline on the front page of the Evening Standard. 'When Bacon went into the box, he said that he had paintings in the Tate Gallery, the Museum of Modern Art in New York, and other galleries,' the report stated. 'Around 15 years ago, during his travels round the world, he twice tried to smoke cannabis in Tangiers but each time had a violent attack of asthma and had never smoked it since.' (His whole face had in fact swollen alarmingly, but that did not deter him: it was almost a point of honour for Bacon to take whatever drugs he was offered in bars and nightclubs.) Dver was described as someone who worked for the artist as a model and a general handyman but who, when drunk, felt he was underpaid and as a result harboured a grudge against his employer. Bacon was acquitted. As he left court, he said: 'I bear no animosity towards Mr Dver. He is a very sick man. I still employ him, and I have kept contact with him while he was in hospital. I shall continue to employ him.'10

Later, with a nonchalance that he had clearly not felt at the time, Bacon told an interviewer that he had not been really worried as to the outcome of the case since he had 'recognized some criminals on the jury'. 11 The artist's connection with the criminal world had developed logically enough out of his earlier years as a homosexual: crooks and queers, whether they liked being lumped together or not, both found themselves outside the law. In more ways than we will ever know about. Bacon revelled in living beyond the pale. In addition to his punishable sexuality, in which he had left no vice unturned, he had engaged in prostitution and theft of various kinds as well as a range of other illicit practices such as keeping a gaming house and assuming a false identity. As for drugs, Bacon would have tried most things at one time or another, out of curiosity and bravado. As a young man, he had once found a large pill stuck between the floorboards of his room and had swallowed it -'Just out of boredom,' he admitted, 'for something to do'; the result was that he became so violently ill that his nanny had to fetch a doctor right away. 12 Nevertheless, his preference remained very markedly for alcohol.

A fascination with lawlessness and an appetite for risk brought the artist increasingly in contact with several of the most notorious

criminals of the day. For Bacon, whose natural impulse was to push every experience to the limit, men who dared to go as far as murder could hardly fail to have a magnetism. His own code of conduct was to live and let live on as grand a scale as possible, and the notion of actively harming someone was abhorrent to him. Nevertheless. a man so unconstrained by ordinary morality as to make a profession out of violence was bound to fascinate Bacon, who had long subscribed to a Nietzschean view of existence. A man beyond good and evil who would stop at nothing was also the kind of man whom Bacon, in his active sexual fantasies, most hoped to meet. Perhaps, at the beginning, George Dyer seemed to hold out the promise of some ruthlessly virile amorality, more likely, in Bacon's romanticized view, to flourish among East Enders; but Bacon was speedily disabused. 'I think it would be absolutely marvellous to succumb utterly to someone,' he remarked. 'I have always longed to meet a man who was tougher and more intelligent than myself. But, unfortunately,' he added acerbically, 'when you get to know them, most men turn out to be terribly weak.'

Reggie and Ronnie, the notorious Kray twins, did not enter Bacon's life directly until he started to spend part of the year in Tangier. Nevertheless, he would have been aware of their status as the most violent and feared operators in the London underworld, with a number of grisly murders to their credit, particularly since the two gangsters had become fashionable, appearing regularly in certain nightclubs where not only lesser crooks but a number of fashionable personalities made much of them. Although on one level he despised what they did and what they stood for, Bacon was particularly fascinated by Ronnie Kray, the more sadistic of the two, who was homosexual. On several occasions Bacon recounted how he had met Ronnie through a friend of his, the actor Stanley Baker.

I suppose he thought it was terribly smart to know them, and he said to me one day in Tangier, 'I've got these friends over from England, can I bring them round to your place for a drink?' And I said, 'Yes, of course.' So then he turned up with the whole dreadful gang of them. Then later Ronnie came to me and said he had fallen for some Spanish boy but he didn't think he could take him back to his hotel. He was worried about the impression it might make, though you wouldn't have thought after cutting all those throats he would care. And he asked me if he could bring him to my place. I had a place with lots of

rooms, so I said if you want to you can bring him here. He did, and after that I never saw the end of him.

That was the trouble with the Krays. You never knew when they would turn up again. Some time later one of the ones who worked for them forced his way into my studio and stole some paintings. He must have been told they were worth a lot of money – the newspapers had printed a story about their selling for colossal sums. He'd been hanging around the studio for some time. He just wanted money I think, because at night there used to be this tap-tap-tap on the door, it went on the whole time, tap-tap-tap, and I was too bored by the whole thing to go down and open up to him. I could probably have given him some money and he would have gone away. It was a great nuisance in the end, because he took some pictures that I terribly didn't want to let out of the studio because they were very bad. Anyway, they disappeared without a trace. Then about a week later, I had to go and see my framer Alfred Hecht, and there this man was: he had just been trying to sell them. When he saw me, he took them and ran out. But of course that wasn't the end of it – it never is with that kind of thing. The next day I went back to the studio in the afternoon and I found them all there, the whole gang, just sitting around, and Ronnie, the one they called mad and bad, saving how long it had been and how nice it was to see me. Of course I didn't know what to do. It sounds absurd, but all I could think of was to ask them if they'd like a cup of tea. And they said they would, so I made them some and we all sat round and they were terribly polite and just sat there drinking their tea. But when they got up to go there was no doubt what they had meant to tell me. So all I could do was drop the whole thing. A bit later I did manage to get the pictures back, but I had to pay some ridiculous sum of money. Anyway, then I was able to destroy them and have done with it.

They were dreadful, of course, just killing people off and so on, but at least they were really different from everybody else. They were prepared to risk everything. In that way they were deeply curious. In a restaurant in Tangier I saw them make someone go down and kiss their shoes in front of everybody. It was a horrible thing to do, but it showed the power they had. They're still very powerful even now they're in prison. I still hear from them. They send me their paintings. They're very odd. They're always these kinds of soft landscapes with cottages in them. That's really the kind of life they wanted – a life of ease in the country. 13

It was not until the early 1970s, after George Dyer's death, that self-

portraits took a dominant place among Bacon's themes. Before that his life was too full of visually fascinating, eminently recordable friends for him to think much of recording himself. The artist was enjoying his wave of success and popularity to the full, and nothing predisposed him to the guilt, melancholy and loneliness which were later to feed his great series of paintings of himself. Throughout the late 1960s, there was too much happening on the outside for Bacon to dwell on himself, and he was delighted to exercise his prowess at fracturing, then capturing, the likenesses of others.

But however absorbing his exterior life had become, with its abundance of friends, celebrations and public acclaim, Bacon remained sharply conscious and critical of himself. To close friends. or indeed to anyone he might have met casually and found at least momentarily sympathetic, he would talk very openly about himself, his experiences, his ideas and his work. As he drank far into the night, he became increasingly unguarded, although one or two themes, a handful of phrases and key notions, would return repeatedly, like a refrain, as his brain slowed under the weight of alcohol and he stated with the emphasis of a fresh thought something he had said a dozen times in the preceding hour. Companions, themselves stunned by drink and the approaching dawn, would be drawn deeper and deeper into the repetitive rhythm of his conversation and obliged, if they were going to stay with him, to submit to it. The way Bacon talked was at certain points very close to the way he painted, concentrating on one particular subject, then returning to it again and again, with little variation but vigorously renewed insistence. It was a process of stripping away to see what - if anything - would remain after the continued verbal assault. The tone, like his approach to painting, was often provocative and aggressive, and very few were the people and themes that escaped this scrutiny unscathed. As the evening progressed, more reputations would be scuttled and definitions pushed further, especially in the domain of art and artists, until the board was almost empty, and Bacon would lean forward with outstretched hands, saying: 'Apart from Picasso and Duchamp, and to some extent Matisse, who has invented anything in art in this century? Despite the fuss that goes on, who else has made a profound innovation? No one.' Even acknowledged heroes were pared down: Michelangelo eventually reduced to his drawings and Degas to his pastels, while much of Picasso outside the biomorphic imaginings that had so affected Bacon – and, above all, the Spaniard's late work – fiercely dismissed.

Bacon's whole discourse was driven by the relentless desire to cut down and clarify. On occasion he indulged happily in odd bits of gossip and never missed the opportunity to prompt or share a good laugh, but he was not given to small talk. The energy which allowed him to paint hard and drink hard day after day on little sleep also fuelled his unusual powers of concentration. Sometimes he would pick away at a subject until he had found a formula for it that seemed to sum up the whole matter with caustic brevity. 'I love phrases that cut me,' he often remarked, and whenever possible, on whatever subject, he delivered himself of a memorable line. 'I like unmade beds.' he came up with once when I apologized about my untidy flat, 'but I like them unmade by love.' He then rendered his mot into French: 'l'adore les lits défaits, mais défaits par l'amour.' 'Homosexuality is more tragic and more banal than what's called normal love,' he said on another occasion, clasping his leather coat to his chest as he entered a dark nightclub; and when the hat-check girl reached out for it, he reared back in mock alarm. 'Can't you just leave it with me?' he asked plaintively. 'I know it's only a bit of old skin, but at my age I've got to have something to hold on to!'

On evenings like these, when he might take in three or four different clubs before tumbling into a taxi and finally making his way up the perilously steep stairs of his mews house, the solicitude of friends, worried when he was clearly no longer in control, was invariably met with irony. 'Why don't we have one leetle more drrrinnk?' he would propose. 'But Francis, we've had too much already.' 'Only too much is enough,' he would thunder back, suddenly sober and imperious, and the drinks would be kept coming. Any notion of being 'sensible' needled Bacon, as if he had a strict duty to overturn all convention, exceed all limits. When signs of fatigue appeared and a companion would suggest it was time to get some sleep, Bacon would often assume a hurt look and hiss: 'I've got such a long sleep coming up, c'est pas la peine!' There was much brayura in the performance, an inborn theatricality and a desire to impress: to show he was tougher and more reckless than anyone. But there was also the need to be with others - whether old friends or the latest catch of the evening's trawl – and keep the brief night at bay for as long as possible. Sleep did not come easily to Bacon, who depended on pills to relax him sufficiently. Avid for conscious life as he was, he tended to consider the night's rest as a medically induced interruption rather than a respite.

During these epic drinking sessions, the artist would touch on a wide variety of subjects outside his main concerns for his art and his friends. He might surprise everyone by saying that human life had originated in the sea or that the human nervous system was 'projected like a blueprint at the moment of conception'. He loved to talk to scientists and doctors (at one point he was a regular reader of The Lancet), and he showed a keen interest in all kinds of research: like the Van Gogh of the Letters he so admired, he was also given to developing the occasional theory in quite specialized areas of knowledge. But this vivacity of spirit, open to all forms of experience, had at its source the most bleak, unconditional nihilism. Paradoxical to the core. Bacon enlivened existence by his painting and his behaviour. by his generosity and his recklessness, by the freedom he generated and the awareness he stimulated; yet he believed, and would repeat ad nauseam, that life meant nothing, that it was no more than a mere spasm of consciousness between two voids. Particularly when drunk, he would drum this lesson inexorably into his companions: 'We come from nothing and go into nothing, and in this brief interlude we might try to give existence a direction through our drives. But there's nothing. Nada. Do you understand? Nada.' Here his face took on an indignant, disgusted expression while his eyes continued to bore into his listeners. The thought would be delivered again and again with the manic insistence of a man fixated: Nada. Not the least of the artist's contradictions was that he held and propagated his non-belief with such intensity that it grew in many ways indistinguishable from religious fervour.

This conviction of the futility of existence, 'a game played out for no reason', often dominated the late-night drinking bouts, with Bacon waxing more peremptory as the evening wore on. But it was an article of faith, ingrained in his being, and it came out in his lighter moods as frequently and indeed more persuasively. When he was in a genial frame of mind, he expressed his belief in nothingness as a simple fact that needed little dwelling on, and his natural flair for conviviality succeeded in turning the bleakest of prospects into a celebration. 'Here's to you,' he might say, holding his champagne glass aloft. 'Here's to everything you want. What more can I offer you? After all, life itself is such a charade there's no reason one shouldn't try to achieve everything one wants. But that's another story. Very few people find their real instincts. Every now and then there's an artist who does and who makes something new and

actually thickens the texture of life. But it's very rare. Most people iust wait for something to happen to them. You have to be able to be really free to find yourself in that way, without any moral or religious constraints. After all, life is nothing but a series of sensations, so one may as well try and make oneself extraordinary, extraordinary and brilliant. even if it means becoming a brilliant fool like me and having the kind of disastrous life that I have had. There it is, I myself have always known that life was absurd, even when I was young though I was never young in the sense of being innocent. I knew it was absurd and even though I could never understand anything at school I always got by by playing the fool and amusing the other boys. There it is. I don't believe in anything, but I'm always glad to wake up in the morning. It doesn't depress me. I'm never depressed. My basic nervous system is filled with this optimism. It's mad, I know, because it's optimism about nothing. I think of life as meaningless and vet it excites me. I always think that something marvellous is about to happen.'

This buoyancy and the belief in himself which Bacon possessed in such abundant measure were about to be put cruelly to the test. In Paris, the city where he had most wanted to succeed, he was about to experience the greatest triumph and the worst disaster of his life.

All the Honours of Paris 1969–72

It's only by going too far that you can hope to break the mould and do something new. Art is a question of going too far.

Francis Bacon (in conversation)

Obsessed though he became with making likenesses of his friends which went as far as possible beyond 'illustration', Bacon was by no means solely preoccupied with portraits during the 1960s. In the decade between the Tate retrospective in the spring of 1962 and the Grand Palais exhibition which opened in autumn 1971 - the two shows which established his international reputation - Bacon was remarkably inventive and prolific. The London exhibition had alleviated the frustrations of half a career spent in semi-obscurity; and the Paris event, which took several years to develop and organize, gave the deeply Francophile artist a prestigious goal to work towards. During that time Bacon succeeded in renewing the possibilities of contemporary portraiture as well as extending the capacities of modern painting to absorb tradition and myth. But this renewed contract with history was negotiated in a spirit of perfect cynicism. In his eyes, the past lay waiting to be raided and reassembled in chance conjunctions which disrupted the continuum of tradition. It was a substance, not unlike oil paint, that invited infinite manipulation.

Certain ways of mixing past and present, Bacon sensed, could become as provocative and disquieting in an age of disbelief as combinations of the religious and profane had once been. The iconoclastic fury of the *Three Studies for a Crucifixion* of 1962, on which the Tate retrospective had ended, was still clearly at work in

him. Three years later – in the middle of a spate of portraits – Bacon returned to the theme, using the same large triptych format and entitling the finished picture simply *Crucifixion*. The two triptychs, while both alarming in their brutality, are significantly different. The artist who painted the first work with its savage reds and oranges (under the influence of alcohol throughout) hardly knew how the imagery came about. The lack of control let through a direct autobiographical reference in the left-hand, 'father and son' panel; juxtaposed in the other panels were the 'poignant' Tangier bed and an inverted corpse linked, in a shorthand of brilliant and appalling realism, to a thick white waste-pipe (a metaphor to which the artist later returned to suggest life ebbing away).

The 1965 triptych is a less emotional and overwhelming work: the colours are cooler, the composition more clearly planned, with a perspective that allows the eye to move in and around the figures. In the central panel the crucified form inspired by Cimabue has been inverted once again and radically reinterpreted. The top half recalls a large bird swooping down and merging into a dramatically foreshortened human figure with limbs neatly butchered and bound; these two distinct halves are curiously conjoined, as if bird neck and human limb had been plaited together. On the left-hand panel, there is a female figure nude and a battered recumbent figure with a rosette fixed to its chest; on the right, a sculptural male figure in contrapposto, inspired by Michelangelo's heroically built nudes, wearing an armband with a delicately drawn swastika.

The sources out of which Bacon conjured these images are too varied and interwoven to allow much definitive analysis; they reflect the artist's deliberate desire to keep his work sealed in enigma. But in this *Crucifixion*, as in several of Bacon's key works, it is none the less possible to identify an astonishing range of influences and borrowings. The central panel alone conflates not only Cimabue and memories of abattoirs and meat markets (John Deakin had in fact photographed Bacon and various friends among the sides of meat at Smithfield market around this period). It also refers to X-ray photography, which Bacon had studied in manuals such as *Positioning in Radiography*, and to images of birds in flight. The latter can be traced to the Muybridge studies of eagles rising and swooping as well as Etienne-Jules Marey's 'chronophotographs' of gulls, where the sequence is kept so tight that it suggests the double image — of the bird and its shadow or reflection — which stirred Bacon's imagination

deeply, confirming an interest he had always had in the enigmatic 'ghost' that images cast. The double image of birds diving into the sea put Bacon in mind of Greek antiquity, and in this case, where a bird dives into the entrails of a man, the Promethean legend is clearly evoked. Years later, Bacon's circling imagination returned to the theme of swooping bird and eviscerated torso in the middle panel of *Triptych* 1976.

Thus, for all the emphasis he laid on his lack of schooling, Bacon can be seen as a deeply cultivated painter; in our century perhaps only Picasso could bring ancient myth and historical association so vividly alive. To transpose Prometheus – and by extension, the Greek concept of hubris and atonement – as well as the theme of the Crucifixion to the meat market is both to empty them of their supernatural content and to make them unavoidably real and urgent. Bacon's *Crucifixion* is dominated by the smells of the slaughterhouse. There is no way out and no redemption: only horror, pain and dead meat.

Bacon's debt to Michelangelo's male nudes is patent in the fleshy figure on the right-hand panel, coiled round his own axis as if he were about to hurl a discus. When he stated that he had 'looked at everything', it was no empty claim. Although he knew the great Florentine's entire *oeuvre* well, Bacon always claimed that he especially liked Michelangelo's drawings for the 'voluptuous' way they rendered male flesh. The fact that Bacon preferred the drawings of artists such as Michelangelo, Seurat and Giacometti to everything else they created is to some extent a reflection of his reluctance to develop his own graphic gifts.²

Bacon himself stated, flatly and quite inaccurately, that he *never* drew. Accordingly, during his lifetime, no drawing of his (apart from a few works of the early 1930s) was ever exhibited or reproduced. But in point of fact, he regularly made preparatory drawings for his paintings – some of them brief outlines in ink, others more fully worked in gouache or oil on paper. With his habitual concern that nothing but what he considered his best work should ever leave the studio, Bacon scrapped any such sketches as soon as the painting in question was under way. Over the years, none the less, a small number of these studies escaped the ritual destruction. Those that have come to light so far share a fluency of movement and a sureness of purpose that confound previous suppositions that Bacon could not draw. It seems much more likely that he did not *want* to draw beyond

setting down the basic notion for a painting. Michael Ayrton once maintained in an essay that Bacon could not draw, and when the two artists bumped into each other later Bacon retaliated. 'Is drawing what you do?' he asked Ayrton sweetly, before adding: 'I wouldn't want to do that.' With very few exceptions, such as the fine sketch after Picasso reproduced in this book for the first time, Bacon's drawings were a means to an end, and most of them indeed resemble fledgling paintings, with the emphasis on flow and volume rather than an exploration of line.

As with the other artists he admired, Bacon knew Michelangelo's work mostly from reproductions; he visited certain museums in London and Paris regularly, but he found he was often more stimulated by works of art in reproduction than by seeing them in the flesh. The Velázquez *Pope* is the most famous instance of a general tendency: Bacon's knowledge of the Old Masters, from Cimabue to Grünewald, Rembrandt to Goya – and particularly of the individual paintings which moved him most – was derived to a significant extent from books. Most of the illustrations which he saw as a young man in pre-war monographs and magazines would have been in black and white; and even much later on in his career, he often preferred monochrome plates to look at and work from.³

There were complex reasons for this preference, the main one being that black and white reproductions allowed Bacon to treat even the greatest works on the same level as photographs: purely as images. Thus they became easier to assimilate with the innumerable other images which he had studied and, in certain cases, actually kept in the thick strew of photos and illustrations covering his studio floor. The widest conceivable range of images of the human body in movement interested him, so that along with the art reproductions there were shots of athletes by the sheaf – boxers, wrestlers, footballers, cricketers – and above all the studies of Muybridge. Later Bacon was to say that he had looked so often at the images of Michelangelo and those of Muybridge that he could no longer dissociate in his own mind the influence of the one from the other.

The 'discus-throwing' nude in the *Crucifixion* is an obvious case in point. The figure is beautifully painted: it appears to rise out of a pool of its flesh and blood, and its rounded fullness bears eloquent witness to the artist's desire at this time to experiment with sculpture. Even the swastika looks beautiful, for all its sinister implications, and Bacon himself confirmed that he had added it for purely formal reasons. It

also gave the figure a shock value, not dissimilar to that of the hypodermic syringe that was plunged into the *Lying Figure* of 1963. The transfer of this heavily loaded emblem had been prompted by the photos of Nazi leaders which Bacon kept to hand as he was painting the triptych. Bacon is on record as saying that he did not much 'care' how people interpreted the swastika armband. But what is curious is that, by using it for formal, aesthetic reasons, the artist has emptied the Nazi emblem of its usual significance – just as the Crucifixion itself is emptied of all its traditional connotations – and turned it, with inspired impudence, into a decorative device. The armband sits most alluringly on this heavily muscled, sensuously rendered male arm. Such pieces of specifically homosexual bravura (so reminiscent of Jean Genet, whom Bacon resembles in several ways) are no less potent for coming perilously close to out-and-out, melodramatic 'camp'. 5

By now, even when he was painting on the grand scale in his large triptychs – with each panel measuring just under two metres tall, the format he would retain for large paintings for the rest of his career - Bacon did not necessarily require mythical or allusive material. He had begun to paint full-length portraits. There were two triptychs of Lucian Freud, in 1966 and 1969, in which the figure holds the pictorial space entirely by the eloquent extremity of his contorted frame and flesh, offered to the spectator's gaze on a typically buckled Baconian couch or trapped within a tubular cage the size of a shallow football net. Bacon also painted a memorable full-length portrait entitled Isabel Rawsthorne Standing in a Street in Soho. The former model of Derain and Giacometti appears, resolute and resourceful as a modern-day Ulysses, surveying the red-light district, while the blurred form of a charging bull, reflected in curved screen behind her, spells impending danger. The full-length portraits of those closest to him amply illustrate Bacon's idea of true friendship, as 'two people pulling each other to pieces'. The friends are taken apart, whipped, mauled and distorted in the strange fury of his love; but they survive, ennobled, like the heroes of an epic struggle, with the artist's vitality visibly flowing through.

The notion of art as a struggle, an *agon*, was self-evident to a painter for whom the success of a painting was linked to the degree of risk it had involved. When Bacon introduced the Promethean myth into his concept of the Crucifixion, he was doubtless mindful of the parallels between the god who stole fire from Olympus for mankind

and the artist who broke, or subverted, convention in the search for a new vision. Bacon admired courage, and during the 1960s, on trips to the South of France and to Spain, he developed an interest in bull-fighting, which he saw as a spectacular test of human bravery and endurance. It also fascinated him as a metaphor: the closer a torero comes to the bull's horn, the more he can display the extent of his daring and the mastery of his art. In this Bacon had been influenced by his friend Michel Leiris, whose fine essay 'De la littérature considérée comme une tauromachie' had greatly impressed him; the French writer also sent him a copy of his Miroir de la Tauromachie in 1969, the year in which Bacon painted his bullfight scenes.6 Thus the bull that had materialized as a symbol of danger in the background of the Isabel Rawsthorne portrait reappeared in two versions of a fully fledged corrida. In taking on a subject which several artists he revered, notably Gova and Picasso, had treated with such inventive brilliance. Bacon himself demonstrated a degree of daring and courage. In both images, the encounter between bull and man is suggested in a superb ellipse of form which nevertheless conveys the full, shuddering weight of the animal. In the first version. the monochrome vellow background is broken up by a mirror-like panel in which a Nazi rally is taking place beneath the Third Reich's eagle-mounted banner. The incongruity already noted in the use of the swastika armband on the male figure in the Crucifixion is equally perceptible here. Although a symbol of this kind may work well in terms of introducing a generalized sense of threat, it raises inevitable questions as to what the coupling of Nazi indoctrination and the bullfight means. The ambiguity could not help prompting the kind of narrative interpretations which Bacon insisted he wanted to avoid. As a result, it seems, his second version contains only a blank screen which, although it avoids the problem of specific reference, does not create a convincing background - a weakness in the artist's organization of pictorial space which he was sometimes visibly at pains to overcome.

When an idea for a painting was particularly strong, and Bacon was working within what one might term his own 'mythology' (which was not the case with the corrida pictures), problems of spatial organization occurred less frequently. In one of his major works of the period, *Triptych Inspired by T. S. Eliot's Poem 'Sweeney Agonistes'* (1967), the composition is perfectly balanced, without a hint of the uneasy articulation between main subject and background

which mars some otherwise powerful paintings. The sense of unspecified threat fills the three panels like a shriek in the night: a nameless violence has taken place, leaving a jumble of blood-stained clothes in the wagon-lit compartment depicted in the central picture. This triptych is one of the purest pieces of Baconian drama. There are no Nazi insignia, almost no devices of any kind, like the arrows and naked lightbulbs that were to become so recognizable – and at times all too repetitive – a part of the artist's repertoire. Clearly, for all Bacon's horror of narrative, a story has been told; but told in such a condensed, disjointed way that one can only speculate as to what has happened.

The title, which has prompted a number of specific interpretations, was in fact given to the painting by Bacon's gallery as a way of identifying it: the artist had mentioned that he had been rereading the Eliot poem while at work on the picture. If the title stuck, it meant that Bacon, who had no qualms about overturning such decisions, accepted it. Given the reference to Eliot, who subtitled his unfinished poem 'Fragments of an Aristophanic Melodrama', one might be persuaded that the two clearly female figures lying side by side on the bed in the left-hand panel refer to Dusty and Doris, all the more so since the line 'The epileptic on the bed / Curves backwards, clutching at her sides' (from 'Sweeney Erect', rather than 'Sweeney Agonistes') describes the nearer figure's convulsions perfectly. Similarly, in the right-hand panel where two figures couple, the man on the telephone reflected as if 'off-stage' in a curving mirror, may well have been suggested by the girls' shadowy 'protector', Pereira; in the poem, he telephones but never appears.7 The middle panel, with its mound of blood-drenched clothes abandoned in a wagon-lit compartment, gives a specifically sinister twist to the whole picture, but it has no discernible link to 'Sweeney Agonistes' beyond its evocation of a violent death.

If the triptych could be 'read' satisfactorily at this level, it would not be a Bacon. Whatever the artist was, he was not ingenuous, and the reference to Eliot is as misleading as it is helpful in any attempt to unravel the painting's 'meaning'. Bacon repeatedly claimed that he himself did not know how his images (particularly those he liked best) came about. He talked of them as emerging semi-consciously from the vast 'compost' of impressions and 'memory traces' that had remained from an entire existence spent scanning all forms of life and art. He had been influenced by everything, from freshly scribbled

graffiti to an evening drinking with the Kray brothers, Baudelaire to abattoirs, two world wars to golf manuals (from the latter, for instance, he borrowed the arrows used to indicate the direction of a drive). In the best modernist tradition, he had – like Eliot, notably – made the most widely diverging sources mingle and merge in the search for his own idiom. (The ankle-deep strew of books, photos, old shoes, paint tubes, rags, etc. that covered the studio floor was like the partial, physical manifestation of the mental 'compost'.) Then what emerged was again transformed in the act of painting itself by Bacon's reliance on what he called 'chance': all the unforeseen possibilities that came into play the moment that he applied one brushstroke on another and the expressive malleability of oil paint suggested more exciting forms than those he had started out with in his mind's eye.

Thus there is little in any Bacon painting that can be equated with a single source. The images have hybrid origins, and as Michelangelo's drawings were inextricably linked in Bacon's imagination to Muybridge photos, so he combined Eliot's modern sensibility and the emotions that Greek tragedy awoke in him. What Bacon admired specifically in Eliot was his ability to evoke in a new language ancient notions of despair, which the painter himself felt deeply and which affected him all the more since he could not accommodate them within the framework of any faith. Sweeney's famous definition, 'Birth, and copulation, and death./That's all the facts when you come to brass tacks', closely echoes Bacon's bleak summary of existence. 'That's all, that's all, that's all, 'Sweeney chants.

The 'inspiration' from Eliot was more a confirmation of what Bacon already believed and out of which he had formed the core of his work. But if a parallel is sought, it can be found: the woman in convulsions may well be giving birth, and the copulation of the Muybridge-derived male figures is quite explicit. For death, Bacon borrowed the circumstances of a famous unsolved murder of the 1920s (another instance of his delight in introducing unexpected source material): a railway compartment had been discovered drenched in blood, but no body was ever found. In the picture, the sleeping compartment is meticulously outlined; Bacon knew it inside out, since he frequently took the overnight 'Train bleu' down to the South of France. The bloodied chaos that has erupted within the narrow walls is the central and most striking image in the triptych. Its mess of clothes and fresh blood speaks louder than the missing

corpse; even the overnight bag, with the minuscule teeth of its zip evilly agape, is overflowing with a demonic energy.⁸

'Death is life and life is death,' Sweeney intones towards the end of Eliot's poem. No one could have been more keenly aware of the ubiquity and possible imminence of death than Bacon. He thought about it every day and frequently wondered out aloud how he would die and whether he wanted to be buried or cremated. (For a long time he decided on burial, on the grounds that 'it would be a bore for people if they had no bones to dig up later on'.) When he bought himself a house in the East End of London, he claimed he would be murdered in it, fearing what his new friends in the criminal world or the 'rough trade' he picked up might do if things happened to get out of hand. He saw death constantly at work, in the shaving mirror, in the ticking wristwatch, even in shadows which he painted like emblems of mortality, seeping out of his figures.

This acute awareness of death seemed to be an integral part of Bacon's love of life, fuelling his vitality. As he turned sixty and showed no signs of slowing up, he came to resemble the hero of Oscar Wilde's Picture of Dorian Gray to an uncanny degree, as if the marks of brutal sex and overindulgence, guilt and fear had been transposed to his battered and writhing figures, leaving the artist untouched. Epic excess and lack of sleep seemed positively to agree with him: he would reappear pink and chuckling after the worst nights, greedily sipping his morning champagne like an elixir of youth. Physical mishaps and beatings that went too far were suffered stoically and barely mentioned. Grisly stories of eyes half put out and punched-in teeth abound. John Russell mentions that Bacon's nose was broken twice within a month, and the photographer Peter Beard recalls a car running over the artist's foot, leaving him barely able to limp away - an incident which Bacon never even referred to the next day. 10 Bacon's doctor, who was called in to treat him for an alarming gash over his eye, was struck by the artist's ability to withstand pain and by the speed with which his wounds healed.11

The combination of recklessness and resilience increased the fascination he exerted: in his life as in his painting, Bacon made a point of going too far. For those who were not emotionally involved with him, there was undoubtedly a thrill in watching him push a situation to its limits, whether it was at the gambling table, with a picture, or in a relationship. For someone who was emotionally involved, it would have been a test, not to say a contest, of nerve. As far as

Bacon was concerned, the relationship with George Dyer was on the wane, above all since the drugs incident, and his amorous interests were engaged elsewhere. But for Dyer, Bacon represented a lifeline. Even though he had been well supplied with money, the vulnerable East Ender was nobody without his famous, confident friend; however much he drank himself and a few spongers into a stupor, he knew he was sinking back into obscurity. It was a situation that had reached its limits. Bacon did not pay much attention to the warning signals: the clumsy pleas for attention, the pathetic hints at suicide. He was used to living on the edge, and he had been emotionally blackmailed by Dyer frequently before. Besides, he was too absorbed by his own life and too excited by the prospect of an important new exhibition. Bacon had always set his sights high. As far as recognition was concerned, he considered that his work should go either to the 'National Gallery or into the dustbin'. The ultimate accolade for a living artist seemed at hand: a full-scale retrospective at the Grand Palais, an honour that had been accorded before only to Picasso.¹²

Bacon's relationship with the Paris art world already went back some forty-five years by the time his retrospective, organized to coincide with his sixty-second birthday, opened there in October 1971. The experience of seeing Picasso's drawings at the Galerie Paul Rosenberg in 1927, when he was not yet eighteen, had provided the first real catalyst in his early development as an artist; and the whole experience of Paris, with its intellectual excitement, sexual freedom and savoir-vivre, made such a mark on the Irish-bred boy that he continued to look to the French as ultimate arbiters in virtually every domain that interested him. After that first stay, when he absorbed with remarkable speed the spirit of surrealism and the basics of furniture design, as well as the subtle art of getting by without employment, Bacon continued to regard Paris as the ideal city and his second home until the end of his life.

It took time, however, for Paris to reciprocate the interest. While other countries, notably Italy and America, had been quick to recognize the artist's disturbing power, France needed much longer to accept an outsider into its pantheon. Apart from the show at the Galerie Rive Droite early on in 1957 and the odd entry into annual gatherings like the Salon de Mai, Bacon's paintings had barely been seen in Paris before the Galerie Maeght put on an exhibition of recent work in 1966. That event and the parallel support of several eminent

Parisians proved decisive, however; a poll to decide on the ten most important living artists conducted a couple of years later by the Paris art magazine *Connaissance des Arts* actually put Bacon in first place. Since Paris had missed the opportunity of taking the Tate's travelling retrospective in 1962–63, a project to give the city its own Bacon retrospective got under way, with the artist's boundless encouragement.

Preparations were already well advanced by 1969. In a letter written at the end of that year, Ann Fleming refers to the show's progress in a wry account of a dinner party at her house: 'We had a very drunken soirée at Victoria Sq. F. Bacon, Sonia Orwell, R. Fedden very abusive to each other ... I tried awfully hard to change topic and never before realised how cross drunks get if you do this thing to them — like taking a bone from mad alsatians. French lady, unknown to me and imported by Francis; she is organizing a retrospective exhibition of his paintings at the Grand Palais; he is the first English painter to have such an honour bestowed upon him, tho' I should think the occasion is in some jeopardy now.'14

One direct result of the Galerie Maeght show had been that the Centre National d'Art Contemporain bought a triptych, Three Figures in a Room, the first work by Bacon to belong to a public collection in France (where, correspondingly, there were no more than a couple of Bacons in private hands at the time). Soon afterwards, the Ministry for Cultural Affairs asked the artist to agree officially to a large exhibition, proposing either the Grand Palais on the Champs-Elysées or the old pre-Beaubourg Musée d'Art Moderne near the Place du Trocadéro. Not surprisingly, Bacon chose the Grand Palais, claiming that the space there was better suited to the size of his paintings; he could not have been unmindful, either, of its considerably greater prestige and the fact that his show would follow the resoundingly successful retrospective given to Picasso. Over the following year. various cultural officials made their way to London to discuss details with the artist and make a preliminary selection of paintings to be shown.

When it came to choosing who should write the text to 'present' a body of work little known to the general exhibition-going public in France, there was no hesitation. Not only was Michel Leiris an eminent man of letters, with a widely admired gift for probing self-analysis, he had also come to know Bacon well and been instrumental in bringing about top-level recognition of his work in France. Leiris's

reputation was greatly enhanced by the fact that he was one of the few surviving surrealist writers and that he had been part of the movement's early struggles and epic dissensions. Moreover, he had long been associated with several of the greatest artists of the age. His wife, Louise, ran the famous Galerie Kahnweiler, and Leiris had developed a lasting friendship with Picasso, seeing him and writing about his work frequently. He also remained close to Giacometti, and by a coincidence that struck Leiris as auguring well it was Giacometti who had first introduced him to Bacon during the sculptor's retrospective at the Tate Gallery in 1965. They met Giacometti again afterwards when the two artists engaged in what Leiris described as a 'Homeric discussion' about their work. Giacometti started by saving that he made things as he saw them and that his attenuated figures were real, Leiris recalled. Bacon replied that he himself distorted reality, and he tried to get Giacometti to admit that he did the same. But Giacometti insisted that he copied the reality he saw.

Thereafter the friendship between Bacon and Leiris developed rapidly. They discovered they had several mutual friends, notably Isabel Rawsthorne and Sonia Orwell, who organized numerous dinner parties for them. Leiris had at first been somewhat daunted by the paintings of Bacon's he had come across and was not reconciled to his work until he had seen his portraits. Thereafter he agreed to write the introduction to the painter's first show at the Galerie Maeght. and the friendship was confirmed. There was an exchange of letters between the two men, and many conversations lasting late into the night, in London as in Paris. A number of portraits of the French writer followed, and they rank among the most beautiful and inventive heads Bacon ever painted. A deeply cultivated man, Leiris was not an art critic in any professional sense but rather a poet drawn to the visual arts. continuing a tradition made famous by Baudelaire and vigorously maintained throughout the twentieth century in France by a host of poets from Apollinaire to Aragon, Reverdy and René Char. Thus Bacon entered the cultural pantheon of Paris through what the French call 'la grande porte'.

Accordingly, it was by climbing an imposing staircase and passing through a very grand door that one reached the Bacon retrospective. During the last few days of October 1971, when Paris basked in an Indian summer, access to the Grand Palais was sealed off as the organizers of the show decided on their final hang; the usual preopening panic had reached new heights because five of the pictures

chosen and illustrated in the catalogue had still not arrived. The confusion was compounded by the fact that President Georges Pompidou, a keen collector of contemporary art, had decided to open the exhibition in person, thereby turning the event into a state occasion. The last-minute preparations grew even more frenetic as questions about security and the finer points of protocol flew back and forth between the Elysée and the Grand Palais. When the presidential cavalcade arrived, however, all seemed miraculously in place, with a detachment of the Garde Républicaine standing at attention. As Pompidou mounted the steps accompanied by his cultural minister, Jacques Duhamel, and a cluster of dark-suited officials, Bacon was waiting in the entrance to accompany the President round his exhibition.

One may only guess at what the artist was feeling. The news had been brought to him the day before that George Dyer had been found dead, apparently of an overdose of drink and drugs, in their hotel bedroom. As he stood waiting for the President, Bacon would not have missed the tragic irony of the red carpet that had been rolled down the steps of the Grand Palais for the opening ceremony; he was too conscious of the relevance of Greek drama to his own life not to see it. By 'trampling the royal crimson', Agamemnon brought about his own swift destruction and unleashed the Furies' quest for further blood. The Furies were insatiable, as Bacon knew from bitter experience. Peter Lacy had died just before the first retrospective; George Dyer had died on the eve of Bacon's second great triumph. It might sound melodramatic, even in circumstances which could hardly have been more horrible, to say that the Gods were jealous; or even that, in the paintings' black vision, a terrible secret of theirs had been revealed. Yet there were parallels and refinements of cruelty down to the last, banal detail that no human mind could have devised. After attempting to vomit a surfeit of alcohol and pills into the sink, Dyer had slumped back on to the lavatory seat in the hotel bathroom and died there. In one panel of the triptych which had been recently bought by the Centre National d'Art Contemporain, Dyer is shown seated on the toilet. Unaware of its connotations for Bacon but ever mindful of national interest, Pompidou paused for some time during his tour, with the artist in attendance, to scrutinize this horribly prescient image.

Dyer's death was immediately hushed up so that the opening of the exhibition would not be overshadowed by media coverage of its lurid circumstances. The popular press, which had already announced the retrospective, could certainly not have resisted the temptation to draw parallels with other *peintres maudits*, such as Van Gogh and Modigliani, and present Bacon's entire significance in that conveniently simplistic light. The artist himself, exulting in the ground swell of acclaim, and manically high as much on fatigue – he had scarcely slept for days – as on champagne, appeared to have barely taken in the news. Impeccably dressed and moving effortlessly between English and French, Bacon remained master of the situation, deferring skilfully to the opinions of official bigwigs, receiving praise with modesty, meeting the press tirelessly and charming everyone down to the humblest museum employee.

Once the exhibition was open and the fanfares had died down, the artist's genial presence was totally eclipsed by the impact of the work itself. The Grand Palais acted as an unexpectedly perfect setting. At first glance, the big glazed paintings in their moulded gilt frames seemed to comply with the forlorn pomp of the huge nineteenthcentury galleries. But in fact this chance alliance served to make the content of the images all the more disquieting: in place of stale historical allegory and decorously titillating nudes, a modern, deformed and tortured humanity writhed behind the glass, sending out waves of panic. The Grand Palais was transformed into a vast theatre of cruelty, its lugubrious space filled with blasphemies and half-stifled cries, obscene utterances of despair not whispered in private but amplified and wholly public. Throughout the retrospective the elegant Parisians moved as if on tiptoe, in a silence of suspended shock, aware that a dreadful secret had come out into the open something unspeakable repeatedly spelt out. The tension the pictures aroused was such that even the visit of Salvador Dali, whose brilliant clowning was much prized by the French, went relatively unremarked. In full fig and accompanied by a tall blonde model in red hotpants, the maestro made his entry and pointed to the paintings with his silver-topped cane, loudly pronouncing the most terrifying among them, with much rolling of his rs, 'Très, très raisonnables!' a nice piece of surrealist upstaging which failed to turn more than a few heads. 15 Many of the people invited were in the habit of attending exhibition openings as part of the season's social round, and they came away stunned not only by the paintings' 'message' but by the bravura with which it was conveyed. The comment which Michel Conil Lacoste, art critic of Le Monde, reported hearing most frequently as he walked round the show was: 'It's like a punch in the face.' 16

Partly because the Grand Palais was such a prestigious venue, most private collectors and museums agreed to lend paintings. Even Painting 1946, a key work in Bacon's early development, which the Museum of Modern Art had declined to send to the Tate retrospective because of its fragility, had been secured. Bacon had insisted that the retrospective should begin with Three Studies for Figures at the Base of a Crucifixion of 1944, thus cutting out all the paintings he had done from the late 1920s to the beginning of the Second World War (four of which the Tate show had included). Henceforth nothing from this earliest period would be admitted to any exhibition during the artist's lifetime, nor even illustrated in the standard monographs; in terms of the artist's own view of his work, it was as if that decade had never existed; and the fact that Bacon succeeded in imposing this view on the art world says a great deal about the extent to which bohemian chaos, drunkenness and metaphysical despair notwithstanding – he controlled his public image. 17 At the time, this understandable – but hardly necessary – self-editing did not appear to matter, even though the whole first half of Bacon's career had been drastically foreshortened, with fewer than a third of the 108 paintings on show representing his development up to 1960. The intention was clearly - and again, perhaps, understandably - to accentuate the impression of unfaltering genius, with the remaining two-thirds of the retrospective devoted to the last decade of the artist's output.

As a result, the portraits of his friends and the huge triptychs dominated. The two big *Crucifixion* triptychs of 1962 and 1965 were certainly a 'punch in the face' for the mainly Catholic public which came to see them; and the swastika armband would have awoken a variety of emotions in Parisians who had lived through the German occupation. As well as the highly charged 'Sweeney Agonistes' picture – Michel Leiris drew attention in his preface to the 'somptueux et terrible paquet sanglant' at its centre – there was the more hermetic but hardly less disquieting *Two Figures Lying on a Bed with Attendants*. Distinctly anthropoid and deliberately identical, the figures lie on the familiar Moroccan-inspired bed in a mess of shadow and a flare of white paint; the latter may have been added, like the famous hypodermic syringe in the female nude, to 'disrupt' the image, but it still looks unmistakably like a heroic stream of semen. Of the 'attendants' in the wing panels, one is naked, the other fully dressed in a

suit; behind them are mirror-like screens, each portraying a small, indistinct figure rising out of its more intensely delineated shadow. Shadows never ceased to fascinate Bacon: they first appear in his very earliest works of the 1930s and recur regularly as one of the most constant motifs of his work. In his pictures, they serve as a constant reminder of death – the ever-lengthening darkness that 'shadows' every life. As a manipulator of form, Bacon was also fascinated by the plasticity of shadows, which – he told me once – he even dreamed about: 'I was going down a street and my shadow was going along the wall with me, and I thought, Ah, perhaps this might help me with my painting, and I reached out and tore the shadow off.'

Bacon had painted five new triptychs specifically with the Grand Palais exhibition in mind, conscious of the fact that the larger the picture the more it would be likely to 'hold' the museum's cavernous space. In *Three Studies of the Male Back* of 1970, a fleshy, sculptural nude is shown shaving in a mirror, then reading a sheet of newsprint with half-formed signs scattered about on it like 'a heap of broken images'. Eliot's early imagery was still very much at work on the artist's imagination, it seems, and in the rosy figure echoes can be found of 'Sweeney addressed full length to shave / Broadbottomed, pink from nape to base' who 'Tests the razor on his leg / Waiting until the shriek subsides'. (The figure, reproduced on the cover of the Grand Palais catalogue, appears literally to be drawing an open blade along his calf.)

In another triptych painted the same year, *Studies from the Human Body*, the sheets of jumbled newsprint reappear, blowing about the malevolently hot orange space of the picture with the sinister aimlessness suggested by Eliot's description in 'Preludes':

The burnt-out ends of smoky days.

And now a gusty shower wraps

The grimy scraps

Of withered leaves about your feet

And newspapers from vacant lots ...

The three panels are beautifully painted and filled with new devices. The lovers in the central image, inextricably coupled as in a fatal mating, appear to be recorded this time by a voyeuristic figure operating a camera as evil-looking as the magnified head of an insect. The use of a folding screen set with mirrors, which also creates the

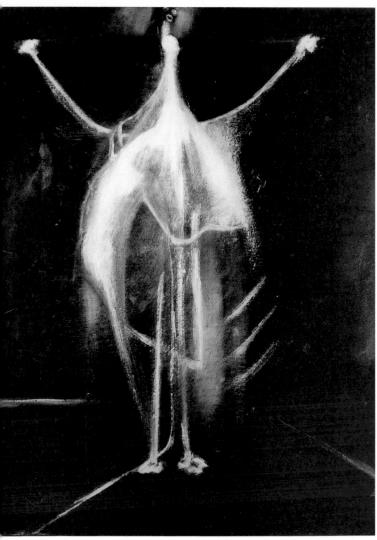

Crucifixion 1933

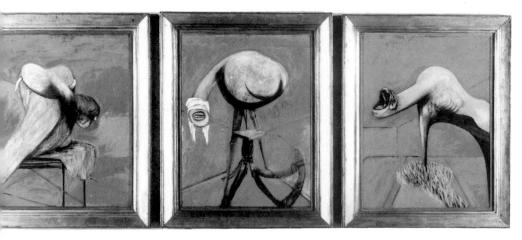

Three Studies for Figures at the Base of a Crucifixion 1944

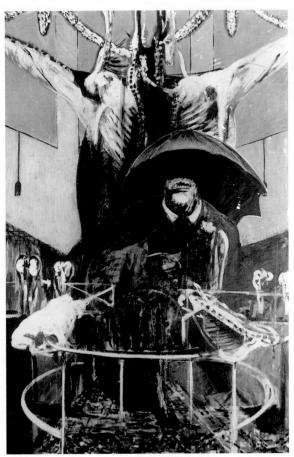

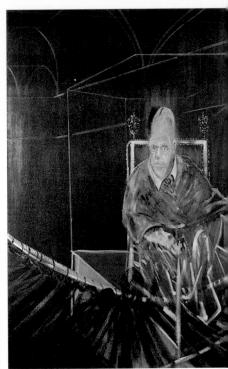

(above) Pope I 1951

(left) Painting 1946

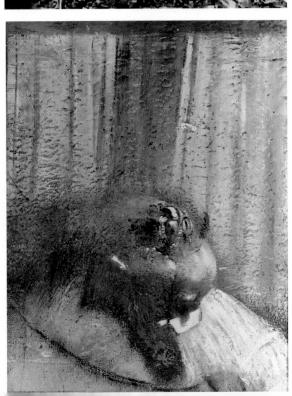

Head II 1949

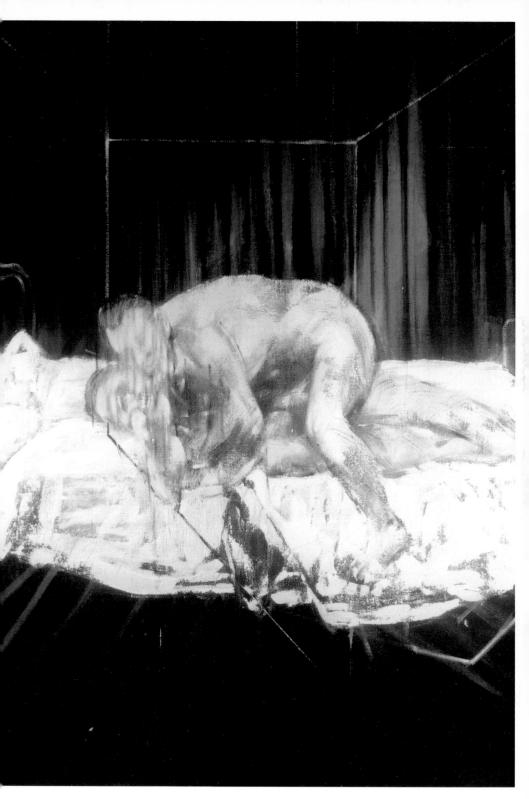

Two Figures 1953

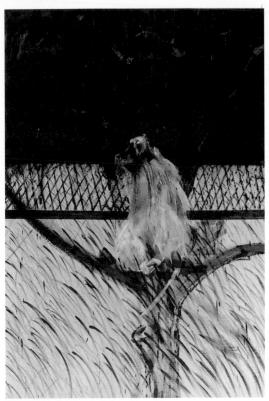

Study of a Baboon 1953

Study for Portrait of Van Gogh VI 1957

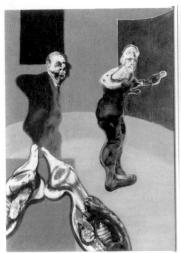

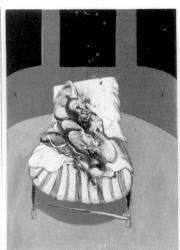

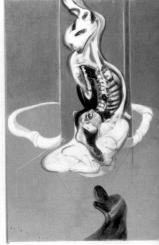

Three Studies for a Crucifixion 1962

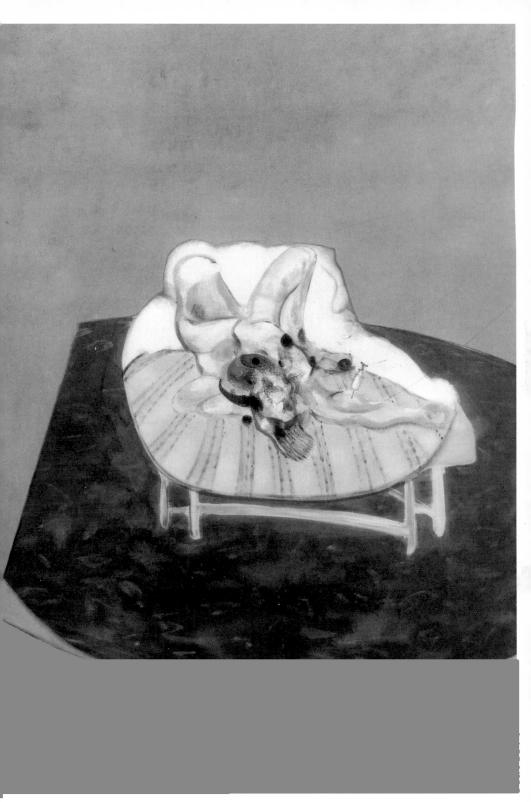

Lying Figure with Hypodermic Syringe 1963

Crucifixion 1965

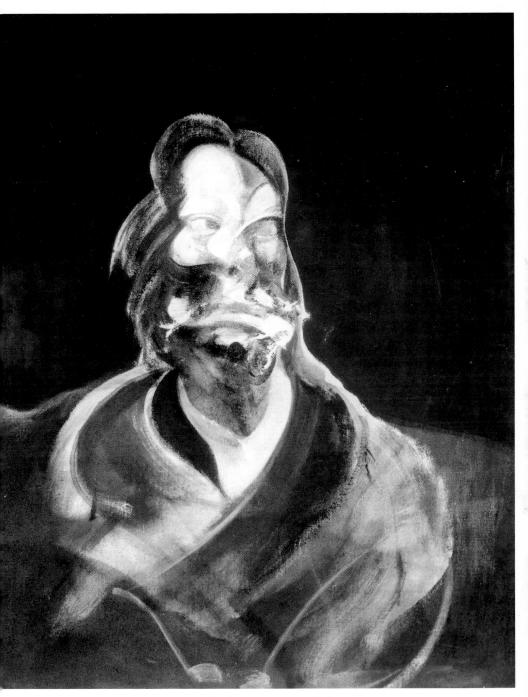

Portrait of Isabel Rawsthorne 1966

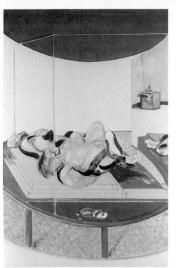

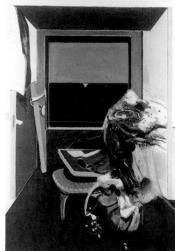

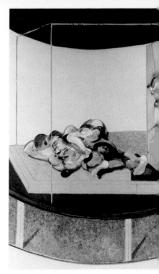

Triptych inspired by T. S. Eliot's Poem 'Sweeney Agonistes' 1967

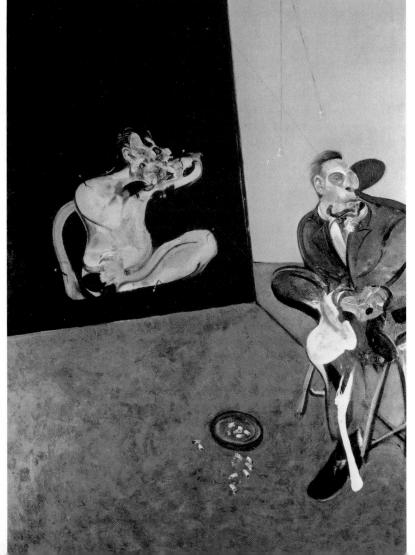

Two Studies for a Portrait of George Dyer 1968

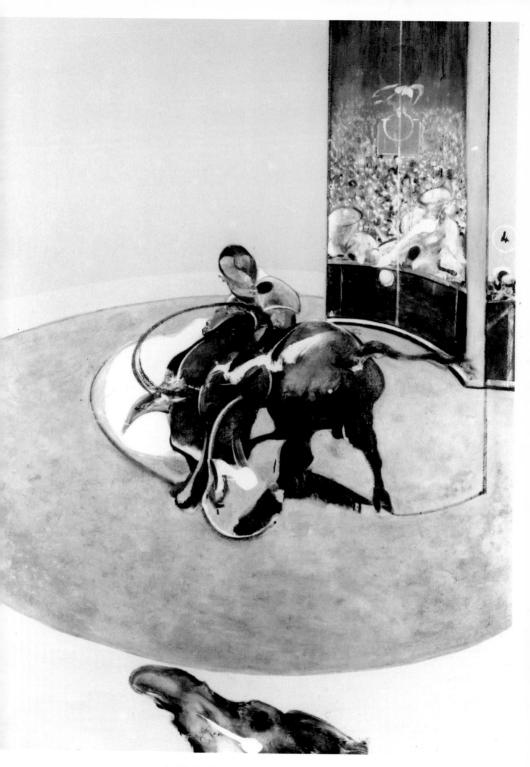

Study for Bullfight no 1 1969

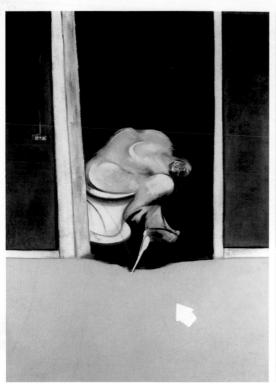

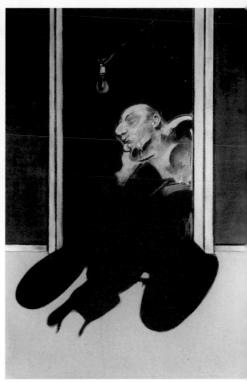

Triptych 1976

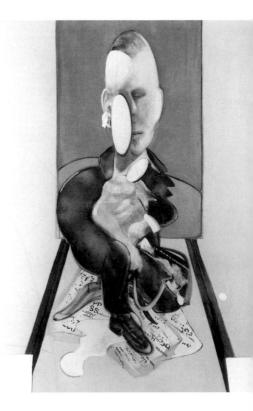

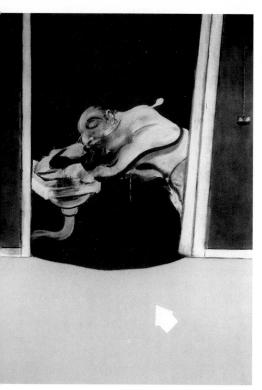

Triptych May-June 1973

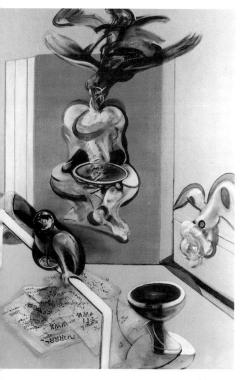

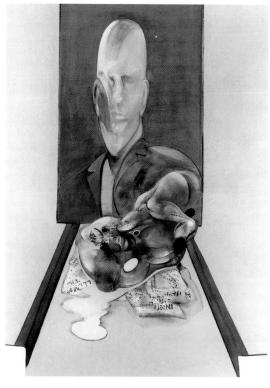

Second Version of Triptych 1944, 1988

illusion of a space within the pictorial space, gives the composition a particularly disturbing vanishing point, as if the eye were travelling further and further into vertiginous artifice. And only Bacon would add to his door-like screens knobs which are the shape and colour of burning lightbulbs, thereby giving the orange inferno a last chromatic twist of discomfort. Given this almost overconfident display of prowess, one might wonder whether the artist did not come occasionally to feel too much at home within his well-established themes of existential anguish, violent homosexuality and loneliness in a hermetically sealed room. Certain pictures had been painted, Bacon explained somewhat disingenuously in an interview at the time, to make up for works which collectors had refused to lend. 18 Thus the exhibition included a brand-new Second Version (1971) of the artist's famous Red Pope of 1962. Technically accomplished though the later 'version' undoubtedly is, it may also be seen as the beginning of a dangerous process of 'self-cannibalization' which was to affect Bacon's work increasingly. The point is perhaps better made if the Second Version of Painting 1946 (completed just before the retrospective, ostensibly because the artist feared that MoMA might not lend the original) is compared with the original image. The second version is far more skilfully painted and the whole alarming conjunction of man and meat carried off with the unhesitating aplomb of the master. But the original, albeit tentative in technique and perilously close to melodrama, is the stronger picture because the unease and struggle in it come through so rawly.

In sinister counterpoint to the frightening revelations in Bacon's paintings, rumours of George Dyer's death spread through the art world with all the speed of ill tidings. By the evening of the official opening, when a large banquet was held, various versions of the news circulated amongst the guests. The dinner had been organized in the Train Bleu, the Belle Epoque brasserie inside the Gare de Lyon; it was the kind of large, lively restaurant with a constant bustle of arrivals and departures that the artist enjoyed, and he had made a point of eating there whenever he took the train down to the South of France. Knowing that Bacon had barely begun to absorb the shock, involved as he was with the opening and also with the medical and legal formalities of an unexpected death, Michel and Louise Leiris suggested that he might prefer to cancel the celebration. But Bacon insisted that nothing in the packed official schedule should change, and a large contingent of friends and admirers from London and

Paris dined at tables that stretched the length of the Train Bleu in an atmosphere of tense conviviality. Though less ebullient than usual, Bacon showed no signs of strain when he rose at the end of the evening to give a brief vote of thanks for the banquet in his honour.

According to Bacon, Dyer had asked him well in advance whether he could accompany him to the opening in Paris. 'There had been nothing between us for ages,' the artist confided later, 'but since so many of the paintings were of him I could hardly say no.' The condition Bacon imposed, knowing how disruptive Dyer was once he was drinking ('I know it sounds mad for an old drunk like me to say so, but George became absolutely impossible when he drank'), was that he should undergo a cure for alcoholism at a specialist clinic in Putney. Dver accepted and, although it made him more withdrawn than ever, he stayed 'dried out' for a while. Bacon was sceptical as to how long the effects of the cure would last; he himself was able to control, and even stop cold, his manic boozing by an act of will. Dyer conspicuously lacked that strength, and once the pair of them began going round the restaurants and bars of Paris, Dyer began drinking 'moderately', inspired by Bacon's own flamboyant freeness with the bottle.

Bacon had booked them both into the Hôtel des Saints-Pères. an established favourite of his because it was close to the boulevard Saint-Germain and because the staff there, whom he tipped lavishly, always gave him a warm welcome. No sooner were the former lovers settled in, however, than their old arguments flared up, at times so violently that guests in other rooms down the corridor were disturbed by their drunken scuffles. Deeply irritated with Dyer, Bacon was in any case too preoccupied with the preparations for the opening to bother much about what he might be getting up to during the day. John Deakin (admittedly not everyone's idea of a chaperon) had been given the unenviable task of looking after the rejected boyfriend in Paris because he spoke French and knew his way around the city. But Deakin's own stay went by in what he called 'a blur of brandy, illness and purple hearts', and as things turned out - 'far from nightly dancing the "Merry Widow" waltz at Maxim's until dawn, ospreys in my hair and my throat ablaze with diamonds', as he had fondly imagined - the usually irrepressible photographer had barely been able to look after himself. 19 Knowing no one and feeling further estranged by the incomprehensible babble around him, Dyer went back on the drink with a vengeance, creating maximum havoc

wherever he was. This desperate and confused plea for attention failed to move Bacon, who was under continuous pressure to give interviews to the press and meet collectors and the movers and shakers of the French cultural establishment. Yet he knew that when drunk Dyer could become recklessly self-destructive. To close friends he sometimes mentioned that once he had come back home to find Dyer passed out from drink and drugs, with a note beside him saying 'We all have to go, it's not so bad'; but on that occasion, and again during their holiday in Greece, Bacon had arrived in time to get him to a hospital. Bacon remained intrigued thereafter by a profound contradiction in his lover's behaviour: 'He was always so careful with himself when he was sober - he couldn't stop washing his hands, and he always looked twice before he crossed a street.' But a mixture of irritation and preoccupation with the exhibition dominated the final days before the opening, and Bacon was only too pleased to leave Dyer to his own devices. Afterwards he repeatedly and bitterly regretted that, when he found their bedroom door locked, he had not gone immediately to ask the manager to have it forced open. It was the same manager who had come to him later, saying: 'I have something terrible to tell you. Your friend has committed suicide.'

When the hotel staff entered the room they found it in total chaos, with sleeping pills strewn everywhere, and Dyer slumped dead. In the medical report the death was described as 'accidental', and for the sake of Dyer's family this remained the official version. After the funeral, however, Bacon was the first to admit that 'poor George' had killed himself; he even insisted on it, whenever a well-meaning friend tried to soften the blow by citing the medical report. He was just beginning, in the middle of his bitter triumph in Paris, to take the facts in. To some, his stoic reaction looked like callousness. When David Hockney went over to him at the Coupole to express his concern, Bacon apparently said, 'Well, you can only laugh or cry,' pretending to weep. But Bacon was not the kind of man to break down and cry: he did not, as a general rule, display his intimate feelings. If there was a harsh side to him, coexisting with a deep compassion and generosity, it was because he had long ago trained himself to expect the worst from life. Conventional signs of grief may not have been forthcoming, but Bacon was profoundly affected. The day after the death, the hotel had moved him to another room: obviously, he did not want to stay where Dyer had died and, in any case, the police had ordered the room to be locked. However he

handled these first few days, Bacon suffered intensely for several years thereafter, and a feeling of loss and guilt remained with him until his death.

At a dinner with a few friends after the opening, Bacon described how, earlier that day, he had seen Dyer on a film that had been made in the run-up to the exhibition: 'He was so good-looking, and suddenly he had never seemed so present and marvellous.' Then, pausing at times, because of accumulated exhaustion and drink. to stare at some detail on the table or to beam mechanically at a passerby. Bacon talked about the death with a poignant simplicity those of us who were there will never forget: 'There it is. He's dead and nothing will make him come back. I've always known that it would go wrong. If I'd have stayed with him rather than going to see about the exhibition he would be here now. But I didn't, and he's dead. Those things have always been impossible. I've had the most disastrous kind of life in that way. Everybody I've ever been fond of has died. They've always been drunks or suicides. I don't know why I seem to attract that kind of person. There it is. There is nothing you can do about those things. Nothing.'

Elegy for the Dead 1972–75

Tous ceux qu'il veut aimer l'observent avec crainte. (All those he would like to love watch him with fear.) Charles Baudelaire, 'Spleen et Idéal'

Once the formalities for transporting the body were completed, Bacon returned to London to comfort Dyer's family as best he could. Emotions ran high during the funeral, with several of Dyer's friends, hardened East Enders, breaking down in tears. As well as grief there was confusion and even anger about the way he had ended his life. As the coffin was being lowered into the ground, one of the friends leant forward and shouted into the grave: 'You bloody fool!' Bacon himself went through the ceremony displaying the same kind of resigned stoicism that he had shown in Paris. Drunk or sober, he repeated his handful of facts with manic regularity: poor George is dead - there it is - nothing will bring him back - my life's always been a disaster - there's nothing you can do about those things. As the weeks went by, the loss began to haunt Bacon with increasing intensity; and by the time he came to paint his great pictures in memoriam, Dyer occupied the artist's thoughts and imagination more obsessively than he had ever done while he was alive.

No sooner had Dyer been buried than Bacon was confronted with the death of another close, if less cherished, friend. The illness that had laid John Deakin low in Paris became so critical that shortly after his return to London he was admitted into hospital to have a lung removed. Bacon, whose generosity never failed when his friends fell ill, gave him the money to go away after the operation and convalesce in Brighton. Having installed himself in a comfortable hotel, Deakin could not resist the grand gesture: the self-styled 'Mona Lisa of Paddington' had, after all, a reputation to maintain. In defiance of the most elementary good sense, he went out on the town with a vengeance, drank heavily and became so weak that he died the following day. While in hospital, he had named Bacon as his next of kin; and to Bacon fell the unenviable task of travelling to Brighton to identify the body. 'It was the last dirty trick he played on me,' Bacon recalled sardonically, making a joke out of the whole macabre business. 'They lifted up the sheet,' he told his friend Daniel Farson, 'and asked: "Is that Mr Deakin?" I replied: "It most certainly is." There she was with her trap shut for the first time in her life.'

There were also less harrowing matters to be attended to by the internationally celebrated artist. The retrospective had taken Paris by storm. One by one, the major art critics had paid homage to Bacon's gift for expressing the poignancy of the human condition, and comparisons were even drawn with great masters of the past, notably Rembrandt and Goya. Some of the critics were clearly exhilarated to be dealing with such powerful figurative images in a period when conceptual art - visually arid and affording little that engaged the passions - was taking over the fashionable Parisian galleries. Leiris wrote to Bacon to underline how well the exhibition had been received: typically, the artist responded by saying that if the show was a success, then it was to a large extent due to Leiris's fine introductory text.² As a result of the visceral pull of Bacon's pictures and the aura surrounding the artist, many people not usually drawn to art exhibitions visited the show. What intrigued and disturbed connoisseurs and general public alike was that, although they had a highly refined aesthetic of their own, the paintings claimed attention with a raw urgency not normally associated with art.

The Italian film director Bernardo Bertolucci, who was about to shoot *Last Tango in Paris*, was so impressed by the paintings that he went back to the Grand Palais to look at them with his leading man, Marlon Brando. *Last Tango*, which has Bacon images in the opening credits, in fact drew deeply on the painter's work. Bertolucci kept a copy of the exhibition catalogue within reach while he was directing, and later he acknowledged the way Bacon's influence had indirectly pervaded the film:

For Last Tango we settled on the kind of light given by the sun at sunset seen through large windows, and thus it was predominantly orange for the interiors. For the exteriors we started from a simple discovery made while we were location hunting. The lights in shop windows are always left on in winter in Paris, even during the hours of daylight, and the effect is a very beautiful contrast between the leaden grey skies and the warmth of the street-lights and signs. There was a grand exhibition of Francis Bacon's work on at the Grand Palais at that time, and the light in his pictures became another major key for the stylistic cyphers we were looking for. I took Marlon to see the exhibition because I wanted him to respond to and reflect Bacon's characters. I felt that his face and body were endowed with a similar, internal plasticity. I wanted Paul to be like Lucian Freud and the other characters that returned obsessively in Bacon's work: faces eaten up by something that comes from within.³

After leaving Paris in January 1972, the retrospective reopened in March at its second and last venue, the Düsseldorf Kunsthalle, a gallery noted for its openness towards the whole spectrum of contemporary art. Germany had been one of the countries, like Italy and the United States, to demonstrate an interest in Bacon from early on. Several German museums already owned examples of his work. and the Düsseldorf show was acclaimed by a well-informed public and a serious, respectful press. Back in Britain the art establishment was generally flattered by Bacon's success abroad - above all in what still struck English artists as the traditionally impregnable citadel of Paris – and undeniably impressed by the ever-higher prices paid for his pictures. Nevertheless, there was nothing approaching the reverential critical acclaim that had greeted the painter in France and Germany. A prophet is not without honour, save in his own country, the saying goes, and certainly several reviewers at home went out of their way to take Bacon to task. John Berger, the Marxist art critic who had written such influential books as The Success and Failure of Picasso, attacked Bacon's 'world view' in an article in New Society, claiming that the artist 'questions nothing, unravels nothing'. He then went on to make a detailed comparison between Bacon and Walt Disney:

Bacon's art is, in effect, conformist. It is not with Goya or the early Eisenstein that he should be compared, but with Walt Disney. Both men make propositions about the alienated behaviour of our societies; and both, in a different way, persuade the viewer to accept what is.

Disney makes alienated behaviour look funny and sentimental and, therefore, acceptable. Bacon interprets such behaviour in terms of the worst possible having already happened, and so proposes that both refusal and hope are pointless. The surprising formal similarities of their work – the way limbs are distorted, the overall shapes of bodies, the relation of figures to background and to one another, the use of neat tailor's clothes, the gesture of hands, the range of colours used – are the result of both men having complementary attitudes to the same crisis.⁴

Bacon professed never to read reviews of his work, saying, 'If I did, I'd probably never paint again.' But he was conscious of the antagonism his pictures still stirred up; he tended in fact to be more attentive to hostility than to praise, believing that, agreeable though it was, praise taught you nothing, whereas criticism might reveal shortcomings that could be worked on. Constant approbation would in any case have signified that his images were losing their vital power to challenge and disconcert, the worst possible situation as far as the artist was concerned. At times, when admirers waxed enthusiastic. Bacon would remind them (not without coquetry) that 'time is the only critic' and that it might take half a century to 'see whether my things have any quality at all'. He himself judged his work in that ambitious historical perspective: if he compared his work at all, it was not with anything contemporary but with the great European tradition. It was this deeply felt admiration for the Old Masters which prompted Bacon, who usually avoided public utterances, to talk on the BBC in March 1972 about the necessity of acquiring Titian's Death of Actaeon, then up for sale, for the National Gallery in London. What he said about this masterpiece related profoundly to his own view of life and to his own painting. Asked why he thought the painting should stay in Britain, Bacon replied:

First, it's a late painting by one of the greatest painters that the human race has so far produced, and now that they [the National Gallery] have both *The Death of Actaeon* and the *Bacchus and Ariadne* one can see the extraordinary development: the early painting is certainly a magnificent painting, but one sees, in this late painting, the way that the whole psyche has locked into the technique; in the corner where Actaeon has been turned into a stag, with the hounds yelping and setting on him, one sees the extraordinary way Titian has been able to weave these forms, as though he's used the light to work into the paint,

so that the images are never absolutely definite and yet they are the suggestion of a tremendously tragic act ... Now one of the reasons that this painting is of deep interest to me concerns the whole problem of painting today. If you think how abstract painting has taken over and how people find it almost impossible to be figurative, you will see, not that this kind of painting could be done today, but that there are all sorts of suggestions by which forms could be used and redeveloped in another way with everyday subjects. When I look at Actaeon being torn to bits by the hounds, I think also of the Eumenides, and it makes me think of how perhaps they could be used. Because we don't only live our life, as it were, in the material and physical sense: we live it through our whole nervous system, which is, of course, also only a physical thing, but it's a whole kind of long process of human images which have been passed down - and yet nobody knows how to go on using them. This painting suggests how forms and images could be remade to carry a meaning as definite as the death of Actaeon.⁵

The words exactly echo the artist's own preoccupation: how to convey, in a modern painting, a fact as 'definite' as the death of George Dyer. However much he attempted to go on living as before, drawing on all his reserves of defiance, Bacon became obsessed with Dyer's death: its hold on him grew as time passed until it emerged as the pivot on which his whole mental existence turned. He referred to it constantly, even in chance conversations in bars with people whom he had met for the first time. Although not given to expressing his deepest emotions to others, above all when sober, he talked to the close friends who had known Dyer well with a directness and candour about what he felt. 'Not an hour goes by, of course, when I don't think about George,' he admitted during a lunch we had at Wheeler's in the early summer of 1972.

I feel profoundly guilty about his death. If I hadn't gone out that morning, if I'd simply stayed in and made sure he was all right, he might have been alive now. It's a fact. He'd tried to do it before but I'd always been able to get him to hospital. He always did it under drink. I came back to the studio once and he was there with these friends of his, they were all dead drunk and just lying round the place. And George was stretched out on the floor with his sleeping pills strewn right round him. So I tried to ask the friends what he'd been doing, whether he'd been taking them or what, but they were just too drunk to know. It turned out he'd been taking them like sweets. He was very

ill after that. It did some permanent damage to his stomach...

He changed completely with drink. Because when he was sober, he was so careful with himself. But there it is. He's dead now. If I'd known what I know now I would have left him exactly the way he was when I met him, however mean it might have looked. Because in the end by giving him enough money to be able to do nothing, I took his incentive away. His stealing at least gave him a raison d'être, even though he wasn't very successful at it and was always in and out of prison. But it gave him something to think about. When George was inside, he'd spend all his time planning what he would do when he came out. And so on. I thought I was helping him when I took him out of that life. I knew the next time he was caught he'd get a heavy sentence. And I thought, well, life's too short to spend half of it in prison. But I was wrong, of course. He'd have been in and out of prison, but at least he'd have been alive. He became totally impossible with drink. The rest of the time, when he was sober, he could be terribly engaging and gentle. He used to love being with children and animals. I think he was a nicer person than me. He was more compassionate. He was much too nice to be a crook. That was the trouble. He only went in for stealing because he had been born into it, into that whole East End atmosphere where it's what's expected of you. Everybody he knew went in for it. If he'd had any discipline, he could have got a job easily, because he was very good with his hands. I got him something with my framer - he was going to learn gilding, which pays very good money. But he didn't make anything of it. I can understand that it's much more exciting to steal than to go out to a job every day, but in the end he did nothing but go and get completely drunk. In that way, my life has been a disaster. So many of the people I've known have been drunks or suicides, and all the ones I've been really fond of have died in one way or another. And it's only when they're dead that you realize just how fond of them you were.

Bacon's suffering was palpable. His face had an almost transparent pallor, and a kind of uncanny coldness emanated from him, as if his emotions had consumed his energy. There was no self-pity, no excuses and no complaints. But he had always been plagued by an acute sense of guilt, caused in part by his homosexuality and the way it had made him an outcast from his own family. He also felt guilty when he failed in terms of his own strict code of behaviour; one of the deep paradoxes in Bacon's nature was that, though ruthless in

getting his own way and satisfying his desires, often perverse and occasionally treacherous, he nevertheless had a keen sense of responsibility towards others. If he decided he had wronged someone, he would get agitated and go to great lengths to try and atone for the misdeed – offering apologies, sums of money or even a picture. But, quite clearly, not all situations were remediable. Peter Lacy's death had saddened him intensely, but Lacy had broken off all contact and devoted himself to his own destruction. Bacon had never felt responsible for him in the way he did for Dyer, who was dependent and vulnerable, and who had wanted not so much to do away with himself as to rekindle Bacon's affection.

Several months after the funeral, haunted by the memory of his dead lover, Bacon began working on some posthumous images of him. It was the only way in which he could fully express - and eventually, perhaps, assuage - his guilt and remorse. He had been thinking in a barely conscious fashion about how he might transform the facts of the death into a painting that would be as direct and conclusive as the bitter experience itself. He was aware, he said at the time, that 'it seems mad to paint people once they're dead, since you know that, if they haven't been incinerated, their flesh has begun to rot'. He also remarked that 'painting them doesn't bring them back'; and yet the paintings arose out of the artist's desire to have Dyer before him again, if only as a figment. Immediately after the death, Bacon had made a first attempt, a triptych entitled In Memory of George Dyer. The central panel shows the red-carpeted hotel staircase and a shadowy Dyer opening the door to the room where he was going to die. The outer panels have Dyer dressed like a boxer and apparently down, as in a knockout photo, on the left, and his image looming on a screen, on the right. With its pale lilac background, the sumptuous painting strikes an oddly false, theatrical. almost hysterical note, prompting the conjecture that Bacon was still in the state of numb confusion in which David Hockney had seen him at the Coupole. The death had to sink much further into his psyche before he could fully address the problem of re-creating the fact.

Obsessed throughout his career with the mortality of human flesh, Bacon would have seemed of all twentieth-century artists the most able to record death in a painting. It is undoubtedly the most demanding theme, full of pitfalls; and the difficulty it presents is directly reflected by the astonishingly small number of pictures

representing death to have been painted in modern times. This thought was clearly in Bacon's mind when he talked on the radio about how Titian's 'forms and images could be remade to carry a meaning as definite as the death of Actaeon': as on previous occasions in his development, he had to look a long way back into the classical tradition to find an image that would help him achieve what he sought.

The full-blooded, melodramatic mood of *In Memory of George Dyer* gives way in *Triptych August 1972* to an unearthly atmosphere in which life appears suspended by a thread. Death has increased its dominion on all three panels, rising as a rectangular black void and eating into the bodies of the lovers at the centre and the single figures in the wings like an acid. What death has not already consumed seeps incontinently out of the figures as their shadows. George Dyer is seated on the left, with a faint dotted line drawn through his partly excised torso, while on the right a figure resembling the artist himself sits slumped and barely conscious, with half its body bled away into the void. Copulation and death, above all death, sum up all the facts here; there is no opening left for a birth; everything has become an end.

While he was working on ways of commemorating Dyer, often completing a large panel within a week, Bacon was also engaged in a parallel series of small self-portraits. He had made a few attempts at painting himself in the late 1960s while he was portraying his close friends, but through the early 1970s he concentrated almost exclusively on images of Dyer and himself, capturing with impressive mastery and detachment the effects of suffering on his own face. In these self-portraits, which came as small heads, singly or in a series, and occasionally as full-length paintings, Bacon used on himself some of the same expressive means he had found to portray his dead lover. Parts of the head are scalloped out or hidden by great black brushstrokes of shadow. In sharp contrast to the theatrical sumptuousness of the paintings of the previous decade, with their emphasis on brilliant new visual metaphors, the heads come out of a need to reduce and simplify. In one series, the black background laps round the artist's face like a liquid, submerging all but a few features. Yet the heads are always instantly recognizable, and all the more vivid for the encroaching darkness.

Bacon referred to the sudden flow of self-portraits with sardonic humour. 'I loathe this old pudding face of mine,' he often claimed,

'but it's all I've got left to paint now.' He knew his own appearance with absolute accuracy, not least from a lifetime of making himself up. Self-portraits remained a dominant feature of the artist's output for the rest of his life, but here they have the particular poignancy of bereavement. In a new large triptych, painted in 1973 and entitled Three Portraits, Bacon portrays himself, a blur of confused movement. seated in the central panel. He is flanked by a heroically muscled and handsome George Dyer on the left, and his old friend Lucian Freud, caught in a sudden contortion on the right. Small portraits or photos of Bacon and Dver, images within images, have been spiked to the walls of the outer panels, but in the otherwise barren interior there is nothing to distract attention from the figures themselves. Another large self-portrait painted the same year records the artist's deepening despair with the graphic detail of a diary: the emotional isolation conveyed by Self-Portrait, 1973, where the figure leans for support on a washbasin, apparently ripped off the wall and left to float on the picture plane, is so tangible that the incongruity of the image simply adds to the immediacy of its impact. This extraordinary picture conveys better than any verbal description the way Bacon was capable of bending reality to his needs with a force and conviction that overrode the protest of logic.

The washbasin was inevitably linked in the artist's mind with George Dver's last moments in the locked bedroom of the Hôtel des Saints-Pères, where Bacon returned to take a room with macabre obsessiveness on subsequent visits to Paris. It reappears in Triptych May-June 1973, the artist's last and most moving memorial to the death. In most of Bacon's triptychs the three panels do not suggest any particular sequence; they can be 'read' in any order, which is what the artist intended, and the main reason why he had each of them put in a separate frame. Time, the essence of narrative, has been removed, as if sucked away like the air in the pictures' shallow, hermetically sealed interiors. Not only is Bacon's space unbreathable, it has been cut off from time and is therefore profoundly disorientating: this, as much as any 'violence' in the imagery, accounts for the unease the pictures arouse. Here, however, the panels inevitably have a sequence, since they record the last actions of a dving man. Given the few known facts, the sequence must begin, on the right, with the figure vomiting into the washbasin; with blood streaming from his nose. Dyer makes a final confused attempt at regaining life. The central panel is more ambiguous: this might be Dyer, moments before,

still 'in the shadow of death', or it might be the actual moment when death strikes. It is impossible to tell, but with the shadow image, cast as if by an unseen bird of prey, Bacon invented a haunting visual metaphor for death, ever circling, ever ready to swoop. Beside this ominous shape, as dark and vengeful as a Fury, a waste pipe obtrudes. In a stroke of brilliant Baconian shorthand, ancient myth and the tragic banality of death in a modern hotel are suddenly yoked together. The basin, the lavatory and the waste pipe all drain away: blood, excrement and vomit. Life itself drains away, whether as part of Greek legend or merely as waste matter. The result is the same, leaving the body doubled over and dead on the lavatory bowl on the left.

With this grand, stark picture, Bacon brought to an end, in pictorial terms, his mourning for Dyer. The dead friend returned in several subsequent works, but more in association with the lost past than as the subject of direct elegy. These commemorative paintings, which are often referred to as the 'black triptychs', stand apart in Bacon's *oeuvre* as the record of a specific ordeal; in purely aesthetic terms, they are also important since they mark the beginning of the artist's late style, with its increasing economy of means and heightened simplification.

The effort and discipline required to give this painful experience its fullest expression in a work of art no doubt helped Bacon to come to terms with it on a personal level, but the memory continued to haunt him. 'They say that time heals,' he said, referring to Dyer's death, 'but I really wonder about that.' Even though he did once remark, when deeply dejected, 'When I think about the whole of life, I sometimes wonder whether George wasn't right to do what he did,' the idea of suicide was utterly alien to Bacon. 'I myself want to go on living as long as I can,' he would say. 'After all, there's nothing else. You can only go on living from moment to moment. You can't even prepare for death, because it's nothing.' Flatly nihilistic though such remarks were, they were often delivered with an exuberant bonhomie that made them hard to disagree with. 'There it is,' he would continue triumphantly, with a glass half raised as if he were about to propose a toast, 'we can just go on living, even though we know something terrible will happen.'

Bacon lived in expectation of the worst. He feared Communism and regularly predicted war, especially with the former Soviet Union,

which he was convinced would at any moment march across Europe. 'Just look in the shop windows – there's nothing left,' I remember him exclaiming once in Paris as we walked together through Saint-Germain-des-Prés. 'You only have to look in the shops to know there's a disaster coming!' Convinced of man's inhumanity to man, he never expressed any dismay or outrage at atrocities reported in the press, which he followed closely. 'When I see them killing each other, in Ireland or wherever, I can't say I get worked up about it.' he remarked. 'I just think, oh well, there's ten or twenty more of them gone.' In his own life, he foresaw potential catastrophe on most fronts. Illness was a constant preoccupation and, although he remained as reckless with his health as when he was young, he staved in close touch with his doctor who, over the years, became one of the artist's most trusted friends. Bacon was adamant that, after Dver's death, he would never have 'an intimate relationship again: that side of life has been cancelled out for me now'. This was not to be the case, but for a time nothing would shake his conviction. As far as his painting went, he often expressed doubts that his work would continue to command high prices or, indeed - given that, 'deep down', people did not like his pictures – any price at all. Having conjured up this grim eventuality, he countered it by saying that if he had no money he would go back to being someone's manservant – a definitely unusual 'gentleman's gentleman'. This option would emerge when he was far gone in drink, which brought a final touch of burlesque to the prospect of a Bacon down on his luck, alarming some hapless employer as he lurched in with the morning tea or staggered among his guests serving too much champagne.

Bacon also worried from time to time about the mews studio in South Kensington which he had rented since 1961. Although it would not have appeared to most people to have any identifiable attraction with its bare, low-ceilinged rooms and minimum comforts, it was essential to Bacon. Like Cromwell Place, where he had painted his first important works, Reece Mews had become a hallowed space because he knew he could work there. The light and the surroundings were definitely dismal, the studio so small the artist could work only on one canvas at a time, and access to the street such that no painting larger than Bacon's habitual format could be squeezed down the stairs and through the door. But these limitations appeared to work in his favour, and as the splashes and trickles of paint thickened on the walls and the great tide of books, photos, artist's materials,

clothes and miscellanea swelled on the floor, Reece Mews became the irreplaceable centre of Bacon's working life.

Since he had never had the chance to buy the lease on his studio. he was concerned that he might eventually be evicted, above all when he saw nearby properties being razed for 'redevelopment'. This anxiety, coupled with a desire to change his surroundings from time to time, led him to buy a succession of other places which, by and large, he never used. There was a profound, possibly neurotic, contradiction in Bacon that made him long for another style of domestic living which, once achieved, was rejected. Although he spent much of his time in restaurants, bars and clubs, he enjoyed a certain amount of domesticity. When his relationship with Dyer was flourishing, he occasionally invited a friend or two to have dinner with them at home. Preparing a meal appealed to his convivial nature, and he found the whole subject of food, which he loved to discuss in detail, pleasantly relaxing; he would read and reread the classic cookbooks, such as Elizabeth David's, especially at night, when he found they had a soothing effect on his recurrent bouts of insomnia. Bacon prided himself on producing food that was both very good and very simple; his specialities included the roast chicken with bread sauce which he made a point of serving to his French friends, with the pleasing result that 'la fameuse bread sauce de Francees' had a cult status among Parisian intellectuals for a while. Nevertheless, Reece Mews did not adapt naturally to entertaining. and Bacon made several attempts to find an alternative solution.

At one point he bought an impressive studio at Roland Gardens, a short walk away on the other side of the Old Brompton Road. He went to considerable trouble to get it decorated and furnished to his liking and then found he could not even begin to work there. It was 'too grand', and that inhibited him from wiping brushes on the wall, letting paint drip and amassing various documents and tools underfoot. Roland Gardens was given to George Dyer, and Bacon returned to the layered and liberating mess of Reece Mews (where even the accumulated dust proved useful, being incorporated into several seminal images). At various times, he took odd rooms around the city, as a change or a refuge from company that was no longer desirable. More curiously, for a man for whom living in the country was anathema, he also bought a house in Wivenhoe, near Colchester in Essex, where he had often gone to visit two old friends. The local newspaper reported the story:

Bacon, whose paintings sell for up to £100,000, has acquired a £6,500 house in Queen's Road. Two of his best friends, artist Denis Wirth-Miller and writer-painter Dickie Chopping, who designed the James Bond book covers, live nearby.

Bacon, wearing leather coat and dark glasses, said: 'My eyes are broken.'

This is no doubt a reference to one of the many 'accidents' to which excessive drinking and sadistic lovers made Bacon particularly susceptible. Once he had recovered, the house in Queen's Road was rarely mentioned and was also given away. Another, more important purchase had been made some time previously, in 1970, the year before Dyer committed suicide, when Bacon bought a house in Narrow Street, overlooking the Thames in Limehouse. For many years, the East End had been a home from home for the artist, who found a quick-witted directness and uncomplicated warmth in the rowdy mix of dockers and sailors, crooks and traders he met there. There was an atmosphere of lawlessness and transience that deeply appealed to him. He frequented a number of pubs in the area, including well-known ones such as Charlie Brown's on West India Dock Road, and the Waterman's Arms, a music-hall house which his friend and drinking companion Daniel Farson had got going on the Isle of Dogs. It was from the East End that several of Bacon's most intimate friends had come, notably Dver and the artist's new companion from the mid-1970s, John Edwards, who at that time was helping his brothers run three pubs. Although there are obvious reasons why Bacon was attracted to the East End, a whole world away from genteel South Kensington, the idea of having a house down there would seem impractical, not to say senseless, unless one took into account the powerful role which fantasy played in the artist's decisions.

One of Bacon's fantasies about Narrow Street emerged clearly when he announced melodramatically: 'I have just bought the house I shall be murdered in.' He also believed that the new premises would bring him a new life: a refreshing freedom, cleared of the falsifying paraphernalia of book culture and art criticism, and a return to the kind of wayward existence he had enjoyed as a youth in Berlin and Paris. The artist made countless long hauls by tube and taxi across the city while the Georgian terrace house was being meticulously restored. He himself undertook the interior design, instinctively revert-

ing to the overall look of streamlined sparseness he had created in 1929 when he converted the garage at 17 Queensberry Mews West into his first studio and showroom. The wooden floors were kept uncarpeted and the walls bare apart from a couple of large mirrors. Brushed steel handrails led from one open-plan floor to the other, and the few pieces of furniture – mostly deal tables and bentwood chairs – were of good quality but of the simplest, most unobtrusively modern design. On the top floor bedroom and bathroom were combined without any dividing wall, with tub and toilet agleam beside the bed. The entire interior was dominated by the light which flooded through the huge windows looking out over the Thames.

The river view gave Narrow Street much of its appeal. The constant interplay between the great expanses of sky and water created the impression that one was on the edge of a limitless world. From the windows or on the small landing stage outside, the river's intricate traffic of lighters and tugs, cargo ships and customs launches vied for attention with the huge cranes swinging bales and crates high in the air before landing them on the old timber wharves. In the evening the hubbub gave way to a silence made more perceptible by a gull's cry and the enveloping smell of river mud. For a time Bacon relished going there to enjoy the maritime pageant with food brought down from Harrods and too many bottles of fine claret from a well-stocked cupboard. Narrow Street was perfect for parties, which no one enlivened and enjoyed more than the artist himself, spluttering with laughter and staggering about the large downstairs room with a freshly opened magnum of frosted champagne. But parties provided only a momentary diversion for Bacon; while his guests nursed their hangovers, he wanted to paint. It was then that Narrow Street let him down. The waterway turned into a cacophony of ships' horns and clanking metal sheets; much worse was the light, a perpetual glittering and flickering on the changing tide that made any consistent progress on a canvas impossible.

Bacon's appearances in Narrow Street grew gradually rarer until he determined, almost out of pique, to get rid of the house. Living space on this choice waterfront had become more fashionable, and the house was duly sold off to Bacon's neighbour, the politician David Owen. One reason for the artist's disenchantment was that he had become deeply involved with another fantasy place. It was in the city where he had always wanted to live since his very first visit, and again just after the war when he had suggested to Graham Sutherland

that they both share a studio in Paris. The impulse was made more urgent by the fact that George Dyer, whose suicide Bacon had just finished commemorating, had died there; out of a mixture of morbidity, guilt and a masochistic desire to suffer more, Bacon had become more strongly drawn to Paris than ever. Since Dyer's death, he had also developed close ties with a handful of friends who lived in the French capital, and although he liked the ease and anonymity of well-run hotels, he wanted to be able to work freely, uninhibited by the alarm even the most sympathetically inclined manager might experience as a room was taken over by impetuous paint marks and a thick layer of the artist's creative 'compost'.

During his visits to Paris, Bacon regularly got in touch with me. I had settled in the city and was living in a small seventeenth-century house which the artist greatly admired in the heart of the Marais. not far from the Place des Vosges. Although Bacon had previously been more at home on the Left Bank, he was immediately attracted by the fallen grandeur that characterized the Marais's classical townhouses, abandoned during the Revolution and mainly inhabited by small artisans who had raised ramshackle workshops in their elegant courtvards. The local people were not unlike the population which had drawn Bacon, with his homosexual fantasies about the working class, to London's East End. Virtually every traditional trade. from wrought ironwork to gilding, flue cleaning to chandelier repairs. was represented in the densely populated streets, behind the blackened, historic façades. The attraction proved mutual: as he rolled around the cafés of the Marais with exuberant open-handedness. Bacon was an instant success. Although diffident about his command of French, he gave a consistently impressive performance. No matter that he would not have passed a scholarship exam with his idiosyncratic grammar and accent: he was able to be entirely himself in French, direct and natural – very much as he had been in painting. without the benefit of schools. Fruit and vegetable sellers who had left their street stalls for a quick one at their local zinc were visibly amazed. Not only did this genial fellow buy them more drinks than they had ever seen and defer to their opinions about politics and life in general – he was also English! At each visit, eating and drinking copiously in the quartier, the artist gave an entirely new spin to the popular French conception of their ill-fed, puritanical cousins across the Channel.

Bacon himself was not unaware of the palpable hit he had made. and he accelerated his search for a small flat in the Marais where he could live, work and become part of the city which had acclaimed his painting. He was looking for a Parisian equivalent of Reece Mews, an uncomplicated space where he could lock himself away and paint whenever the sterner side of his personality dictated it. As impetuous in such decisions as he was in placing counters on the roulette table, Bacon plumped for the first property I found for him: a single large room with a high, open-beamed ceiling and perfect north light falling through two tall elegant windows. From this impressive living space, stairs led down to a large kitchen and bathroom. The size and light were perfect and, equally important, the compact flat was off the street, on the second floor overlooking a cobblestoned courtyard. It was as close to a mews as one might find in Paris, with the added advantage of being in a protected historic building just beside the Place des Vosges.

No sooner had Bacon acquired the flat on the rue de Birague than he gave an impromptu party there for a number of his friends. He was delighted with everything about his new Paris studio except for the decoration, and in particular the expensive black and gold flock wallpaper put in by the previous owner, a rather pompous architect who prided himself on his taste. The architect had met Bacon several times during the exchange of contracts and was gratified that a famous painter should have admired his taste enough to buy the flat. Bacon had not disabused him. But as the party warmed up and the champagne, coming on top of a well-wined lunch, began to have its effect, the artist could no longer restrain himself. He grabbed a loose corner of the flock paper and began to tear it off in handfuls. His guests, who included Sonia Orwell from London and several luminaries in the Paris art world, gleefully joined in at various points round the room. Unfortunately, in the drunken merriment nobody noticed that the door had been left ajar and that the architect was standing there, transfixed, watching his flock fall.

Once the entire space had been whitewashed and some favourite furniture – a fine old sea chest and a circular marble table – had been installed, Bacon began to stay regularly in the rue de Birague for several weeks at a time from the autumn of 1974 onwards. After five or six years, the stays became shorter and more sporadic; nevertheless, he continued to make regular use of the flat for over a decade. At the outset, Bacon's enthusiasm was unbounded. He

separated the room into a sleeping area and a studio, which he equipped with an easel, a stack of large, stretched canvases and a painting table on which a coagulated heap of half-used paint tubes. brushes and rollers, sponges and rags grew with each working session. He also located a good-sized dustbin lid to help him trace large circular shapes, and a couple of T-squares. Paint-soaked socks and cashmere sweaters, the latter much prized by Bacon for the delicate ribbing effect they produced when pressed on the canvas, also appeared in the heap, alongside brilliantly daubed dinner plates and frying pans which the artist had seized on for want of a more traditional palette. Other odds and ends turned up in this visually fascinating mound, such as an oyster knife, restaurant bills, photos, Métro tickets and handfuls of loose change, that gave it an organic. self-transforming presence. When no pictures were being painted, the table dominated the room, as if future images were germinating there within its seething, multicoloured hump.

On shelves and on the floor the source material quickly proliferated. Books on Egyptian art, Michelangelo or Degas lay beside crumpled, paint-spattered photos of birds in flight, beak and talons outstretched, charging rhinos, athletes springing into the air and Nazi leaders haranguing the crowds. Much of the visually intriguing mess lay around the easel where, in the evening, it would be caught in the glare of a whole ramp of spotlights which Bacon had fixed on the room's massive central beam overhead. As in the London studio, there were also an increasing number of reproductions of his recent paintings, one of several signs that he had begun to reinterpret his own work and become his own source of inspiration. There were also the latest books by his French writer friends Michel Leiris. Marguerite Duras and Jacques Dupin, as well as several volumes sent by writers such as Hervé Guibert, one of a growing band of young French admirers – artists and authors, photographers and drifters – who followed Bacon as he went around the city in the hope of getting to know him.6

Although he had chosen the flat because 'I knew from the moment I walked in it was a place where I could work', Bacon did not try to work much during his first few rapturous stays. Paris itself and his widening circle of friends were too fascinating. He allowed himself to be lured out every day, often all day, and frequently for most of the night. Soon he knew the geography of the city as well as he knew London. In Paris, even when you had dined and taken in some

nightclubs, there was always somewhere else to go on to, even after the old Halles de Paris, where Bacon had loved to pitch up at the end of a long night out, had been pulled down. Able to go for long stretches with almost no sleep, he had twice as much time as most people, and used it to the full: having endless lunches, then drifting through the afternoon drinking too much and arriving, to all appearances miraculously sober, at formal dinners or receptions, before disappearing into the night to run the gamut of more specialized bars where, as he put it archly, 'I might meet someone I could talk to'.

Bacon's Paris existed at a number of different levels. As in London, he enjoyed from time to time the luxurious security of Paris's great hotels. Within a few months he knew the Crillon and the Plaza-Athénée almost as well as he knew Claridge's and the Connaught back home. He understood from a lifetime's experience whom to tip, in what amounts and when. Just to make sure, he always overtipped, thereby securing himself the warmest of welcomes. Dropping in to the Paris Ritz for tea or sharing a bottle of Krug in the Crillon bar became a way of resting for Bacon as other people would take a siesta. He would emerge refreshed, ready for the boring dinner with the dull but important collectors or for the long night's drinking that lay ahead. Similarly, within a year or so, there was hardly a prominent restaurant that the artist did not know and have a decisive opinion about. Often he would have both lunch and dinner in famous establishments because, he would insist, if you can't go home to a lightly boiled egg and a green salad, it is difficult to follow a supreme meal at Taillevent or Lucas Carton with an insipid stew at a local bistro. Whatever else was happening in his life, Bacon made eating well an absolute imperative. Deeply sensual by nature, he never quite forgot the shortages and rationing that had made good meals such a rarity in war-time England. He also made sure that he had a properly balanced (if excessive) diet in the hope that it would offset the ravages of alcohol. A healthy appetite and an exuberant love of making merry would sometimes find him following a large lunch and larger dinner by a substantial late-night supper at one of his favourite brasseries like the Coupole in Montparnasse, or Bofinger, just off the Bastille and a short walk from his flat.

Bacon's idea of restraint in restaurants was to avoid dessert, but that did not prevent him from making his way through three courses and sometimes, to accompany one last bottle of claret, a savoury. He also took great care what he chose, studying the menu intently and often ordering the lightest dishes, such as oysters and grilled fish; then he would become hungry and eat a great deal of bread and cheese. Whenever there was no call to go to a grand restaurant – to treat old friends, or impress a collector or potential lover – Bacon was delighted to try a 'simple' bistro, particularly if it served the rough country fare he enjoyed. But his standards were very exacting, and (especially when too much drink had soured his mood) nothing would compare to the *tête de veau* he had eaten twenty years previously; then the bistro in question would be dismissed as 'simply filthy'. Bacon considered quality and taste, in food as in art, of paramount importance, and nothing brought the venom out in him as quickly as a bad meal.

There was no shortage of friends with whom to share these culinary ups and downs. During each visit to Paris, Bacon made so many new acquaintances in his wanderings that he soon seemed to know or certainly be seeing more people than in London. Even so, he was as discriminating in questions of what he called 'the company she keeps' as in food: few casual encounters, however promising he imagined them to be at first, lasted beyond a night of bars and disjointed conversation. For all his tendency to regard the person most recently met as his 'latest and greatest friend', Bacon ensured that it was with his old Parisian friends that he spent a large part of his seemingly boundless available time.

On each visit, he rarely failed to have at least one long lunch with Michel Leiris. The relationship between the two men, based on unwavering mutual admiration, deepened considerably during the years that Bacon was making regular use of the flat in the rue de Birague. Their friendship flourished partly because the painter happened to be a committed Francophile and the writer a vintage Anglophile. Only eight years older than Bacon, Leiris appeared nevertheless to belong to the previous generation because he had been at the forefront of French intellectual life from an early age. Leiris was intimately linked to the Surrealist movement (of which he remained one of the last surviving members) and to Picasso; and these were the two phenomena in French intellectual life which interested Bacon most. He was particularly fascinated by Picasso's influence on surrealism. 'Even if Picasso was not a Surrealist.' Bacon remarked in a letter to Leiris, 'he was in a sense a precursor with his superb Femme en Chemise of 1912.'7

Bacon's correspondence with Leiris constitutes one of the very few

written records that he left behind. In all, he sent some forty-seven letters, postcards and telegrams to Leiris, who carefully preserved them. The letters, virtually all in French, range from the briefest of greetings to a detailed analysis of 'realism'. They testify primarily to the close intellectual friendship that evolved between the two men. Bacon read Leiris's books as they were published and often referred to them admiringly in the letters; he was particular impressed by Frêle Bruit, the last volume of Leiris's four-part autobiographical La Règle du Jeu (the preface to which had once encouraged Bacon, in despair about his work, to start painting again). Many of the letters convey his gratitude to Leiris for one of the texts he had written on his painting. 'I don't know how to thank you, Michel,' one of them runs, 'it's the first time that someone has explained what I want to do, even if I don't succeed in doing it. And thank you, too, for saying that I am not an expressionist.'8 Later, in the same vein, he tells Leiris that he is 'the only one to have understood and to have put into words all sorts of things that I have tried to do'; 'I know', he adds, 'that I am very privileged to have had texts written about me by the greatest writer of our time.'9

Leiris admired Bacon because he showed a daring in his art and in his life to which Leiris subscribed fully in his books but which he felt incapable of incorporating into his decidedly comfortable, sheltered existence. Not for nothing did Leiris entitle one of his essays 'Bacon le hors-la-loi' (Bacon the outlaw), or compare him in the opening paragraph of his monograph on the artist to a succession of legendary heroes: Orestes, Hamlet, Don Juan and Maldoror. 10 Leiris had visited London frequently, not only for events such as the Tate's Giacometti show and to see friends like Sonia Orwell, but also to be fitted for the suits which he had made in Savile Row. London appealed to Leiris's liking for understated elegance, and to his love of the exotic and the bizarre. He was delighted to find, for example, that there was a real place called the Elephant and Castle, and deeply intrigued by the atmosphere and the members of the Colony Room, which he visited under the aegis of his more ebullient painter friend. With amused awe, he would recall the occasion when one of Muriel's habitués had staggered drunkenly across the room towards him, taken him in his arms and asked: 'Are you alone?'

Although he realized that some of the subtlety of Leiris's complex style might elude him in French, Bacon was deeply impressed by his writing. When the question arose as to who might be entrusted with the translation into French of Bacon's conversations with David Sylvester, Leiris seemed an obvious and prestigious choice. With characteristic scrupulousness, Leiris objected that his command of English was insufficient, but he later accepted on condition that a cotranslator provide a literal translation on which he could build his own version.¹¹

At Bacon's request, I supplied a word-by-word rendering, and while Leiris set to work, meeting me periodically at the Deux Magots to discuss nuances and clarify potential ambiguities. Bacon decided to make a portrait of him. In the mid-1970s he had continued to paint small heads of himself, and in 1975 he had produced two small triptychs of the American photographer and author Peter Beard, who had been a close friend for some ten years. Beard was a strikingly good-looking young man, and Bacon knew his appearance well from having observed him closely and from the sheaves of photographic studies Beard had sent him. Leiris had already been portrayed by several artists, including André Masson and Giacometti, but far removed as he was with his slight frame and ageing face from the English painter's habitual ideal of youthful virility, no one captured his appearance and his spirit - both timorous and stubborn, conventional and rebellious – as closely as Bacon. Dated 1976, the first of what were to be two studies of Leiris folds several different viewpoints of the writer's head into a simultaneous image; through the confusion of features, a single eye fixes the spectator with an astonishing intensity. The portrait is a masterpiece of controlled distortion, and Leiris emerges from it with the force of a survivor. The second head is less distorted and also less lifelike. Bacon himself was not satisfied with it. Having given me the portrait, he took it back one evening with the intention of reworking it – usually a sign that he was about to destroy it. Fortunately he did not, because although less spontaneously convincing than the earlier portrait, it conveys the mixture of compassion and despair which Bacon saw as the essence of Leiris's personality.

Another French writer whom Bacon greatly liked and admired was the poet and gallery director Jacques Dupin. Dupin wielded a decisive influence at the Galerie Maeght, where he worked closely with the artists, preparing and hanging their exhibitions as well as writing about their work. He had first met Bacon through Isabel Rawsthorne, and began to see more of him during trips to London to help Giacometti set up his retrospective at the Tate. In the run-up to

Bacon's 1966 show at the Galerie Maeght, the two men spent a great deal of time together. Dupin recalls numerous epic evenings with the painter in London where, after plenty of drinks and a good dinner, they would go on to gamble at one of the clubs Bacon frequented, and where the staff knew that he usually stayed until he lost everything. Accordingly, Dupin would be allowed to do better and better, until he had a fortune sitting in front of him which the house then slowly proceeded to win back. Eventually, having both lost, they would end up in Covent Garden for some supper and more drinks. Late one night, Dupin remembers, Bacon fell in with an ex-boxer, and while they were in each other's arms, the artist's face would reappear from time to time through the boxer's caresses and continue the discussion on Velázquez they had begun earlier. When Dupin finally left Bacon around dawn, exhausted and longing for his bed, the artist would tell him that he was off to the studio to work.¹²

Work did not appear to be a primary concern of Bacon's during his extended stays in Paris. The city excited him, and friends of all kinds proliferated. Besides the contingent of writers and art world people that the artist saw regularly, there was an ever-changing host of drinking companions whom Bacon encountered on the nightclub circuit. The people with whom he had a passing or more lasting acquaintance were of a prodigious variety, ranging from a lesbian heiress who appeared only at night, accompanied by her bodyguard, to a guick-witted carpenter whose very 'ordinariness' appealed to Bacon. And yet somehow, early in the morning when others slept and the telephone had not begun to ring, the artist worked, as if translating rapidly on to canvas the images that had been formulating in his mind as he caroused the days and nights away. 'You have to be disciplined in frivolity - above all in frivolity,' he reiterated, and the paintings completed in his Paris studio were tangible proof of his own iron will. Major exhibitions of his work were soon to take place with increasing frequency, and in the sea of faces and the blur of champagne, Bacon never lost sight of his first and most compelling commitment.

'My Exhilarated Despair' 1975–81

Grant me an old man's frenzy, Myself must I remake ... W. B. Yeats, 'An Acre of Grass', 1936

However much Bacon gave himself over to private pleasures, his public persona and his career continued to develop as if they had a life of their own. In 1975 the Metropolitan Museum in New York put on a show of his recent work which deeply divided opinion in America. That a controversial living artist was presented in such a prestigious institution meant that Bacon became the focus of increased attention throughout the international art world. Solo exhibitions of his work, with all the attendant fanfare and media attention, were to take place subsequently in key cities round the world roughly at the rate of one or two per year until the end of the decade, with the momentum increasing through the 1980s.

Bacon's dealers were working strategically behind the scenes to promote the work to full advantage; he was by now one of the most famous living artists, and this fact was amply reflected in the mounting prices his pictures commanded. Bacon himself continued to affect a marked nonchalance towards his success. 'Time is the only critic,' he repeated, as his paintings fetched record sums at auction. 'The prices mean nothing. No one will know if my things are really any good for another fifty years.' Nevertheless, while generally allowing the Marlborough *carte blanche*, he kept a sharp eye on certain aspects of the way he was being represented. He had the final say on the choice of works or the texts included in the catalogue for an exhibition; he

was also occasionally concerned by more mundane matters and made it clear, for instance, that he expected to be consistently backed up by the Marlborough when paintings of his came to auction. As in all Bacon's important relationships, there was a strong element of sadomasochism in his dealings with his gallery. He liked to present himself as exploited, even as a kind of holy fool who could be taken advantage of without realizing it. But he knew instinctively how to get his own way when it seemed important, and he retained a delicate knack of throwing a spanner into the works if some long-planned project suddenly no longer met with his approval.

Given the conflicts inherent in the artist-dealer relationship, however, Bacon and his gallery maintained a generally cordial and mutually fruitful association. The artist admired Frank Lloyd, the Marlborough's founder, not only for his proven business acumen but for his 'eve'. 'It's a very rare thing,' Bacon conceded, 'but he knows right away whether a thing has quality or not. Most people have no instinct about images, which after all are entirely to do with artifice. People generally have to be told before they begin to see anything. The critics, especially. But Frank really does have a sense about painting.' Bacon made a point of being on the best of terms with the gallery's directors and the staff in general, and he was well looked after, especially by Valerie Beston, who became responsible for managing the prodigious volume of day-to-day business generated by a world-famous painter. The occasional grumble apart, Bacon was conscious that his career was in good hands: he had only to measure the distance he had travelled between leaving the Hanover Gallery and receiving the rare distinction of a show at the Metropolitan Museum some seventeen years later. This awareness was confirmed by the fact that he remained with the Marlborough to the end, despite the constant blandishments of other dealers, forever circling around, eager to handle such a major 'star'. And detached though he often sounded when he touched on the subject, Bacon cooperated fully in the lead-up to all the important exhibitions. He made out a rough list of the new paintings he wanted to include in each show, Valerie Beston remembers, and he would make every effort to produce them in time.2 As an opening approached, Bacon also threw himself unreservedly into the gruelling round of interviews, appearances and receptions which preceded the event, somehow managing to keep his appointments while drinking a succession of journalists and museum officials under the table.

The Metropolitan Museum had taken the then unusual step of organizing an exhibition of a living artist at the instigation of several influential figures in the New York art world. One was Theodore Rousseau, the museum's perceptive French-born director, who had been bowled over by the Bacon show at the Grand Palais. When Rousseau died in 1973, the project was taken forward by the new head, Thomas Hoving, who had a lively interest in post-war European figuration, and by the museum's twentieth-century curator, Henry Geldzahler, known for his independence in matters of taste. Deciding that the Guggenheim retrospective of 1963 had adequately covered Bacon's early development, Geldzahler chose to concentrate on showing recent work, beginning with the portraits of George Dyer and the *Bullfight* pictures of the late 1960s and continuing through the early 1970s, with the emphasis on the 'black' triptychs.

Having had no major exhibition since the Grand Palais, Bacon was able to offer Geldzahler a substantial number of new works to choose from: half of the thirty-six paintings selected for New York had in fact never been seen before in public. Most of them were connected in one way or another with George Dyer's death, but the very last in date, painted during 1974, appeared at first sight to mark a change in focus. Triptych May–June 1974 is a mysterious painting, marking one of the rare instances when Bacon allowed his imagination to work outside the confines of a closed room. An unexplained ritual is unfolding across the three panels, rather like the setting of a scene in an allegorical drama. Here only a few keys to the allegory are available: we look at the painting very much as we would an image from the past whose secrets have been lost. With his intense admiration for Greek tragedy and Egyptian art, both of which we know we understand imperfectly, Bacon sets out to evoke mysteries half understood (which he might have construed as a serviceable metaphor for human existence), like the utterances of an oracle or the punishments of a god. Bacon's claim that he was following 'a long call from antiquity' is manifested very graphically in this triptych. Throughout his career he reflected on what that call signified. When he asked me once whether I thought prophecies still came from the oracle at Delphi, the question was light-heartedly rhetorical, but the mysteries of antiquity intrigued him and found an echo in his work. In this picture, a ceremony of vital importance is taking place which implicates us – without allowing us to grasp what is happening.

Bacon had obtained a copy of the rare Lemoisne catalogue raisonné

of Degas's work, and he kept it in the studio during this period, frequently leafing through the hundreds of images that Degas, whom he admired more than any other nineteenth-century artist save Van Gogh, had created during his long lifetime. Clearly, the riders by the sea – meticulously delineated by Bacon, like a gifted and conscientious art student - had been taken directly from Degas. But the sea existed for Bacon as a symbol of hope and regeneration. He firmly subscribed to the idea that human life had evolved out of the sea. On occasion, too, he referred to it as a source of optimism. 'When you're young, the sea can fill you with a feeling of hope,' he once said, adding regretfully, 'but at my age that kind of hope has been cancelled out.' It is tempting, given the luminous expanse of sand, sea and sky that create this beautifully desolate locus of the mind, to see some glimmerings of a return to life after the trauma of Dver's suicide. But the figure on the right, clutching his umbrella as if he is about to be swept into the sea, is undeniably George Dyer; and the two powerful Michelangelesque backs most likely represent him also. In the central panel, the back, rising above its ethereal violet shadow, is flanked by two heads that dominate the scene like giant portrait posters at a political rally. The head on the right is surely a simplified effigy of the artist's great friend Michel Leiris: the left-hand one, with its spade-shaped beard and old-fashioned neckwear, is reminiscent of photographs of Sigmund Freud. Together they radiate an atmosphere of authority, like father figures. The foreground is occupied by a sinuous, goggle-eved creature, which Bacon later painted out; the work then became known as Triptych 1974-77.

As Bacon intended, the picture remains highly enigmatic. It may well 'open the valves of sensation', triggering off a chain of subordinate images in the mind; but it also frustrates, since it contains apparent elements of narrative or indicators of meaning which, in the end, lead nowhere. The artist claimed, of course, that he himself did not know what his paintings 'meant'. Certainly, he was at pains to ensure that nobody else would be able to attach a specific interpretation to them, covering his tracks in certain cases with care and even glee. On one occasion, when a visit to a museum had sparked off an idea for a picture, he told a friend triumphantly: 'No critic will ever know where *that* one came from!'³

Yet some of the pictures can be understood very easily at this level of interpretation once a key is available. Never short of a paradox, Bacon insisted that he and his paintings were above all 'simple'.

'When I hear certain people talk, I always think I belong to a very ancient simplicity. I'm probably the simplest person you know,' he suggested to me. 'I'm simple and natural. After I'm dead people will see how absolutely natural my distortions are.' The Sleeping Figure of 1974, which was included in the Metropolitan exhibition, can be seen to exemplify that simplicity once one knows that it portrays the artist himself in hospital recovering from a gall-bladder operation. The figure in question is transparently thin, as if the operation (to 'dredge out the sludge of years', as Bacon later put it) had drained its substance away. Similarly. Seated Figure, completed just in time for New York, may be seen as an undisguised avowal of the guilt the artist still felt about Dyer's death. The picture shows a solitary figure averting his head in horror as a nightmarish creature invades the narrow confines of his room. This unlovely, grey-fleshed apparition recalls Bacon's famous howling figures of 1944 and, less directly, the animal baring its fangs in Fragment of a Crucifixion (1950); but nothing else in the long interim.

The form returns, however, in several *subsequent* works: menacingly hybrid shapes materialize, as inevitably as the Furies in Eliot's *Family Reunion*, throughout the late 1970s, making a particularly gruesome late appearance in the *Triptych inspired by the Oresteia of Aeschylus* of 1981.⁴ It seems most likely that this rapacious mutant, often bloodsmeared and as if about to pounce on its prey, represented a deeply uneasy conscience. However much he insisted that he was not 'constricted by morality', Bacon reflected deeply on what was right and wrong, particularly in extreme situations; once he had come to a conclusion, he would act accordingly, irrespective of the risk or discomfort involved.⁵ When he remarked that 'the Furies often visit me', he was alluding to what he considered the most insidious punishment of all: the gnawing of guilt. This awareness of guilt, surely one of the great motors of Bacon's creativity, comes through most strongly in the early and late phases of the artist's work.

The Metropolitan's press release said that Bacon was 'considered by many to be the most important and original artist of postwar Europe'. Geldzahler knew that the exhibition would spark off deeper controversy in New York than in Europe, where the artist's work had been seen and discussed more regularly. Bacon's aggressive figuration was also more likely to shock the American public, long used to the less specific, less threatening content of abstract art. The curator's catalogue essay opened on a pre-emptive note:

It is a tribute to Francis Bacon that his work can still elicit adulation from some and be dismissed thoroughly by others. He has been a major figurative painter since the mid-forties, yet his work can stir as much debate as that of a debutant. Bacon himself says that his work is hated in America. That is both true and untrue. The audience that admires his work is large; the audience that dislikes it is smaller but more vociferous, made up of artists and critics committed to the idea that we live in an era when the human figure has simply defied being portrayed explicitly.

The exhibition received an unusually wide coverage in the press. The New York Times alone published the differing critical views of John Russell and Hilton Kramer, as well as a detailed profile of the artist by Anthony Bailey and an interview by Grace Glueck.⁶ Bailey's amiable piece included a verbal 'head' of Bacon ('a pear-shaped face that seems assembled of disparate elements: the forehead belonging to an ascetic thinker, the eyes to a tragic actor, the cheeks to a plump cherub') and a quote from the artist describing the three things which exhilarated him: 'When a painting, however despairing, seems to come right. When I meet someone I get on well with. And when I have a marvelous win.' For Russell, the importance of the exhibition was self-evident: here was the work of a great contemporary, and 'nothing quite like it has been seen before'. But in no way did it convince Kramer, who compared Bacon to Boldini ('who once achieved a comparable celebrity by combining surface pyrotechnics with a basically academic sense of form') before concluding that 'Mr Bacon's stylish horrors' could not be taken entirely seriously. A vigorous debate ensued, dividing opinion right across the New York art world, and in the end nearly 200,000 visitors became sufficiently curious to go and test their own reaction to what the British painter had always planned as an 'assault on the nervous system'.

Bacon himself enjoyed the few days he spent in New York enormously. He put up at the Stanhope Hotel, a stone's throw from the Metropolitan Museum, revelling in its old-fashioned luxury and the knowledge that the Kennedy family often stayed there. Profoundly European as he was, he was impressed by the affability of Americans, even though he found them strangely 'abstract' as people. ('It's not surprising they love abstract art,' he said, 'they're so abstract themselves'.) Andy Warhol invited him down to the Factory, where Bacon was fascinated to see him at work on the portraits of well-

known New York drag queens, which he described, approvingly, as 'really rather curious'. Warhol was 'very charming', Bacon decided, but characteristically he added some reservations about his work: 'I've always been a great admirer of his films. I thought *Flesh* was an extraordinary film. But I'm not so sure about his painting.' Another artist Bacon spent time with in New York and liked instinctively was Robert Rauschenberg. He also found time to go to several parties and loved meeting hosts of new people, although he was convinced that someone had spiked his drink with a drug – as a 'joke'; for several days thereafter, he said, he felt 'extremely strange'.

The best comments on Bacon's work came from the artist himself. whose conversation on this and many other topics had been noted down over the previous years by his friend and admirer Peter Beard. Having interested Bacon in his remarkable photographs of wildlife. and in particular of dead elephants, Beard had spent a great deal of time in London accompanying the artist on his nocturnal odyssevs round the bars, restaurants and clubs. The young American photographer was fascinated by the freedom and insight with which Bacon talked about virtually anything as they drifted through the magical night town which opened up at the artist's touch. Often the most perceptive remarks were delivered with staccato brilliance at the beginning of any encounter, to be expanded, repeated and eventually drowned as bottle followed bottle and club gave way to club. Beard's instinct for the splendours of wildlife had not deceived him as he followed Bacon through this peculiar jungle: at the end, as he might have photographed a magnificent animal unawares, he caught the most penetrating observations, before the talk rambled, and preserved them.

The remarks were edited and selected for the Metropolitan catalogue, and although they do not achieve the sustained brilliance of the talks with the artist which David Sylvester published as a book in the same year, they give a wonderful rough outline of Bacon's tastes and temperament. He appears even to foresee the objections to his work that were being aired in the American press, as when he talks to Beard about 'horror':

I've never known why my paintings are thought of as horrible. I'm always labelled with horror, but I never think about horror. Pleasure is such a diverse thing. And horror is, too. Can you call the famous Isenheim altar a horror piece? It's one of the greatest paintings of the

Crucifixion, with the body studded with thorns like nails, but oddly enough the form is so grand it takes away from the horror. But that *is* grand horror in the sense that it is so vitalizing, isn't it; isn't that how people came out of the great tragedies of Greece, the *Agamemnon?* People came out as though purged into happiness, into a fuller reality of existence.

Like his paintings, Bacon's conversation revolved mostly around a handful of grand themes - art and desire, mortality and despair - to which he returned time and again in the hope that he might define them more clearly and concisely. He also liked to trade aphorisms with his friends (as risky a business for them as recommending a wine in his presence, since Bacon sent anything he considered less than the best sharply back). But although he was often at his most remarkable when he was talking about his own work or art in general, he had perceptive views on a wide variety of things: a surprisingly pragmatic insight into how a business might be run, a keen (and emphatically pessimistic) analysis of a political situation, or the best way to make mayonnaise.7 His opinions were always grounded in personal experience, and however extreme they became they never lost touch with a sense of day-to-day reality. Partly as a result of this, he could also be extremely funny. When he was advised by an accountant to become a resident of Switzerland for tax purposes, he replied in shocked tones: 'I couldn't do that - not with all those fucking views!'8 And there was the lovely occasion at a smart reception when one of the grand guests, not recognizing Bacon, then at the height of his fame, asked him what he did. 'I'm an old poof.' Bacon replied.

Peter Beard was not alone, of course, in recognizing that Bacon expressed himself almost as memorably in words as in paint. David Sylvester had been recording his conversations with the artist since the early 1960s, and by 1975 he had assembled and edited enough material to bring out the first edition of his *Interviews with Francis Bacon*. Their publication revealed the artist in a new dimension and changed both the specialist and eventually the lay view of his work. For an artist as internationally established and influential as Bacon, the amount of information available had been unusually limited. Apart from the Rothenstein–Alley *catalogue raisonné*, which documented the artist's development up until 1963, and John Russell's perceptive monograph, little existed to provide the serious admirer of

Bacon's work with the kind of background material that abounded on lesser-known painters. The level of critical commentary on Bacon had been consistently high, so that there was no lack of subtle and imaginative interpretations, in countless catalogue prefaces, essays and reviews. But the genesis of the work and the life of the man behind it remained peculiarly elusive. The extent of this may be gauged from the uncertainty that existed even about Bacon's date of birth until the first Tate retrospective; and his parents' names were not accurately established until very recently.

The *Interviews* were a landmark, not only because Bacon replied brilliantly and candidly to Sylvester's searching questions but also because of this dearth of factual information about him. Therefore what Bacon had to say about the artistic and literary sources he had drawn on and his working methods, as well as aspects of the life that had some bearing on the painting, came truly as a revelation. As in the very best critical writing, the artist's own commentary took the reader closer to the heart of the complex and ambiguous activity of image-making. In discussing the problems that he himself faced in his search to reinvent within the tradition of European painting, Bacon also provided a highly original insight into the whole dilemma of late twentieth-century art.

The Interviews were quoted so extensively in the ever-increasing volume of articles about the artist that they became the prime sourcebook for any kind of Bacon scholarship. After decades of mystery enshrouding the painter and his work, their effect was oracular. The artist had spoken. The power of Bacon on Bacon grew to such a degree that it became axiomatic that the artist himself was the greatest. if not the sole, authority on his work. This was, in itself, an astonishing feat. Bacon had managed not only to create a corpus of extraordinary images whose meaning could not be reduced to some vague statement about the human condition or, worse, a 'story', like a bourgeois conversation piece. He had also provided a supremely intelligent guide to how they should be understood, which was, briefly stated, that they should not be 'understood' at all. The images, as far as the artist himself was concerned. were to all intents and purposes ineffable. Not unlike a mystic who has had a vision, he did not know how they came about: chance brushstrokes occasionally threw up a mysterious form that he retained and worked on. They were images, vectors of sensation, untranslatable into words and impervious to rational understanding. They were to be glazed, framed

like Old Masters, then exhibited to the crowd. The passionate atheist, who would denounce the sham of faith in every bar, had made pictures for which he demanded the unquestioning acquiescence of religious conviction. In their commanding position on a museum wall, these richly coloured images, glazed and aglint with gold, were to be approached much as the faithful once approached an altarpiece.

Bacon's desire to control the way he himself and his pictures were interpreted did not diminish as he grew older and ever more respected. He continued to affect indifference to what was written on the subject, but in the last years of his life he took extreme measures to prevent several texts from being published about his life and work.¹⁰

Predictably enough, the first foreign edition of the *Interviews* came out in French, in 1976, the year that the Musée Cantini in Marseilles put on the first Bacon exhibition to be held in France outside the capital. The artist had been enthusiastic about the project from its inception. The sprawling port city, with its huge North African population, had always attracted him, from his earliest wanderings along the Mediterranean with Eric Hall; on subsequent visits, he had found it closer to the Tangier he loved than anywhere else in Europe. He liked the bars, the brothels and the generally louche, sexually tolerant atmosphere created by generations of seamen on shore leave. There was also the lure of a perfect bouillabaisse, eaten within view of the harbour.

Best of all, there was the siren call of continued French adulation. The exhibition was held under the aegis of the city's mayor, Gaston Deferre, one of the most powerful politicians in France. Gaëtan Picon, who had worked directly under André Malraux in the Ministry of Culture, had written the introduction to the catalogue which, setting a precedent that would last for the rest of Bacon's career, carried numerous quotes from the Interviews, emphasizing the painter's own views on his art and its implications. No more than sixteen paintings (of which half a dozen were nevertheless full-scale triptychs) from between 1969 and 1976 had been chosen for the Musée Cantini's relatively intimate space, and the whole event remained far more low-key than it would have been in a capital city. Bacon enjoyed the fact that he did not have to 'perform' too much for the regional dignitaries and the local press. Fascinated by masculinity and power, he had been curious about Gaston Deferre's reputation as absolute boss of the unruly and traditionally ungovernable Marseilles. At an informal Provençal dinner with a few friends, the two men were relaxed and affable. Yet at odd moments, as the conversation roamed from racial tension to sailing on the Mediterranean and where to find the finest olive oil, one could see the artist's eye taking the politician's looks and body language apart, as if he were engaged on a portrait, in search of the basic instinct and the mortality beneath the polished façade.

From time to time paintings by Bacon which he had 'abandoned' but not destroyed surfaced on the art market. Usually the artist had left them behind in one of the many rooms where he had worked as a younger man, assuming, somewhat ambivalently, that they would simply disappear. Since Bacon used only the rough, unprimed side of the canvas, preferring the 'dragged' effect it gave to paint, these pictures had sometimes been given to indigent artist friends with the notion that they could use the 'proper', prepared side to work on themselves. Not surprisingly, the 'abandoned' works, which sometimes seemed as good as many in the accepted canon, were kept and eventually put on the market. Bacon was often distressed when these rejected images turned up again, discouraging everyone in his sphere of influence from acknowledging them as his; later in his career, he took pains to ensure that works he had rejected were razored to bits. But to this day a certain number of paintings have continued to languish in this curious limbo, virtually unknown since they have not appeared in any 'official' Bacon exhibition or been reproduced in any of the books about his work.11

Meanwhile, a new category of pictures had begun to infiltrate the market. Attracted by the six-figure sums being paid for the artist's work, a group of left-wing students based in Milan had been successfully palming off their paintings in the master's style as genuine Bacons, using the proceeds to fund political activities; they even forged art critic John Russell's signature on a document certifying the paintings' authenticity. By 1976 the situation had become sufficiently serious for Scotland Yard to start investigations; once it became more difficult and dangerous to sell their wares, the forgers lost heart, and the traffic in fake Bacons petered out. Some of the fakes were ludicrously obvious, and in all of them the students had made the basic error of painting on the primed side of the canvas. A few pictures showed more talent, however. Troubled at first by having to deal with the problem, Bacon was not unaware of its comical side, since he himself had 'borrowed' so much from other artists. Holding

up a photo of one of the better fakes one day, he studied it intently as those around him prepared for a vicious dismissal. 'This one's got a very interesting staircase,' he said slyly. 'I might just use it.'

The key exhibition of Bacon's work in the late 1970s was the one which opened in January 1977 at the Galerie Claude Bernard in Paris. Over five years had passed since George Dyer's death, and although Bacon appeared to have come through his period of mourning and to have resumed completely his swaggering attitude towards death and the devil, feelings of loss and guilt inhabited him still. He might have chosen to live part of the year in Paris at any period in his mature life. If he had gone there in 1974, it was partly because he had been so enthusiastically acclaimed by the French; but it was also in part to be close to the scene of George's death. By tormenting him, that particular pathos fed his art. For an avowed atheist, who viewed life as a tragic absurdity between two voids, the death of a lover opened as deep and complex a well of feeling as the death of Christ opens in a believer; the whole nature of existence is brought into question. As if impelled by the force of his emotions, Bacon the atheist had ransacked the central rituals of both the Greek and the Christian faith: only there, he was convinced, could he find a structure to convey the extent and the implications of his own drama.

That drama lies at the heart of the whole enigma of Bacon's art. Although he did not often touch on the subject directly in conversation, it is clear from his paintings that he identified closely with the myths, using them as what he called an 'armature' on which he could 'hang' all kinds of sensations and feelings. In the earlier part of his career, the Crucifixion was a dominant theme; in the latter part, it was the Greek myths, and above all the *Oresteia*. (His continuing fascination with T. S. Eliot undoubtedly relates to the fact that the poet was also strongly influenced by both themes.) In this sense one might say that Bacon identified with Christ crucified in the years leading towards his maturity, then, as he grew old, with the hunted and haunted Orestes.

The 1977 Paris show formed a complete episode, closely documenting Bacon's turmoil over the years since the fateful opening at the Grand Palais. As from *Triptych 1971* and *Triptych May–June 1973*, with its hallucinating portrayal of Dyer's last moments, virtually all the paintings chosen evoked an aspect of the suicide and of the artist's tormented mourning. Portraits and self-portraits led up to a big new work which created enormous excitement not only because

it had never been seen before but because it showed Bacon's imagination to be working at its highest pitch. *Triptych* 1976 came across as a summation of the guilt he had felt since Dyer's death and also represented a stage in its expiation. Bacon had written to his friend Leiris while he was at work on the picture, mentioning the *Oresteia* and Conrad's *Heart of Darkness* as two 'influences'; he also said that Leiris's *Frêle Bruit*, which he had re-read, entered into the work. But he insists, in the short letter, that whatever happens in the imagery will be the result of 'accident'. More than ever, separating the various layers of allusion and meaning in this complex, highly charged allegory is hazardous, however tempting it may be to suggest specific links with Conrad's haunting story or even to find a real-life model for the phantom which rises in both side panels. ¹³

Nevertheless, the picture surely treats of sexual love – that 'crime'. as Baudelaire put it, in which one is fated to have an accomplice and the suffering it frequently sets in motion. The two outer panels clearly refer to desire. The phantom young man is portrayed on a screen, like a matinée idol; he is half naked on the left, and on the right he stares out like an impassive observer over two grappling bodies. In the central image, a pair of birds - coupled like the bodies into a single flailing image - swoop down on an eviscerated corpse. If they represent one Fury, another sits on a railing with bared fangs, while the third, one of Bacon's strangest-looking bugaboos, presses its amorphous grey bulk against a transparent pane, as if arriving from off-stage eager to join the central fray. Two offerings, a bowl of entrails and a bowl brimming over with blood, complete the sacrificial scene. The themes of crime, guilt and punishment are all strongly represented in this magnificent work. Yet, as often in Bacon's drama, time has stopped. There is no hint of a sequence from panel to panel. The triptych is a continuum. From this stasis no outcome is possible, no purging of the turbulent passions, almost as if, in his deep-seated masochism, the artist had chosen constant pain over catharsis.

With the pale green-blue background rendered all the more icy and unforgiving by blood-red and orange shadow, the picture and the show as a whole caused an immediate sensation. Bacon's reputation had stood very high in Paris ever since the Grand Palais retrospective, and once the French public had admitted him as a new hero in their cultural pantheon their enthusiasm knew no bounds. The press build-up had been considerable, with *Newsweek* running a portrait of the artist on its cover to announce: 'Francis Bacon's Big

Paris Show'. During the opening, police cordoned off the rue des Beaux-Arts in an attempt to control the crowds pressing down the boulevard Saint-Germain. In a couple of hours, some eight thousand people had pushed their way into the gallery's relatively restricted space: a mood of exhilaration, but also of panic — of something that was about to get completely out of hand — ran through the narrow street.

The effect of the images, which most people had not seen before, was not so much the 'punch in the face' that the retrospective had dealt as the sensation that a terrible but necessary truth was being revealed. With the mixture of intellectuals and collectors, art groupies and sensation seekers, aesthetes and layabouts, the gallery quickly became half sideshow, half shrine. Before the crush became too great, Bacon was on hand in the middle of the throng, pink-cheeked and immaculately dressed, greeting friends, signing posters and catalogues, laughing appreciatively and generally behaving as if nothing could have been more normal than the single-minded mobbing of which he and his pictures had suddenly become the object.

The mobbing continued, though in a more sophisticated fashion, as part of the milling crowd made its way across the Seine to a reception at the Bourse du Commerce, the great domed grain exchange in the Halles, Paris's old food market. Claude Bernard Haim, who had been working towards a Bacon exhibition at his gallery for several years, was well aware of the 'coup' it represented in the international art world, though even he was taken back by the nearriot which the opening had caused. Famous for his lavish hospitality. Haim did not stint on this occasion. The vast trading floor beneath the exchange's dome had been decked out with sumptuous buffet tables. Many of the guests had made the journey specially from abroad to be present: in addition to a large contingent from England, there were collectors and dealers from all over Europe and, no doubt as a result of the Metropolitan show, a greater than usual number of Americans. As the champagne flowed and several hundred guests circulated, the artist weaved through the crowd, more drunk on success than on wine, talking and laughing, as relaxed as if he were in an infinitely extended version of Muriel's drinking club in Soho. He dismissed the mobbing of his show as an aberration or at most a passing trick of fashion, but without a doubt, behind the glistening smile and the elegant dismissal, he was deeply thrilled: not so much by the obvious adulation as, with the old surrealist love of disruption

still strong in him, by the chaos that had nearly been unleashed. Glass aloft, toasting old friends and seducing new ones, having unlocked more 'valves of sensation' in one evening than many artists do in a lifetime, Bacon was totally in his element.

Being in his element, and conspiring with circumstances of all kinds to ensure that he remained so, has surely to be seen as one of Bacon's supreme gifts. Recklessly pushing his luck, repeating that he believed in nothing, cared about nothing, he nevertheless managed time and again to turn the most unfavourable situations to his advantage. Perhaps because he was able to absorb more pain and punishment than most people, he seemed almost doomed to court disaster. When most players would take their gains or cut their losses. Bacon would go on - losing more or winning more, it did not seem to matter. In intimate relationships, the same pressure applied, inevitably and, at times, disastrously. As Valerie Beston, a staunch friend and supporter whose responsibility at the Marlborough for all Bacon's interests inescapably involved her in his private life, said reflectively: 'I can't think of anything more terrible than being loved by Francis.' Bacon himself remained convinced that an artist had to go to every extreme, to 'stretch one's sensibility' through excess and suffering, in order to be able to feel and communicate more. His reading of Nietzsche, but also of Aeschylus and Shakespeare, confirmed the belief with a resonance echoing through the centuries. Having lived his entire life in this provocative manner, Bacon was unusually adept at 'damage control', and was able by some well-developed sixth sense swiftly to avert the worst while it was still possible. This capacity also gave him exceptional self-confidence, both in the day-to-day business of living and in metaphysical speculation. When, at the end of their last interview together, his friend David Sylvester suggested that a 'believing Christian who felt that he was damned would prefer not to have an immortal soul than to live in eternal torment', Bacon replied that he thought that people are 'so attached to their egos that they'd probably rather have the torment than simple annihilation'. He himself, he continued, would prefer the torment because 'if I was in hell I would always feel that I had the chance of escaping'. 14

Being wildly successful in Paris, with a studio beside the Place des Vosges, a circle of devoted friends and a host of admirers, was no hell, and Bacon was enjoying life to the hilt. He was constantly being approached in the streets and cafés; although he referred to his

lionization sardonically ('The thing is, when people come up to you and say, "Are you Bacon?" you can't actually say "No"), he always looked delighted when he was recognized. To these admirers it seemed as if advancing years, traumas, ill health and excess had left no mark on him. Old friends noticed that he laughed less and repeated himself more, that he was not so reckless when he drank and sometimes looked pale and abstracted. But to the world, as he approached his seventieth year, he seemed, on a good day, to be in his early fifties. Adept with makeup since adolescence, he used a range of artifices to give his skin and hair a sheen of youth. But there was no counterfeiting the sharp gaze, the quick riposte or the lithe stride (which became more of a buoyant weave as the drink took over). Women questioned him closely about the 'secrets' of his youthfulness, and with charming disclaimers Bacon literally glistened with pleasure. To some he would tell the story of a whore he had once known in the late 1920s when he was drifting in a not altogether different capacity around the bars in Montparnasse: 'She said to me: 'Listen, Francees. je me fais jeune – I just make myself young,"' Bacon would repeat, laughter bubbling up at the absurd simplicity of it all. 'Voilà. Je me fais jeune."

Bacon's youthful allure and the impression he gave of always being ready to have fun may well have been partly a matter of will, because he certainly made few concessions to what is generally considered a healthy life. He still slept little, ate and drank immoderately, took whatever stimulants were going, was self-destructive in love and gaming, and did not exercise beyond an obsessive pacing up and down in front of the canvas. He continued to consult his doctor very regularly, however, and from time to time he manifested certain, fairly eccentric dietary convictions. Bacon's idea of looking after himself in this respect appeared to consist in taking large amounts of garlic pills and avoiding egg yolks, dessert and coffee. No matter that he had absorbed half a dozen bottles of different wines and numerous chef's concoctions, he held firmly to these safeguards, delicately separating the white from the yellow of a hard-boiled egg and leaving his coffee, ordered but ignored, to grow cold. Other mannerisms, such as his refusal to countenance any kind of water on the table or his love of overtipping, were prompted more by a desire to impress and amuse - an integral part of the captivating exhibitionism he had perfected over decades of sweeping parties of people into grand restaurants and seedy bars.

In Paris, he adhered closely to this mode, beginning the evening in the gilded security of the Ritz or the Belle Epoque splendour of Lucas Carton, and ending it in the grimiest bar, downing dubious alcohol under flickering neon, adrift on the night, in search of a moment's oblivion with a passing 'friend'. Occasionally he was robbed or roughed up, reappearing the next day barely able to move his torso, with a dismissive story about slipping on the bathroom floor: but whatever the risks he courted, an instinct for self-preservation. whenever a sado-masochistic situation got out of hand, enabled him to escape too much permanent damage. For long periods of time. however, he charted a more modest course between the two extremes. dining with one or other of a small group of friends, then ending the evening with champagne or a late supper at a favourite haunt like the Club des Sept on the rue Sainte-Anne, which by the late 1970s had become a major cruising ground for homosexuals, and not least for a breed of large black transvestites known as the Brésiliennes. Bacon loved the luxurious space and theatrical atmosphere of the Sept, conceived by the talented entrepreneur who went on to convert an old municipal bath house into the famous Bains-Douches nightclub. With his reputation as a famous artist who was also a notorious homosexual and his openhandedness with money, Bacon always received a special welcome there; and it became a place where he could go alone and sit at the bar, chatting to the waiters or indulging his old love of watching others 'carry on' as they plied to and fro between the restaurant and the dark, throbbing dance floor downstairs.

The period around the end of the 1970s marked the high point of Bacon's decade of extended stays in Paris. He was taken out and about by his new dealer, Claude Bernard Haim, and even more by the dealer's sister, Nadine, who proved a boon guide and companion for Bacon through the more exotic reaches of Parisian nightlife. Out of fondness for the Haims and respect for their gallery, which had become a prominent cultural force in the city, Bacon even agreed to write a short tribute to Giacometti when they put on a show of his drawings. 'For me Giacometti is not only the greatest draughtsman of our period,' Bacon wrote in French, 'but one of the greatest of all time.' Giacometti himself, of course, had regarded the act of drawing – so peripheral for Bacon – as absolutely crucial to creating form, in painting as in sculpture. Despite the deep mutual admiration that had existed between the two artists, Jacques Dupin, who was

close to both men and knew their work well, considers that the compliments they exchanged on each other's artistic achievement were 'not altogether sincere'. Dupin, who has put on key shows of both artists' work, makes the important distinction that 'Giacometti was uncomfortable with the fact that Bacon didn't draw, and Bacon, in the end, singled out only Giacometti's drawings for full praise'. 17

Another of the very few contemporary artists whom Bacon admired, albeit with marked reservations, was Balthus, who had already settled into a somewhat ambiguous Old Master status in the French art world. In the exquisitely made, erotically charged universe of Balthus's paintings Bacon preferred the early scenes set in Paris, notably the two versions of La rue, with its somnambulistic figures, and to a lesser extent, the more polished Passage du Commerce Saint-André. Balthus had been one of a mere handful of painters working inventively with the human figure when Bacon was attempting to find his way, and he had accordingly scrutinized the older artist's work. As so often, he admired only a fragment of the oeuvre. 'I think Balthus is trying to do something new with an old technique, as Gertrude Stein said about Derain,' he concluded in his peremptory fashion one evening over dinner in Paris. 'I myself think you have to break technique, break tradition, to do something really new. You always go back into tradition, but you have to break it and reinvent it first.' Nevertheless, there was an aura about Balthus - an aristocratic indifference and disdain - that could not have failed to intrigue the English artist. During his time in Paris and later in Rome, the older painter had created a myth around himself that was less dramatic but hardly less enticing – with its adolescent heroines, abandoned castles and bizarre genealogical claims - than the legend surrounding Bacon.

Claude Bernard Haim also represented Balthus (a large selection of the reclusive master's delicate drawings had been put on show at his Paris gallery in 1971), and now the dealer took it upon himself to bring the two artists together. By this time Balthus had compounded the mystery in which he loved to cloak his life and his work by accepting the post of director at the Villa Medici, where for nearly three centuries the French Academy has been sending young artists to draw inspiration from the Eternal City. Balthus flourished in the position, which Ingres had held long before him, and he set about restoring parts of the grand villa with meticulous care. Wary as he was about accepting unofficial visits to this magnificent sanctum that he had made so much his own, Balthus would not have refused to

see Bacon. However different their work, each artist considered the other to have made one of the few valid pictorial experiments of the latter half of the century. Nevertheless, like Bacon, Balthus was by no means uncritical in his judgement. 'All those meandering lines,' he once complained about Bacon's way of creating form to a mutual friend, the sculptor Raymond Mason, 'it's like looking down on railway tracks from a bridge.' He also made a scathing reference to Bacon's having 'lifted' his cages from Giacometti. 18 Balthus received Bacon cordially at the Villa Medici, and the two painters ranged over a variety of subjects in English (which Balthus, a lifelong Anglophile, speaks perfectly). Bacon was pleased to be back in Rome, which he had not seen since he wandered around the city nursing his obsession with Peter Lacy in 1954. But no rapport between the two great figure painters developed. Bacon remained polite and appreciative, vet when he returned to Paris he talked about Balthus as if the latter were interesting above all for his restoration work; and by his account the high point of his visit was when he was taken by his host to see the garden with its belvedere which Velázquez captured in two memorable studies during his stay at the villa around 1650.

Bacon was, in fact, not especially given to friendships with other artists, above all later in life. Roy de Maistre and Graham Sutherland had been of vital importance to him; and his friendship with Lucian Freud had been highly prized, although its spontaneity slowly eroded over the years as their paths diverged until it ceased abruptly. 19 But as he became more famous, he also grew more openly outspoken, not to say vituperative, about other artists' work. He occasionally rued his outbursts, complaining rather petulantly that 'people always mind more what you say about their painting than their personalities. because the painting is already out and they think they can still work on their personalities'; but that did not stop him being devastatingly, and often quite unreasonably, dismissive of others' achievements. One of the death blows he had dealt to his friendship with Sutherland came when he described the older painter's recent portraits as 'very nice ... if you like the covers of Time magazine'. 20 His best-aimed barbs were of course reserved for the most successful figurative painters (abstract art having been relegated long before to mere 'pattern-making'). David Hockney was, not unexpectedly, a prime target. 'I can certainly see why he's popular,' Bacon would begin waspishly. 'People like his work because they don't have to struggle with it.' Hockney admired Bacon's work, despite what he considered

an inherent weakness in the lack of underlying draughtsmanship, and he particularly liked the tangible physicality of his male nudes. After seeing Bacon's paintings at the Marlborough in 1960, Hockney remarked pungently: 'One of the things I liked about them was that you could smell the balls.' The two English painters greeted each other cordially whenever they met, and occasionally spent time together. Frank Auerbach, R. B. Kitaj and Freud himself – all painters whose work Bacon had liked and supported at one stage – also came in for criticism, habitually delivered in a single terse remark, in a tone that did not encourage discussion.

Bacon could of course be equally harsh about his own work, but that did not stop his remarks from alienating several artists who would otherwise have remained good friends. Bacon later complained. perversely enough, that he had nobody he could 'really talk to'. In almost the same breath, he also claimed that he did not really care for intellectuals at all - however much he was seen lunching and dining with the writers who were committed to his work. What he preferred really, he often suggested, was crooks and drifters and people who ran drinking or gambling clubs; they were 'less boring'. 23 In point of fact, he continued to live his life at different levels. Emotionally and erotically, it is quite true that he was drawn not to people of similar interests and culture but to quick-witted, street-wise young men, often from the East End, who showed not the least interest in such seemingly futile activities as painting, talking about painting, writing or reading. He had, moreover, a deep conviction that 'simple', untutored people would be less likely to betray him, as if lack of culture betokened a lack of guile.

Of the relationships which Bacon had begun during his stays at the house in Narrow Street, one was to prove durably important. As a young man, the artist had sought father figures; after his tortured liaison with Peter Lacy, he had been drawn to increasingly younger men, whom he attracted, whether homosexual or not, by the liberating excitement he created around himself. George Dyer's untimely end had made the urge to have a son even stronger: there was a tender, caring side to Bacon's character, most evident in the deep affection he had shown to his old nanny, which looked for a more sustained outlet than occasionally settling old friends' hospital bills.

He had first got to know John Edwards during his drinking bouts round the East End pubs. Edwards had been helping his brothers manage three pubs in the area. Having been told of an impending visit by Bacon and his friends, the young man had specially ordered quantities of champagne; but the party from the West End had not turned up, and since his regulars did not go in for such luxuries, Edwards felt he was stuck with it, and made a point of telling Bacon so in no uncertain terms. This unvarnished reaction touched an old chord in Bacon, who immediately wanted to get to know him better. The artist had long thought that East Enders were less cut off from the brutal reality of life than the general run of people. Edwards had the added advantages of good looks and a companionable charm; he was also observant and a shrewd judge of character. They began to see more of one another, and Edwards immediately took to Bacon's world of drinking and gambling in eccentric clubs, even though he perplexed the older man, who always aimed to turn dinner into a feast, by steadfastly preferring a sandwich to any delicacy the best chefs could provide.

On the surface their relationship resembled the one which Bacon had begun with Dyer; and not a few pundits in the artist's entourage shook their heads and predicted as dire an end. But beyond the similar gap in age and culture, there were few enough parallels. Bacon's interest in Dyer had been intensely sexual. With Edwards it was to do more with companionship and a paternal protectiveness. After Dyer's death, Bacon had in fact ruled out any subsequent sexual relationships for himself, partly as a self-inflicted punishment, and partly because he felt (prematurely, as events were to show) that he was too old. 'I've always liked bodies that function perfectly,' he confided. 'But of course age cancels those things out. There it is,' he continued, grandly elegiac, repeating a phrase of Michel Leiris, "la vieillesse est horrible et sans remède" - old age is ghastly and incurable.' He mentioned that he had quickly realized that his friendship with Edwards would have another basis; and no doubt this also freed him from the destructive feelings of guilt he might otherwise have experienced. On his side, Edwards was a far remove from the victim-like helplessness which had been so central a part of Dver's predicament. Self-reliant in an unobtrusive way and a handy protector if Bacon stirred up a bar brawl, the new companion also knew how and when to put a certain distance into the relationship, a situation considerably facilitated by the fact that Edwards already had a wellestablished partner in his life.

Despite its evident contradictions, indeed to some extent because of them, the relationship flourished. Bacon took the younger man

everywhere, introducing him to all the people and places he cared for. It soon became obvious to the artist's other close friends that Edwards's arrival on the scene had brought an element of security. even serenity, to Bacon's day-to-day existence. After a long stint in the studio, Bacon had come to dread the prospect of having to spend the evening alone; with Edwards in his life, he could count on a regular source of affection and uncomplicated companionship. He rarely looked happier than when he rounded off a well-wined dinner with Edwards in the happy-go-lucky atmosphere of a small casino like Charlie Chester's, chuckling and rosy with bonhomie as he moved between the tables, deftly dropping off little columns of counters as the roulette wheel was spun. Even the metaphysical despair which had become so much part of his stock-in-trade was replaced by more immediate anxieties. Whenever Edwards was late for a rendezvous or unobtainable on the telephone, Bacon reacted like a worried parent, unable to concentrate on anything until he had been reassured as to the young man's whereabouts. 'I'm just an old poof,' he claimed in doleful self-mockery. 'I pay his rent and I never know where he is.' The guip he once made when asked what he would have liked to be had he not been a painter ('A mother!') took on another dimension when he was seen thus agitated. But it was a small price to pay, and it seemed if anything to fuel his affection.

The new paintings mirrored the change in the palette of Bacon's emotions. The portraits of John Edwards in particular communicate an eery sense of calm, like a harmony achieved through violent discord. It is difficult to know whether the pale colours and concentrated form betoken reconciliation or a certain weariness, not to say a resignation. There are flashes in a painting like the *Three Studies of John Edwards* (1984) of the supernatural atmosphere that makes Shakespeare's last plays so magical. Here, the figures are so much less distorted as to become almost naturalistic; they appear to rise for the first time above their inherent confusion as self-consciously mortal creatures. Similarly, the stage on which they are presented has been emptied of almost all Bacon's traditional props and devices, leaving a heightened sense of emptiness behind.

In part, however, the new calm stemmed from a growing fatigue. Bacon's prodigious vitality had always seemed to carry everything before it: chronic asthma, close friends dying, relentless excess and even the weight of years. For a man who had turned seventy, he was still astonishing. It was only the odd detail – a loss of memory

and an absorbed, absent look – that gave his age away. He had not slowed up, declining, as the French say, to put water in his wine; museum curators and art critics, new friends and old, continued to be drunk under the table. But Bacon paid, as he put it, more and more dearly for his fun. Monumental benders gave way to blackouts: he would wake up, in London or Paris, filled with guilt because he could not remember a single thing about where he had been, with whom, what had happened or anything that had been said. Knowing his own sharp tongue, he feared he might have verbally abused and possibly alienated someone he really liked; he returned to certain restaurants and bars half expecting to be rebuked for an incident of which he had no recollection. Alcohol had liberated him throughout his life. When drunk he had, quite literally, appeared to breathe more easily: drink kept inhibitions and ennui at bay, allowing him to lose innumerable bores and spongers on the perilous nightly sprees. Alcohol was his magic sphere, the alchemy in which he could transform the appearance and the meaning of the world while himself remaining invulnerable, with the mystery of his real personality and his art intact. Having realized that he was unusually well equipped to withstand its ravages, he had used drink to escape from his hidebound, upper-class background and the guilt he felt at being homosexual: he had used it to excite himself and liberate his attitudes: he had also employed it, in vino veritas, to get a better idea about the people around him. But this, like all arrangements that bestow such powers, was a Faustian pact. And the drink had come back to claim him.

Having for so long been as precise and punctual as a good accountant in keeping his appointments and fulfilling his obligations, Bacon began to miss the odd train and rendezvous. In apology for forgetting to turn up at a party given in his honour in Paris, he wrote a letter to his host blaming his forgetfulness and saying: 'On ne peut plus lutter' (You can't fight it any more).²⁴ Then he would resume his usual round, apparently unfazed, and still, as John Edwards was the first to say, quite 'fabulous', although by now he had to sit down from time to time in the middle of a drunken odyssey. Even from a strictly medical point of view, he remained phenomenally good for his age; his doctor was impressed not only by his continuing physical stamina but by the clarity of his mind. Nevertheless, the sands of time had gone on trickling. Francis Bacon, the Dorian Gray of his generation, was growing old.

Alone in the Studio 1981–84

The tragedy of old age is not that one is old, but that one is young
Oscar Wilde, The Picture of Dorian Gray, 1891

Bacon had defied illness and old age more successfully than most of his contemporaries. From his middle years on, he had railed incessantly against the horrors of growing old, his tone turning from camp theatricality to seething disgust. 'Well, I myself don't want to be what's called playing footsie under the table when I'm seventy,' he announced as he bought champagne for the knot of afternoon regulars round the bar at Muriel's, sometimes adding with more venom: 'And I certainly don't want to grow old and grey with some other ghastly old thing. Quelle hor-reur!' He also enjoyed quoting Cocteau's *mot* about watching death at work in the shaving mirror every morning. Yet for longer than most of the people around him could even remember, he had himself appeared untouched by the ravages of time, as if his very preoccupation with ageing had held them at bay.

At the same time, he was obsessively aware of other people growing old. In Paris, for instance, he became fascinated by an aged woman in black who appeared to spend her entire day in a café he went to from time to time: 'I do understand', he remarked, eyeing the wizened but resolute-looking woman with considerable fellow-feeling, 'that when you get to that age you'd prefer to spend your time looking at life in a café rather than being shut away in some little room.' He also thought and talked constantly about death. At lunch one day at a grand old hotel in London, he glanced at the rest of the clientele,

virtually all of whom were well advanced in years, and observed rather loudly: 'Do you know why they're really here? They've come here to die. It's a very good idea. I think I'll move in here too, just to have a place to die in.'

But as he passed his three score years and ten, the tone of his conversation changed. He sometimes joked about what he called his 'decrepitude' and debated at length, often with John Edwards joining in the game, whether he should be cremated or buried. But he sounded more resigned than defiant. Phrases like 'What's unpleasant when you get to my age is that you know for certain you won't live much longer', or 'My life's nearly over and all the people I've been fond of are dead', cropped up more frequently; and in the wake of heavy drinking bouts, his mood often turned very black and he saw nothing but catastrophe on every side — an 'après moi le déluge' of a particularly savage kind. Then he foretold of impending economic doom, saying things like 'The whole of England has ground to a halt, nobody wants to work and the pound has gone totally to confetti.'

By the same token, Bacon would drum into his friends, it was obvious that none of his paintings would ever sell again (despite recent record prices in the salerooms); be that as it may, he repeated he could always go back to being someone's manservant (with no one in his respectfully listening circle daring to suggest that, as a valet, Bacon might be past his prime). In these sombre, Cassandralike moments, the artist grew readily convinced that the entire world was on the brink of disaster. One of his terrors was that Europe would suddenly be taken over by the Communists, which would mean the end of all personal freedom. On certain days he said that he could almost hear the Russians marching, there was nothing to stop them, no one was prepared for their military superiority; and once, after a period of amnesia brought on by heavy drinking, he woke up convinced that his worst fears had been confirmed and the Soviets had successfully invaded.

Inevitably, the black moods which struck Bacon more often in old age grew worse whenever a close friend died. A whole crop of disappearances had made his own seventieth birthday an unusually lugubrious affair. What affected him most was the death of Muriel Belcher in 1979. Only one year older than himself, Muriel had been a cherished companion and confidente from the day they met in her newly opened Colony Room in 1948. Bacon always talked about her with an affection and pride that he rarely showed for his more

intellectual friends. Her looks, which he had attempted to re-create in several portraits, struck him as very 'grand and ancient', taking him back in imagination to what he believed people might have looked like in the Babylonian world. He also respected her judgement about people and the speed with which she assessed total strangers, either accepting them right away into the club's fold, with all their faults, or sending them in no uncertain fashion back through the door.

More than a friend, Muriel had come to stand for a whole congenial, freewheeling way of life. At unproductive moments in his career. Bacon had spent almost more time in her club than in Reece Mews. The studio represented solitude and the struggle with a blank canvas. whereas Muriel's held out the promise of unbuttoned conversation and drunken tomfoolery with old friends as well as the lure of meeting someone new. It was a place, Bacon repeated with great satisfaction. 'where you can lose your inhibitions', and he loved to luxuriate. champagne glass filled to the brim, in the drab but liberating little room. It was where he had talked most freely, above all about himself. In the waning afternoons and extended evenings he had also heard the sexual secrets of others, since Muriel's particular skill had been to create an atmosphere in which there was no orthodoxy in desire beyond the right to laugh about it. With its clients opening up about themselves and regularly pushing back the limit of acceptable behaviour under Muriel's darting eye, the Colony came to look not unlike a sea of Bacon portraits: loosened by drink, the faces blurring in self-conflict and confusion, then collapsing in despair or snapping into a new clarity, a deeper truth, about themselves. Certainly, the club had been the place par excellence where the artist had observed the endless conjugations of inner emotion and its exterior expression. fascinated as he was by the way a face often talked far louder than the words that streamed out of it. In this sense, too, the Colony was an annexe to his studio, a place where the portraitist could find in concentrated form all the raw material he would ever need as the nightly flow of clients passed before him, the undisputed king of the club, the owner's favourite 'daughter' and the source of most champagne.

But with Muriel gone, Bacon believed, that kind of life was also mostly gone. The Colony had been in many ways their joint creation, its atmosphere at its best when they were both there working the room with their respective wits. Thereafter Bacon continued to use it as a port of call in Soho, if only to trade insults with Muriel's former barman, Ian Board, who had taken the club over ('Why does he have to pick on a poor little thing like me?' Bacon quipped with mincing irony once a few barbs had been exchanged). But he went there with increasing reluctance, since the place was now living off the past — a sensation Bacon himself experienced often as life around him changed and he, with the inflexibility of old age, did not. As a last homage to Muriel and to the ancient beauty she incarnated for him with her proudly held head and hooded eyes, he painted her as a sphinx, a theme which he had not taken up since the mid-1950s. It is a disquieting image, 'with woman breast and lion paw', its ambiguous shape silhouetted against a bright orange ground. But the casting was accurate even on a mundane level. Until they had satisfied her quizzing, no newcomer to the Colony got further than the stool by the door from which Muriel presided over her domain.

In the following year, 1980, another close friend, Sonia Orwell, died after a fight against cancer during which Bacon gave her the kindest, most constant support. With the lively Anglo-French salon she had established. Sonia appeared to have found a role that suited her natural talents and temperament. Yet she never forgave herself for not having created more in the literary and intellectual spheres she admired so passionately; her psychological state was also impaired by heavy drinking, in which she emulated Bacon without having his resilience. Then her finances went awry: she sold her house and went to live in a small rented apartment in Paris, where she never regained the social prestige that she had enjoyed in London, and not long thereafter she fell seriously ill. Her sudden decline brought out the compassionate side in Bacon, who was moved by her confusion and vulnerability. When she returned to London for treatment, he took a room for her in a luxury hotel near the hospital and, in a very Baconian gesture, made sure it was kept stocked with champagne.

With Sonia Orwell's death, as with Muriel Belcher's, an important side of Bacon's world disappeared. The two women had in reality presided over opposite ends of his social life. While Muriel offered an ambience which encouraged him to let his hair down, Sonia set the scene for more serious talk with English as well as French artists and writers. Without Sonia, Bacon's life would have lacked the vital stimulus which only other creative people could provide. Left entirely to his own devices, he would have headed every evening towards Soho or the East End: the rough and tumble of drunken evenings

gave him, understandably enough, more release after the tension of a day's painting than the thrust and parry of intellectual exchange. But he needed the contact with other creative minds, not only to exercise his formidable analytical powers but to discuss the very real problems he encountered every time he attacked the canvas that awaited him in the clutter of his studio. Sonia Orwell's house in Gloucester Road had provided Bacon with another kind of club where he could exchange ideas about life and art and, above all, test his own definitions on an appreciative audience until he found the phrase which seemed, for the purposes of that particular soirée at least, to put everything into the terse elegance of a repeatable aphorism.¹

The loss of people close to him continued when Ann Fleming died in 1981. A hostess on a grander scale than Sonia, she had given Bacon another alternative to Soho by including him in a sophisticated mix of social, political and artistic personalities at a time when he still needed recognition and support. Bacon had met a number of remarkable people at her house, from Evelyn Waugh, whom he detested ('he spoke in farts' was the artist's summing up of the author), to Lord Goodman, whose advice he had sought on the drugs charge as well as other occasional problems. During the same year, his younger sister, Winnie, who had been suffering from multiple sclerosis, also died. Bacon had been an adolescent at the time of her birth and definitively beyond the family pale as she grew up. In the end, it was her illness which brought them together. Although he hated watching the progress of the incurable affliction and loathed the atmosphere of hospitals, he visited her assiduously until the end, doing everything he could to make her last days more bearable.

This was the near-saintly side of someone who would also demolish other artists' work mercilessly or suddenly round on a close friend without provocation. The man who would relish a companion's discomfiture as his barbs went home would also rush off to tend an old friend of his dead nanny's or make a large, anonymous contribution to a cause he thought worthwhile. Those who knew Bacon best would go to him in real need, but they could never be sure of coming through an evening in his company with their sense of themselves unscathed. Part of the fascination of spending time with the artist lay in the element of risk. A stray opinion, a deeply held belief or even a haircut might be held up abruptly for derisive scrutiny; and there was no scorn quite like Bacon's if one persisted in liking certain

artists, restaurants or wines once they had failed to find favour with him. By the same token, while he might wax ludicrously dictatorial in matters of taste, he would spend hours subtly coaxing a friend out of a depression; his own vitality was infectious and his hospitality on these occasions so lavish that it became almost comical, revealing an undeniably brighter side to life. These extremes of behaviour were a source of trepidation for Bacon's friends, above all as he grew old, since they never knew at what moment he might turn from joviality to a sudden, sharp-eyed suspiciousness and a bitter remark, such as 'I'm not quite the old fool you think I am', which heralded the beginning of a storm. It was usually triggered by the glass too many that soured the quantity of wine already drunk. The change could be alarming and memorably disagreeable. But it did not decrease the high-risk fascination of staying the course with Bacon and observing, close-up, a sensibility stretched to irreconcilable extremes.

Naturally no one was more conscious than Bacon himself that a whole world had begun to disintegrate around him. In earlier days he had claimed that 'once youth has gone, we spend the rest of our lives watching over our own decay'. Then it had been more part of the elegantly phrased nihilism he had developed, champagne glass in hand, at Muriel's bar; now it was actually happening. Without his favourite hostesses, London had become a much colder place, even for someone of Bacon's unusual resourcefulness. It took time for him to absorb the losses, above all the shock of not finding Muriel on her bar stool behind the Colony Room door.

Nevertheless, London was now a far cry from the post-war city in which Bacon's entertainment revolved around the fixed poles of the Colony and Wheeler's. Every day the city offered more possibilities for the kind of nightly drifting that Bacon had turned into a voluptuous lifestyle, and he was not slow to avail himself of the range of new clubs and restaurants on offer. Always prodigal by nature, Bacon was now able to spend ever more extravagant sums on wining and dining both his friends and the constant stream of writers, photographers and museum curators that had grown in proportion to his considerable fame. As the art market generally moved into a boom phase, his large pictures were fetching phenomenal prices. Even though Bacon himself received nothing (if the work was completely out of his hands) or only a fraction of these amounts, after commissions and the usual deductions, he had few expenses outside his own pleasures; and unless a disastrous session at the roulette

tables had set him back badly, he had an apparently endless surplus of cash to lavish on his guests. He usually carried this in large wads about his person. Not the least part of the spectacle the artist made of an evening out came when he dug his hand deep into his trouser pocket and dragged up a huge ball of crushed notes, some of which would flutter to the ground, exciting the attention of nearby waiters who would then engage in a compelling paper chase (bits of which the genial host would return as tips when he departed).

These ceremonies often took place in the capital's grandest hotels, where the discreet atmosphere and polished service had a soothing effect on the mercurial artist. Bacon had frequented the Ritz since his earliest days in London, and he still enjoyed the hushed opulence of its dining room. In another mood, Claridge's or the Connaught would beckon, and Bacon would be shown to his favourite table and offered a vintage he had enjoyed before. This was a degree of luxury which he had spent a lifetime developing and refining, like a certain technique in his painting. It had begun with the hunt balls to which. as an adolescent, he had accompanied his pleasure-loving Firth grandmother, and it had been given a memorable dimension during his stay at the Adlon, where the allure of four-poster beds and swannecked breakfast trollevs had been heightened by the knowledge of the poverty that marked every street in Berlin. In the pinkish light and Art Deco splendour of Claridge's, he could indulge in fantasies of a Communist takeover, and as the Tziganer orchestra struck up, he would lean forward confidentially and say: 'Now one knows exactly what it felt like to be a Russian aristocrat on the eve of the Revolution.' With this uncertain historical parallel in mind, he and his guests could then delicately torture themselves over whether to take vodka or champagne with their caviare.

But the spoiling of his friends and himself did not extend much beyond these banquets and the champagne that flowed in the progressively less grand bars that followed them. Bacon continued to pay the greatest attention to his appearance, it is true. That also became, like the hotels, grander and more discreet. Gone were the gorgeous, rainbow-hued shirts that he began wearing in the early 1970s (and in which he appears in several self-portraits painted in those years). Gone, too, were the hallmark grey flannel suits with patch pockets and the ubiquitous desert boots. Long a connoisseur of good tailoring, Bacon began to look more like a slightly eccentric banker with an

impeccable, if slightly gangsterish taste. Perfectly cut, dark double-breasted suits with the hint of a stripe became the order of the day, with a button-down shirt and silk-knit tie giving them a slightly raffish air. When he was bound for a night in Soho, he would replace the suit with a soft leather blouson, often with epaulettes, and very narrow, sharply creased trousers. This ambiguous look, half military, half effeminate, became more sinister when the artist donned one of his black leather trenchcoats, which he wore tightly belted round his still agile frame; when the lamplight glinted on it in a darkened Soho street, he looked as threatening as any of the Nazi chiefs whose photographs he had incorporated into his imagery.

No superfluous adornments – pocket handkerchiefs, cufflinks or rings – had ever been admitted into Bacon's canon of male elegance, which he summed up as looking 'ordinary but better'. Still the only jewellery that his stringent code would allow was the wristwatch, which took on a fetishistic importance and, like certain clothes and shoes, figured in many self-portraits, ticking away as inevitably as life itself. Breakages and thefts by pick-ups ensured that the watch changed frequently: a long succession of ultra-thin, obviously expensive gold watches gave way in later years to a chunky Rolex which Bacon displayed on his smooth, thick, white forearm, fiddling with it constantly with all the coquetry of a woman fingering her pearls.

These luxuries, which Bacon enjoyed most when he could share them, contrasted starkly enough with his daily routine at the studio. When he awoke there, after however much cosseting, he was confronted by the comfortless chaos which he had established long ago as his preferred 'domestic' mode. More agreeable interiors still hindered him from working. In Reece Mews not much had changed, in fact, over the two decades since the artist had moved in, although scores of pictures had been conceived there; consequently, for any admirer of Bacon's work, the barren space was intensely alive with remembered images. Alterations had been confined to the skylight that had been let into the studio ceiling to improve the mediocre east west light that came in through the room's small lateral windows. The naked floorboards, curtainless windows and unshaded lightbulbs were exactly the same, and no record price at auction was going to persuade Bacon to soften their harshness: it was as if any 'home comfort' were incompatible in the artist's mind with the discipline of painting. The big mirror retained its great starry smash, and the furniture, apart from the Boulle commode, was limited to the same

few basic essentials. More dust and more chaos – books ripped apart and scattered, discarded clothing and a coagulated mass of painting materials – had accumulated in the interim. Occasionally part of the rubble on the floor was swept into garbage bags, only to reappear in different visually fascinating combinations. Where more orderly artists went to their bookcases to look for a reference or an image, Bacon dredged through the layers of photos and reproductions underfoot.

Up before first light, out of long habit but with less alacrity than in his younger days, Bacon continued to dispose of more time than most people. Having always found it difficult to relax, he had got into the habit of taking a hefty dose of sleeping tablets before going to bed. But he rarely seemed to rest for more than four or five hours. whether or not he had been drinking heavily, and he never complained of tiredness. At times he was clearly exhausted, barely able to stand or to keep his eyes open, but he refused to give in to fatigue and rarely allowed himself the luxury of not staying to the bitter end of any party or drinking bout. Bacon equated sleep with nonexistence, and therefore with death. What he liked was 'conscious existence'. Dreams did not particularly interest him, he said, claiming that he rarely remembered them, and that in any case they were too deeply irrational to allow of any satisfactory interpretation. For a period, nevertheless, Bacon actually noted his dreams down. There was the significant one in which he ripped his shadow off the wall. There was also a remarkable dream during this period which he recorded as follows:

Night of 21/22/12/84 I dreamed ... a whole set of new pictures ... on a blue velvet satin curtain the images of everything done in a new more shorthand of all the themes I have done in *all* my work before tonight This ... is ... 2.55 in the morning of 22/12/84 now already the images ... fade, of course it was not only of images on blue satin but of seascapes the sea filled with figures – images – of an intensity I have never seen before and a shorthand of intensity and an intensity of imagery not arrived at before.

Bacon was nevertheless an avid reader of Freud, and he developed a characteristically personal approach to his work (even though, in his most sweepingly dismissive moments, he would claim that 'you can find the whole of Freud in Nietzsche'). What appealed to him most was what he called the 'clarity' of Freud's investigative method: he was excited by the mixture of deep classical culture and scientific analysis that informed the great psychoanalyst's writings. Although Bacon claimed to set little store by dreams, he did refer a great deal to the power of the unconscious. He pictured the latter as a great 'sea' or 'well' out of which his own most potent images arose, with 'all the foam of their freshness wrapped round them', as he put it. To explain what those images meant, Bacon never ceased to inform his commentators, presented as impossible a task as explaining what the unconscious itself meant; by equating the two, of course, the artist neatly and somewhat disingenuously sidestepped the issue, since what he really meant was that he had no wish for *his* imagery to be analysed.

Bacon had little confidence in psychoanalytical practice, which he had often discussed with his friend Michel Leiris. Unlike the French poet, he had never explored its therapeutic possibilities; and when he was searchingly questioned by Bacon on the subject. Leiris himself no longer appeared to set much store by them. On the other hand. Bacon believed implicitly in the advances of modern medicine and remained unusually well informed about new breakthroughs. Understandably, he lived in hope of a miracle drug being found to cure his own chronic asthma, but he also kept abreast of research being done on a number of diseases, such as cancer or multiple sclerosis, which had afflicted people he knew. Not surprisingly for someone so obsessed with youth and looks, Bacon had been fascinated by rejuvenation treatments ever since he had come across some doctors specializing in these shadowy areas during his stays in Monte Carlo: and he once admitted that 'if there was any way of regaining youth, even if it meant an unpleasant operation, I'd be the first to do it'. Having scrutinized the results of face-lifts on several close women friends, he regularly toved – but only toved – with the idea of having one done himself.

Medicine was one of several subjects which preoccupied Bacon and which cropped up often in his conversation. He kept abreast of international affairs and occasionally his imagination was caught by a particular issue, above all if it cast an unusual light on an aspect of human nature. Although predominantly right-wing in many of his opinions, Bacon was too individualistic and contradictory to be politically classifiable. He tended to see himself as an old-style liberal and his preference went instinctively to whatever form of government would intervene least in the individual's affairs. Scandals often delighted him: the revelation of a spy or sexual deviant in high office

struck him as the very stuff of comedy and further convinced him of the innate hypocrisy of public figures. But after a cursory discussion of a topic or a piece of gossip which had caught his fancy, he liked to go straight to the questions of art and literature which never left his mind.

Bacon's conversation was rarely more brilliant and to the point than when he had just finished working in the studio. He had been alone all day, prompting the chance effects of oil paint and struggling with their infinite unpredictability, and now he eagerly anticipated the moment when he could lose himself in the pleasures of the night. He had bathed and changed into one of the freshly pressed suits that hung in cellophane beside the stairway. The guest who had been lucky enough to be invited round to see a new painting before going on to dinner might share the artist's first drink of the day. ('When I'm alone I never have a drink, even though there's masses of stuff here,' Bacon once explained disarmingly. 'I suppose in that sense I'm not what's called a complete drunk, though I'm sure I would be if I didn't also want terribly to paint.') The guest would stand ankledeep in the 'carpet' of visual tools and materials that lay underfoot while the artist went up to the image on the easel, shrouded in a sheet in the best nineteenth-century studio tradition, and without more ado unveiled it. There followed a pregnant pause, but before the guest could flounder in inadequate praise Bacon had shot out of the studio and could be heard busily uncorking the wine.

Back in the living room, the artist would receive any compliments on his latest painting - which he always tended to consider the best he had ever done - with practised suavity ('I'm particularly glad you like it'), then deliberately steer the conversation towards another topic. The table where Bacon sat to read and write letters was covered with mounds of books, and often he would pluck one of them out and begin to talk about it. The book might be something new by one of his writer friends - Caroline Blackwood, Bill Burroughs, Lawrence Gowing or Jacques Dupin, for instance – or a recent discovery such as the prose-poems of Henri Michaux (whom Bacon had long admired as a visual artist, having once even bought an ink drawing by the painter-poet). It might equally well be a catalogue of a new exhibition of Seurat or Velázquez, or something quite homely, such as the wellthumbed copy of Mrs Beeton's Book of Household Management, which Bacon once claimed, in a prominent Times interview, had had a great influence on his work.² Bacon gave away many of the books that

came his way, even if they had been sent with a personal dedication by the author; he felt, once he had read or at least glanced through them, that most of them had no further use. He used the same cursory 'reading' on paintings, rarely pausing in front of any image in a gallery for more than a few seconds, and he also gave away any works by other artists which he had bought or been asked to accept. What mattered, he believed, was what, in however indirect or subliminal a fashion, the imagination retained and consequently transformed. The 'grinding machine' heard all, saw all, read all in the single-minded search for that one element which might spark off the idea for another image.

Of the many and varied influences that had left their mark, this self-schooled artist maintained, poetry had had the greatest effect on his imagination. Much as Michelangelo, Velázquez and Rembrandt, Degas and Van Gogh, Picasso and Duchamp (to mention only the most obvious artists) had meant to him, he frequently implied that the 'atmosphere' of Aeschylus and Shakespeare, Proust and Joyce, Yeats and Eliot had 'bred' more images in his mind. Suggestion was all in art, as far as Bacon was concerned. It was not what an image, whether visual or literary, meant in itself, but the power it had to set off a stream of other images and sensations in the brain. The art that mattered stimulated the irrational and the unforeseen; at its most effective, it was hypnotic, stirring the great 'well' of the unconscious in those whom it touched.

It may be, too, that Bacon preferred to ally himself more closely in later life with writers in order to disguise his borrowings from other artists more completely. He was very adept at covering his tracks. And it is noticeable that if, in his early career, he cites Velázquez and Van Gogh in his picture titles, it is to Eliot and Aeschylus that he pays homage in later life. Certainly he talked as well about literature as about art, quoting Shakespeare and Yeats quite accurately before the evening wore on. One of his favourite topics was to compare Proust's achievement with Joyce's, since they seemed to him to represent perfectly the cross-over from a great tradition to modernism. He admired Joyce intensely, not so much for his linguistic inventiveness (Bacon felt that Finnegans Wake had gone so far with language as to become impossibly 'abstract') as for his unrivalled ability to evoke Dublin and the Irish.3 Parts of Ulysses and above all certain short stories in Dubliners remained among Bacon's favourite pieces of prose.

Yet his admiration for Proust went much deeper, because he felt that the French writer had 'invented within tradition', which Bacon thought, significantly enough, a greater achievement than Joyce's brilliant technical innovations. Bacon was also more deeply moved by what he called Proust's 'recording' of a dying way of life and by his analysis of the psyche.⁴ 'I think the *Recherche* is the last great tragic book to have been written,' Bacon said to me on several occasions. 'I keep rereading the *Temps retrouvé*. It may be the morbid side of my nature, but there's something so extraordinary about the way all these characters Proust has made change. When Charlus falls on the cobblestones, he's reduced to nothing – after being so pompous, he becomes completely pathetic, fallen there. And of course it goes on for pages. In the end, all the characters Proust has created turn out to be ciphers out of which the book itself has been made.'

Much of what Bacon said acted as a prelude to talking about painting itself. He was, of course, preoccupied above all by his own ambitions and difficulties; here the conversation often took the form of a monologue which he tested on his friends to see how it might be developed or made more trenchant. If one reads the wide range of interviews Bacon gave, it seems obvious that few artists have ever talked with such originality and perceptiveness about their work. But Bacon could be almost as illuminating about the work of others, if he liked it. To hear him analyse Monet's Nymphéas in the Musée de l'Orangerie was to feel the acuity of his eve as he summarized the interlocking of perception and technique. Similarly, his descriptions of pictures he especially admired, such as Goya's La Junta, made one want to go immediately to see the canvas in question. 'The space has got such grandeur,' he said, describing the picture in Castres, 'you can actually feel the light moving around all the figures with which Goya filled the room he created for them.'

If he was discussing his love of Michelangelo's drawings or Degas's pastels, no praise was too high. But outside a well-defined chain of masterpieces, stretching from certain Egyptian sculptures to a particular period of Picasso, Bacon viewed most art with suspicion or disdain. At times, the peremptory judgements were delivered with the bland assurance of the magician pulling a rabbit out of a hat: 'After all,' the artist regularly confided, 'Cubism is nothing more than a kind of decoration on Cézanne.' Such sweeping statements sometimes turned into venomous outbursts of pique, with Bacon insisting (about Matisse, for instance, whose sculpture he nevertheless

much admired): 'I really hate those squalid little forms of his', or again (about many people): 'So you think he's good, do you? Then just tell me this: what has he ever invented? Nothing, you see.' The verdicts were at times harsh to the point of being comical. But little infuriated Bacon more quickly than arguing with him over a point of taste. If one persisted in disagreeing about the excommunication of some considerable figure, his scorn would be withering: 'Well, with a taste as coarse as yours, you would think that, wouldn't you?' When his aggression was thoroughly aroused, the hairs at the back of his neck would stand up, like an animal about to attack.

After its spectacular success at the Galerie Claude Bernard, Bacon's work had continued to be shown across the globe. A retrospective opened in Tokyo in summer 1983 and toured Japan throughout the rest of the year. It was in fact the first time that a non-Western audience had been confronted by Bacon, apart from the odd image in a travelling group show and a couple of works in Japanese museums (Tokyo's Museum of Modern Art, for example, had bought the artist's *Sphinx* portrait of Muriel Belcher). The artist had little affinity with the Far East and decided not to make the trip to Tokyo, although he was intrigued by the Japanese reaction to seeing his paintings *en bloc*. This was undoubtedly on the mind of the exhibition organizers as well, and they prevailed on the artist to contribute a brief foreword to the catalogue. 'I don't know what the Japanese public will make of my work,' Bacon wrote circumspectly, 'but I hope it will interest them.'

A few recent paintings had been included in the selection for Japan, and by now many people who had fallen under the spell of Bacon's raw imagery were eager to find out, if only from the catalogue of a show in a distant location, what new shocks the master had in store for them. Some of these enthusiasts collected or dealt in paintings, or played a specific role as critics or curators in the art world. A significant number of others were drawn to Bacon, quite simply, as a source of truth — an unvarnished view of human existence that struck home with a force and immediacy which they had not encountered before, whether in art or religion. Their lives had been touched by his paintings in unexpected ways, and they haunted his shows in search of further revelation. These groupie-like followers, who were mostly young, and often unsuccessful or would-be artists, kept abreast of everything that went on in Bacon's world as closely

as they could, often circulating – purely out of admiration – stories that were unfounded or wildly exaggerated. A sizeable colony of them had been building up in Paris ever since Bacon's retrospective at the Grand Palais. They turned out again in almost unmanageable force, with a strong punk addition that made them look more threatening, when the Galerie Maeght Lelong opened its show of the artist's recent work in January 1984.

The exhibition was literally mobbed, and the Parisian press wrote of 'l'effet Bacon' and 'le phénomène Bacon'. The artist had become a cult hero in the city; his status was neatly confirmed when the words: 'ONLY FRANCIS BACON IS MORE WONDERFUL THAN YOU' appeared on the graffiti-covered house where Serge Gainsbourg, the anarchic poetcum-singer, lived. Public acclaim ran so high that the disappointment of certain connoisseurs with Bacon's most recent work went unnoticed.⁵ In their view, the best paintings at the Maeght Lelong show were the small portraits of Isabel Rawsthorne, Michel Leiris and the artist himself, executed prior to 1980. The main part of the exhibition, made up of large works of the early 1980s, was dominated by a series of truncated human forms against an orange background and a couple of curiously biomorphic landscapes, one representing a desert, the other a sand dune. The images had an ethereal, almost otherworldly quality which seemed the antithesis of the full-blooded rage out of which Bacon's best work had been born. The paint itself had grown thin, almost transparent; the traces of struggle within the pigment, long the nub of Baconian style, had melted into a ghostly smoothness. Yet the works had not lost their power to disquiet. Bacon had found a tone of orange that grated on the nerves when spread behind the pale pink bodies, while his dune undulated with a sickening semblance of life, like a vast organism heaving itself free of the primeval swamp. Arrows proliferated in these most recent pictures. as if the artist himself had felt that the contents needed pointers to bolster their reduced substance. Ouite distinctly, a late period had emerged.

'The Greatest Living Painter' 1984–92

When you look at the other living painters, there's not much competition.

Francis Bacon (in conversation)

In retrospect, the fact that the artist's style changed radically in old age does not seem in the least surprising - difficult though it was for some admirers at the time to come to terms with an apparently bloodless Bacon. His whole drive as a painter had been towards condensation, his ultimate ambition being to produce the one image which would sum up and supersede all the others. The human body had been compressed, head and limbs pruned, with the trunk's essence bled into a shadow on the floor; and regularly the artist had emptied the background of any inessential prop or conceit. There was a definite logic in the development. The bodies now appeared not only compacted, but weightless, against a virtually unoccupied expanse of colour. Like an endgame in chess, the whole momentum was to clear the last vestiges of movement away, 'leaving not a wrack behind'. This desolation, a true wasteland where nothing could take root, reached a curious extreme in a subsequent composition called Jet of Water, painted in 1988. From an opened water main, water gushes up into a space defined by two rudimentary and functionless machines. In its way, this was the grimmest painting Bacon ever produced. Mankind had been swept off the stage; so had the last shred of vegetation. All that remained was a kind of deserted factory, its futility highlighted by the vigour of escaping water. It was also Bacon at his funniest - one might say, his most Beckettian. For here was

a vision far blacker and more insidious than man abandoned to his fate. Man had already been wiped off the scene, leaving behind only a post-industrial dumb show of his inadequacy.

Bacon himself loved the picture. Although he usually spoke with a deliberate, guarded diffidence about his work, he was openly boastful about this particular canvas. I remember him referring to it throughout an afternoon in Paris, first over lunch at his favourite fish restaurant. Le Duc, then in the Montparnasse bars where, some sixty years before, he had used all his youthful charms to succeed in the city's homosexual milieu. He became progressively drunker, at one point creating a mild sensation at the Sélect by throwing his glass of port into the sink behind the bar and demanding something better, which the alarmed barman quickly gave him; and he completed the spectacle by staggering around the café, talking loudly and looking at himself in a shocking-pink plastic hand mirror that he kept producing from his pocket. 'There it is,' he said repeatedly, 'I'm idiotic, but I'm curious and brilliant. I don't care about anything, and I don't believe in anything. Nada. There's just my brilliance and the brilliance of life. There. That's all there is. Nada. I think I've just painted the best picture I've ever done. I've always thought it would be marvellous to have the sea concentrated into one image, so you'd look into this kind of box and you'd have the whole sea there. I wanted to do a wave, and it turned into a simple jet of water. It's nothing but this bit of water smeared over the surface, you see, but there is something very mysterious about it ...' Then the mirror came out again, and Bacon returned to another refrain: 'Do I really look that young? Well, there it is. There's nothing you can do about those things. You're always as old as you are, even if every now and then someone comes along who thinks you're much younger, then of course who's very shocked when you tell them your age. That's just what's called the horror of growing old and having everybody else dying round you like flies. I've got nobody left to paint now except myself. There it is. Even if it's just this old pudding face of mine. You see, I myself and the life I've lived happen to be more profoundly curious than my work ... Then sometimes, when I think about it. I'd prefer everything about my life to blow up after I die and disappear.'

In his late work Bacon set out deliberately to reduce the content and the means of expression to a minimum. In one of the last interviews he gave, he emphasized the fact that with age 'You're

more conscious of the fact that nine-tenths of everything is inessential. What is called "reality" becomes so much more acute. The few things that matter become so much more concentrated and can be summed up with so much less.'2 Accordingly, Blood on the Floor, also painted in 1988, was exactly what its title suggested: a realistic splattering of blood on a canvas-coloured slab shaped like a diving-board, with nothing but an orange background and a naked, molten vellow bulb highlighting the stark fact. 'Things are not shocking if they have not been put into memorable form.' Bacon said at the time. 'Otherwise. it's just blood spattered against a wall. In the end, if you see that two or three times, it's no longer shocking. It must be a form that has more than the implication of blood splashed against a wall. It's when it has much wider implications. It's something which reverberates within your psyche, it disturbs the whole life cycle within a person. It affects the atmosphere in which you live. Most of what is called art, your eye just flows over. It may be charming or nice, but it doesn't change vou.'3

With fame, and the fatigue of old age, simplicity had become all. In his life as in his work, Bacon began to reduce. Even having a studio in Paris, which had provided him with a second centre to his life for over a decade, began to strike him as too complicated. That, too, had something to do with growing older. From the mid-1980s. he began to prefer the comforts and services of a good hotel when he made his trips to Paris: meals could be brought to the room, messages taken and, if necessary, a doctor quickly found. Finally, having kept it on as a place where he could go and paint if the mood came on him. Bacon abandoned his flat in the rue de Birague altogether, much as he had given up his house in Narrow Street, because his enormous initial enthusiasm had waned. Although he had completed more paintings there than in any other location outside London, the Paris studio no longer gave him the impetus it had over the first half-dozen years. Again, as with the East End, no sooner had he given up the place in the Marais than he began to regret it; and at one point he even began to look for another, more comfortable apartment in Saint-Germain-des-Prés.

Bacon's reputation in Paris stood higher than anywhere else in the world. The French philosopher Gilles Deleuze had in 1981 devoted a brilliant essay to a number of concepts he found in Bacon's imagery, suggesting the most unusual, subtle and personal approach to the work yet published.⁴ This dazzling disquisition, entitled *Logique de la*

sensation, put discussion of Bacon's painting on a new plane of pure, often playful and always inventive intellectual conjecture. Bacon himself was delighted by the attention and intrigued by the text, of which Deleuze had sent him his original manuscript. Following the book's publication, the philosopher and the painter met to spend the evening together, with Deleuze arriving with what Bacon described as a little 'court' of admirers; but although there was a perceptible sympathy and admiration between the two men, no friendship evolved.

Somewhat later, in 1983, Michel Leiris brought out his most complete text on the artist: a richly illustrated monograph which was translated into several languages.⁵ Leiris had decided that his new essay would attempt to define the concept of 'realism' in regard to Bacon's work; and for several years, over long lunches, the two friends had exchanged, developed and refined their ideas on what proved to be a most evasive subject. It obsessed Bacon quite as much as it did Leiris. For years the artist had tried to describe succinctly what he meant by the (equally elusive) term 'instinct', coming up with such evocative, distinctly 'Baconian' phrases as: 'We all live by the hidden areas of our makeup ... Instinct arises out of that whole unconscious sea inside us.'6 When Bacon honed his definitions of realism, however, it became clear that he was talking about what he had hoped to achieve in his most recent paintings. Realism was to be the aspiration and the rallying-cry of the late work, and Bacon wrote a letter specially to Leiris to distil his thoughts on the subject:

For me realism is an attempt to capture appearance with all the sensations which that particular appearance has suggested to me. As for my last triptych and some other pictures painted since rereading Aeschylus, I have attempted to create images of the sensations which certain episodes have bred in me. I was incapable of painting Agamemnon, Clytemnestra or Cassandra, which after all would have been just another history painting. So I have tried to create the image of their effect on me.

Perhaps, at its deepest level, realism is always a subjective thing. When I see grass, I sometimes want to pull up a clump and simply plant it on the canvas. But of course that would not work, and we need to invent the techniques by which reality can be conveyed to our nervous system without losing the objectivity of the thing portrayed.⁷

As a footnote to this uncharacteristically long letter, Bacon appended

a quotation from Nietzsche, saying that it corresponded very much to his own way of thinking, notably about the complex question of realism: 'There is no event, no phenomenon, no word and no thought which does not have a multiplicity of meanings.' During this period of intense friendship and exchange between the two men, Bacon wrote a personal tribute to Leiris for publication in a special issue of a literary magazine devoted to the author. Being never less than himself in whatever he undertook, Bacon set the tone of his encomium with the opening words: 'More than anyone Michel Leiris has shown us that human grandeur is intimately linked with futility.'

Although Paris beckoned to him at all levels, events were to keep Bacon grounded in London from the mid-1980s. Prominent among them, of course, was the new retrospective which the Tate Gallery had been planning for several years. This was to be the largest exhibition of Bacon's painting ever organized, with no fewer than 125 works, many of them triptychs. The choice began with the Tate's own 1944 triptych, publicly imposed by Bacon as his 'first' work. and continued right up to one of the most recent, highly simplified compositions, Three Studies for a Portrait of John Edwards of 1984. The emphasis had been put very clearly on the artist's mature and late periods, with over two-thirds of the paintings chosen executed after Three Studies for a Crucifixion of 1962, the astonishingly vivid masterpiece on which the first Tate show had ended. Unmistakably, the intent was to highlight the artist's development since the earlier retrospective, as if the most important work had been accomplished in the interim: a point of view which will exercise art historians and connoisseurs for many years to come, in much the same way as Picasso's late work still divides opinion. The official nature of the event was further underlined by the fact that few small canvases had been included. Thus the earlier, technically 'clumsier', more intimate and often more exciting painter was given less place than the accomplished, complex master of the big triptychs. By according him a second retrospective exhibition in the country's foremost modern art gallery, the cultural establishment sent a clear signal; however unwelcome his work remained in some circles, Bacon was to painting what Henry Moore had long been to sculpture, an undisputed worldclass master, and as such a national asset.

Patently, it had taken longer to accord this status to Bacon, the painter of screaming heads and flayed bodies, the atheist and homosexual who scorned public honours. But the desire to do so appeared to be the more powerful for coming so late in his life. In his foreword to the catalogue, Alan Bowness, then Director of the Tate, suggested not only that Bacon was 'the greatest living painter' but that the 'terrible beauty' in his paintings placed them 'among the most memorable images in the entire history of art'. Even Bacon, with his unbounded ambition and his insatiable, if well-disguised, desire for praise, was visibly gratified. In the extensive coverage the artist and his exhibition received in the press, the description of Bacon as 'the greatest living painter' was too handy not to be used time and again, and it proved to be an epithet that stuck. However deftly Bacon shrugged it off ('After all, when you look at the other living painters,' he remarked with well-enunciated waspishness, 'there's not much competition'), he knew that this exhibition represented the summit of his career and his power over the public. Moreover, he had achieved the top honours entirely on his own terms. His control over which pictures were to be exhibited and how they were to be perceived extended even to the catalogue. Detailed notes had been prepared on each of the paintings, and they were to have been included in the catalogue to help visitors find their way among the ranks of baffling, nightmarish imagery. But once he saw them, Bacon feared their effect might be to diminish the precious enigma which he had striven so consciously to preserve at the heart of his pictures. and at his emphatic request the notes were dropped.

Like most artists who undergo the ordeal of seeing their life's work laid out before them. Bacon grew unusually tense as the opening of the exhibition approached. Walking through the galleries to look at the final hang, amiable though he remained with museum staff, he underwent the most violent conflict of emotions: there were strong images and less strong images, but they were all out of the studio now and nothing more could be done to any of them. He knew the inner turmoil well, of course, because it came with every opening; but his work had never before been shown on so massive a scale. nor, more poignantly, at a time when he had become so conscious of the ever-increasing limitations of old age. From the early Popes and other 'father figures' to the most recent portraits of John Edwards, the painter's favourite 'son', his life story had been largely told. Only he would ever really know how these images had come about: to what extent they had been born of hard work and repeated failure, and how often they had been the flukes, the happy collisions of shapes which he liked to tell his attentive pundits they were. Only

he, in the end, knew what private sensations had been buried in the screams and the writhings he portrayed. 'If I had not had to live,' he had said some years before, 'I would never have let any of this out.' And again, he alone knew what part real emotion had played, and what had come out of technical cunning, the seasoned cynicism that comes from having brought off a similar effect countless times before. At times he would insist that his whole life had gone into the painting; at others, that it was all distortion, all artifice, and certainly no painter had been more aware of Degas's dictum about painting falsely, then adding the 'accent of nature'.

But no trace of either elation or distress was apparent when the exhibition officially opened. As usual, Bacon had cooperated fully by attending the various receptions and putting himself through his well-practised paces with the press. There was widespread advance coverage of the event, with everything from new 'profiles' of the artist to endlessly retold reminiscences by Soho drinking cronies. The preparations and the various pressures combined with drinking bouts lasting through the afternoon and well into the night had taken a visible toll this time. At the huge buffet supper served in the Tate Gallery on the opening night. Bacon weaved dutifully among his guests. The invitation list had been scrupulously prepared to make sure that none of his many good friends and allies, in England and abroad, had been forgotten. The Soho contingent, for whom this was a local affair, however prestigious, at first stood out, instinctively generating a Colony Room atmosphere, all loud innuendo and crashing laughter. But they were absorbed in the sheer variety of people who constituted Bacon's world: its ramifications surprised even his closest, oldest friends, including as they did grandes dames, distant relatives and old neighbours. The artist went through the throng, attentive to everybody, yet withdrawn, as if anxious about the outcome of the evening. But although several old Bacon hands had darkly predicted another tragedy - 'First Peter Lacy, then George Dyer - whose turn is it now?' - disaster did not strike. On the contrary, the machinery of success, which Bacon had played fast and loose with throughout his career - courting it apparently only to spurn it – appeared to have taken over. The press fell over itself to recognize the 'greatest living painter', and the number of visitors to the show went into six figures. Nevertheless, the work still shocked and disconcerted. Not all the reviews were positive, and a cartoon in Punch cleverly summed up an underlying public reaction when it showed well-dressed, well-balanced citizens striding confidently into the Francis Bacon retrospective and coming out of it on all fours, screaming and vomiting. ¹⁰ Bernard Levin, in his influential column in *The Times*, called the admiration for Bacon that had swept through the press 'one of the silliest aberrations of our exceptionally silly times'. ¹¹

The latter reaction was quite as welcome to the artist as the praise: if his images still stirred up controversy, that was the surest sign that they had not lost their bite. Bacon's ambiguous attitude towards fame hid an old fear that popular success might soften the power of his art until it grew harmless; and his desire to shock remained correspondingly strong right up until the end. Before stepping out of the limelight, which he was more than happy to avoid once an exhibition had been well launched, the artist had to fulfil a longstanding promise. Under the title 'The Artist's Eye', the National Gallery had invited a number of artists to curate their own shows from works in the collection. Bacon, whose selection was to open in October 1985, had decided first on twenty, then on sixteen, paintings (this characteristic Baconian whittling down took place once the hanging began and the catalogue had been printed). His choice ranged historically from a Masaccio altarpiece to a Degas pastel, taking in on the way Michelangelo's unfinished painting of The Entombment, Velázquez's Rokeby Venus, portraits by Velázquez, Goya, Rembrandt and Ingres, then Turner's Rain, Steam and Speed, Manet's Fragments of the Execution of Maximilian, Seurat's The Bathers, Asnières and Van Gogh's The Chair and the Pipe. In introducing his choice, Bacon was typically brief and blunt:

I have often tried to talk about painting but writing or talking about it is only an approximation as painting is its own language and is not translatable into words.

The Manet I have chosen I know is completely changed from what Manet painted but I very much like the montage that has been made of the fragments. The question of fragments is a fascinating and endless question. Would the Elgin Marbles have been so beautiful to us if we had them now in their original state?¹²

Although only masterpieces had been included, the effect of seeing them together was not in the least overwhelming: the vitality of the images complemented each other with an elegance which only a curator of Bacon's visual daring might have foreseen. Hung together by a painter who had drawn deeply from the entire course of Western tradition, these great works from several different periods offered both a master course in the art of looking and a subtle insight into Bacon's 'imaginary museum'.

After closing in London, the big Bacon retrospective moved first to Stuttgart and then, early in 1986, to the Nationalgalerie in Berlin. Although Berlin had left an indelible impression on him. Bacon had been loath to revisit it on the grounds that he would barely recognize the city he had experienced in 1927. But the opportunity to visit his own retrospective in the city and the enthusiasm of his young companion, John Edwards, overruled his previous reluctance, and the two of them left London in March to spend a few days there. But Bacon had been right. Although he found the atmosphere of the bombed, divided and rebuilt city intriguing, little remained to bring back the time, some sixty years earlier, when he had drifted from the cocooned luxury of the Adlon to the fiercely flaunted perversities of the nightclubs. He took advantage of the trip to cross over into East Berlin to visit the Pergamon Museum, where the collection of antiquities, and above all of Egyptian statuary, fascinated him. But what the trip brought home to him with unexpected force was how old he had grown, his youth already buried under the sands of time.

This disagreeable realization had become part of Bacon's everyday experience. Occasionally it hit him from an unexpected angle, as in Berlin, or when he revisited Monte Carlo and could not find a single barman, croupier or White Russian he had known during the gilded years he had spent there. This made him particularly wary when his friends suggested a holiday in some place he had known and liked. 'A holiday,' he would retort in mock astonishment, making himself unavailable, 'but I don't need a holiday. After all, my whole life is a holiday!' Yet, occasionally, there would be encounters of another kind, whose powerful charm resided in the fact that they allowed him to forget the stealthy encroachments of old age. He referred from time to time to the odd sexual adventure, but usually in archly rueful tones. 'They go with you for a moment, for the money of course, but then you amuse them more and they come back. But when you tell them your age, they're disgusted. There it is. It's tragic to go on desiring when one's old.' There were also the haunting possibilities of promises not fulfilled. With great animation, Bacon once described how a 'very young, very good-looking man' had clearly noticed him

while they were both travelling on the Underground: when the young man got out, he turned to the artist and indicated that he should follow, but as Bacon moved forward the doors shut, separating them, and the train moved on. This image – of impossible longing – stayed with him, and he thought for a time he might incorporate the closing doors in a new painting. Then he forgot the incident because what had seemed impossible to him actually happened.

A young Spanish admirer had sent him several letters after seeing the retrospective at the Tate. Bacon let the Marlborough sort through his mail and rarely answered any of it himself. Then he met the young man, who turned out to be very handsome and markedly different from Bacon's usual 'type': he was well-educated, well-off and socially sophisticated. The fact that he was Spanish, spoke several languages, worked in finance (a field which fascinated Bacon as much as it baffled him) and was deeply interested in painting also impressed the artist. Very quickly the two men became passionately involved with each other. The age difference, nearly half a century, seemed to have worked more as a catalyst than an impediment. For Bacon, the new friendship was an unexpected gift, reinforcing the sense he had of a unique destiny and gratifying his vanity. He became jubilant, finding a fresh source of energy in the relationship which helped him to surmount a spate of illnesses that had been making him unusually crabbed. Old friends immediately noticed the transformation, and in their company Bacon could not resist gloating over his young lover's charms. But, being Bacon, he could also turn caustic, particularly about the Spaniard's desire for anonymity and for keeping his homosexuality secret.

For a time Bacon was severely incapacitated by the operation he underwent in 1989 to have a cancerous kidney removed. He grew thin and pale, going out more rarely and often eating only soup or an omelette in place of the extravagant dinner he usually enjoyed. Then flashes of his old exuberance began to return. Accompanied by his good-looking Spaniard, he began to return to all his old haunts, and he took great pleasure in introducing his new friend to the vast range of people, from famous writers to powerful financiers and professional drunks, who doted on him and whose life immediately brightened in his company. He started to go abroad again with his companion, to Paris as always, but also to Colmar to see the great Grünewald altarpiece he had admired from reproductions since his youth, and to Madrid for the Prado's outstanding Velázquez exhi-

bition. Spain began to preoccupy the ageing English artist: he had always loved its great painters, and he took enormous pleasure in discovering the Spanish way of life. The dry heat of the south suited him, and nothing amused him more than going from bar to bar right through the evening before dining, Madrid-style, well after midnight. Learning Spanish became a priority, and he began to study it with the enthusiasm of a young student for whom a new world was opening up. A sign that he was getting to grips with the language came when he began referring pointedly to his seventeenth-century hero as 'Belathqueth', pure Castilian with a camp emphasis, even to his English friends.

As Bacon's private life flourished in his old age, so did his public image. One of the strangest episodes in a career that had been steeped in follies and grandeur was the exhibition which opened, after lengthy negotiations, at the New Tretyakov Gallery in Moscow in the autumn of 1988. Initiated by James Birch, an enterprising young art dealer who had become friendly with Bacon, the show was the first by an important living artist from the West to take place in the Soviet Union. then in mid-perestroika. Several of the works originally chosen were rejected by the Soviet officials as 'pornographic'; but eventually a selection of twenty-two paintings, representing the artist's development from 1945 to 1988, made its way to Moscow, where it aroused the most extreme reactions, from disgust to exhilaration. Russian artists were, of course, particularly alive to the impact of Bacon's vision: Ilya Kabakov, the Russian installation artist whose work has become much admired in the West, said how deeply he was moved by the show. The Soviet artists could not fail to be aware as well that official acceptance of such controversial imagery denoted a degree of liberalization which would have repercussions on their own status and freedom.

If Bacon encouraged the whole project from the start, it was in part because, surrealist to his soul, he saw it as an ideal opportunity for provocation. Given the Russians' cultural isolation and their savagely repressive attitude towards homosexuality, his images were bound to create a commotion. At first Bacon was very keen to go to Moscow to observe the likely outrage at first hand, and it was clear from the foreword he wrote for the catalogue that the event meant a great deal more to him than, say, his retrospective in Japan. 'It is a great honour to be invited to have an exhibition of paintings in Moscow,' the short text began. 'When I was young, I feel I was very

much helped towards painting after I saw Eisenstein's films *Strike* and *The Battleship Potemkin* by their remarkable visual imagery.' Bacon had been initially fascinated by the idea of seeing Russia, and he had even attempted to teach himself some rudiments of the language. But his enthusiasm waned as he realized how uncertain his health had become, and how constrictingly 'official' the opening might turn out to be. His doctor also formally opposed the idea, and in the end Bacon decided not to attend, simply pleading some recent 'bad goes of asthma'.¹³

There was certainly no shortage of mammoth shows and ceremonial openings in the last couple of years of Bacon's life. To mark his eightieth birthday, another blockbuster exhibition of his work toured the United States, opening at the Hirshhorn in Washington in October 1989 and ending nearly a year later in New York, at the Museum of Modern Art, whose purchase of Painting 1946 had given such a powerful boost to the artist's early career. Although the cry of 'greatest living painter' was not taken up by the American critics, the response frequently bordered on the reverential (with some notable dissent, as ever: Hilton Kramer compared him, not to Boldini this time, but to Bouguereau). 14 The art market was not slow to confirm the artist's status with astronomical prices: a Bacon triptych sold for over six million dollars at Sotheby's in New York. The indifference which Bacon had always affected towards his financial success did not change. 'The whole thing has become so boring and bourgeois. Art is just a way now of making money,' he once snapped. 15 As the art market reached the feverish climax that was to spell its own downfall, he showed an exemplary sense of what really counted by offering the most powerful work of his late period, the blood-red Second Version of Triptych 1944 (valued around £3 million), to the Tate Gallery, where it was accepted with none of the hesitation which had met Eric Hall's bequest forty years before. The eightyyear-old Bacon also claimed that he was ready at any moment to return to the materially meagre conditions of his youth, and indeed no record sale changed the austerity of his life at home. Confronted by the masses of flowers sent to the Reece Mews studio by wellwishers on his birthday, his response was characteristically arch: 'I'm not the sort of person who has vases.'

However flattering the tributes paid to him in the press and in private, the prospect of death was rarely far from Bacon's thoughts, even though he believed that 'there's nothing you can do to prepare for it – you just go on living'. Nobody, least of all the artist himself, had imagined he would reach anything like the age of eighty. Old friends continued to die. After the death of Diana Watson, his cousin and staunch supporter, came those of Michel Leiris, his boon companion in Paris, and Isabel Rawsthorne, one of his oldest, closest friends and the model for the most majestic of his portraits. Bacon's own health. already seriously undermined by kidney cancer, began to deteriorate rapidly. He still assumed a jauntiness that belied his years, and on a good day, even within a few months of his death, flashes of the old wickedness would return. I remember a last lunch at Bibendum in London with Bacon confiding in tones that rang out in one of the silences that happen suddenly in crowded rooms: 'My life hasn't changed much, you know. I still masturbate.' At his best he radiated an amused serenity, eating and drinking too much and demolishing every reputation in sight with lethal deftness; yet he had grown pale and visibly weaker. Although he desperately wanted to go on painting – and, if possible 'drop dead' while he was actually at work – the state of his health made it increasingly impossible, particularly as he had large-scale projects in mind. Miraculously enough, he found the strength to complete one last picture, using a new painter friend. Antony Zych, as his model: dated December 1991, Study from the Human Body showed a foreshortened and compacted human frame. radically reduced vet much less 'distorted' than most of Bacon's figures. In this image he gave, perhaps, the most conclusive example of the 'realism' that he had discussed at such length throughout the previous decade.

In the final months, Bacon appeared at times to be barely present, as if all the magnificent energy that had made him such an electric presence had been absorbed elsewhere; he had become his own ghost. The painter Zoran Music found him sitting alone at a table at the Hôtel du Pont-Royal, on his very last trip to Paris: 'He was not looking at all well. I went over to greet him, but he said very little, not because he could not speak, but as if he weren't there any longer.' As he grew weaker, Bacon began to keep more and more to Reece Mews, where he often had to be helped out of bed in the mornings. His near-invalid status distressed him so much that he told his doctor, who several times had to rush him to hospital in his car, that he would rather die than go on living in such a diminished state – even though, until that moment in his life, Bacon would have

chosen any pain and anguish over what he considered to be the absolute extinction of death.

Exasperated by his constant sickness and confinement to the studio. Bacon decided in April 1992, against his doctor's advice, to take a trip to Madrid - where, in a last gamble, he hoped a few days with his young Spanish friend might give him back some vitality. He knew he no longer had much time to live, but above all he was haunted by the thought that he might be kept alive artificially. On arriving in Madrid, he was so weak that he had to be helped out of the aeroplane. Four days later, he became critically ill and was admitted to a clinic with 'renal and respiratory deficiencies'. At eight-thirty the following morning, 28 April, he had a heart attack from which he died. By a strange turn of fate, he was looked after in his last moments by two nuns belonging to the order of the Servants of Mary: to die amongst nuns had been Bacon's worst nightmare, and it had happened. Yet he had been treated in the clinic by the same sisters on previous occasions, and he spoke fondly of them. For all his vehement denunciations of religious faith as blindness or hypocrisy, he had returned knowingly to the nuns' care.

The two sisters later remarked on how uncomplaining the artist had been and how he had expressly wished to avoid causing any disturbance to the other patients in the clinic. A photograph was taken of the dead body, laid out in a shroud; on the forehead was a piece of surgical tape bearing the deceased's name. The body was then put into a coffin with a lid bearing a metal sculpture of Christ on the Cross before being taken to the cemetery of La Almudena to be cremated. According to Bacon's last wishes, no ceremony took place, and no one was invited to attend.

A life filled with the extremes of human emotion and devoted to expressing them with the utmost force had ended, all but anonymously, in utter silence.

POSTSCRIPT

People do not die immediately for us, but remain bathed in a sort of aura of life ... It is as though they were travelling abroad.

Marcel Proust, Remembrance of Things Past, 1913-1927

Francis Bacon has attracted more media coverage since he died than during his lifetime. His death was widely reported before his body had been cremated and his ashes flown back to England, where they were scattered in a very private ceremony. Scores of obituaries appeared, underlining the exceptional role Bacon had played in the art of his own country ('the greatest British painter since Turner') and, more tentatively, his place in the history of modern art as a whole.

However numerous the tributes, little that was not already generally known about Bacon emerged until more personal memoirs. written by old friends, began to appear. Bryan Robertson provided several telling anecdotes about the artist's life, both in London and Monte Carlo, and ended his reminiscence with a striking description of Bacon's 'fantastic feeling for the figure in space: trapped, pinned down or imperilled like a moth or a hunk of meat'. Lucian Freud. who had once called Bacon the 'wildest and wisest' person he knew. talked in passing about the older painter's importance to him as a man and as an artist.2 Perhaps the most substantial and certainly the most provocative memoir came from the late Caroline Blackwood. who had seen Bacon frequently while she was married to Lucian Freud. Blackwood's vivid reminiscence centred round a post-war ball in London at which Princess Margaret seized the microphone to sing Cole Porter songs to a captive audience until a fearlessly derisive Bacon booed so loudly she was forced to flee. It was Blackwood who told the story (which she had heard at second hand) about young Francis being horsewhipped by his father's grooms; and she quoted the poignant phrase with which the artist summed up his recollections of family life in Ireland: 'Surely there's nothing worse than the dusty saddle lying in the hall.'

While the tributes flowed, there was also keen speculation in the media as to the extent of Bacon's wealth and the terms of his will. The initial estimate of £60 million was based on the number of paintings, summarily valued at £1 million apiece, which the artist might have left in the studio at his death. The size of the sum induced a momentary sense of piety in the press which Bacon would certainly have sayoured. 'He lived an unworldly life,' one report concluded, 'never moving from his small 2-bedroomed home.'4 When Bacon's will was published in December 1992, however, his estate in England was valued at just under £11 million net, the sole beneficiary being the artist's long-time companion and frequent model, John Edwards. Bacon's Reece Mews studio was included in the bequest: Edwards stated that he would use it during his own lifetime, preserving it as Bacon had left it, then donate the famously chaotic building to the nation. There was mention of a further huge sum of money which Bacon had invested abroad, but no details of what happened to it have been published.

Posthumous shows of Bacon's work have easily kept pace with the lively public interest reflected in the media. 'The Body on the Cross', a group exhibition which Bacon had been particularly eager to see, opened at the Musée Picasso in Paris six months after his death. Numerous studies of the Crucifixion by Picasso were shown alongside Bacon's triptych of 1944 and his *Fragment of a Crucifixion*, with works on the same theme by several other artists, including Sutherland and de Kooning. Bacon had given what was to be his last interview to the curator of the show, Gérard Regnier, who published it in the catalogue. The artist talked predominantly about his admiration for Picasso, but thoughts of death were clearly in his mind, and he made a point of referring to the way Picasso had been 'disgusted' by the idea of dying.⁵

The implications of Bacon no longer being present to control his public image became instantly apparent in March 1993, when a posthumous retrospective exhibition was organized at the Museo d'Arte Moderna in Lugano. For the first time in thirty years, several paintings (as well as a rug and a decorated screen) which had been made prior to the Tate's triptych of 1944 were exhibited, thus creating a more complete and accurate view of Bacon's evolution than the one imposed by the artist himself. Clearly derivative and

astonishingly mild-mannered, the early Bacons came across as the work of a totally different, self-consciously tasteful painter. They could hardly have seemed more removed from the *Sturm und Drang* of his mature work; and as a result they increased the dramatic impact of the exhibition by suggesting that a traumatic caesura had cut the young artist's life in two. Yet seeing these early decorative efforts hung in relation to the late works also suggested that tastefulness might be more deeply ingrained in Bacon's genius than has been generally acknowledged. Rhetorical stylishness had always come easily to Bacon, facilitated no doubt by his gift for assimilating the most diverse influences; but for a long time it had been disrupted by the force and urgency of his vision. In the last phase of his work, however, when his technical mastery was supreme, a strong element of style for style's sake emerges, with the result that extreme subject-matter is conveyed with aesthetic elegance.

Exhibitions reflecting Bacon's self-constructed image and the ways his work should be seen did not end with his death, nevertheless. A more orthodox retrospective, organized under the aegis of the British Council, was put on shortly afterwards, in the summer of 1993, at the Museo Correr in Venice. Centred on Bacon's great triptychs from Three Studies for a Crucifixion (1962) to the Second Version of Triptych 1944 (1988), the choice of work showed Bacon at his most overpowering; with the strong Venetian sunlight filtered through muslin curtains, the paintings made a more awesome, if less original, impact than at Lugano.

Several exhibitions have been held showing Bacon in conjunction with other artists. In summer 1995 a double bill of Bacon and Lucian Freud was put on at the Fondation Maeght in Saint-Paul-de-Vence, and a year later he was paired with Giacometti at the Sainsbury Centre for the Visual Arts in Norwich. But most stimulating was the confrontation staged at the National Gallery in London in May 1996 between Velázquez's *Portrait of Pope Innocent X* – on loan from the Galleria Doria Pamphilj in Rome – and, opposite, four Bacons which had been inspired by the masterpiece. All the Bacons chosen – *Head VI* (1949), *Pope I* (1951) and two later studies of the Supreme Pontiff (1961 and 1965) – came from collections in Britain. Bacon had deliberately avoided going to see the Velázquez portrait while he was in Rome, and doubtless he would have resisted being shown opposite the painting he prized above all others. But, despite the compelling mastery of the Velázquez, two of the Bacons stood up to it and even

enhanced its authority as one of the most penetrating studies of human nature and human power ever made. Bacon's twisted, fragmented figures led less to a comparison with the insight and skill of Velázquez's Pope, in fact, than to reflections on the profound changes over three centuries in the ways a human being can be portrayed in painting. A sign of the gathering interest in the autobiographical content of Bacon's art came when a tenuous resemblance between a photograph of Eddy Bacon and the Velázquez portrait was highlighted in the media.

An artist who becomes a legend in his own lifetime while limiting and controlling all the available information about his life is doomed to attract an avalanche of conjecture and revelation once he dies. At least three books were prevented by Bacon from being published during his lifetime, and many more were adroitly discouraged. In 1993, two accounts appeared of the tantalizingly colourful but notoriously elusive artist. The first, entitled The Gilded Gutter Life of Francis Bacon, was written by a long-standing friend, Daniel Farson, who had interviewed and photographed the artist on a number of occasions. The other book, Francis Bacon: His Life and Violent Times. came from the novelist and social historian Andrew Sinclair. The two accounts could not have been more different, and this says as much about the protean nature of Bacon and the impact he created as about the temperaments of the two authors. The first book is essentially a series of amiable, rambling and often amusing anecdotes by a companion who viewed his subject from the perspective of mid-century Soho. Impressively well-researched, the latter book provides a great deal of background information but little sense of its complex and quicksilver protagonist, whom the author knew only slightly.

Other revelations about Bacon's life and art have included the previously unrecorded exhibition with Roy de Maistre and Jean Shepeard in 1930, discussed in Chapter 3, and a hitherto unknown and undocumented early 'self-portrait'. The portrait shows a young man painted in a boldly coloured, post-Cubist manner. It has been suggested that Bacon held on to it for some fifty years before giving it to its present owner. This in itself is curious, since he kept very little from the past and for much of his life was constantly changing addresses; he also went to considerable lengths to destroy all his available early work. The canvas board on which this small oil painting was executed was originally estimated as dating from around

1930, although that claim has since been convincingly disputed.⁶ Attribution is made more problematic by the fact that the style of the portrait in no way resembles any of Bacon's few extant paintings of the period, which conspicuously lack the vigour and audacity we associate with his later work. It is unlikely, but not impossible, that the young Bacon – about whom even now so little is known – should have made a sudden breakthrough into a more forceful idiom. In stylistic terms, the picture could then be shown to derive from Roy de Maistre, Bacon's mentor, with the important distinction that it is more brash than de Maistre's genteel imagery ever was.

It is also feasible that other works by Bacon in a similar style once existed but were destroyed. Indeed, the owner of the portrait, who has chosen to remain anonymous, claims he possesses half a dozen other early works on hardboard which Bacon had originally given him, in his capacity as the artist's occasional handyman, to incinerate (though one might well ask why Bacon should have waited half a century to destroy them). The 'handyman', who took it upon himself to preserve them, has shown me three of these works. They are small heads, in differing indistinct Picassoesque styles; in my view, they are markedly inferior to the 'self-portrait', indeed of no artistic value in themselves. Apart from the fact that one of them bears a certain caricaturish likeness to Bacon's face, and the handyman's plausible account of how they came into his possession, no convincing evidence has yet emerged to indicate that any of these paintings is by Bacon. Yet it is worth recalling that the daughter of Yvonne Bocquentin. with whom the young Francis stayed outside Chantilly, remembers the 'Cubist-inspired' drawings he showed her family during his first extended visit of 1927-28. The debate over the 'self-portrait' may peter out for want of verifiable facts. But if it was ever proven to be an early Bacon, it would certainly change the accepted view of the artist's mysterious formative years.

It is only right that this view, cloudy and partial as it is, should be challenged. Each time Bacon's paintings are shown in a new exhibition space, a different perspective is imposed which calls into question the established assumptions about their significance; that is one of the fundamental reasons for holding an exhibition. The latest, full-scale retrospective at the Centre Georges Pompidou in Paris is a case in point. When the paintings hung in the solemnly ornate nineteenth-century galleries of the Grand Palais in 1971, they were perceived above all as a modernist revolt within the great European

tradition. At the Centre Pompidou, which is devoted entirely to the art of the twentieth century, they could be seen more as a revolt within modernism itself, since their allegiance (however ambiguous) to the past stood out all the more clearly in that context. This most recent exhibition broke new ground by including three paintings of the 1930s and half a dozen 'works on paper' – all of which Bacon would have peremptorily excluded. The three early paintings formed an unusual, almost pastoral prelude to the *terribilità* to come; once again, they seemed to be the work not so much of an immature as of a radically different artist. Of the drawings two were finished compositions in gouache of 1933, both of them documented; the others were studies for specific paintings of the early Fifties and Sixties and their existence was hitherto unknown.

In one fell swoop, two preconceived notions about Bacon have thereby been confounded. The first is the artist's own assertion that he *never* drew (few enough of his drawings have survived, because he destroyed them as soon as they had served their purpose as outlines of an image). The other received idea is that he *could not* draw; and on the evidence of these few sketches alone, it is obvious that he possessed a natural graphic fluency. Yet even here, Bacon was more preoccupied with volume than line; and linear drawings, such as his study after Picasso's portrait of Apollinaire reproduced here, are almost unknown. Drawing remained for him a means to an end, never an end in itself.

New approaches to Bacon will be prompted not only by 'finds' of unknown works or documents but also by questioning, and to some extent disregarding, his own emphatic contradictory reading of his art. Rarely has the dictum not to heed what an artist says, only what he does, been more applicable. Bacon suppressed as much biographical information about himself as he could, insisting that his work had to stand by itself, without reference to his life; yet, apart from Picasso, there is no artist in the twentieth century for whom the life lived and the images made are so intimately mixed and interdependent. Bacon proclaimed his extreme distaste for narrative or literary painting, for any imagery that 'told a story'; yet, in the latter half of this century, no one has created as vivid and compelling a relationship between painting and poetic drama. Bacon despised religious belief. Part of his credo as a militant atheist was that his work, although alive with symbol and allusion, 'meant nothing'. Yet the mystique he created

with and around his paintings (effigies that seemed to say so much, but said nothing) amounted to a substitute religion; and by assimilating hieratic images of the past, he sought to reclaim for the art of our times the mystery and power of great religious art.

For most of Bacon's life, his art was indissolubly linked, in the public imagination at least, to the notion of 'horror'. Yet his work exerts a widening fascination, with his recent exhibition in Paris drawing up to five thousand visitors every day, many of them young people in their twenties. For them, it seems, the element of horror has paled beside the visual inventiveness, the beauty of the paint and, above all, the sense of a violently transmitted struggle to convey a truth about the human condition. 'It may be a profoundly vain thing to say,' Bacon reflected not long before his death, 'but I think my life has been more curious than the times I have lived through. I think it has gone deeper than what are called the *mœurs* of my own times.' As our century ends, the 'shock' of Bacon's imagery may take on a more subtle and profound function, crystallizing the past, foreshadowing the future.

NOTES

PART ONE 1909-44

- 1 Origins and Upbringing, 1909–26
- 1 Hugh M. Davies, Francis Bacon: The Early and Middle Years, 1928–1958, New York, 1978, p. 173 n. 3.
- 2 I am grateful to Robert Jenkins of Kington, Herefordshire, for his generous help in tracing the Bacon family history. If Francis Bacon were indeed collaterally descended from his famous namesake, he would be directly descended from the accomplished painter, Sir Nathaniel Bacon (1585–1627). Byron's biographer, Leslie Marchand, suggests that the poet may have had an affair with Charlotte Harley, Francis Bacon's great-grandmother.
- 3 Cannycourt was by far the largest house in the vicinity. John Boylan, next on the census return, lists his household as nine people occupying two rooms.
- 4 Bacon repeatedly referred to his nanny as Cornish. According to her birth certificate, she was in fact born to a labourer's family in Lancashire; but she may have been brought up in Cornwall.
- 5 John Russell, Francis Bacon, revised edition, London, 1993, p. 74.
- 6 Quoted by Rothenstein in his introduction to the Tate Gallery exhibition catalogue, 1962.
- 7 Caroline Blackwood in the *New York Review of Books*, 24 September 1992, pp. 34–5.
- 8 I am grateful to Bryan Robertson for emphasizing the effects asthma had on Bacon.
- 9 Daniel Farson, *The Gilded Gutter Life of Francis Bacon*, London, 1993, p. 167.
- 10 Letter from Mr E. S. Hoare, a fellow-pupil of Bacon's at Dean Close.
- 11 A memoir by Mr A. L. Jayne, a fellow-pupil at Dean Close.

2 Educated Abroad: Berlin and Paris, 1926–28

- 1 With this anecdote in mind, it is interesting to remember how central the subject caught unawares in a mirror was to become to Bacon's compositions.
- 2 Ronald Blythe, *The Age of Illusion: England in the Twenties and Thirties*, London, 1963, p. 37.
- 3 Christopher Isherwood, *Christopher and His Kind*, 1929–1939, London, 1977, pp. 19–20.
- 4 Alfred Döblin, *Berlin Alexanderplatz*, English translation by Eugene Jolas, Harmondsworth, 1982, p. 141.
- 5 Elias Canetti remembers numbers of patrons in Berlin in the late 1920s who actively sought out young talents to support, in his autobiography, *The Torch in my Ear*, English translation by Joachim Neugroschel, London, 1989.
- 6 Davies, for example, assumes that Picasso's Dinard paintings were included in the Rosenberg show (Davies, op. cit., p. 15).
- 7 Dawn Ades discusses Bacon's interest in *Documents* in her essay published in the catalogue to the second Tate retrospective (p. 12). The quotation from Michel Leiris's essay comes from Ades's catalogue for the 'Dada and Surrealism Reviewed' exhibition (p. 235) at the Hayward Gallery, London, 1978.
- 8 Jean Laurent in the magazine La Rampe, Paris, April 1930.

3 A Brief Apprenticeship, 1928–33

- 1 This address has hitherto been given, incorrectly, as 7 Queensberry Mews West in Ronald Alley's *catalogue raisonné* (*Francis Bacon*, London, 1964) and in several, more recent publications. In 1930 Bacon is listed, with his telephone number (WES 1244), in the Kensington Directory at no. 17 Queensberry Mews West; and in 1931, both Jessie Lightfoot and John Eric Alden appear on the electoral roll as living at no. 17.
- 2 The Studio, London, August 1930.
- Bacon certainly made a lasting habit of 1930s Bohemianism. Even as an old man, he would lather his face for shaving with an old sock if he had no brush to hand; until late middle age, when a determined dentist took him in hand, he was still using Vim as his regular toothpaste. Similarly, in the studio, all sorts of everyday objects were put to an ingeniously different use. In his Paris studio, he kept a large dustbin lid for making circles or semi-circles; several frying pans and large dinner plates were used for mixing colours, and, famously, the

finest cashmere sweaters were soaked with pigment in order to obtain the delicate, ribbed effects of colour the artist liked to leave as the final impression on his many-layered images.

- 4 However disrupted, even inconsequential, the course of Bacon's early life appears, nothing that might serve his art was ever lost. Even the 'white faïence seagull by Adnet', placed on a side table in the young decorator's studio, came back during the 1960s in the guise of disquieting bird-objects; it may also have inspired the statuette-sized homunculi, such as the one of George Dyer.
- 5 Later Patrick White also bought the glass and steel dining table which Bacon had designed for Rab and Sydney Butler.
- 6 Bacon's very first recorded painting, *Watercolour* (1929), was later acquired from Alden by Roy de Maistre.
- 7 John Russell, op. cit., p. 18.
- 8 Heather Johnson, *Roy de Maistre: The English Years*, 1930–1968, Roseville, New South Wales, 1995, p. 21.
- 9 Sir John Rothenstein, 'Roy de Maistre', in *Modern English Painters II: Lewis to Moore*, London, 1956, pp. 258–9.
- 10 Patrick White, *Flaws in the Glass: A Self-Portrait*, London, 1981, p. 62.
- 11 Interview with Valerio Adami, Paris, February 1994.
- The exhibition ran from 4 to 22 November 1930. I am grateful to Jean Shepeard's niece, the sculptor Doreen Kern, for providing me with documents relating to the show which she discovered among her late aunt's effects. It is difficult to ascertain with any certainty which of Bacon's known early works were in the exhibition. Ronald Alley, in his catalogue raisonné, suggests that the gouache of 1929 showing a section of brick wall was included. Thus one might reasonably presume that it corresponds to the work listed as The Brick Wall, except that the latter was priced at 45 guineas, which seems a great deal for a small gouache when Tree by the Sea, a large oil, was selling for only 25 guineas. The portrait of the boy with diseased skin also poses a problem. It was at one time accepted as a self-portrait, since it clearly resembles the artist as a young man. Later Bacon denied that it was a portrait of himself; he had painted it, he said, after having seen Ibsen's Ghosts, a play in which the father's sins are visited on the son. The so-called 'self-portrait' which has come to light since the artist's death is discussed in the Postscript to this book.
- 13 Bryan Robertson, quoted in Farson, op. cit., p. 28.
- 14 Michael Wishart, quoted in ibid., p. 110.

- 15 Heather Johnson, op. cit., p. 217 n. 38.
- Michael Wishart, High Diver: An Autobiography, London, 1978, p. 63.
- 17 Michel Archimbaud, Francis Bacon in Conversation with Michel Archimbaud, London, 1993, p. 152.

4 'Insufficiently Surreal', 1933-39

- 1 See Jean Clair's interview with Bacon entitled 'Pathos and Death' in the English-language edition of the catalogue to the exhibition 'The Body on the Cross' at the Musée Picasso, Paris, 1992, p. 132.
- 2 Anton Zwemmer: Tributes from Some of His Friends on the Occasion of His Seventieth Birthday, London, 1962, pp. 3–4.
- 3 Lawrence Gowing makes the comparison with Masson in his essay published in the catalogue to the exhibition 'Francis Bacon: Paintings 1945–1982', Tokyo, 1983.
- 4 For a full description of the period, see Charles Harrison, English Art and Modernism 1900–1939, London, 1981.
- 5 Time and Tide, 6 May 1933.
- 6 Kenneth Clark, Another Part of the Wood: A Self-Portrait, London, 1974.
- 7 Heather Johnson, op. cit., p. 24.
- 8 Davies, op. cit., p. 33.
- 9 Positioning in Radiography by K. C. Clark, London, 1939. Bacon made use both of the positioning of the bodies to be photographed and of the X-rays themselves.
- The reaction may be judged from the opening of Anthony Blunt's review of 'Superrealism' published in the *Spectator*, 19 June 1936: 'Take Blake's anti-rationalism, add Lamartine's belief in the individual, stir in some of Coleridge's faith in inspiration, lard with Vigny's ivorytower doctrines, flavour with Rimbaud's nostalgia, cover the whole with a thick Freudian sauce, serve cold, stone-cold (dead, stone-dead), and you will have before you roughly the Superrealist dish, varieties of which are now thrilling, horrifying, puzzling, scandalising or just boring London in the exhibition of Superrealism at the new Burlington Galleries.'
- 11 I am grateful to Denis Wirth-Miller for drawing this information about Virginia Woolf from Bacon.
- 12 The Referee, 17 January 1937.

5 A Vision Without Veils, 1939–44

- 1 The shot of the panic-stricken crowd can be seen in the photographs Sam Hunter took in 1950 of the clippings Bacon kept pinned to his studio wall. The scene is identified as a street battle in Petrograd in July 1917.
- 2 John Lehmann, In the Purely Pagan Sense, London, 1976.
- 3 The fortune had been made by Hall's father, a successful surveyor and builder.
- 4 The complex question of Bacon's abandoned works is discussed below in chapter 9 n. 27.
- 5 See Andrew Durham's informative 'Note on Technique' in the catalogue to the second Tate Gallery retrospective (1985).
- 6 Bacon would already have noted Picasso's obsessively brilliant reference to genitalia in works such as the *Study for a Crucifixion* (1929), in which Mary Magdalen is shown with her head thrown back and a long, unmistakably phallic nose.
- 7 London Bulletin, no. 6, October 1938.
- 8 Rolf Lassøe, 'Francis Bacon's Crucifixions and Related Themes', *Hafnia*, no. 11, Copenhagen, 1987, n. 16.
- 9 Eliot refers to the Furies as the Eumenides, and Bacon adopted the term. They are in fact called the Erinyes until the third and last play in the *Oresteia*, when Athena persuades them to forsake vengeance and become Eumenides or 'kindly ones'.
- 10 The film was directed by Pierre Koralnik for Radio-Télévision Suisse Romande.
- 11 Possibly the one thing Bacon regretted about having had so little formal education was that he had no knowledge of ancient Greek, since he longed to read Aeschylus in the original. Foreign languages as a whole fascinated him. He made valiant attempts to learn modern Greek before visiting Athens, and later managed to get some grasp of Spanish. Although he insisted that he had no facility for learning languages, he came to speak French fluently after making extended stays in Paris in the 1970s.

PART TWO 1944-63

6 Father Figures and Crucifixions, 1944-46

In the early 1970s I wrote an account of my friendship with Bacon, including a detailed sketch of his life, which he encouraged by

providing me with many missing biographical details. Extracts which he had read and approved were prepared for publication, but at the last moment he asked me to set the entire book aside. Other examples of this desire to control, unexpected in someone who otherwise scorned precaution, are abundant. A curator at the Tate Gallery who had prepared detailed notes on each painting chosen for Bacon's second retrospective was requested not to include them in the catalogue. More notoriously, the writer and editor Bruce Bernard put together a 'scrap-book' which juxtaposed extracts from articles with documentary photographs and reproductions. Bacon encouraged the project right up until publication, when he stepped in to block the book (see Bruce Bernard, 'About Francis Bacon', *Independent Magazine*, 2 May 1992).

- 2 Rolf Lassøe made a brilliant interpretation of this key remark in 'Francis Bacon's Crucifixions and Related Themes'. I am indebted to this essay as well as to his article 'Francis Bacon and T. S. Eliot', published in *Hafnia*, no. 9, Copenhagen, 1983, pp. 113–30.
- 3 David Sylvester, *Interviews with Francis Bacon*, London, 1993, revised edition, p. 46.
- 4 Nolde and Beckmann come to mind as two other artists in the earlier part of the century for whom the Crucifixion was an important theme. It returned in certain artists' work as the only adequate symbol for expressing the sense of loss and desolation brought about by the Second World War. Much earlier than Sutherland, Renato Guttuso painted a *Crucifixion* (1940–41) which caused charges of blasphemy and Bolshevism to be brought against him.
- 5 Caroline Blackwood, New York Review of Books, 24 September 1992.
- 6 Russell, op. cit., p. 12.
- 7 The two most important studios, in Cromwell Place and Reece Mews (which Bacon occupied for the last thirty years of his life), are within minutes of each other. And the only one not to be within easy walking distance of these is the studio in the flat Bacon shared from 1955 to 1961 in Prince of Wales Drive, Battersea.
- 8 At the private view to open the Wilson Steer retrospective at the Tate, on 18 June 1943, both Roy de Maistre and Graham Sutherland talked to John Rothenstein about their talented friend Francis Bacon.
- 9 See Jeffrey Bernard, Tatler, May 1985, p. 128.
- 10 Roy de Maistre was sufficiently impressed by the number of big cars drawn up outside the Cromwell Place studio during the gaming parties to have remarked on it to Eric Hall's son, Ivan. Interview with Ivan Hall, London, February 1996.

- 11 Michael Wishart, op. cit., pp. 61–2.
- 12 Anne Dunn subsequently married the painter Rodrigo Moynihan, a good friend of Bacon's who was Professor of Painting at the Royal College of Art.
- 13 With this elegant statement of intent, the Gargoyle Club was inaugurated by David Tennant in 1925.
- 14 Michael Luke, David Tennant and the Gargoyle Years, London, 1991.
- 15 A handful of members' names gives some idea of the diversity: Noël Coward, Dylan Thomas, Nancy Mitford, Maynard Keynes, Kim Philby, George Melly.
- 16 Roy de Maistre had been taken aback when Bacon asked him the most elementary questions about painting in oil. But within a year, Bacon had showed sufficient mettle for de Maistre to be happy to exhibit with him.
- 17 Russell, op. cit., p. 10.
- 18 Apollo, May 1945, p. 108.
- 19 New Statesman and Nation, 14 April 1945, p. 239.

7 Towards Other Shores, 1946–50

- 1 Roger Berthoud, *Graham Sutherland: A Biography*, London, 1982, pp. 110–11.
- 2 Ibid., p. 130.
- 3 Horizon, no. 120-1, December 1949-January 1950.
- 4 All Bacon's favourite studios were either part of a mews, like Queensberry Mews West and Reece Mews, or backed on to one, as Cromwell Place does. Even the studio the artist chose in Paris overlooks a cloistered cobbled courtyard very similar to a London mews.
- 5 In Millais's day, distinguished visitors to the studio had included Richard Wagner and Lewis Carroll. See Alyson Wilson, *Art Quarterly*, no. 17, Spring 1994, pp. 23–4.
- 6 Berthoud, op. cit., p. 129.
- 7 Bryan Robertson, who was then working at the Lefevre Gallery, remembers Bacon telling him about a nanny who, when he was a baby, had put a safety pin carelessly and very painfully through his nappy.
- 8 The photograph was taken by John Deakin and published in *Vogue* in 1954.
- 9 On a simpler level, it is worth recalling that Bacon liked the sensation of enclosed space, and that he was most at ease in small rooms with drawn blinds and strong spotlights.

- 10 See Alexander Dückers, *Francis Bacon Painting*, 1946, Stuttgart, 1971.
- 11 Bacon could become entranced by all kinds of odd marks. I remember when we were sitting at the Coupole in Paris, he suddenly became fixated by the shape a pool of spilt milk had made on the table.
- 12 Georges Bataille in *Documents*, no. 6, November 1929.
- 13 Letter to Graham Sutherland. This and all subsequent letters quoted are in the Tate Gallery Archive.
- 14 Both these undated letters and other documents relating to the Hanover Gallery are amongst the papers Erica Brausen left to the Tate Gallery Archive. Since most of the *Heads* were painted in 1949, and since Bacon refers to Jeffress's recent holiday in Italy, the most likely date for this letter is late summer 1949.
- 15 Wishart, op. cit., 1978, p. 74.
- 16 See Bryan Robertson's posthumous tribute to Bacon in the *Guardian*, 29 April 1992.
- 17 The correspondence actually begins with a letter dated 8 February 1943, which Bacon wrote from his temporary retreat at Petersfield, inviting the Sutherlands to dinner ('I still know one or two places where the food is not too bad') when they are next in London.
- 18 Berthoud, op. cit., p. 87.
- 19 Ibid., p. 131.
- 20 Observer, 19 December 1952.
- 21 The Grünewald drawing is reproduced in Wieland Schmied, *Francis Bacon: Vier Studien zu einem Porträt*, Berlin, 1985, p. 54.
- Gowing, preface to the catalogue to the 'Francis Bacon, Paintings 1945–1982' exhibition, Tokyo, 1983, p. 105.
- 23 *Time*, 21 November 1949.
- 24 Gowing, loc. cit., p. 105.
- 25 The Times, 22 November 1949.
- 26 Nevile Wallis, Observer, 20 November 1949.
- 27 The Listener, 12 May 1949.
- 28 Ibid., 17 November 1949.

8 Hounded by Furies, 1950-54

- 1 The Bath Club's original premises in Dover Street had burnt down and by this date it had merged with the Conservative Club in St James's Street.
- 2 The flurry of correspondence around this bequest is in the Tate Gallery Archive. Rothenstein lost no time, however, in accepting the

Three Studies: in a letter to Hall dated 22 May 1953 he refers to the picture as 'Figures at the Foot of the Cross', which is no doubt the title which Bacon had originally given to it.

- 3 The Times, 20 October 1959.
- 4 Buhler painted a rather uninspired portrait of Bacon reproduced in Robert Melville's article, 'The Iconoclasm of Francis Bacon', *World Review*, January 1951.
- 5 Wishart, quoted by Farson, op. cit., p. 110.
- 6 I am grateful to Angus Stewart for these details about Bacon's mother as a hostess.
- 7 Quoted in a review written by a certain 'Rospigliosi' for *Time* magazine on 12 December 1952 (in the Tate Gallery Archive).
- 8 This was notably the case when Bacon painted his posthumous portraits of George Dyer.
- 9 See Sam Hunter's photographs of the clippings on Bacon's wall.
- 10 'Mr Francis Bacon has recently made two journeys to Africa, and in view of what his appalling imagination has previously made of the European scene there is reason to be thankful that what he has discovered in the dark continent is no worse than it is' (*The Times*, 16 December 1952).
- 11 Artist's statement published in the catalogue to a loan exhibition at the Granville Gallery, New York, 1963.
- 12 Bacon's interest in photographic images of all kinds has yet to be fully explored. In the visually fascinating clutter on his studio floor, there were, for instance, numerous photos of trains and aerial shots of railway lines.
- 13 See the Hanover Gallery records in the Tate Gallery Archive.
- 14 Of all the writings on Bacon of this period, Melville's various essays remain the most evocative.
- 15 Bacon was a cult figure for students and young artists even before he became unofficial 'artist in residence' at the Royal College of Art in autumn 1950. Carel Weight, who had started teaching at the college in 1947, remembered that Bacon was 'a hero to the students' by the late 1940s (see Alyson Wilson, *Art Quarterly*, no. 17, Spring 1994, pp. 23–4). The early shows at the Hanover and the stories that circulated about Bacon fed an already lively legend.
- 16 Quoted in the catalogue to the Tate Gallery retrospective, 1962, p. 29.
- 17 Introduction to the catalogue to the 'Helen Lessore and the Beaux Arts Gallery' exhibition, Marlborough Fine Art, London, 1968.

- Published in the catalogue to the 'Matthew Smith Paintings 1909 to 1952' exhibition, Tate Gallery, 1953.
- 19 See Notizie d'Arte, Milan, March-April 1983.
- 20 This and the following letter are in the Tate Gallery Archive.

9 Truth Told by a Lie, 1954–58

- 1 Lottie herself was modelled on Rosa Lewis, who ran the fashionably disreputable Cavendish Hotel in Jermyn Street.
- 2 Colin MacInnes, England, Half English, London, 1961, p. 73.
- 3 The photograph was published in Max Brod's biography of Kafka.
- 4 Jeffrey Bernard, John Deakin, Henrietta Moraes and Bruce Bernard make up the rest of the group.
- 5 Bacon originally gave the college his first *Bullfight* painting, then exchanged it for *Study for the Human Body: Man Turning on the Light* (1973–74), which now hangs in the Senior Common Room.
- 6 The painter Michael Andrews remembered many years later the excitement Bacon's talk generated: 'What Francis said that day went through the current art jargon like a cleaver.' See Bruce Bernard, 'His Friends on Bacon', *Tatler*, May 1985.
- 7 Quoted in Frances Spalding, Dance till the Stars Come Down: A Biography of John Minton, London, 1991, p. 175.
- 8 Malcolm Yorke, Keith Vaughan, His Life and Work, London, 1990, p. 162.
- 9 Bacon particularly enjoyed Ann Fleming's parties, not only because he liked her but because he met so many of his friends there. The party she gave to celebrate Cyril Connolly's fiftieth birthday in October 1953, for instance, included Bacon, Lucian Freud, Caroline Blackwood, Sonia Orwell, Stephen Spender and Cecil Beaton. See Barbara Skelton, *Tears before Bedtime*, London, 1987, p. 175.
- 10 Quoted in the catalogue to the exhibition 'John Deakin: The Salvage of a Photographer', Victoria and Albert Museum, 1985, p. 18.
- 11 See George Melly's introduction to Daniel Farson, *Soho in the Fifties*, London, 1987, p. xv.
- 12 The Listener, 27 January 1955.
- 13 To Turin, then to Milan and Rome.
- 14 See Alley, op. cit., p. 86.
- 15 Stephen Spender, *Journals* 1939–1983, London, 1985, p. 153.
- 16 Kenneth Vaughan, *Journals* 1939–1977, London, 1989, p. 99.
- 17 Evelyn Waugh, Letters, ed. Mark Amory, London, 1980, p. 482.
- 18 Letter dated 5 July 1957, Tate Gallery Archive.

- 19 Kingsley Amis, Memoirs, London, 1991, pp. 174-6.
- 20 The Hirshhorn Museum, Washington DC, and the Sainsbury Centre for Visual Arts, Norwich.
- John Rothenstein describes the party given to open the show in his autobiography, *Time's Thievish Progress*, London, 1970, pp. 84–5.
- William Burroughs, The Naked Lunch, London, 1993, pp. 91–3.
- 23 The Letters of Ann Fleming, ed. Mark Amory, London, 1985, p. 197.
- 24 Quoted in Farson, *The Gilded Gutter Life of Francis Bacon*, pp. 139–40.
- 25 David Herbert, Engaging Eccentrics, London, 1990, p. 83.
- 26 Letter to Paul Danquah, quoted in Farson, op. cit., p. 158.
- 27 Bacon often left behind unfinished or unsatisfactory canvases in the various studios he used. Inevitably, many of these abandoned pictures have resurfaced on the market; and no doubt others will eventually emerge. Although these paintings will never have full status in the *oeuvre*, the artist may have been in two minds about their quality if he did not destroy them outright.
- 28 Quoted in Ted Morgan, Literary Outlaw: The Life and Times of William S. Burroughs, London, 1991.
- 29 Ibid., p. 267.
- 30 Interview quoted in the Guardian, 2 May 1992.

10 Recognition at Home: The Tate Retrospective, 1958-63

- 1 Tate Gallery Archive.
- 2 Idem.
- 3 See Archimbaud, op. cit., pp. 26–7.
- 4 I am grateful to Sir Alan Bowness for sharing with me his recollections of St Ives in the late 1950s.
- 5 Eric Newton was writing in *Time and Tide*, and Lawrence Alloway in *Art News and Review*, April 1960.
- 6 Cecil Beaton, *The Restless Years*, London, 1976, pp. 100–7. Beaton in fact made two series of portraits of Bacon: the first, in 1951, took place in his own house, with Lucian Freud in the background; the second, in Bacon's Battersea studio, in 1959. All these photographs are now kept in the Beaton Archive at Sotheby's, London.
- 7 The Letters of Ann Fleming, p. 205.
- 8 Ibid., p. 236.
- 9 Rothenstein, op. cit., pp. 79–80. The sculptor Raymond Mason recalls seeing both artists at a meeting at the Institute of Contemporary Arts in the mid-1950s. Bacon soon became bored and wanted to

leave; Moore seemed inclined to stay until Bacon literally dragged him out of the room by the arm. (Interview with Raymond Mason, Paris, October 1993.)

- 10 Tate Gallery Archive.
- 11 Rothenstein, op. cit., p. 86. The 'American scholar-collector' was no doubt James Thrall Soby.
- 12 See the photograph of the artist's father published in Andrew Sinclair, *Francis Bacon: His Life and Violent Times*, London, 1993 (plate 2).
- 13 Interview with Janetta Parladé, Creysse, France, August 1993.
- 14 Rothenstein, op. cit., pp. 89-90.
- 15 Stephen Spender, for instance, refers twice to Bacon's sadness at Lacy's death in his *Journals* 1939–1983, London, 1985.
- 16 The outraged comment appeared in the *Manchester Evening News*, 24 May 1962.
- 17 Observer, 27 May 1962.
- 18 Max Kozloff, Nation, November 1963.
- 19 Part of this statement is quoted in Chapter 8 above.
- 20 David Sylvester's *Interviews with Francis Bacon* first appeared in book form in 1975.
- 21 'From a Conversation with Francis Bacon', Cambridge Opinion, 1964.

PART THREE 1963-92

- 11 'A Brilliant Fool Like Me', 1963–9
 - 1 In Curiosités esthétiques.
 - 2 See above, chapter 5 n. 10.
 - 3 In Writing Home (London, 1994), Alan Bennett notes the respect the waiters at the Brasserie Bofinger in Paris paid to Bacon as he left. Perhaps it was because they had a natural admiration for a great artist, as Bennett says; they undoubtedly admired his tips.
 - 4 Bacon described his fruitful dalliance with sculpture in David Sylvester, *Interviews with Francis Bacon*, revised edition, London, 1993, pp. 108–12. Bacon's interest in Giacometti extended to searching out and buying a copy of *Paris sans fin*, the relatively rare book of lithographs and writings by the Swiss artist published in a limited edition in 1969.
 - 5 See interview with the artist published in *Chroniques de l'Art Vivant*, no. 72, Paris, December 1971–January 1972.

- 6 The traditional hierarchy of artistic subjects, codified towards the end of the seventeenth century, placed history painting at the top, followed by portraiture, landscape and, finally, genre.
- 7 Quoted in Isabel Rawsthorne's obituary in the *Daily Telegraph*, 29 January 1992.
- 8 Interview with Henrietta Moraes, London, 6 December 1993.
- 9 In the catalogue to the Victoria and Albert Museum exhibition *John Deakin: The Salvage of a Photographer*, London, 1985, p. 8.
- 10 Evening Standard, 2 June 1971.
- 11 Quoted in the New York Times Magazine, 20 August 1989, p. 76.
- 12 He was treated by Dr Stanley Brass, who became his regular physician. When Dr Brass retired, Bacon consulted his son, Dr Paul Brass, who became a key friend and his doctor for the rest of his life.
- 13 Bacon dreaded the day that the Krays would be released. Ronnie Kray died in prison in March 1995.

12 All the Honours of Paris, 1969-72

- 1 Positioning in Radiography is a collection of over 2,500 plates compiled by Kathleen Clara Clark and first published in 1939. For a detailed discussion of their importance to Bacon, see Lawrence Gowing, 'Positioning in Representation', Studio International, January 1972.
- 2 David Hockney remarked perceptively that, because Bacon did not draw, the forms he created in painting risked becoming mannered and repetitive.
- 3 Even the beautiful series of monographs called *Les Demi-Dieux*, which included a Velázquez published just after the war, were in black and white. Similarly, the early volumes of Zervos's *catalogue raisonné* of Picasso (like, of course, the Lemoisne catalogue of Degas's work, which Bacon also consulted frequently) were in black and white. The great French art magazines used little colour until Tériade founded *Verve*, which ran from 1937 to 1960.
- 4 See Sylvester, op. cit., p. 65.
- 5 Almost exact contemporaries, both Genet and Bacon were self-taught late starters. Both delighted in provocation and extreme paradox. Having been branded from birth as outsiders, they made a cult of putting themselves as far beyond convention as they could. There are numerous parallels in their lives and attitudes as homosexuals. In each of them, moreover, the creative urge was deeply rooted in erotic fantasy and self-dramatization.
- 6 See the thesis by Patricia Laligant, Etude des relations de Francis

Bacon et Michel Leiris, Université de Paris 1, September 1994. 'De la littérature considérée comme une tauromachie' in fact served as a preface to Leiris's famous autobiographical L'Age d'homme. When it was published in the literary review Les Temps Modernes, Bacon wrote to Leiris (in a letter from Reece Mews dated 25 January 1966): 'Je suis dans un très mauvais état avec mon travail et votre pièce m'a vraiment donné la volonté de recommencer' (I've been in a very bad way with my work and your text has really given me the will to get going again).

- 7 Lassøe gives a perceptive analysis of this triptych in his essay 'Francis Bacon and T. S. Eliot'.
- 8 The triptych was bought in 1968 by Joseph Hirshhorn. Willem de Kooning wrote to Hirshhorn and his wife to congratulate them on the acquisition, adding that he had met Bacon earlier that year in London: 'I knew he [Bacon] was a terrific guy ... and he was.' (Letter postmarked 5 December 1968, reproduced in the catalogue for the travelling exhibition 'Willem de Kooning from the Hirshhorn Museum Collection', 1993–95.) De Kooning, who openly admired Bacon's intelligence and sense of humour, was clearly more generous in his appreciation of fellow-artists than Bacon himself.
- 9 See Russell, op. cit., p. 169.
- 10 Like several people who knew Bacon well, Peter Beard was impressed by his resilience and stoicism.
- 11 Interview with Dr Paul Brass.
- 12 The Picasso retrospective was actually shown in both the Grand and the Petit Palais in 1966–67.
- 13 'Francis Bacon en tête des artistes importants', *Connaissance des Arts*, January 1971.
- 14 The Letters of Ann Fleming, p. 400.
- 15 Dali was visibly put out by the lack of attention paid to him and by the obvious grip Bacon's painting had over the Parisian public.
- 16 In 'Francis Bacon: le paradoxe du tragique et du suave', *Le Monde*, 3 November 1971. Bacon was particularly pleased by the choice of the adjective '*suave*' (though its connotations in French and English are different). 'I've always loved that word,' he remarked after reading the article. 'It reminds me of rustling silk.'
- 17 The only exception appears to be the monograph by Hugh Davies and Sally Yard (*Francis Bacon*, New York, 1986), which includes two *Crucifixions* of 1933. The first exhibition to show work prior to the *Three Studies* of 1944 was also the first museum exhibition to take

place after Bacon's death, at the Museum of Modern Art in Lugano, in March–May 1993.

- 18 In Chroniques de L'Art Vivant, loc. cit.
- 19 See Farson, op. cit., p. 188.

13 Elegy for the Dead, 1972–75

- 1 Farson, op. cit., p. 190.
- 2 'I'm so pleased you think the exhibition has had some success and I'm sure it was greatly helped by your fine preface.' Letter sent from Reece Mews dated 17 January 1972.
- 3 Quoted in Enzo Ungari, Bertolucci by Bertolucci, London, 1987.
- 4 New Society, 6 January 1972.
- 5 The Listener, 16 March 1972 (transcribed from 'Arts Commentary', Radio 3). After Bacon's death, it was revealed that he had himself donated a 'substantial' sum of money towards buying the Titian for the National Gallery (see the letter from Sir Michael Levey published in the Independent, 11 May 1992).
- 6 See Hervé Guibert, *The Man in the Red Hat*, London, 1993, pp. 33–5. When Bacon sat in a café in Paris, people would regularly come up and talk to him about all kinds of things. He once mentioned a young Frenchman who had started up a conversation, telling him he took too much cocaine. 'He expected me to say: "Oh, that's bad for you. You should stop." So I said: "Yes, why not? I think cocaine's a very good idea."'
- 7 Undated letter to Michel Leiris. Bacon made the remark after seeing the exhibition 'Dada and Surrealism Reviewed' at the Hayward Gallery early in 1978.
- 8 Letter to Leiris dated 9 November 1966.
- 9 Letters to Leiris dated 11 June 1971 and 16 September 1981.
- 10 The monograph was published as *Francis Bacon, face et profil*, Paris, 1983.
- 11 The French translation, with a foreword by Michel Leiris, came out in 1976.
- 12 Interview with Jacques Dupin, Paris, November 1993.

14 'My Exhilarated Despair', 1975-81

1 Bacon often put himself at a disadvantage in all kinds of relationships, particularly where money was concerned. He seemed to enjoy allowing himself to be 'ripped off'; but it was also a way of testing people, including his closest friends, and he took good note as to who abused his apparent guilelessness.

- 2 Interview with Valerie Beston, October 1995.
- 3 See Russell, op. cit., p. 180.
- 4 It comes back again, in another blood-soaked variation, in *Oedipus* and the Sphinx after Ingres (1983).
- 5 Bacon did not much believe in signing petitions, but his doctor remembers that he worried for a long time over whether to sign one asking for a Gay Rights bill recommending that children be taught about homosexuality. He did not mind exposing his name, he told Dr Brass; but was the cause justified?
- 6 The articles appeared in the *New York Times* on 16, 20 and 30 March 1975.
- 7 Bacon was a source of good practical advice, and he regularly helped his friends on various projects, putting them in touch with influential lawyers, financiers, etc.
- 8 Also quoted in Farson, op. cit., p. 118.
- 9 For a long time Bacon's date of birth was often given as 1910 or 1911 (see letter from J. T. Soby to Sir John Rothenstein, 1 June 1962, in the Tate Gallery Archive). Confusion as to his parents' full names arose because they were both known by their *second* Christian names.
- 10 See chapter 6 n. 1 above.
- 11 Except for the Alley–Rothenstein *catalogue raisonné*, where there is a special section devoted to 'Abandoned Pictures'. But the last work included in this section is dated c.1954; any works 'abandoned' after that date have yet to be catalogued.
- 12 The letter to Leiris is dated 3 April 1976.
- 13 It is possible that Bacon used photographs that he had of Peter Beard with his head shaven for this enigmatic figure. (Interview with Peter Beard, New York, March 1994.)
- 14 See Sylvester, op. cit., p. 200.
- 15 Reproduced in Bacon's handwriting in the catalogue and dated 8 October 1975, the original reads: 'Pour moi Giacometti n'est pas seulement le plus grand dessinateur de notre époque mais parmi les plus grands dessinateurs de toutes les époques.'
- 16 Giacometti made the point ceaselessly, saying on one occasion: 'I don't really know what forms are. I think only about drawing.' (See the interviews with Giacometti entitled *Je ne sais ce que je vois qu'en travaillant*, Paris, 1993, p. 8.)
- 17 Interview with Jacques Dupin, Paris, November 1993.

- 18 Interview with Raymond Mason, Paris, October 1993.
- 19 Bacon often referred to the end of the friendship with ironic detachment, but there is no doubt that he missed Freud's conversation and company. Years later Bacon still had photographs of Freud, whom he had painted so often, mixed in the debris on his studio floor.
- 20 See Farson, op. cit., p. 197.
- 21 Quoted in Peter Webb, *Portrait of David Hockney*, London, 1988, p. 28.
- 22 I remember going with Bacon to visit Hockney in his Paris studio in Saint-Germain-des-Prés, just beside the passage du Commerce Saint-André (where Balthus had set one of his most famous pictures). Hockney took several Polaroids of Bacon and me during the afternoon.
- 23 See the revealing interview with Bacon in John Gruen, *The Artist Observed*, Chicago, 1991, pp. 1–11.
- 24 Letter to the author dated 23 April 1982.

15 Alone in the Studio, 1981–84

- 1 Bacon loved to distil a maximum of content into a minimum of words, even if the result often made his opinion on any particular subject sound more extreme than it was in reality. 'I like phrases that cut me,' he said.
- 2 See *The Times*, 15 September 1983.
- 3 For Bacon, 'the whole of twentieth-century literature in English has been done by the Irish or the Americans'. He particularly admired the Irish way with words, not only in writing but in conversation, remarking that 'The Irish just seem to exist to talk.'
- 4 Bacon was impressed by the way Proust felt that, once his great work had been written, he could allow himself to die. Thinking about this one day, Bacon said, unexpectedly enough: 'In a way, you could say that Proust's was the last saintly life.'
- 5 Several of Bacon's most perceptive admirers believed that the later work lacked the daring and spontaneity which had drawn them to his painting in the first half of his career. The writer John Richardson put it succinctly: 'What I liked most was when Bacon was painting like Beau Brummell tying cravats discarding one after another until something perfect and fresh came about. When he found painting difficult, the pictures were good. But once he knew how to do it and had all the technical ability, he started repeating himself.' (Interview with John Richardson, New York, November 1993.)

16 'The Greatest Living Painter', 1984–92

- 1 Bacon himself rejected any comparisons between Beckett's work ('all those ghastly dustbins') and his own. But their vision and even their sense of humour is strikingly similar at times.
- 2 Art International, Paris, Autumn, 1989.
- 3 Ibid.
- 4 Francis Bacon: Logique de la sensation, Paris, 1981.
- 5 Francis Bacon: Face et profil, op. cit.
- 6 The artist talking on the Acoustiguide to the Tate retrospective of 1985.
- 7 Letter to Michel Leiris dated 20 November 1981. A friend of Bacon's in Paris, Eddy Batache, helped Bacon to write the original text in French.
- 8 From Thus Spake Zarathustra, part 2.
- 9 In L'Ire des vents, no. 3/4, Paris, 1981.
- 10 Punch, 5 June 1985.
- 11 See Bernard Levin, In These Times, London, 1986.
- 12 Bacon expanded his point about the Elgin Marbles amusingly when he talked to Peter Beard: 'I love, for instance, the Elgin Marbles in the British Museum, but whether they're more beautiful because they're fragments, I've often wondered. I don't know whether one would have liked the Parthenon so much if we'd seen it painted up like a Christmas tree, as it was originally.' See the catalogue to the exhibition 'Francis Bacon: Recent Paintings 1968–1974' at the Metropolitan Museum of Art. New York, 1975.
- 13 Letter to James Birch, 23 August 1988.
- 14 See Hilton Kramer, 'Bacon Show at MoMA: Nasty Art by That Darling of the Smart Set', *New York Observer*, 4 June 1990.
- 15 Art International, Paris, Autumn 1989.
- 16 Interview with Zoran Music, Paris, 1996.

POSTSCRIPT

- 1 Guardian, 29 April 1992.
- 2 In an interview with William Feaver in the *Observer*, 6 December 1992.
- 3 New York Review of Books, 24 September 1992.
- 4 Manchester Evening News, 3 December 1992.
- 5 See the interview with Jean Clair entitled 'Pathos and Death' in the

English-language version of the catalogue to the exhibition 'The Body on the Cross', Musée Picasso, Paris, 1992.

- 6 In a letter published in *The Times* of 2 March 1996, the art historian Richard Shone stated that the 'Rathbone' canvas board on which the portrait was painted was, according to his research, not available until 1937.
- 7 This most recent retrospective exhibition was scheduled to close in Paris on 14 October 1996 and be shown at the Haus der Kunst in Munich from 4 November 1996 to 31 January 1997.

MAIN EXHIBITIONS

1934	Transition Gallery, London
1949	Hanover Gallery, London
1950	Hanover Gallery, London
1951-52	Hanover Gallery, London
1952-53	Hanover Gallery, London
1953	Durlacher Bros, New York
	Beaux Arts Gallery, London
1954	British Pavilion, Venice Biennale
	Hanover Gallery, London
1955	Institute of Contemporary Arts, London
	Hanover Gallery, London (with Scott and Sutherland)
1957	Galerie Rive Droite, Paris
	Hanover Gallery, London
1958	Galleria Galatea, Turin; Galleria dell'Ariete, Milan and L'Ob-
	elisco, Rome
	Victoria Art Gallery, Bath, Arts Council touring exhibition (with
	Matthew Smith and Victor Pasmore)
1959	Richard Feigen Gallery, Chicago
	Hanover Gallery, London
	V Bienal, São Paulo
1960	Marlborough Fine Art, London
	University of California, Los Angeles (with Hyman Bloom)
1961	Nottingham University, Nottingham
1962	Tate Gallery, London; Kunsthalle, Mannheim; Galleria Civica
	d'Arte Moderna, Turin; Kunsthaus, Zurich; Stedelijk Museum,
	Amsterdam (in 1963)
	Galleria d'Arte Galatea, Milan
1963	Galleria il Centro, Naples (with Sutherland)
	Marlborough Fine Art, London
	Granville Gallery, New York
1963–64	Solomon R. Guggenheim Museum, New York; Art Institute,
	Chicago; Contemporary Arts Association, Houston
1965	Kunstverein, Hamburg; Moderna Museet, Stockholm; Museum
	of Modern Art, Dublin
	Marlborough Fine Art. London

1966	Toninelli Arte Moderna, Milan
1966–67	Galerie Maeght, Paris; Marlborough Galleria d'Arte, Rome;
2,000.	Toninelli Arte Moderna, Milan and enlarged version at Marlbor-
	ough Fine Art, London
1967	Rubens Prize Exhibition, Siegen
1968	Marlborough-Gerson Gallery, New York
1970	Galleria Galatea, Turin
1971-72	Grand Palais, Paris; Kunsthalle, Düsseldorf
1973	Museo de Bellas Artes, Caracas (with Giacometti, Dubuffet and
	de Kooning)
1975	Metropolitan Museum of Art, New York
	Galerie Marlborough, Zurich
1976	Musée Cantini, Marseilles
1977	Galerie Claude Bernard, Paris
1977-78	Museo de Arte Moderno, Mexico; Museo de Arte Contem-
	poraneo, Caracas
1978	Fundación Juan March, Madrid; Fundació Joan Miró, Barcelona
1980	Marlborough Gallery, New York
1983	Museum of Modern Art, Tokyo; Museum of Modern Art, Kyoto;
	Aichi Prefectural Art Gallery
	Marlborough Fine Art, London
1984	Galerie Maeght Lelong, Paris
	Marlborough Gallery, New York
1985	Marlborough Fine Art, London
1985-86	Tate Gallery, London; Staatsgalerie, Stuttgart; Nationalgalerie,
	Berlin
1987	Marlborough Gallery, New York
	Galerie Beyeler, Basle
	Galerie Lelong, Paris
1988	Central House of Artists, New Tretyakov Gallery, Moscow
1988–89	Marlborough Fine Art, Tokyo
1989	Marlborough Fine Art, London
1989–90	Hirshhorn Museum and Sculpture Garden, Smithsonian Insti-
	tution, Washington; County Museum of Art, Los Angeles;
	Museum of Modern Art, New York
1990	Marlborough Gallery, New York
1990–91	Tate Gallery, Liverpool
1992–93	Galería Marlborough, Madrid; Marlborough Gallery, New York
1993	Museo d'Arte Moderna, Lugano
	Museo Correr, Venice
	Marlborough Fine Art, London
1996–97	Musée National d'Art Moderne, Centre Georges Pompidou,
	Paris; Haus der Kunst, Munich

SELECTED BIBLIOGRAPHY

A full Francis Bacon bibliography was published in the catalogue of the artist's retrospective exhibition at the Tate Gallery in 1985. A more recent bibliography has appeared in the catalogue of the Francis Bacon exhibition at the Centre Georges Pompidou (1996) in Paris.

Since these two excellent reference works exist, I have made a more personal choice here, above all listing publications which have been of particular interest and use to me in writing this book. I have also concentrated on compiling a list of works that are not directly about the artist but which have a distinct relevance to his life and art. These 'General Works' are not included in either of the bibliographies quoted above.

There are now many hundreds of articles about Bacon, as well as dozens of printed interviews. References to those which I found most relevant can be found in the Notes.

MONOGRAPHS

Ades, Dawn, and Forge, Andrew, Francis Bacon, London, 1985.

Alley, Ronald, and Rothenstein, John, Francis Bacon, London, 1964 (catalogue raisonné).

Archimbaud, Michel, Francis Bacon in Conversation with Michel Archimbaud, London, 1993.

Davies, Hugh, Francis Bacon: The Early and Middle Years, 1928–1958, New York, 1978.

Davies, Hugh, and Yard, Sally, Francis Bacon, New York, 1986.

Deleuze, Gilles, Francis Bacon: Logique de la sensation, Paris, 1984.

Farson, Daniel, The Gilded Gutter Life of Francis Bacon, London, 1993.

Leiris, Michel, Francis Bacon, Full Face and in Profile, London, 1983.

Russell, John, Francis Bacon, revised edition, London, 1993.

Schmied, Wieland, *Francis Bacon: Vier Studien zu einem Porträt*, Berlin, 1985.

- Sinclair, Andrew, Francis Bacon, His Life and Violent Times, London, 1993.
- Sylvester, David, *Interviews with Francis Bacon*, revised edition, London, 1993.

EXHIBITION CATALOGUES

- 1955: Institute of Contemporary Arts, London. Text by Max Clarac-Serou.
- 1957: Galerie Rive Droite, Paris. Texts by Roland Penrose and David Sylvester.
- 1960: Marlborough Fine Art, London. Text by Robert Melville.
- 1962: Tate Gallery, London. Texts by John Rothenstein and Ronald Alley.
- 1963: Marlborough Fine Art, London. Interview with David Sylvester.
- 1963: Granville Gallery, New York. Statement by the artist.
- 1963: Guggenheim Museum, New York. Text by Lawrence Alloway.
- 1965: Marlborough Fine Art, London. Text by John Russell.
- 1966: Galerie Maeght, Paris. Text by Michel Leiris.
- 1967: Marlborough Fine Art, London. Text by Michel Leiris. Interview by David Sylvester.
- 1968: Marlborough-Gerson Gallery, New York. Text by Lawrence Gowing.
- 1971: Grand Palais, Paris. Text by Michel Leiris.
- 1975: Metropolitan Museum, New York. Text by Henry Geldzahler. Interview by Peter Beard.
- 1976: Musée Cantini, Marseilles. Text by Gaëtan Picon.
- 1977: Galerie Claude Bernard, Paris. Text by Michel Leiris.
- 1983: Museum of Modern Art, Tokyo. Texts by Lawrence Gowing and Masanori Ichikawa.
- 1984: Galerie Maeght Lelong, Paris. Text by Jacques Dupin. Interview with David Sylvester.
- 1985: Tate Gallery, London. Texts by Dawn Ades and Andrew Forge.
- 1987: Marlborough Gallery, New York. Interview with David Sylvester.
- 1987: Galerie Beyeler, Basle. Text by Werner Schmalenbach.
- 1987: Galerie Lelong, Paris. Text by Jacques Dupin. Interview with David Sylvester.

- 1988: New Tretyakov Gallery, Moscow. Texts by Grey Gowrie and Mikhail Sokolov.
- 1989: Hirshhorn Museum, Washington. Texts by Lawrence Gowing and Sam Hunter.
- 1993: Museo d'Arte Moderna, Lugano. Texts by Ronald Alley, Rudy Chiappini, Hugh Davies, Jill Lloyd and Michael Peppiatt.
- 1993: Museo Correr, Venice. Texts by Gilles Deleuze, David Mellor, Daniela Palazzoli, David Sylvester and Lorenza Trucchi.
- 1993: Marlborough Fine Art, London. Texts by William Feaver and John Russell.
- 1996: Centre Georges Pompidou, Paris. Texts by Fabrice Hergott, Yves Kobry, Jean-Claude Lebensztejn, Jean-Louis Schefer, David Sylvester and Hervé Vanel.

GENERAL WORKS

Ackrovd, Peter, T. S. Eliot, London, 1984.

Ades, Dawn, Photomontage, London, 1976.

Adlon, Hedda, Hotel Adlon, London, 1958.

Aeschylus, The Oresteia (trans. Robert Fagles), London, 1979.

Auerbach, Frank, exhibition catalogue, Hayward Gallery, London, 1978.

Barbedette, Gilles, and Carassou, Michel, Paris Gay 1925, Paris, 1981.

Barnes, Djuna, Nightwood, London, 1936.

Bataille, Georges, Documents, Paris, 1968.

Baudelaire, Charles, Curiosités esthétiques, Paris, 1868.

Beaton, Cecil: *Self-Portrait with Friends* (selected diaries, ed. Richard Buckle). London, 1979.

Bellony-Rewald, Alice, and Peppiatt, Michael, *Imagination's Chamber:* Artists and Their Studios, London, 1983.

Berthoud, Roger, Graham Sutherland: A Biography, London, 1982.

Blythe, Ronald, *The Age of Illusion: England in the Twenties and Thirties*, London, 1963.

Burroughs, William, The Naked Lunch, Paris, 1959.

Canetti, Elias, *The Torch in My Ear* (trans. Joachim Neugroschel), London, 1989.

Clark, Kathleen Clara, Positioning in Radiography, London, 1939.

Coke, Van Deren, The Painter and the Photographer from Delacroix to Warhol, Albuquerque, 1972.

Compton, Susan (ed.), *British Art in the Twentieth Century*, exhibition catalogue, Royal Academy of Arts, London, 1987.

Conrad, Joseph, The Heart of Darkness, London, 1902.

Dada and Surrealism Reviewed, exhibition catalogue, Hayward Gallery, London, 1978.

Döblin, Alfred (text), and von Bucovich, Mario (photographs), Berlin 1928, Portrait d'une ville, Paris, 1993.

Döblin, Alfred, *Berlin Alexanderplatz* (trans. Eugene Jolas), Harmondsworth, 1982.

Eliot, T. S., Complete Poems and Plays, London, 1952.

Fargue, Léon-Paul, Vélasquez, Paris, 1946.

Farson, Daniel, Soho in the Fifties, London, 1987.

Finlayson, Iain, Tangier, London, 1993.

Ford, Hugh, Published in Paris: American and British Writers in Paris 1920–1939, Yonkers, 1975.

Freud, Lucian, exhibition catalogue, Hayward Gallery, London, 1974. Garnier, Philippe (ed.), The Phaidon Encyclopaedia of Decorative Arts 1890–1940. Oxford. 1978.

Gee, Malcolm, Dealers, Critics and Collectors of Modern Painting – Aspects of the Parisian Art Market 1910–1930, New York, 1981.

Giacometti, Alberto, exhibition catalogue, Nationalgalerie, Berlin, 1988.

Giacometti, Alberto, Je ne sais ce que je vois qu'en travaillant, Paris, 1993.

Goldscheider, Ludwig, Michelangelo, London, 1953.

Gowing, Lawrence, Lucian Freud, London, 1982.

Gruen, John, The Artist Observed, Chicago, 1991.

Harrison, Charles, English Art and Modernism 1900–1939, London, 1981.

Ibsen, Henrik, Ghosts, London, 1888.

Isherwood, Christopher, Mr Norris Changes Trains, London, 1935.

Isherwood, Christopher, Christopher and His Kind, 1929–1939, London, 1977.

Johnson, Heather, Roy de Maistre: The English Years 1930–1968, Roseville, New South Wales, 1995.

Joyce, James, Dubliners, London, 1914.

Joyce, James, Ulysses, Paris, 1922.

Lavin, Maud, The Weimar Photomontages of Hannah Höch, London, 1993.

Lehmann, John, In the Purely Pagan Sense, London, 1976.

Leiris, Michel, Journal 1922-1989, Paris, 1992.

Leiris, Michel, L'Age d'homme, Paris, 1946.

Lessore, Helen, A Partial Testament: Essays on Some Moderns in the Great Tradition, London, 1986.

Lord, James, A Giacometti Portrait, New York, 1965.

Lord, James, Giacometti, New York, 1985.

Marr, David, Patrick White: A Life, London, 1991.

Maxwell, Marius, Stalking Big Game with a Camera in Equatorial Africa, London, 1924.

Michaux, Henri, exhibition catalogue, Guggenheim Museum, New York, 1978.

Minotaure (1933), facsimile edition, Geneva (undated).

Mock, Jean-Yves, Erica Brausen: Premier marchand de Francis Bacon, Paris, 1996.

Moraes, Henrietta, Henrietta, London, 1994.

Muir, Robin, *John Deakin*, exhibition catalogue, National Portrait Gallery, London, 1996.

Muybridge, Eadweard, The Human Figure in Motion, New York, 1955.

Nietzsche, Friedrich, Thus Spake Zarathustra, London, 1899.

Oberhuber, Konrad, Poussin: The Early Years in Rome, Oxford, 1988.

Ozenfant, Amédée, Foundations of Modern Art, London, 1931.

Paulson, Ronald, Figure and Abstraction in Contemporary Painting, London, 1990.

Penrose, Roland, Picasso: His Life and Work, London, 1981.

Penrose, Roland, Scrapbook 1900–1981, London, 1981.

Penrose, Roland, and Golding, John (eds), *Picasso* 1881–1973, London, 1973.

Picasso, Pablo, exhibition catalogue, Grand Palais, Paris, 1979.

Prat, Jean-Louis (ed.), L'Art en mouvement, Fondation Maeght, Saint-Paul-de-Vence, 1992.

Proust, Marcel, A la recherche du temps perdu, Paris, 1913-1927.

Read, Herbert, Art Now: An Introduction to the Theory of Modern Painting and Sculpture, London, 1933.

Roskill, Mark (ed.), The Letters of Van Gogh, London, 1974.

Rothenstein, John, Time's Thievish Progress, London, 1970.

Sachs, Maurice, Chronique joyeuse et scandaleuse, Paris, 1947.

Sachs, Maurice, Du temps du boeuf sur le toit, Paris, 1939.

St Ives, exhibition catalogue, Tate Gallery, London, 1985.

Schräder, Barbel, and Schebera, Jürgen, *The 'Golden' Twenties: Art and Literature in the Weimar Republic*, London, 1988.

Shelden, Michael, Friends of Promise: Cyril Connolly and the World of 'Horizon', London, 1989.

Spalding, Frances, Dance till the Stars Come Down: A Biography of John Minton, London, 1991.

Spender, Stephen, Journals 1939-1983, London, 1985.

Spender, Stephen, World Within World, London, 1951.

Stanford, William Bedell, Aeschylus in His Style: A Study in Language and Personality, Dublin, 1942.

 ${\it Sutherland, Graham, exhibition catalogue, Tate Gallery, London, 1982.}$

Vaughan, Keith, Journals 1939-1977, London, 1989.

Waugh, Evelyn, Vile Bodies, London, 1930.

White, Edmund, Genet, London, 1993.

White, Patrick, Flaws in the Glass: A Self-Portrait, London, 1981.

Wilcox, Tim (ed.), The Pursuit of the Real: British Figurative Painting from Sickert to Bacon, exhibition catalogue, Manchester City Art Gallery, 1990.

Willet, John, The New Sobriety: Art and Politics in the Weimar Period, 1917–1933, London, 1991.

Wishart, Michael, High Diver: An Autobiography, London, 1978.

Yeats, W. B., Collected Poems, London, 1950.

Zervos, Christian, Dessins de Picasso, 1892–1948, Paris, 1949.

INDEX

NOTE: Works by Bacon appear directly under title; works by others under the name of the artist or author

Abstraction (FB; painting), 75–6 Abstraction from the Human Form (FB; painting), 75-6, 86 Acton, (Sir) Harold, 26 Adami, Valerio, 50 Aeschylus: influence on FB, 96, 100, 279, 299, 306; Oresteia, 82, 89-92, 269, 276-7 Age d'or, L' (film), 39 Agnelli, Gianni, 209 Agnew's (London gallery), 75, 76 Albright-Knox Art Gallery, Buffalo, 148 Alden, Eric: buys rugs from FB, 48; shares Queensberry Mews with FB, 54; regrets FB's destruction of paintings, 68 Alley, Ronald: catalogue raisonné of FB, 272 Alloway, Lawrence, 183, 193-4 Amis, (Sir) Kingsley: Memoirs, 166 Andrews. Michael. 149, 156; The Colony Room, 158 Apollinaire, Guillaume, 234, 322 Apollo (magazine), 109 Apollo Place, London, 136, 147 Aragon, Louis, 234 Archinto, Cardinal Filippo, 148 Arp, Hans, 38 Art et Décoration (magazine), 45 Art Institute, Chicago, 194 Artaud, Antonin, 169 Arts Council, 166 Ashton, (Sir) Frederick, 187

Auden, W.H., 29, 165

Auerbach, Frank, 149, 156, 284 Ayrton, Michael, 226

Bacon, Alice (née Lawrence; FB's

Baboon (FB; painting), 148

grandmother), 4
Bacon, Anthony Edward Mortimer (FB's father; Eddy): marriage and background, 4–6, 21; character, 6–7, 9, 15, 21, 25, 100; horse-training, 6, 21; treatment of FB as child, 6–7, 9–10, 15–18, 74, 99–100, 317; and son Edward's death, 10, 21; First War service, 11–12; and IRA threat, 13; homes, 20–1; expels FB from home, 21, 23–4; and FB's parentage, 55; death and will, 74, 81–2, 133; marriage relations, 81; and FB's *Three Studies for a Crucifixion*, 190; photograph of, 320

Bacon, General Anthony (FB's greatgrandfather), 4, 95

Bacon, Christina Winifred Loxley (*née* Firth; FB's mother; Winnie): marriage and background, 4, 7, 21; character, 8–9, 15; remarries, 9, 136; in South Africa, 9, 200; in wartime England, 14; allowance to FB, 24, 41; antagonism with husband, 81; FB resumes relations with, 136–7, 139; entertaining, 137

Bacon, Edward (FB's brother): birth, 4; death, 10, 21; photographs of, 52

Bacon, Edward (FB's grandfather), 4

Bacon, Francis: birth and family, 3-6, 339n9; childhood in Ireland, 3, 7-11, 15-16, 20; relations with father. 6-7, 9-10, 15-18, 21, 25, 74, 81, 99-101, 133, 190; asthma, 9, 16-17, 83-4, 119, 136, 297, 314; closeness to Iessie Lightfoot, 9-10. 54-6, 74, 103-4, 133, 135, 204; move to London in Great War. 12-14; and IRA threats, 13-14; paints 'attendants' in pictures, 14; flogged as boy, 16-17, 317; optimism and self-belief, 16, 222; homosexuality. 17, 21, 24-6, 39-41, 78-81, 95, 100, 145, 177, 216, 248; schooling. 17–21; daydreaming, 18; as racing secretary to Gilbey, 20, 24: banished by father, 21-4; on instinct and chance, 23, 58, 306; allowance from mother, 24, 41: moves to London, 24-5; casual jobs, 25; cooking and domestic life, 25, 254: extravagance and love of luxury, 25, 80, 120, 156, 186, 200-1, 260, 293-4; visits Berlin with uncle, 26-31, 40-1, 77; furniture designs and interior decorating, 30, 44-8, 57. 318–19; moves to Paris (1927), 30, 32-42; appearance and dress, 31. 55-6, 74, 114-15, 161-2, 183-4, 193, 231, 280, 294-5; learns French, 32-3, 44; early drawings and watercolours, 37, 42, 51; wears women's underwear, 42, 102, 190: bohemian lifestyle, 43–4, 46, 103– 6, 125, 133, 153, 201-3, 220; drinking, 44, 70, 151, 153, 160-1, 202, 219-21, 260, 287, 298; gambling, 44, 53, 70, 104, 120-4, 133, 153, 201, 264; returns to London from Paris, 45, 48, 51-3; technical backwardness and curiosity, 50-1; paints first oils, 51; self-portraits, 52, 167, 192. 218-19, 250-1, 263, 294, 320-1; restlessness and moving house, 53-4, 57, 101, 135-6, 151-2, 185; finds lovers through The Times advertising, 55; uses make-up,

55-6, 95, 97, 280; sado-masochistic tastes and practices, 58, 95, 101. 102, 144, 169, 187, 190, 231, 281; and mouth motif, 60-1, 72, 85-6, 117, 128, 131, 141-2, 164, 167; critical reactions to, 64, 108-9. 129-30, 142, 144-5, 148, 150, 183, 193, 236-7, 244-6, 270; destroys own work, 68, 75, 127, 181; abandons painting (1935), 70, 76; excluded from 1936 Surrealist exhibition, 70-1: promiscuity, 70. 139; collects and uses photographs. 71-2, 85, 141-3, 259; interest in industrial filters, 72-3; relations with Eric Hall, 73-4, 81-3, 101-3, 135, 151; character, 76-7, 115, 279; in World War II, 77–84, 111: interest in disasters, 78, 84; and father's death, 81-2; gastronomic tastes, 82-3; interest in Greek tragedy, 82-3, 89-92; rents country house, 84: aesthetic credo, 95-8. 149-50, 163-4, 194-5, 246-7, 263, 271-4, 279, 306; indifference to pain and toughness, 95, 114, 231; privacy and reticence, 96-7. 99, 179, 188-9, 273, 322; disdains narrative art, 97-8, 189, 228-9. 323; routines, 101, 295-6; observes people 'carrying on', 106, 120, 177-8, 281; creative instinct. 107-8; post-war recognition and reputation, 112-13; confidence, 113; meets Brausen, 113, 117-19; moves to Monte Carlo (1946), 119-24: finances, 122-3, 133, 144, 179, 200-1; in Tangier, 124, 136, 153, 170-5, 176, 179, 217; atheism. 125, 140-1, 274, 276, 323; technique, 128-9, 140, 302; prices of paintings, 131, 144, 166, 214, 245, 265, 275, 289, 293, 314; reputation abroad, 131, 151, 164, 193, 245, 305; nihilism, 132, 221-2, 230. 252-3, 304: adolescent manner, 133; ends relationship with Hall, 133-4; relations with Lacv.

134, 144–7, 151–2, 161, 164, 169, 172, 175, 178, 181, 190, 211, 283-4: resumes relations with mother, 136-7, 139; in South Africa, 136-8, 142, 200; interpretation of imagery, 140-2, 229-30, 268-9, 273-4, 308-9, 323; in Italy 151-2: attachment (1954).London. 153-60, 255, 293-4: stands in for Minton at Royal College of Art, 158-9; public image and legend, 162-3; studio disorder, 162, 183, 185-6, 230, 253-4, 259, 295–6, 298; increasing success and sales, 166; influence, success and fame, 166, 184-5, 193-200, 265, 278-80, 308-10; creative output. 176, 181, 182-3; taste for low life and criminals, 177, 187, 202-3, 216-17, 255, 284; leaves Hanover Gallery for Marlborough, 179, 266; criticizes abstract painting, 181-2, 195: works in St Ives (1959–60), 181-2; portraiture, 183-4, 207-13, 223, 227; socializing, 186-8; grief at Lacy's death, 192, 249; conversations, opinions and discussions on work, 194-5, 219-22, 263, 271-4, 279, 298, 300-1; declines official honours, 199; prize awards, 199; films on, 200; spartan practices, 201-2; daily routine, 202; women friends, 203-6; relations with Dyer, 206-7, 211-12, 214-15, 217, 232, 28; charged and acquitted of possessing cannabis, 215-16; and drugs, 216; and Kray twins, 217-18; drawings and sketches, 225-6, 322; knowledge of Old Masters from reproductions, 226: in bull-fighting. interest sources of imagery, 228-30, 268; consciousness of death and mortality, 231, 247-50, 276, 185-6, 314-15; and Dyer's death, 235-6, 239-43, 247-9, 252, 257, 268-9, 276–7: suppresses early work, 237; and Deakin's death, 243-4; gen-

erosity, 243, 291-3; compared to Disney, 245-6; argues for National Gallery purchase of Titian, 246–7; guilt feelings, 248-9, 269; buys properties, 254-6; fantasies, 255; relations with Edwards, 255, 284-6: entertaining, 256, 293; visits to Paris, 257–61, 264; acquires Paris flat/studio, 258-60; eating and diet, 260-1, 280; friendship and correspondence with Leiris, 261-2; commitment to work, 264-5; dealings with Marlborough, 265-6; gallbladder operation, 269; in New York, 270-1; comments on own work, 271-4; abandoned works. 275, 334n27; fakes and imitations, 275; and religious myths, 276, 323; immoderate behaviour, 279-80: meets Balthus, 282-3; criticisms of other artists, 283-4; ageing and decline in vitality, 286-9, 293, 304-311-12, 314-15; death of friends, 289-93, 315; dreams, 296; interest in medicine. 297; political views, 297: literary influences on, 299-200; youthful followers, 301-2; late painting style, 302-5, 319; French studies of. 305-6: realism. 306-7: introduces favourite paintings at National Gallery, 310; cancerous kidney removed, 312; finds young Spanish lover in old age, 312, 316; 80th birthday, 314; final illness, death and cremation, 316; tributes and obituaries, 317-18; will and estate, 318; posthumous studies of, 320; supposed works by, 320-1; achievements. 323; see also Exhibitions; and titles of individual works Bacon, Francis (Viscount St Albans), 4 Bacon, Harley (FB's brother): birth, 4; death in South Africa, 10

Bacon, Ianthe (FB's sister): birth, 4; marriage and life in South Africa,

Bacon, Lady Charlotte (née Harley; FB's great-grandmother), 5

11.136-7

Bacon. **Nicholas** (16th-century ancestor), 4 Bacon, Winifred (FB's sister): birth, 4; misfortunes, 81-2; settles in South Africa, 136; death, 292 Bailey, Anthony, 270 Bains-Douches nightclub, Paris, 281 Baker, Josephine, 27 Baker, Stanley, 217 Balla, Giacomo: Dynamism of a Dog on a Leash, 143 Balthus (Balthasar Klossowski), 125, 282 - 3Barnes, Djuna: Nightwood, 36 Barr, Alfred, 98, 118, 166 Board, Ian, 291 Bataille, Georges, 39, 117 Battleship Potemkin (film), 30, 34, 38, 167, 314 Baudelaire, Charles, 139, 230, 234, 277 Bauhaus, 30, 46-7 Bomford. Beach, Sylvia, 36 Beard, Peter, 231, 263. 271-2.339n13 Beaton, (Sir) Cecil: portrayed by FB, 183-4; and Ann Fleming, 187 Beaufort Gardens, Chelsea, 135 Beauvoir, Simone de, 107 81 Beaux-Arts Gallery, London, 147-50 Beckmann, Max, 31, 329n4 Bedales Lodge, Steep, Hampshire, 84 Beeton, Isabella Mary: Book of Household Management, 298 Behrens, Timothy, 156 Halasz), 62 Belcher, Muriel: owns and runs Colony Room, 156-8, 262, 288; FB portrays, 182-3, 207-8, 290-1, 301; FB's affection for, 204-5, 290; death, 289, 293; see also Colony Room Bell. Vanessa. 47 Bell, Walter, 8 Belle de Jour (film), 39 Bellmer, Hans, 73 breaks from, 179-80; on FB's bio-Berger, John, 245 Berlemont, Gaston, 155 graphical reticence, 179; FB pays for Berlin: FB visits with uncle (1927). medical treatment, 180 26–31, 40–1, 77; FB travelling exhi-Breton, André, 35, 39, 62, 70

bition in (1986), 311; see also Nationalgalerie Bernard, Bruce, 333n4 Bernard, Jeffrey, 160, 203, 333n4 Bertolucci, Bernardo, 244 Beston, Valerie, 266, 279 Birague, rue de (Paris), 258, 261, 305 Birch, James, 313 birds: in FB's paintings, 224-5 Blackett, Leonard ('Granny'), 105-6 Blackwood, Caroline, 298, 317 Blake, William, 164 Blood on the Floor (FB; painting), 305 Bloomsbury Group, 53 Bocquentin, Yvonne, 32-3, 40, 321 'Body on the Cross, The' exhibition, Paris (1992), 318 Boisgeloup, Château de, Gisors, 61-2 Boldini, Giovanni, 270, 314 Mr and Mrs **James** (collectors), 191 Bouguereau, Adolphe William, 314 Bowles, Jane, 174 Bowles, Paul, 170, 173-4 Bowness, Sir Alan, 308 Bradford Peverell, near Dorchester, 20. Brancusi, Constantin, 70 Brandon, Marlon, 244-5 Braque, Georges, 64 Brass, Drs Paul and Stanley, 336n12 Brassaï (photographer; i.e., Gyula Brauner, Victor, 73 Brausen, Erica: and 'Toto' Koopman. 40; as FB's dealer, 113, 117-20, 131, 149; and FB in Monte Carlo. 122-3; and FB in South Africa, 137; and FB in Italy, 152; conceals FB's Two Figures, 161; Barr requests to document FB's work, 166; FB writes to from Tangier, 172, 176, 179; supports and promotes FB, 178; FB

Breuer, Marcel, 45 Cimabue (Bencivieni di Pepo), 62, 191, 224, 226 Brick Wall, The (FB; gouache), 52 British Broadcasting Corporation Clarac-Sérou, Max. 163 Clark, Kathleen Clara see Positioning in (BBC), 246 British Council: 1993 posthumous FB Radiography exhibition, 319 Clark, Kenneth (later Baron), 62, 65, 75, 112–13 Brown, Ford Madox: The Last of Clarke, Arundell, 57, 66, 74 England, 117 Brownell, Sonia see Orwell, Sonia Club des Sept, Paris, 281 Buhler, Robert, 135, 160 Cocteau. Jean: homosexuality, 40; and bull-fighting, 228 Christopher Wood, 53; on death, Bullfight series (FB; paintings), 267, 288 333n5 Colmar: FB visits, 312 Buñuel, Luis, 38-9, 51-2, 140 Colony Room, London ('Muriel's'), 145, 156-9, 171, 202-3, 262, Burden, William, 148 Burroughs, William, 170–1, 173, 298; 289-91, 293 The Naked Lunch, 173 Compositions (FB; gouaches), 67 Burton, Richard, 210 Connaissance des Arts (magazine), 233 Connolly, Cyril, 113, 119, 160, 203 Butler, Richard Austen, 47 Butler, Sydney (née Courtauld), 47 Conrad, Joseph: Heart of Darkness, Byron, George Gordon, 6th Baron, 5 115-16, 277 'Constable to Bacon' (exhibition, Cahiers d'Art (magazine), 38, 46, 62 1962), 199 Cairo, 138 Cooper, Douglas: acquires FB furniture, 47; FB meets, 49; at de Maistre's Cameron, Juila Margaret, 143, 210 Canetti, Elias, 325n5 studio, 50 Corner of the Studio (FB; painting), 48 Cannycourt House. Kilcullen. Co. Kildare, 6, 11 Corner of the Studio (FB; pen and wash Capote, Truman, 170 drawing), 69 Côte d'Azur see Riviera Carluccio, Luigi, 178 Carnegie Award in Painting (Pitts-Courtauld, Samuel, 47 burgh International Exhibition). Coward, Noël, 170 199 Crété de Chambine, Anne-Marie, 32 Carnegie Institute, 166 Crevel, René, 39 Carroll. Lewis, 110 Croft-Cooke, Rupert, 171 Caruso, Enrico, 29 Cromwell Place, London: FB occupies Millais House, 83, 101-2, 104, 114; Centre Georges Pompidou, Paris, 321-2 FB leaves, 111, 135 Centre National d'Art Contemporain, Cromwell Road, London, 136, 151 Paris, 233, 235 Cézanne, Paul, 167, 300 Crucifixion: as subject of FB's art, 52, 57, 63-9, 87, 98-101, 126, 189-Chamberlain, Sir Austen, 72 Chamberlain, Neville, 86 90, 207, 224-8, 237, 276, 318 Chantilly, France, 32-4, 321 Crucifixion (FB; triptych, 1965), 224-Char, René, 234 8, 237 Chermayeff, Serge, 47 Crucifixions (FB: series of three Chien Andalou, Un (film), 38-9 paintings), 52, 57, 63-5, 67-9, 87, Chirico, Giorgio de, 37, 46, 51, 70, 73 101, 126, 207, 237 Cubism, 46, 300, 321 Chopping, Richard, 255

Daintry, Adrian, 20 Dali, Gala (Helena Deluvina Diakinoff), 70 Dali, Salvador, 38, 64, 70, 236 Danguah, Paul, 136 Dark Child (FB; lost print), 52 David, Elizabeth, 254 Deakin, John: takes portrait photographs for FB, 143, 208; group photograph in Wheeler's, friendship with FB, 160, 203, 211; photographs Henrietta Moraes, 210; travels to Greece with FB and Dyer, 215; photographs FB at Smithfield meat market, 224; with Dyer in Paris, 240; illness and death, 243-4; photographed with FB, 333n4 Dean Close school, Cheltenham, 10, 18 - 21Dean's Bar, Tangier, 171 Deferre, Gaston, 274 Degas, Edgar, 167, 219, 268, 299-300, 309; catalogue raisonné (by Lemoisne), 267 de Kooning, Willem see Kooning, Willem de Deleuze, Gilles: Logique de la Sensation, 305 - 6de Maistre, Leroy Leveson Laurent Joseph (Roy): influence on FB, 48-50, 58, 74, 81, 283, 321; paintings of FB's studios, 51, 66-7; portraits of FB, 52, 74; on FB's appearance and lifestyle. 54: exhibited Agnew's, 75, 320; uses Sundeala board, 87; experiments with music and colour, 92; Catholicism, 125; Figure by Bath, 66 Derain, André, 205, 227, 282 Deville, I.S., 164 dictators: FB's interest in, 75, 84, 116-17, 141, 190 Dinard: Picasso at, 61 Disney, Walt: Berger compares FB with, 245-6 Dix, Otto: Big City Triptych, 31 Döblin, Alfred: Berlin Alexanderplatz, 30

Documents (magazine), 39 Dog (FB; painting), 134 Dominguez, Oscar, 73 Dorn, Marion, 46 Dostoevsky, Fedor, 123 Douglas, Kirk, 168 Dublin, 3, 6 Duchamp, Marcel, 70, 96, 140, 219, 299 Duhamel, Jacques, 235 Dunn, Anne (later Wishart; then Movnihan), 105 Dupin, Jacques, 259, 263-4, 281-2, 298 Duras, Marguerite, 259 Durlacher Bros. New York, 147-8 Düsseldorf Kunsthalle, 245 Dyer, George: relations with FB, 206-7, 211–12, 214–15, 217, 232, 285; FBportrays, 207-8, 211-13: appearance, 211; drinking and drug-taking, 214-15, 240, 241, 247–8; plants cannabis on FB, 215– 16: death, 218, 235-6, 239-43, 247-9, 252, 268-9, 276-7, 309: FB's commemorative paintings of. 249-52, 257, 267-8, 276; FB gives Roland Gardens studio to. 254

Easter Rising (Ireland, 1916), 12 Edwards, John: relations with FB, 255, 284–7, 311; FB portrays, 286, 307– 8; and FB's ageing, 289; inherits FB's estate, 318 Egyptian art, 138 Eisenstein, Sergei, 30, 34, 51, 52, 167, 245, 314 Eliot, T.S., 85, 89, 96, 105, 276, 299; The Family Reunion, 89-91, 100, 269; 'Preludes', 238; 'Sweeney Agonistes', 228-31, 237 Eluard, Paul, 70 Ensor, James, 69 Epstein, Jacob, 205 Ernst, Max, 52, 64, 70 Estorick, Eric, 166 Etty, William, 14

Exhibitions (FB): 1930 Queensberry Mews (with Jean Shepeard), 51-2; 1934 Transition Gallery (London), 1949 Hanover 66-8: Gallery (London), 120, 123, 127, 129-32; 1950 Hanover Gallery, 141; 1953 Durlacher Bros (New York), 148; 1953 Hanover Gallery (London), 167; 1954 Venice Biennale, 151; 1955 Beaux-Arts (London), 148-9; 1955 ICA (London), 163; 1957 Galerie Rive Droite (Paris), 164, 232: 1957 Gallery Hanover (London). 168: 1958 travelling (Italy), 178; 1960 Marlborough (London), 182-4, 191; 1961 Nottingham University retrospective, 187; 1962 Tate Gallery retrospective, 126, 188-92, 223; 1962 travelling retrospective (Turin, Zurich and Amsterdam), 193-4; 1963 Granville Gallery (New York), 193-4; 1963 Guggenheim Museum (New York), 193-4; 1967 Galerie Maeght (Paris), 212, 232-4, 264; 1971 Grand Palais (Paris), 223, 232-9, 321; 1975 Metropolitan Museum (New York), 265, 267, 269-70, 278; 1976 Musée Cantini (Marseilles), 274; 1977 Galerie Claude Bernard (Paris), 276-8, 301; 1983 Tokyo (and Japan), 301; 1984 Galerie Maeght Lelong (Paris), 302; 1985 Tate retrospective, 307–9; 1986 Nationalgalerie (Berlin), 311; 1988 New Tretyakov Gallery (Moscow), 313; 1989 Hirshhorn (Washington), 314; 1989-90 US travelling, 314; 1993 posthumous British Council (Venice), 319; 1993 posthumous Lugano, 318; 1995 joint with Giacometti (Norwich), 319; 1995 joint with Lucian Freud (Saint-Paul-de-Vence), 319; 1996 with Velázquez, ioint National Gallery (London), 319; 1996–7 Centre Georges Pompidou (Paris), 321 - 2

Farmleigh, near Abbeyleix, Co. Kildare, 8, 13, 20 Farson, Daniel, 160, 244, 255; The Gilded Gutter Life of Francis Bacon, Fedden, Robin, 233 Feigen, Richard, 166 Fermor, Patrick Leigh, 187 Figure Getting out of a Car (FB; painting), 84, 86 Figure in a Landscape (FB; painting), 108 - 10Figure with Meat (FB; painting), 163 Figure Study II (FB; painting), 116 Figures in a Garden (FB; painting), 69, 75, 163 Firth Steel, 5 Firth, John Loxley (FB's maternal grandfather), 7, 16 (FB's Firth. Thomas maternal ancestor), 7 Fischer, Harry, 180, 188 Fitzgerald, F. Scott, 35 Fleming, Ann. 160, 171, 187, 216, 233; death, 292 Fleming, Ian, 170-1 Fondation Maeght, Saint-Paul-de-Vence, 319 Forge, Andrew, 149 Foujita, Tsugouharu, 35 Fragment of a Crucifixion (FB; painting), 98, 112, 141, 143, 269, 318 Freud, Lucian: at 1954 Venice Biennale, 151; friendship with FB, 156, 158, 204, 284; FB portraits of, 159, 207-8, 227, 245, 251; on beauty of blemishes, 186; and Henrietta Moraes, 210; FB criticizes, 284; tribute to FB, 317; joint exhibition Saint-Paul-de-Vence with FB. (1995), 319Freud, Sigmund, 268, 296: The Interpretation of Dreams, 117

Gainsbourg, Serge, 302 Galerie Claude Bernard, Paris, 276–8, 301 Galerie du Dragon, Paris, 163

16, 292

Galerie Kahnweiler, Paris, 234 Gowing, Lawrence, 128–9, 212, 298 Galerie Maeght, Paris, 212, 232-4, Goya, Francisco, 226, 228, 244-5; La 263 - 4Junta, 300 Galerie Maeght Lelong, Paris, 302 Grand Palais, Paris: 1971 FB exhi-Galerie Rive Droite, Paris, 164, 232 bition, 223, 232-9, 244-5, 277, Galleria dell'Ariete, Milan, 178 321 Galleria Galatea, Turin, 178 Grant, Duncan, 47 Gance, Abel, 38 Granville Gallery, New York, 193-4 Gargoyle Club, London, 106–7 Gray, Eileen, 46, 124 Greek tragedy: FB's interest in, 82-3, Garland, Madge, 47 Gascoyne, David, 70 89-90, 230 Gris, Juan, 38; Composition, 118 Geldzahler, Henry, 267, 269 Genet, Jean, 205, 227 Grünewald, Matthias: Isenheim Altar-George V, King, 26 piece, 62, 64, 87–8, 271, 312; Germany: homosexuality in, 27–9; influence on FB, 126-7, 226; Christ FB's reputation in, 245; see also Carrying the Cross, 87; Mocking of Berlin Christ, 87 Giacometti, Alberto: at 1936 Inter-Guggenheim Museum, New York, 193 national Surrealist Exhibition, 70; Guibert, Hervé, 259 standing and influence, 149; studio, Guttuso, Renato: Crucifixion, 329n4 186, 205; accessibility, 195; effect Haim, Claude Bernard, 278, 281-2 on FB, 205-6, 225, 283; and Isabel 205. 227: Haim, Nadine, 281 Rawsthorne. 1956 262 - 3: Tate retrospective, 206. Hall, Eric: acquires FB rug, 48; portraiture. 208: 1965 relations with FB, 73-4, 81-4, 101retrospective, 234; friendship with 3, 135, 146, 151; encourages FB's Leiris, 234; portrait of Leiris, 263; work, 75; dispute with Rutter, 76; tribute to. 281-2: joint background and career, 102; buys exhibition with FB (Norwich, FB's Three Studies, 109; inspires FB's 1995), 319; Palace at 4 a.m., 73; Figure in a Landscape, 110; on French Paris sans fin (book of lithographs), Riviera with FB, 120, 122; religious 335n4 faith, 125, 134; rift with FB, 133-Gide, André, 40 4; buys FB's Dog, 134; death and Gilbey, Geoffrey, 20, 24 estate, 134, 185; presents FB work Ginsberg, Allen, 170, 173-4 to Tate, 134, 314; in Marseilles with Glass, Douglas, 161 FB, 274 Glebe Place, Chelsea, London, 73, 84, Hall, Ivan (Eric's son), 102–3, 134 101 Hamilton, Gerald, 29 Glueck, Grace, 270 Hamnett, Nina, 35 Goebbels, Josef, 85, 139 Hanover Gallery, London, 113, 118-Gogh, Vincent van: FB admires letters, 20, 123, 127–32, 138–9, 141–2, 53, 167–8; influence on FB, 103, 166-7, 168, 179, 266; see also 163, 167, 221, 268, 299; FB por-Brausen, Erica trays, 167–9, 173, 178; alienation, Harcourt-Smith (FB's uncle), 26–7, 31 169; The Painter on his Way to Work, Heads (FB; series), 87, 101, 112, 120, 62, 168 123, 127–30, 133, 141, 168, 319 Goodman, Arnold, Baron, 187, 215-Heber-Percy, Robert, 136, 138

Hecht, Alfred, 216, 218

individual cities

Juda, Hans, 123

Italy: FB in (1954), 151–2; see also

Hemingway, Ernest, 35-6 Henley-on-Thames, 152, 164; see also Hurst Hepworth, Barbara, 181 Herbert, David, 170, 172 Heron, Patrick, 181 Hirschfeld, Dr Magnus, 28 Hirshhorn, Joseph, 166, 337n8 Hirshhorn Museum, Washington, 314 Hitchens, Ivon, 75 Hitler, Adolf, 75, 84, 86, 141 Hockney, David, 241, 249, 283-4 homosexuality: FB's, 17, 21, 24-6, 39-41, 78-81, 95, 100, 145, 177, 216, 248; in Berlin, 27-9, 40; Surrealism and, 39-40; in France, 40-1; illegality and repression in England, 78–9, 169; in wartime London, 79-80 Horizon (magazine), 113, 203 House in Barbados (FB; painting), 146 Hoving, Thomas, 267 Howard, Brian, 26 Hunter, Sam: visits FB, 85; photographs of FB's studio, 87; reviews FB's work, 148 Hurst, near Henley-on-Thames, 135-6, 146-7, 151 Ingres, Jean-Auguste-Dominique, 167, In Memory of George Dyer (FB; painting), 249-50 Innocent X, Pope, 62, 125, 129, 133, 139, 168 Institute of Contemporary Arts, London, 163 Institute for Sexual Science, Berlin, 28 Interior of a Room (FB; painting), 69 International Surrealist Exhibition, London (1936), 70, 73, 206 Ireland, 3, 6, 12-13, 20 Irish Republican Army (IRA), 12-13 Ironside, Robert, 131 Isabel Rawsthorne Standing in a Street in Soho (FB; painting), 227–8 Isherwood, Christopher, 28-9; Mr Norris Changes Trains, 29

Jacob, Max, 38
Jagger, Mick, 209
Japan, 301
Jeanneret, Pierre, 76
Jeffress, Arthur, 118, 122–3
Jesmond Towers, Northumberland, 7, 14–15
Jet of Water (FB; painting), 303–4
Johnson, Edomie ('Sod'), 105
Joyce, James, 36, 299–300
Juda, Elsbeth, 123

Kabakov, Ilva, 313 Kafka, Franz, 158 Kandinsky, Vassily, 65 Kauffer, Edward McKnight, 46 Kenya Castle, SS, 136 Khan, Aga, 8 Kiki (Paris model), 35-6 Kitaj, R.B., 183, 284 Klee, Paul, 64 Knox, Seymour, 148 Kooning, Willem de, 182, 318 Koopman, 'Toto', 40 Kossoff, Leon, 149 Kramer, Hilton, 270, 314 Kray, Reginald and Ronald, 211, 217-18, 230 Kruger Park, South Africa, 138

Lacoste, Michel Conil, 236
Lacy, Peter: relations with FB, 134, 144–7, 151–2, 161, 164, 169, 172, 175, 178, 181, 190, 211, 283–4; moves to Tangier, 153, 169, 171–2, 174; death in Tangier, 173, 175, 192, 235, 249, 309; FB portrays, 178, 192
Landscape with Car (FB; painting), 84
Landscape near Malabata, Tangier (FB; painting), 173, 176
Lang, Fritz, 30
Lanyon, Peter, 181
Last Tango in Paris (film), 244

Lautréamont, Comte de (i.e., Isidore Lucien Ducasse), 71, 163 D.H.: Lady Chatterley's Lawrence. Lover, 35 Le Corbusier (Charles Edouard Jeanneret), 45 Lefevre Gallery, London, 46, 108-91, 115, 187 Léger, Fernand, 46, 51, 64 Lehmann, John: In the Purely Pagan Sense, 79-80 Leighton, Frederic, Baron, 14 Leiris, Louise (née Kahnweiler), 204, 234, 239 Leiris, Michel: on sexual vices, 39; Sonia Orwell introduces FB to. 204: writes introduction to FB's Galerie Maeght catalogue, 212; on bullfighting, 228; introductory text to FB's Grand Palais exhibition, 233-4, 237, 244; FB portrays, 234, 263, 268: and official entertainment for FB. 239; on success of Grand Palais exhibition, 244; FB reads books by, 259, 262; friendship and correspondence with FB, 261-2, 277, 297, 306-7; and Surrealist movement, 261; in London, 262; translates FB's conversations Sylvester, 263; on old age, 285; and psychoanalysis, 297; monograph on FB, 306; death, 315; Frêle Bruit, 277: La Règle du Jeu, 262 Lerski, Helmar, 31 Lessore, Helen, 148–9, 187 Levin, Bernard, 310 Lewis, Wyndham, 130, 144 Lightfoot, Jessie: closeness to FB, 9–10, 54–6, 74, 103–4, 133, 204; as FB's conjectural mother, 10, 55; in London, 12, 54; shoplifting, 54, 104: idiosyncrasies, 56: stays with FB in Monte Carlo, 122, 124; death, 135, 139, 185 Linton Hall, Gloucestershire/Herefordshire, 20

Lloyd, Frank, 180, 266

London: FB's attachment to, 153–60,

streets and galleries London Gallery: 1938 Picasso exhibition, 86 Lorant, Stefan, 85 Losch, Tilly, 53 Louis Trichardt (town), South Africa, 137 Lugano see Museo d'Arte Moderna Lurcat, Jean, 46 Lust for Life (film), 168 Lying Figure (FB; painting), 182, 227 Lying Figure with Hypodermic Syringe (FB; painting), 210 Macdermot, Gladys, 48 MacInnes, Colin: England, Half English, 157 Madrid: FB visits, 312, 316 Magritte, René François Ghislain, 70 Maistre, Count Joseph de, 48 Malevich, Kasimir, 31 Mallet-Stevens, Robert, 46 Mallord Street, Chelsea, 136 Man in Blue (FB; series), 164 Man with Dog (FB; painting), 148 Manet, Edouard, 167, 310 Marey, Etienne-Jules, 143, 224 Margaret, Princess, 317 Marlborough Fine Art, London: FB transfers to, 179; FB exhibition (1960), 181-4, 191; and 1962 Tate exhibition, 188, 191; shows FB's recent work (1962), 193; FB's dealings with, 265-6, 279 Marlborough-Gerson Gallery, York. 212 Marseilles, 274 Mason, Raymond, 149, 283 Masson, André, 63, 263 'Masters of British Painting 1800-1950' (exhibition, 1956), 164 Mathewson, Miss (London dance studio), 53 Matisse, Henri: decorates Gargoyle Club. 106: FB on. 219, 300-1 Matthews, Pamela (née Firth; FB's cousin), 10, 72

177, 255, 293-4; see also individual

Maugham, W. Somerset, 126 Mayor Gallery, Cork Street, London, 64 Melly, George, 160 Melville, Robert, 113, 144, 183-5 Merleau-Ponty, Maurice, 204 Metropolis (film), 30, 38 Metropolitan Museum, New York: 1975 FB exhibition, 265, 267, 269-70, 278 Michaux, Henri, 298 Michelangelo Buonarroti, 219, 224–6, 299-300 Milan, Italy, 275; see also Galleria dell'Ariete Millais House see Cromwell Place Millais, John Everett, 101, 114 Minnelli, Vincente, 168 Minnesota, University of, 179 Minotaure (magazine), 62-3, 87 Minton, John, 158-60 Miró, Joan, 64, 70, 118 Mitchell, Charles, 7, 14 Mitchell, Eliza Highat (née Watson; FB's great-aunt), 7, 14 Mondrian, Piet, 38 Monet, Claude: Nymphéas, 300 Montagu of Beaulieu, Edward Douglas-Scott-Montagu, 3rd Baron, 169 Monte Carlo: FB moves to, 119-24, 177; in FB paintings, 143; FB revisits in old age, 311 Montparnasse, Paris, 34-6, 41 Moore, Henry: at de Maistre's studio. 50; exhibitions, 64; Sadler supports, 65; and 1936 International Surrealist Exhibition, 70; Marlborough acts for, 180: relations with FB, 188 Moraes, Henrietta, 160, 207, 209-10, 333n4 Morocco, 153, 169-70, 173, 176; see also Tangier Mortimer, Raymond, 109, 111 Moscow, 313-14

Moynihan, Anne see Dunn, Anne

Moynihan, Rodrigo, 136, 160

Munich agreement (1938), 86

Muriel's see Colony Room

Musée d'Art Moderne. Paris. 118-19 Musée Cantini, Marseilles, 274 Musée Picasso, Paris, 318 Museo d'Arte Moderna, Lugano, 318 Museo Correr, Venice, 319 Museum of Modern Art. New York. 98, 118, 144, 148, 163-4, 239, 314 Music, Zoran, 315 Mussolini, Benito, 75, 116, 191 Muybridge, Eadweard, 71–2, 141-3, 161, 224, 226, 230 Nadar (photographer; i.e., Gaspard Félix Tournachon), 139, 143, 210 Nairn, Bryce, 172 Napoleon (Gance film), 38 Narrow Street, Limehouse, London, 255-6Nash, John, 53 Nash, Paul: technique, 51; and radical art, 52; decorative art, 53; exhibitions, 64; and 1936 International Surrealist Exhibition, 70-1 National Gallery, London, 246: 'The FB and Velázquez (1996), 319

Artist's Eye', 310; joint exhibition of Nationalgalerie, Berlin, 311 'Neue Sachlichkeit' exhibition, Berlin

(1927), 31

'New American Painting' (exhibition, Tate Gallery, 1959), 182

New Burlington Galleries, London, 70 'New Decade, The: 22 European Painters and Sculptors' (exhibition, New York, 1955), 163

New Tretyakov Gallery, Moscow, 313 Newton, Eric. 183

New York, 270-1

New York Times, 270

Nicholson, Ben: in Paris, 52-3; exhibitions, 64; at 1954 Venice Biennale. 151: Marlborough acts for. 180; in St Ives, 181

Nietzsche, Friedrich, 279, 296, 307 'Nineteenth and Twentieth Century Masters' (exhibition, 1966), 199 Nolde, Emil, 31, 69, 329n4

Nottingham University: FB retrospective (1961), 187 Nuremberg, 143

Obelisco, L' (gallery), Rome, 178 Observer (newspaper): reviews FB exhibitions, 130; profile of FB, 192–3 Oedipus and the Sphinx after Ingres (FB; painting), 338n4

Old Decanian (school old boys' magazine), 19

Oresteia see Aeschylus Orlovsky, Peter, 173

Orwell, George, 203-4

Orwell, Sonia (*née* Brownell; *later* Pitt-Rivers), 160, 203–4, 212, 233–4, 258; death, 291–2

Overstrand Mansion, Prince of Wales Drive, Battersea, 136, 161 Owen, David (later Baron), 256 Oxford, Edward Harley, 5th Earl of, 5

Ozenfant, Amédée: Foundations of Modern Art, 72

Painting 1946 (FB), 98, 101, 112–13, 115–16, 118, 127, 144, 163, 182, 191, 237, 314

Painting (1958; FB; earlier Pope with Owls), 176

Paris: FB moves to (1927), 30, 32–42, 232; FB revisits, 119, 257–61, 264, 278–81, 305, 312; FB attempts to work in, 124–5; low life in, 177; FB's admiration for, 232; FB acquires flat/studio in, 258–60; FB abandons flat/studio, 305; see also individual galleries and museums

Pasmore, Victor, 75

Pechstein, Max Hermann, 31

Pedro, Don (of Portugal), 4
Penrose, Roland: and 1936 International Surrealist Exhibition, 70–1; founds ICA, 163; catalogue text for 1956 Galerie Rive Droite exhibition, 164

Pergamon Museum, East Berlin, 311 Peter, Saint, 191 Petersfield, Hampshire, 84–5 Picabia, Francis, 38, 70

Picasso, Olga (Koklova; Pablo's first wife), 60

Picasso, Pablo: FB visits 1927 Paris exhibition of drawings, 36-7; influence on FB, 37-9, 50-2, 57-60, 62-3, 68, 71, 73, 86, 89, 100, 109, 126, 207, 219, 299, 318; and Christopher Wood, 53; and Marie-Thérèse Walter, 60-1: paints semiorganic forms, 60-2; in 'Thirty Years' exhibition (London, 1931). 62; in 1936 International Surrealist Exhibition, 70; London Gallery exhibition (1938), 86; and FB's Three Studies, 87–8; FB criticises later works, 89; and Crucifixion theme, 99; FB on 'jaded' look, 125; erotic representations, 161; public image, 162; admires catalogue of 1962 FB Tate retrospective, 192; accessibility, 195; and use of wealth, 202; Deakin photographs of, 210; historical references, 225; and bull-fighting, 228; Grand Palais retrospective (1971). 233; friendship with Leiris, 234, 261; portrait of Apollinaire, 322; Abstraction (series), 63; Baigneuses (series), 61, 64; Crucifixion, 61-2, 64, 109; The Dream and Lie of Franco (etching), 86; Guernica, 86, 88, 115; La Plage, 62; Study for a Crucifixion, 328n6

Picon, Gaëtan, 274

Picture Post (magazine), 85, 126, 129

Piper, John, 75

Pitt-Rivers, Michael, 203

Pitt-Rivers, Sonia *see* Orwell, Sonia Pittsburgh International Exhibition,

199

Pius XII, Pope, 141

Pollock, Jackson, 182 Pollock, Peter, 136

Pompidou, Georges, 235

Ponti, Carlo, 151

Pope III (FB; painting), 98

Pope with Owls (FB) see Painting

Pope, The: as subject of FB's art, 87. 98, 125, 129, 133, 139–42, 147– 8, 172, 191, 239 Popes (FB; series), 87, 98, 145, 147, 214, 308, 319 Positioning in Radiography (comp. Kathleen Clara Clark), 71, 224 Pound, Ezra, 105 Poussin, Nicolas: Massacre of the Innocents, 33-4, 36, 38, 85, 167 Présages, Les (ballet), 63 Prescott House, near Cheltenham, 18 Prometheus, 225, 227 Proust, Marcel, 107, 299-300; Sodome et Gomorrhe, 41 Pulham, Peter Rose, 84 Punch (magazine), 309 Quarter, The (magazine), 35 Queensberry Mews West, London. 45, 48, 51, 53-4, 57, 114, 162, 256 Quinn, Anthony, 168 Radiguet, Raymond, 133 Rauschenberg, Robert, 271 Rawsthorne, Isabel: FB attempts sex with, 17; as FB's friend and model. 160, 204-7; character and background, 204-5; FB portrays, 207-9, 213, 227–8, 302; friendship with Leiris, 234; introduces Dupin to FB, 263; death, 315

263; death, 315
Ray, Man, 36, 70
Read, Herbert: and 1936 International
Surrealist Exhibition, 70–1; encourages contemporary artists, 75; on
Picasso's *Guernica*, 88; *Art Now*, 64–
5, 68, 126
realism: FB defines, 306–7, 315
Redfern Gallery, London, 118
Redgrave, Michael, 89
Reece Mews, London, 162, 185–6, 200, 253–4, 290, 295, 318 *Referee, The* (magazine), 76
Regnier, Gérard, 318
Reid and Lefevre Gallery, London, 62
Rembrandt van Rijn, 226, 244, 299

Reverdy, Pierre, 234 Révolution Surréaliste, La (magazine). 34 Richards, Ceri, 50, 75 Richardson, John, 340n5 Rimbaud, Arthur, 133, 162-3 Riviera (Côte d'Azur): FB visits, 119-20, 123; see also Monte Carlo Robertson, Bryan, 54, 115, 124, 317 Roland Gardens, London, 254 Rome, 282-3; see also individual gal-Rosenberg, Paul (Paris gallery), 36–7. 53, 57-8, 232 Rothenstein, Sir John: hears of FB's upbringing, 15; and de Maistre, 49; relations with FB, 103, 112, 126, 187-8; encourages FB to write statement, 149; writes introduction to 1962 Tate catalogue of FB, 191-2 Rousseau, Theodore, 267 Royal College of Art, London, 135-6. 158-60, 332n15 Royal Hospital Road, London, 66, 73 Rubens prize: awarded to FB, 199 Rubinstein, Helena, 35 Russell, John: praises FB in reviews. 108, 145, 183, 193, 270; monograph on FB, 145, 199, 272; on FB's broken nose, 231; signature forged for 'authentication', 275 Russia, 313–14 Rutter, Frank, 76

Sackville-West, Vita, 74
Sade, Donatien Alphonse François, Marquis de, 58
Sadler, Sir Michael, 65, 67–8
Sainsbury Centre for the Visual Arts, Norwich, 319
Sainsbury, Robert and Lisa: collect FB paintings, 144, 166, 191; FB portrays, 166–7
St Ives, Cornwall, 181–2
Salon de Mai, Paris, 232
Sargent, John Singer, 207
Sartre, Jean-Paul, 107
Schurmann, Gerard, 164

Seated Figure (c.1936; FB; painting), Studio Interior (FB; painting), 68–9 Studio, The (magazine), 44-7 75 Seated Figure (1975; FB; painting), 269 Study for a Figure (c.1944: FB: Second Version (of Red Pope; FB; painting), 85 painting), 239 Study for Figure (1956-57;FB: Second Version of Painting 1946 (FB; painting), 178 painting), 239 Study from the Human Body (FB: painting), 315 Second Version of Triptych 1944 (FB; painting), 98, 314, 319 Study for the Human Body: Man Turning Self-Portrait (1930; FB), 52 on the Light (FB; painting), 333n5 Self-Portrait (1955; FB), 167 Study of the Human Body (FB; painting), Self-Portrait (1973; FB), 251 108 - 9Seurat, Georges, 225 Study for Man with Microphones (FB; shadows: in FB paintings, 238, 250 painting), 116 Shakespeare and Company, Paris, 36 Study for the Nurse in the Film 'Battle-Shakespeare, William, 279. ship Potemkin' (FB; painting), 167 299: Macbeth, 91 Study for Portrait (FB; painting), 147– Shepeard, Jean, 52, 320 Sickert, Walter, 75 Study for Portrait VII (FB; painting), Sinclair, Andrew: Francis Bacon, His 148 Life and Violent Times, 320 Study for Portrait IX (1957; FB; Six Studies for a Pope (FB; painting), painting), 178 191 Study for Portrait of Van Gogh (FB; Sketch for a Portrait of Lisa (FB), 167 painting), 168 Sleeping Figure (FB; painting), 269 Study for Van Gogh (FB; painting), 144 Smith. (Sir) Matthew, 149-50 Sturm, Der (magazine), 27 Soby, James Thrall, 148, 335n11 Stuttgart: FB travelling exhibition Soho, London, 155-8, 160, 177 (1985), 311South Africa: FB in. 136-8, 142, Sunderland House, Curzon Street. 200 London, 66 Soutine, Chaim, 37 Supple, Kerry, 8, 13, 15 Spain: FB visits, 312–13 Supple, Winifred Margaret (formerly Spear, Ruskin, 106 Firth; then Bell; FB's maternal grand-Spender, (Sir) Stephen, 160, 165, 183, mother; 'Granny Supple'): character, 187, 194, 204 7–8; close relations with FB, 8, 18, Sphinx I (1954; FB; painting), 150, 20; relations with husband, 15-16 Surrealism: effect on FB, 38-40, 42, 151 52, 57, 60, 71, 73, 107, 116, 174, Sphinx (FB portrait of Muriel Belcher), 291, 301 261, 278; International Exhibition (London, 1936), 70-1; and Cru-Stanford, William Bedell: Aeschylus in cifuxion theme, 99; Leiris and, 261 his Style, 82, 90–2 Stein, Gertrude, 282 Sutherland, Graham: design and dec-Straffan Lodge, near Naas, Co. Kildare, orative work, 45; at de Maistre's 20 studio, 50; relations with FB, 58, Studies after Velázquez (FB; painting), 103, 112-14, 124-7, 283; exhibited at Agnew's, 75; uses Sundeala Studies from the Human Body (FB; board, 87; introduces FB to Brausen, 113, 117; FB invites to share Paris painting), 238

studio, 119, 125, 256; on Côte d'Azur, 123–4, 126; religious faith, 125; crucifixion paintings, 126, 318; FB criticizes work, 126, 283; reputation, 127; influence of FB on, 163; Marlborough acts for, 180; Crucifixion, 126; The Deposition, 126 Sutherland, Kathleen, 114, 123–4 Swiss television: film on FB, 200 Sylvester, David: praises FB in reviews, 145, 163; FB portrays, 147; writes texts for FB catalogues, 151, 164; conversations and discussions with FB, 194, 263, 271–2, 279; Interviews with Francis Bacon, 271–4

Tangier: FB in, 124, 136, 153, 170–5, 176–7, 179, 217; Lacy in, 169, 171–2, 174; sexual freedom in, 169–71

Tate Gallery, London: 1962 FB exhibition, 15, 126, 188–92, 195, 223, 233; FB's *Three Studies* in, 92, 98, 109, 134; Hall presents FB paintings to, 134, 314; 1956 Giacometti exhibition, 206, 262–3; 1985 FB retrospective, 307–9; FB gives *Second Version of Triptych* 1944 to, 314; *see also* 'New American Painting'

Thomas, Dylan, 210

Three Figures in a Room (FB; painting), 233

Three Portraits (FB; painting), 251
Three Studies for a Crucifixion (FB; painting), 189, 223, 307, 319

Three Studies for Figures at the Base of a Crucifixion (FB; triptych), 43–4, 66, 70, 76, 83, 85–90, 92, 98, 101, 105, 108–9, 115–16, 134, 151, 237, 307

Three Studies of the Human Head (FB; painting), 150–1

Three Studies of the Male Back (FB; painting), 238

Three Studies for a Portrait of John Edwards (FB; painting), 286, 307 Time magazine, 126–7, 129, 148

Times, The: FB advertises in, 55;

reviews FB's exhibitions, 67, 142, 130; FB interview in, 298

Titian, 116, 148; Death of Actaeon, 246-7, 250

Titus, Edward, 35

Tokyo Museum of Modern Art, 301

Tooth, Arthur & Sons, London (gallery), 46

Train Bleu (restaurant), Paris, 239–40 *transition* (magazine), 36

Transition Gallery (Sunderland House), London, 66–8, 70

Tree by the Sea, The (FB; painting), 52

Trevelyan, Julian, 75

Triptych 1971 (FB; painting), 276

Triptych 1976 (FB; painting), 225, 277

Triptych August 1972 (FB; painting), 250

Triptych Inspired by the Oresteia of Aeschylus (FB; painting), 269

Triptych Inspired by T.S. Eliot's Poem 'Sweeney Agonistes' (FB; painting), 228–9, 237

Triptych May-June 1973 (FB; painting), 251, 276

Triptych May-June 1974, later retitled Triptych 1974–77 (FB; painting), 267–8

Turin see Galleria Galatea

Two Brothers (FB; lost painting), 52

Two Figures (FB; painting), 161

Two Figures in the Grass (FB; painting), 161, 163

Two Figures Lying on a Bed with Attendants (FB; painting), 237

Two Studies of George Dyer (FB; painting), 212

umbrella: as device in FB's work, 116–17, 173

Valentino, Rudolph, 29

Valéry, Paul, 110

Van Gogh in a Landscape (FB; painting), 173

Van Gogh series (FB), 167–9, 173, 178; see also Gogh, Vincent van

Vaughan, Keith, 159, 165
Velázquez, Diego: influence on FB, 103, 116, 129–30, 143, 299; in Rome, 283; FB visits Madrid exhibition, 312–13; joint exhibition with FB (1996), 319; Portrait of Pope Innocent X, 62, 125, 133, 139–41, 151, 168, 226, 319

Venice: 1954 Biennale, 151, 164; see also Museo Correr Victoria, Queen, 5 Villa Medici, Rome, 282 Voque (magazine), 145, 156, 163

Wadsworth, Edward, 52 Wallis, Nevile, 127, 144 Walter, Marie-Thérèse, 60–1 Warhol, Andy, 270–1 Watson, Diana (FB's cousin): relations with FB, 74, 115; buys FB work, 75, 109; death, 315

Waugh, Evelyn: *Vile Bodies*, 26, 156; requests FB painting for book cover, 165–6; Ann Fleming writes to, 187; FB dislikes, 292

Welles, Orson, 210

Wheeler's restaurant, Dean Street, London, 155–6, 158, 247, 293

White, Patrick, 47, 49–50, 54, 56, 69, 82

Whitechapel Gallery, London: exhibits Picasso's *Guernica*, 86

Wigoder, Basil, QC, 216

Wilde, Oscar, 211; Picture of Dorian Gray, 231

Williams, Dennis, 165

Williams, Tennessee, 170

Windsor, Edward, Duke of, and Wallis, Duchess of, 170

Wirth-Miller, Denis, 146, 255

Wishart, Michael: speculates on Jessie Lightfoot as FB's mother, 10, 55; on FB making up, 56; on FB's life-style, 104–5; on FB's appearance, 115; on FB's gambling, 123; on effect of Jessie Lightfoot's death on FB, 135

Witt, John, 188

Wivenhoe, Essex, 254-5

Woman in the Sunlight (FB; painting), 64

Wood, Christopher, 52-3

Woolf, Virginia, 74-5

World Review, 144

Wound for a Crucifixion (FB; painting), 67–8

Yacoubi, Ahmed, 174 Yeats, W.B., 299; 'The Second Coming', 168

Zervos, Christian, 38, 62 Zweig, Stefan, 27–8 Zwemmer, Anton, 62 Zych, Antony, 315

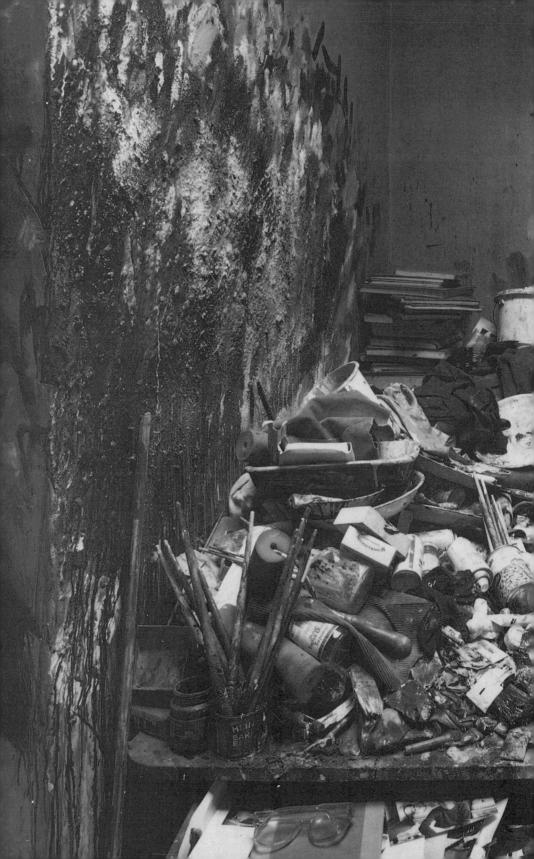